THE TROUBLED REPUBLIC

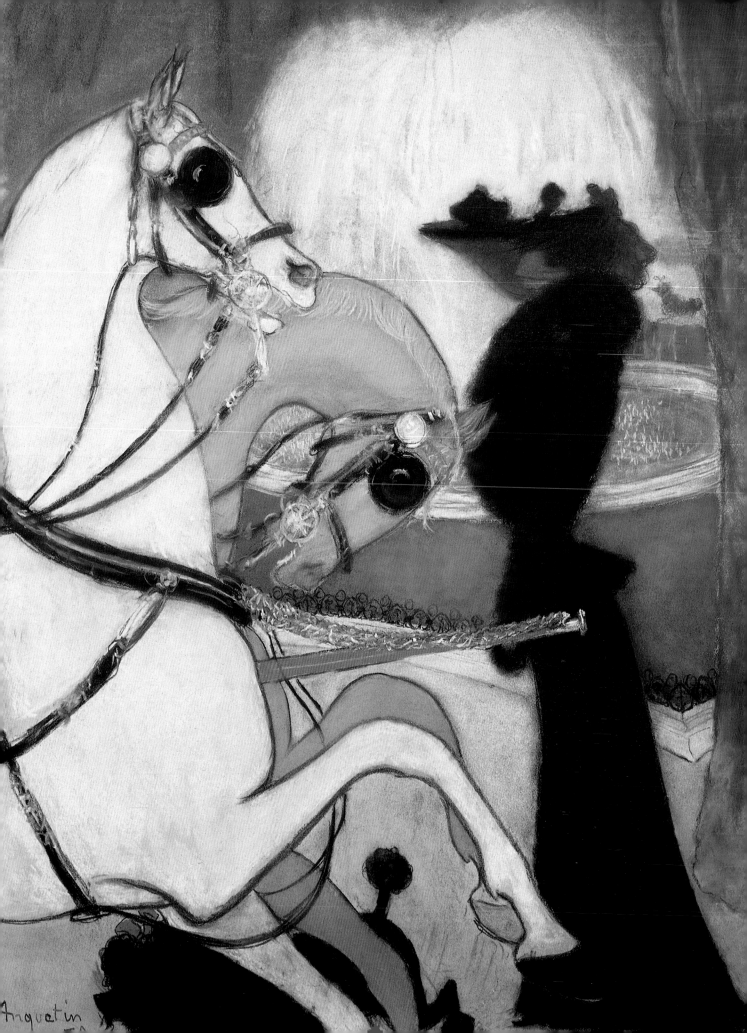

THE TROUBLED REPUBLIC

VISUAL CULTURE
AND SOCIAL DEBATE
IN FRANCE
1889–1900

RICHARD THOMSON

YALE UNIVERSITY PRESS
NEW HAVEN AND LONDON

Designed by Gillian Malpass

Printed in China

Library of Congress Cataloging-in-Publication Data

Thomson, Richard, 1953-
 The troubled republic / Richard Thomson.
 p. cm.
 Includes bibliographical references and index.
 ISBN 0-300-10465-0 (cl : alk. paper)
 1. Art and society–France–History–19th century.
 2. Art, French–19th century–Themes, motives.
 3. Eighteen nineties. 1. Title.
 N72.S6T49 2004
 700'.944'09034–dc22
 2004002267

A catalogue record for this book is available from
The British Library

Frontispiece Louis Anquetin, *Le Rond-Point des Champs-Elysées*
(The Roundabout on the Champs-Elysées), 1889.
Saint-Germain-en-Laye, Musée Départemental Maurice Denis.
Detail of fig. 29.

For Mark Francis, Richard Ritchie,

and in memory of Patrick Crawley

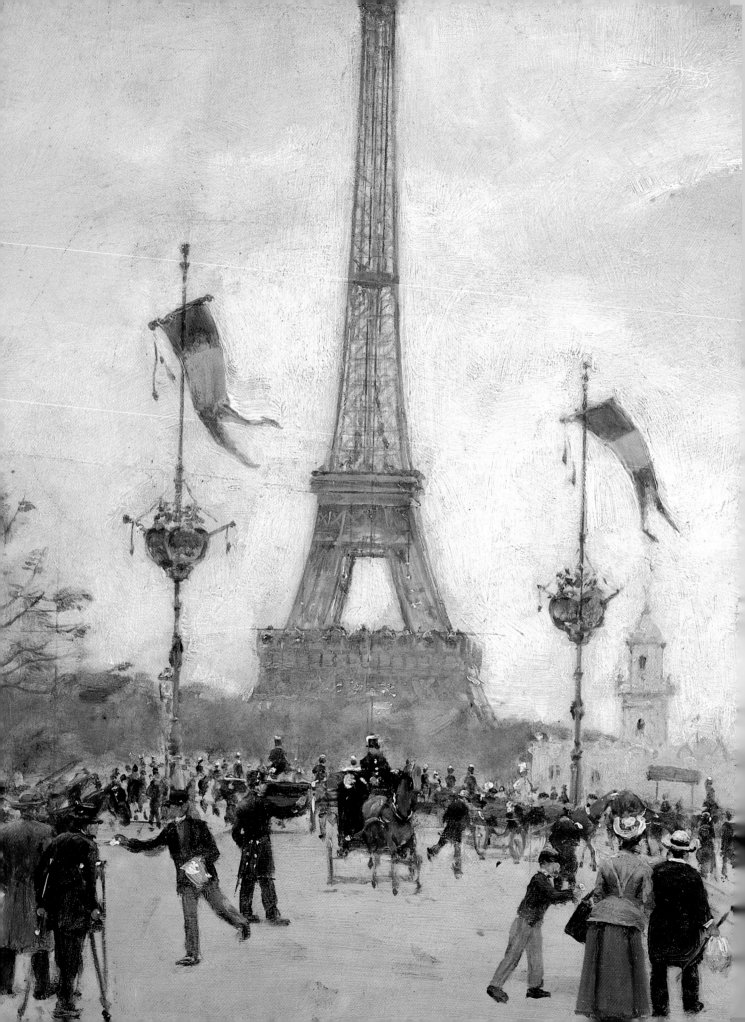

CONTENTS

facing page Jean Béraud, *L'Entrée de l'Exposition Universelle de 1889* (detail of fig. 66).

ACKNOWLEDGEMENTS

The germ of this book goes back a long way, probably thirty years to a January evening at Pear Tree Cottage and being swept up by Roger Shattuck's *The Banquet Years*. Starting work on Toulouse-Lautrec as a tyro art historian over twenty-five years ago I was struck by the fact that, apart from some of its major avant-garde figures, the 1890s in France has been an extraordinarily neglected decade in the history of art. It still seems to me that the literature tends to treat the work of a Monet or a Cézanne in that decade as part of the seamless continuity of their careers rather than as rooted in a particular moment in history. Equally, by that modernist account we still know and care very little about 'peripheral' figures such as Cottet and Carrière whose work was in fact a vital contribution to the art of the decade and deeply sited in contemporary debates. When working on the *Monet to Matisse* exhibition while on a Guest Scholarship at the Getty Museum in 1993, I began gathering information on the 1890s from a wide range of sources. That catalogue, published by the National Gallery of Scotland in 1994, has much material on landscape painting during the 1890s, which explains why that important theme is not featured in the present book.

I am extremely grateful for a Research Fellowship from the Leverhulme Trust which in 1995–6 enabled me to lay the foundations of research for this present book. I would like to express my warm thanks also to the Arts and Humanities Research Board for Research Leave in the Spring Term of 2001, during which a great deal of the writing was done. During its extended gestation the project has undergone a number of changes. It began as a comparison of Nancy and Toulouse at the end of the nineteenth century, taking two contrasting cities as case studies. This material I have published elsewhere. While the present book is a study of ways in which visual culture inter-related with historical processes and social problems during the 1890s, as work progressed I became increasingly interested in artistic style and social formation, and in how and why the avant-garde went through a relatively docile period during that decade in contrast to the competition and innovation of the 1880s and 1900s. That will be the subject of my next book.

I should like to acknowledge the helpful support of staff at the following libraries: the University of Edinburgh Library; the John Rylands University Library and Deansgate Libraries in Manchester; the Bibliothèque Nationale, Paris; the Service de Documentation at the Musée d'Orsay, Paris, and in particular to Dominique Lobstein and Monique Nonne; the Library of the National Gallery of Scotland and Penny Carter; the National Library of Scotland; the Witt and Conway Libraries of the Courtauld Institute, London; the Library of the J. Paul Getty Centre, Malibu: and the Library of the Jane Voorhees Zimmerli Art Museum at Rutgers University, New Jersey.

My debts of gratitude in the study of this field are extensive. Thanks must first go to Dennis Cate, for sharing his remarkable knowledge of the underbelly of the 1890s and

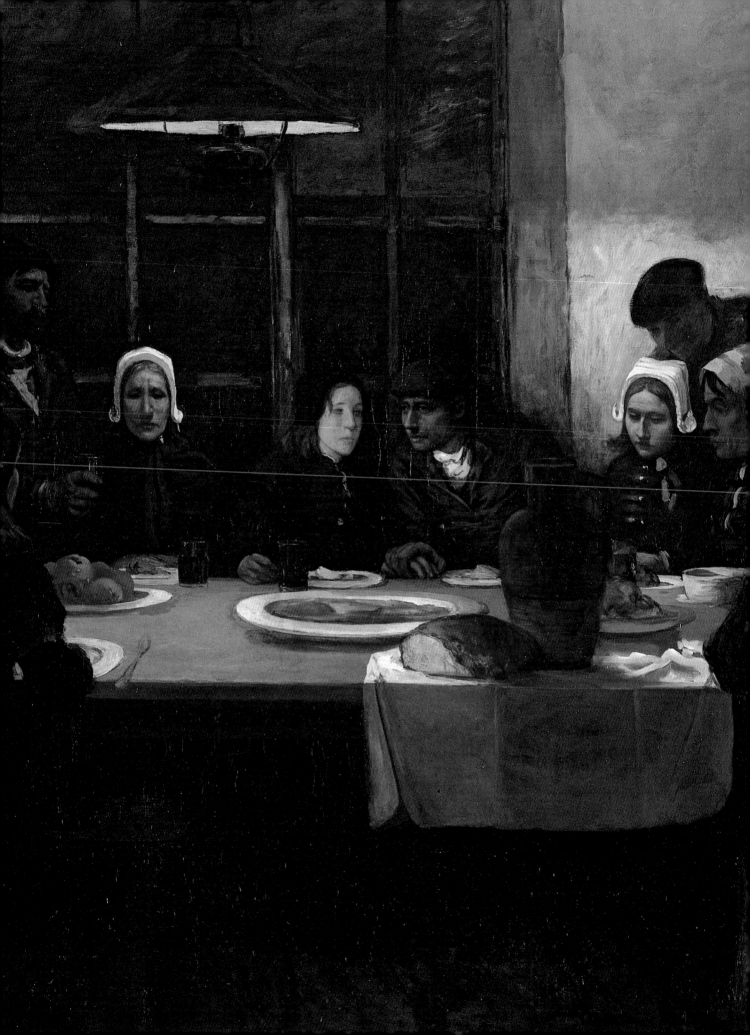

for his collecting instincts, so demonstrable at the Zimmerli. Under the aegis of the Visual Arts Research Institute, Edinburgh, over the last few years I have chaired a Research Seminar on France in the 1890s, and I should like to express my gratitude to my stimulating colleagues: Dario Gamboni, Neil McWilliam, Sîan Reynolds, Juliet Simpson and Belinda Thomson. In January 2001 Alain Schnapp, Philippe Sénéchal and Pierre Wat kindly invited me to lecture at the Institut National d'Histoire de l'Art in Paris, and arranged for me to see otherwise inaccessible works. I had fine colleagues – Claire Frèches-Thory and Anne Roquebert – while working on one Lautrec exhibition - and Mary Weaver Chapin and Dennis Cate – while working on another. Throughout France and elsewhere I have been kindly received by museum curators, private collectors and dealers – too numerous to mention – who have shown me works in their keeping. On these missions Matt Braddock did much of the driving.

For their help with pictures, ideas, arguments and the little bits of business that make up a book (except for the errors which are mine alone) I thank Lucile Audouy, Juliet Wilson Bareau, Laurence des Cars, Elizabeth Childs, Michael Clarke, Holly Clayson, Evelyne Cohen, Lizzie Cowling, Douglas Druick, the late Peter Ferriday, Frances Fowle, Pauline Gibb, Gloria Groom, June Hargrove, Cornelia Homburg, John House, Samuel Josefowitz, James Kearns, Richard Kendall, John Klein, Maurice Larkin, Patricia Leighten, John Leighton, Antoinette Le Normand-Romain, François Lespinasse, James McMillan, Alain Pougetout, Rodolphe Rapetti, Jim Rule, Marie-Pierre Salé, Herbert Schimmel, Peter Sharratt, MaryAnne Stevens, Peter Zegers and others I have obtusely neglected to mention. This is also perhaps an appropriate moment to thank those who taught me a generation ago: the late Francis Haskell, T. J.Clark, John Golding and Alan Bowness.

At Yale I have benefited greatly from the readers' useful comments, Laura Bolick's diligent pursuit of the illustrations and Katherine Ridler's tactful editing, and remain dazzled by the patience, good humour and intelligent taste of Gillian Malpass.

Belinda has shared it all with a scholar's love and a wife's criticism, and vice versa.

facing page Charles Cottet, *Le Repas d'adieux* (detail of fig. 112).

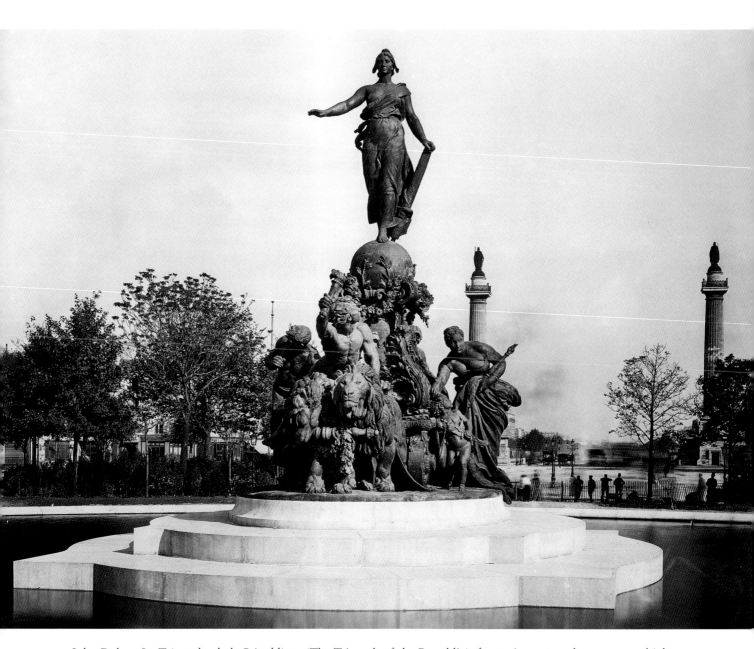

1 Jules Dalou, *Le Triomphe de la République* (The Triumph of the Republic), front view, 1899, bronze, 1200 high. Paris, place de la Nation.

INTRODUCTION

Let me begin with two completely contrasting works, as ranging shots. The double in-auguration in Paris of Jules Dalou's great sculptural allegory *Le Triomphe de la République* spans more or less the decade I am going to address. It was shown first in public on 21 September 1889, when the full-size plaster version was temporarily installed in the place de la Nation. The definitive bronze was not finally ready for un-veiling there until the last days of both the decade and the century, 19 November 1899 (fig. 1). Dalou's massive monument takes the form of a vast chariot, pulled by lions and surmounted by a globe upon which strides the figure of Marianne. Its progress is accompanied by Liberty, Justice and Labour, with Abundance following behind, broad-casting flowers from her cornucopia (fig. 2). This dynamic allegory is as confident in the Rubensian neo-Baroque of its swelling forms as it is in its Republican ideology. For this was public art with a public message, emphatically ideological at various levels. The date of its first unveiling commemorated the day of the establishment of the First Republic in 1792, and implicitly the deep-rootedness of its ideo-logical principles a century on.[1] In diverse ways the iconography of the sculptural group promoted the values of the Third Republic, whether a philosophical abstraction such as Liberty emblematised by the flaming torch, class equality via the proletarian figurative types, or practical goals such as education, prompted by a putto clutching books. The spectator needed only the most limited cultural literacy to recognise that Dalou's *Triomphe* should be read as progressive, its figures moving the Republic forward. Indeed, the group's placement – turned towards the *faubourg* Saint-Antoine, as though entering Paris from the east and heading for the place de la Bastille – was intended as a symbolic counter-part to the Arc de Triomphe in the west: the latter a monument to military might, the former to democratic strength.

Henri de Toulouse-Lautrec's *Salon de la rue des Moulins* could hardly be more different (fig. 3). Painted in mid-decade, it is the largest of the substantial group of canvases that Lautrec had devoted to brothel life in recent years. The foreground figure is life-size in relation to the spectator, drawing one into this apparently tranquil world of women. But it is a painting full of contradictions. One seems to be granted a fictional physical presence in the stuffy salon, with its crimson plush sofas and elaborate plas-terwork, seated at the same level as the prostitutes working in this smart brothel in central Paris. And yet for all the nonchalant confection of belonging, the canvas is obvi-ously painted: the underdrawing visible, the layers of medium thin, the contrivances of studio practice all too visible. Again, the women are represented as ordinary, undemon-strative, scarcely sexually enticing. And yet there to the side is a figure just sauntering into or out of the field of vision, chemise hitched above her buttock, suggesting some kind of action off. What makes this painting remarkable is the fluency of its draughts-manship, its precise observation of types and the humidity of its colour. But while

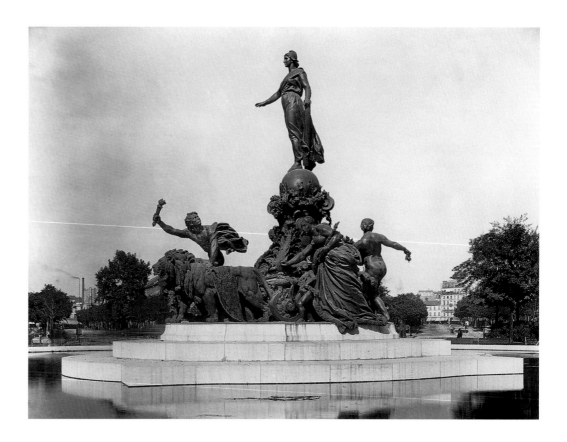

Lautrec's *Salon* has none of the demonstrative iconography of Dalou's *Triomphe*, this does not mean that it should be left unread. For this is an image of prostitution behind closed doors, confined within the *maison close* as the Third Republic's laws required. It deals with the control of sexuality, the reduction of impoverished women to whoredom, the channelling of disruptive male desires to where they can ostensibly do least harm. These may be the social functions that Lautrec's scene depicts; they do not disguise the artist's ability to infuse them with melancholy, humanity and even a sense of the ridiculous.

Here is a matrix of contrasts. One contrast is that of medium – in this case between sculpture and painting – which will be endemic in this book. Another is that of style. Dalou's *Triomphe*, grand of gesture in its neo-Baroque and naturalist in the frankness of its forms, was typical of the legible grandeur favoured by the establishment of the Third Republic. Lautrec's economy of line, ample zones of colour and undisguised craftsmanly activity were consistent with more avant-garde practice. A further contrast is that they were works of art for different publics and purposes. Dalou's monument was designed to be seen, if not noticed, by the tens of thousands who would pass it every day. Just seeing the *Triomphe* meant you remained a passer-by; but noticing it reminded you of your status as *citoyen de la République*. Lautrec's painting, for its part, would have been seen by a few friends in his studio and possibly by those who attended his one-man show at the Galerie Manzi-Joyant in January 1896, though not all visitors were allowed access to the more *risqué* paintings and it is not known for certain if the *Salon de la rue des Moulins* was even included. Dalou's sculpture was pitched at the

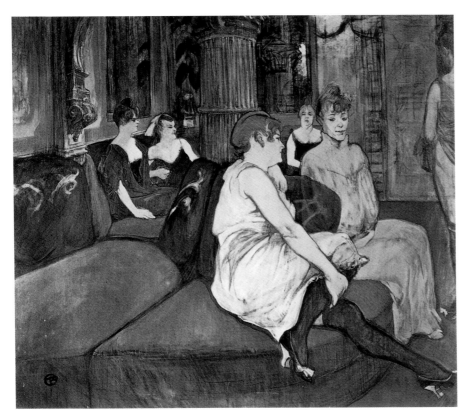

2 (*facing page*) Jules Dalou, *Le Triomphe de la République*, side view, 1899, bronze. Paris, place de la Nation.

3 Henri de Toulouse-Lautrec, *Le Salon de la rue des Moulins* (Salon at the rue des Moulins), *c.*1894, charcoal and oil on canvas, 111.5 × 132.5. Albi, Musée Toulouse-Lautrec.

public, whereas Lautrec's painting was of a private world, displayed in private. There is a contrast of reputation, too. By 1900, when my book closes, Dalou's sculpture was celebrated while Lautrec's painting was obscure. In 2000, as I planned the book, Lautrec has a canonical place in the history of modern art, while Dalou has long been a neglected figure.

Crucial to both these divergent works, however, is the representation of the human figure. Of course, the figure had for centuries been the fundamental element in artistic training as well as the standard form with which painter or sculptor sought to convey their skills. But because the body is inescapably at the core of our experience of the here and now, its representation reveals much about the textures of history, about social order, personal behaviour and *mentalité* in a particular society. How Dalou and Lautrec dealt with bodies in their two works intersects with issues and debates in the Third Republic of the 1890s. The figure of Abundance which follows the other figures in Dalou's *Triomphe* is wide-hipped and fully fleshed, an apt image of female fecundity in a nation fearful of its stagnant birth rate. His Marianne atop her globe is a stirring image of the Republic of modern France designed to replace the Virgin of the Assumption on her crescent moon, symbol of Catholicism and the *ancien régime*. Lautrec's docile prostitutes coalesce into the controlling system set up for them by a heterosexual male establishment as eager for furtive sexual conveniences as to protect family morality. The woman with her hitched-up chemise may be about to submit herself to a medical inspection: is she the beneficiary of the progressive Republic's commitment to science to protect its citizens or the victim of an oppressive system of state supervision? In the event,

4 General view of the 1889 Exposition Universelle.

Dalou's *Triomphe* served its purpose as an iconic monument. The ceremony of its in-auguration in November 1899 came a couple of months after the re-trial of Captain Dreyfus on charges of spying for Germany. Passions were running high. A crowd of 250,000 gathered, but the occasion passed off peacefully. A contingent of 1600 workers carrying their tools like the figure of Labour in the *Triomphe* took part in the parade, along with co-operatives, professional societies, trade unions and university associations. It was an organised crowd, in contrast to the rioting mobs from the right which had tried to stage a *coup d'état* in February that year. Health and decadence, Republic and religion, crowds and control, anti-German nationalism: these issues preoccupied France in the 1890s, and all interplay with the two contrasting works with which I have begun.

Current understanding of France during this period can be seduced into a set of assumptions and clichés. Political historians can focus on the convoluted shifts of political personnel that characterised the apparently incessant instability of the Third Republic's governments, or they can turn their spotlight on moments of high drama, the lethal terrorism of anarchism's 'propaganda by deed' early in the decade or the vicious divisions of the Dreyfus Affair which closed it. Cultural historians tend to consider the 1890s as the apogee of Symbolism: the apotheosis of Mallarmé and Verlaine, the emergence of new theatrical languages, the seedbed for Proust and Debussy. Art his-

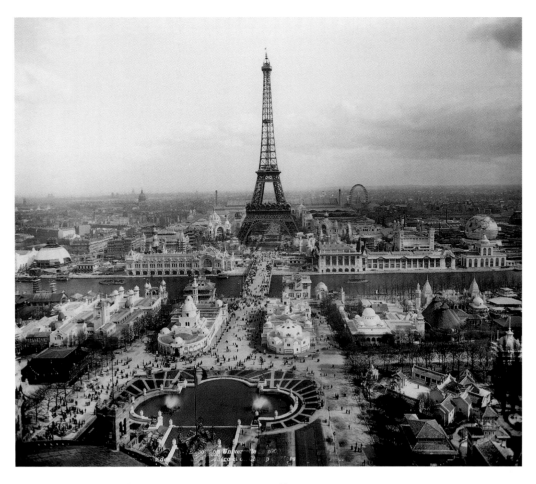

5 General view of the 1900 Exposition Universelle.

torians either neglect the decade as a fallow period between the great innovations of the 1880s and the 1900s or treat it partially, often as another phase in the work of an already established avant-garde master. French contemporaries themselves must take some blame for the buoyancy of such generalisations. Theirs, after all, were the terms *fin de siècle* and *la belle époque*. But here, if one gives the merest attention to these terms, one begins to encounter deeper and trickier currents. For these are terms of mood, not historical analysis. Nevertheless, they hint at real historical issues below the surface of the glib encapsulation. *Fin de siècle*, one might say, carries with it implications of weariness at the end of a century's long haul as well as some anxiety about what the next century might bring. *La belle époque* resonates with a self-satisfied bonhomie and nostalgia, neither of which one can believe were universally shared. This book leaves both terms aside.

The time span of this book is framed by two Expositions Universelles. That of 1889 was staged to celebrate the centenary of the outbreak of the French Revolution; in that sense it was an affirmation of the Third Republic's historical roots (fig. 4). As events transpired, it served to paper over the cracks in the Republic's authority, for the January elections that year had seen massive support for the charismatic General Georges Boulanger, whose potent if incoherent brew of nationalism and social reform threatened

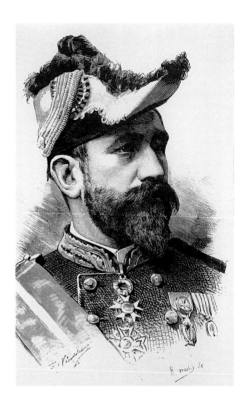

6 *General Boulanger*, c.1888. Paris, Musée d'Orsay.

the political centre (fig. 6). Although Boulanger baulked at a coup, fleeing to Brussels in April, the momentum behind his name remained, and the opening of the Exposition in May allowed a relieved government to distract public attention from fractious politics. In the year 1900 another Exposition Universelle was mounted, this time to celebrate the new century (fig. 5). It too had political ramifications. On the one hand, it had been necessary for Paris to see off Berlin's bid to stage a great world's fair during that beacon year. On the other, the festering sore of the Dreyfus Affair had erupted in 1899. Huge crowds had demonstrated both for and against the Jewish army officer wrongly condemned for treason; two coup attempts had foundered; and Dreyfus himself had accepted a pardon. The opening of the Exposition in April 1900 was yet again an opportunity for the French Republic to present the watching world with a united front, a mask over deep divisions.

If the two Expositions Universelles used culture to veil social and political flaws, cultural forms could also be used to expose or exacerbate frailties in the body politic. For the Third Republic in the 1890s was fraught with divisions and problems, tensions that nevertheless polarised rather than fragmented the nation. The Republic had been born in September 1870, as the Second Empire collapsed under an invasion of German states led by Prussia. Humiliating defeat in the Franco–Prussian War exposed the weakness of the French military and established on the eastern flank of the *hexagone* a united Germany rendered more powerful by France's forced cession of Alsace and much of Lorraine. The fledgling Republic had asserted its authority in May 1871, by suppressing the Paris Commune which, with similar uprisings in other cities, menaced the new regime with the threat of a radicalised mass proletariat. It was only in 1879, with the election of the genuinely republican Jules Grévy as president, that the Republic came of age as a reforming regime, within a few years lifting censorship, liberalising the divorce laws and legalising the trade unions. To some such changes seemed dangerously progressive, the Catholic Church, for example, dogmatically resistant to the laicisation of education and the new divorce legislation. But to others reform seemed sluggish and partial, the Republic unwilling radically to address *la question sociale*, the matrix of labour problems encompassing working hours and conditions. By the 1890s there were deep fissures. Paris and the large cities were the domains of the dominant bourgeoisie, spread across a spectrum of the subtly differentiated *couches sociales*, an agglomeration of the middle classes which generally supported the Republic but was troubled by a rising socialist tide which won 600,000 votes in the 1893 elections. Socialism had begun to coalesce within the large proletariat that serviced the cities, from the textile towns of the north to the Mediterranean ports in the south, and manned the industrial and mining towns such as Carmaux, Saint-Etienne and Le Creusot. Also antagonistic to the stolid Republican power base on the far left were, for instance, the anarchists, be they the 100,000-odd intellectual sympathisers critical of the regime or the insurrectionary handful whose campaign of terrorist violence horrified Paris in the early nineties and culminated in the assassination of President Sadi Carnot in 1894.

The left was matched by the right as a subversive force. Boulangism survived the disappearance of its figurehead, mutating into an aggressive nationalism which, under the leadership of men like Paul Déroulède, motivated mass support against a revision of the Dreyfus case and in favour of a war of *revanche* (revenge) against Germany to reclaim the lost provinces. Elements of the right also coalesced around the Church. Some Catholics would have no truck with the *République laïque*; others sought an accommodation though the Ralliement, launched in 1890. Pressures upon the Republic from within were matched by others in foreign relations. As the decade began France, despite an energetic programme of colonial expansion, was without allies. This perpetuated her weak position vis-à-vis Germany. With the signing of the Franco–Russian defensive alliance in 1894, France's place among the Powers took on a more confident complexion. These were large patterns of political and social change, taking place under the public gaze. Underlying them were other pulses, discreet but insistent, troubling the national identity. Was France in a state of moral and physical degeneration? Was ordered society under threat from the populations now massed in modern cities? Did religion have any role in a modern nation? Could France ever reclaim Alsace-Lorraine?

There were various ways of coping with such questions, of diagnosing problems, of articulating solutions and beliefs. A persistent factor in the national *mentalité* was fear. 'We are afraid. We are afraid of everybody, and everybody is afraid under this regime', wrote Guy de Maupassant in 1889: 'Fear of the elector, fear of cities, fear of the countryside, fear of majorities', and fear of newspapers and the opinions they voiced.[2] Fear and anxiety created a pervasive *mentalité*. They ran throughout society, from an aristocracy that had lost its political power, through a bourgeoisie that feared its grip on power might be wrested from it by a Boulanger or the mob, to the lower middle classes squeezed between big business and rising socialism and the lower classes for whom impoverishment and forces of order were twin shackles against their desire for social improvement.[3] Fears were raised by the nation's self-diagnosis of its own decline, traced by diverse opinions to causes as various as declining birth rate, atheism, sexual behaviour and alcohol abuse. If France was afraid of private vices, it was also suspicious of public gatherings. Although the Republic had liberalised the laws of assembly in 1881, it was still a requirement to register all public meetings and the numbers attending with the police, while dates were only changed with difficulty. This had its effect on cultural life. The Théâtre de l'Oeuvre, for instance, set itself up as a club on a subscription basis to provide greater freedom, and creative groups clustered in public places such as cafés and cabarets where association was permitted or in private homes; the use of Paul Ranson's apartment on the boulevard du Montparnasse as a rendezvous for the Nabis group may have been as much for artistic independence as for comfort.

A more positive *mentalité* was the scientific cast of mind that inflected the thinking of the educated classes. The Republic, distancing itself from the 'superstitions' of its ideological rival the Church, set great store by its progressive and scientific rationalism. During this period France made great strides in science, technology and the social sciences, with figures such as the bacteriologist Louis Pasteur, the engineer Gustave Eiffel and the sociologist Emile Durkheim becoming national figures, even heroes. In particular, it was the ideas of an Englishman, Charles Darwin, which by the 1890s had entered not just academic thinking but also the public imagination. The notion of existence as an evolving process, a 'struggle for life', the inevitable success of the strong and the failure of the weak, with the positive prospect of upward evolution and the nega-

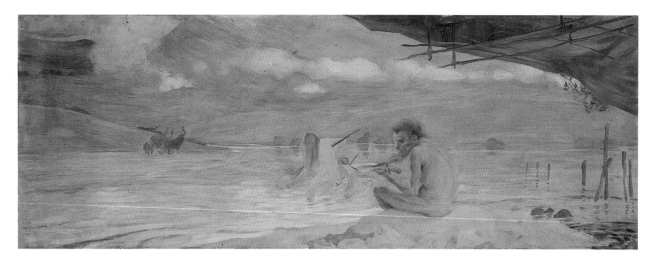

7 Albert Besnard, *L'Homme préhistorique* (Prehistoric Man), study for the work in the Ecole de Pharmacie, Paris, completed 1887, oil on canvas, 50 × 110. Private collection.

tive one of downward decline, of decadence, had an uncomfortable resonance in a nation which had recently lost a major war and whose birth rate was troublingly feeble. Matthias Duval's course for the Ecole d'Anthropologie, published as *Le Darwinisme* in 1886, assured students that the evolutionary analysis was applicable to all fields, and, indeed, the journalist Jules Huret's 1891 literary *enquête* for *L'Echo de Paris* was predicated on the notion of a 'struggle' between naturalism and symbolism in contemporary writing.[4] Although Darwin's views on evolution were challenged or differently angled by other scientists, in the public mind it was his name that was attached to the general grasp of evolutionary thought. Darwinian allusions were common coin in the 1890s. The German doctor Max Nordau's 1892 attack on modern French culture not only took its title – *Degeneration* – from Darwin but even its insults; quoting Huret's description of the poet Stéphane Mallarmé's faun-like ears, Nordau speciously brought in the English scientist as an authority to identify such features as simian and criminal.[5] Everyday thought was permeated with such allusions. Proud of his fitness gained on military service, Gabriel Trarieux wrote to his friend Maurice Denis saying he was 'well muscled and well up for my "struggle-for-life" this winter (modern style)', while Claude Monet's letter of 1890 to the Ministre des Beaux-Arts, officially offering the French state Edouard Manet's painting *Olympia* (1863, Paris, Musée d'Orsay), purchased by subscription, spoke of the 'hostilities' surrounding Manet's career, the 'war' against him, and how he was 'the representative of a substantial and fecund evolution'.[6] Some artists and writers had even read Darwin – Eugène Grasset and Francis Jammes among them – and it was inevitable that his scientific concepts found visual form.[7] Albert Besnard's murals for the Ecole de Pharmacie, contemporary with Duval's text, contrasted two central panels. In the first prehistoric man and his family, naked and hirsute, fish by their crude shelter; in the second *l'homme nouveau* ('modern man') sits book in hand on a terrace overlooking a busy port (figs 7, 8). The contrast is evidently evolutionary, but Besnard seems to convey a degree of ambivalence; *l'homme préhistorique* is physically active in a more verdant environment, while the reflective lassitude of his modern counterpart is matched by a more violet, artificial tonality.

8

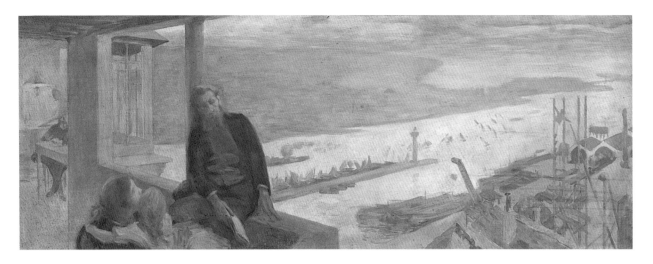

8 Albert Besnard, *L'Homme nouveau* (Modern Man), study for the work in the Ecole de Pharmacie, Paris, completed 1887, oil on canvas, 51 × 133. Beauvais, Musée départmental de l'Oise.

France in the 1880s and 1890s was at the forefront of advances in psychology, a relatively new branch of medical science. Doctors were exploring and categorising the secret workings of the mind, and their specialised results – in an age preoccupied with scientific progress and with the daily press keen to advertise advances – soon entered the public domain in popular form, just as Darwinian notions did. As concepts from psychology infiltrated the way people explained the world around them, so by return were interpretations of external reality voiced in terms of mental solutions. Thus when Paul Flat spoke of decorative painting – such as Besnard's – in his review of the 1893 Société Nationale des Beaux-Arts (SNBA) he insisted that such work was 'a part of our modern minds [*âmes*], rich in psychological complexities and refined feeling'.[8] Psychology and modernity went hand in hand.

The *psychologie nouvelle* 'explored the human organism as a febrile, mechanistic system of nerves'.[9] One of psychologists' main interests was to analyse the ways in which the inner workings of the mind were affected, even controlled, by other stimuli, whether from the patient's physical condition or from external sources. Dr Hippolyte Bernheim, a key figure in the Nancy school, held that all individuals are susceptible to hypnosis, while Jean-Martin Charcot, professor at the Salpêtrière mental hospital for women in Paris, countered that susceptibility was not universal but depended on personal psychopathology.[10] The broader social and cultural importance of such professional debates among medical specialists is that the issues raised by the dissemination of their researches seemed to reach out to many of the wider problems of contemporary France. Doctors increasingly diagnosed modern psychological problems in terms of modern social conditions and vice versa. Charles Richet's book *Le Surmenage mental dans la civilisation moderne* (Mental Overexertion in Modern Civilization) (1890) blamed the deleterious effect of contemporary urban existence, resulting in excessive stress – *surmenage* – on the nervous system, while Fernand Levillain's *La Neurasthénie* (Neurasthenia) (1891) argued that this hyper-nervous condition prevalent in the metropolis affected all classes, a democratic neurosis. Both were colleagues of Charcot.[11] Inevitably this kind of thinking affected the way art was made and discussed. The 'modern' man in Besnard's

Ecole de Pharmacie mural one might diagnose as suffering from *surmenage*. Léonce Bénédite's purview of the pictures at the 1898 Salons is also a case in point, a hybrid of Darwinism and psychology. 'What an incoherent and agitated world have we descended to! What an Olympus of the Salpêtrière or Bicêtre! ... Everything is in a sort of general Saint-Guy's dance. Here a group embrace effusively; there a little woman risks letting everything go; further off a big lad wields a heavy axe, while a soldier ... points his revolver at you ... It's a non-stop ballet of epileptics and lunatics.'[12] In such a context Albert Aurier's interpretation of Vincent van Gogh's art seems less unusual. By referring to him as 'a fanatic ... almost always classifiable as pathological ... a hyperaesthetic, exhibiting all the symptoms, perceiving with abnormal intensity', the critic cast van Gogh as a better artist for his apparent mental instability.[13] Aurier in 1890 was using up-to-the-minute ideas from a scientific discipline to define a modern art-critical typology, the artist as *névrosé*. And by so doing he was casting himself as a particularly modern critic, able to diagnose the condition; he had, in fact, studied texts from scientific and sociological fields, notably criminology.[14] The currency of the *psychologie nouvelle*, both at professional and popularised levels, typified more than modernity's scientific inflection. Its adaptation into the public domain – into the understanding of mass political movements, criminology or art criticism – as well as into the private – into female suggestibility and sexual attraction – was symptomatic of broader patterns of tension and struggles that characterised the 1890s.

Public and private lives were both forced to respond to the widely perceived increase in the pace of life during the 1890s. As the decade began the writer Marcel Schwob complained that 'we live in a terrible century where there's hardly time to think any more.'[15] People's relationship with the physical environment was speeding up. In a century that had begun at the speed of the step of man or horse, change had come with the spread of the railways in mid-century. But the transport revolution took a new leap in the 1890s. Begun in 1898, the Paris Métropolitain opened with the 1900 Exposition Universelle and carried fifteen million passengers in its first year.[16] Mass public transport underground was matched by another 'democratic' development on the roads: the bicycle. But the impact of the bicycle was soon shared with the automobile, an élite form of transport even more geared to the modernity of momentum. In the *Paris-Almanach* of 1897 Charles Morice rang out the technocratic anthem 'Laissons cycler, et nous, qui sommes dernier cri, *automobilisons*!/Voilà! Les concours d'automobiles! Voilà qui est bien moderne!' only to go on to bemoan the noise and smell of the motor car, that 'amputee carriage', and hope that artists would soon be employed to ameliorate the ugliness of its design.[17] The public presence of the car grew rapidly in the nineties – founded in 1895 with 25,000 members, by 1900 the Touring Club de France had quadrupled in size – and, as with the bicycle, visual forms were mobilised to puff its modernity.[18] Equating the fashionable woman with the motor vehicle and the Eiffel Tower, eliding engineering, chic and speed, Clouet's poster for the 1895 Exposition de Locomotion Automobile was an early example of this lasting commercial gambit (fig. 9). Using the *tricolore* to link Paris and Bordeaux, between which a race was staged, the artist conveyed the national dimension to the new pace of life.

While for some the impact of new technologies and the changes to the pace of life they brought was exciting, to others it was troubling. Anxieties about 'Americanisation' manifested themselves in forms as varied as caricatural verse and art criticism. The humorous Montmartrois poet Raoul Ponchon satirised the ideal city of the progressive

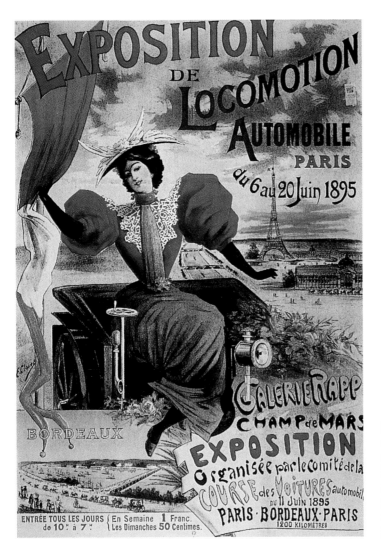

9 E. Clouet, *Exposition de Locomotion Automobile* (Exhibition of Motor Car Transport), 1895, colour lithograph, dimensions unknown. Chaumont, Maison du Livre et de l'Affiche.

municipal councillor. He fantasised about a totally tarmacadamed city crisscrossed by trams and trains, sewers showing their efficiency through transparent piping, and tubes, rails, wires everywhere: all because Lutetia must not fall behind Chicago.[19] The critic Thiébault-Sisson, reviewing the 1897 Salons in the new periodical *Art et décoration*, bemoaned the modern condition: 'At present, we live at double speed. Our increased activity is matched by a heightened nervous diathesis. We must have everything, straight away, at hand.' Damning the intrusion of telephones and the *théâtreophone* into the home, predicting that typewriters would become prevalent and that people would soon be able to telephone the police from home – as in the U.S.A – his prognosis was a descent into tasteless utilitarianism.[20] Thiébault-Sisson's objection was the intrusion of modernity into the private domestic world, the result of which was neurotic disorder. Modern pressures brought modern symptoms. Modernity, then, is crucial to an understanding of the 1890s, a modernity at once anxious and confident, cautious and expansive.

The kind of multifaceted and paradoxical character that I take to characterise France between 1889 and 1900 might also be taken as symptomatic of the Republic itself. The Republic was a broad church, with widespread if sometimes truculent political support.

But its somewhat sprawling, even occasionally shambolic nature was more stable that it appeared. It did not fall to Boulangist nationalism, cave in to socialism, revert to monarchy or collapse at the Dreyfus Affair. It survived myriad changes of government and the Panama Scandal's revelations of corruption among the governing élite. Now a generation old, by the 1890s the Third Republic had achieved, perhaps *faute de mieux*, a bulky centrality in the life of the nation. Even those whose allegiances diverged from mainstream republicanism nevertheless were prepared to advance their ideological imperatives within the Republic's framework. This applies as much to the *revanchard* nationalist Déroulède, for instance, or the devout Catholic artist Maurice Denis as to the radical art critic Gustave Geffroy on the left: all figures to be encountered in the chapters that follow.

Visual culture was central to the necessary business of promoting the values of the Republic, of instilling them in *citoyens* old and young, and in seeing off the imagery of rival ideologies. This promotion of the Republic's identity took many forms, all of which will be met in this book, from monumental sculpture and public decorations to portraits of leading figures and types characterising the workaday French man and woman. The regime commissioned such work for municipal parks and buildings, purchased them for its museums and distributed them around the country. Authorised images were circulated in printed or photographic form to schools and government offices. The initiative with most universal effect was the minting of a new coinage. Roger Marx, the Inspecteur des Beaux-Arts who was one of the project's leading lights, had the vision of a work of art in every Frenchman's pocket.[21] Oscar Roty's design for the franc pieces, appearing in 1895, represented the gracefully heroic embodiment of the Republic, Marianne, sowing the seeds of the future before a rising sun (fig. 10). Dynamic in image and democratic in circulation, Roty's coin, constantly to hand, was the paradigmatic example of the Republic's use of the visual to promote its ideology.

Visual culture was created round, and was complicit with, republican ideology. It was also developed in reaction to that ideology. But this was not just a case of pro and contra. France was faced with complex debates for which there were no clear conclusions. Visual means were a way of making arguments, promoting positions, attempting to achieve consensus. The visual was central to public debates. However, current art-historical writing on the 1890s, with very few exceptions such as Paul Tucker's work on Monet's series paintings, makes little attempt to explore the complex exchange between the making of art and the social and political concerns of the period. Equally, the often excellent historians working on the period – among them Eugen Weber, Christophe Charle and Christophe Prochasson – scarcely bring pictorial evidence into play in their cultural analyses. My purpose in this book is to establish some lines of communication between the two fields.

To do so I have taken several crucial public debates in 1890s France and studied them through the filter of visual culture. I have attempted to get some purchase on the decade's sense of modernity by exploring four social problems widely aired in contemporary discourse in relation to the imagery that formed part of such discourse. This approach is based on the belief that imagery is integral to social debate, and my endeavour has been to adumbrate ways in which this complex, subtle and truculent process functioned

10 Oscar Roty, Maquette for the 2 franc piece, 1898, plaster, dimensions unknown. Paris, Musée de la Monnaie de Paris.

in 1890s France. The first chapter deals with issues surrounding the body. France was worried about the fitness of the national body, about the stagnant birth rate, about male virility and female fecundity. Physical health and – necessarily if often reluctantly – sexual behaviour were central to social debate. They were also central to art. Painters and sculptors learned their trade on the human figure, and – unless they gave it up by becoming a landscapist or decorative designer – the body remained the pivot of their work. By representing it, they touched on, even engaged in, debates about degeneration, sexuality or public health. The theme of the second chapter is the crowd. During the 1890s widespread dissemination of theories about the urban crowd took place, concepts generated to comprehend mass unrest in the past and to learn how to control it in future. A common view was that the crowd can act as a single body, a concentrated threat to public order and even the Republic itself. Robert Nye, Susanna Barrows and others have admirably analysed anxieties and their diagnoses. But, as yet, there has been scant assessment of how contemporary theories about crowds may relate to the ways in which crowds were represented pictorially. Once again, the antagonism and rapprochement between the Republic and the Catholic Church during the 1890s has been carefully studied by historians such as John McManners and Maurice Larkin, and in this case Michael Driskel has initiated art-historical study of this tension. The intensely fraught dialogue between these rival systems of belief was richly manifested in visual culture, as the third chapter demonstrates. The final chapter examines nationalism and militarism, and in particular the notion of *revanche* against Germany to reconquer the lost provinces of Alsace and Lorraine. There is consensus among conventional historians that *revanche* was only a marginal preoccupation by the 1890s, maintained by a minority of nationalists in the face of predominant public and political apathy. But, using evidence drawn from visual culture, I argue against this consensus, contending that such material makes a strong case for more widespread public, and even establishment, support for *revanche*.

These debates are various in their subjects, and so too is the material I shall bring into play. But these pressing national concerns are linked also by certain consistencies. On the one hand, the chapters about the crowd and *revanche* are concerned with highly public issues, although ones that had an impact on private lives. On the other, issues relating both to the body and to religion were often deeply private matters brought into the public domain. Sexual matters in particular were intimate and secret, and evidence is difficult to discover and assess. I have tried to approach these matters frankly and without prurience, taking images and textual material accessible to other scholars but trying to suggest how they might be written about in new ways. In trying to phrase my writing differently I have given attention to the moral as well as the sexual, in the belief that sensitively textured history should avoid neither as both are lodged in the fabric of people's lives. Probably few will quibble at a high-minded account of Charles Cottet's noble triptych *Les Adieux*. But I hope that an interpretation of some of Degas's pastels, which reads compositional decisions and mark-making in moral and psychological terms instead of reductive modernism, offers a challenging new departure. Although I could have selected other debates in France during the 1890s – about the role of women, labour conditions, anti-Semitism, colonialism or the dialogue between city and country – the four chosen are, I believe, crucial and symptomatic. Perhaps the themes I selected in some way resonate with my own forebears in Britain during the 1890s whose concerns and professions – as regional gentry, farmers and shopkeepers; a nursing sister, a

Guards officer and a Doctor of Divinity – paralleled those of their French contemporaries discussed here. In the final analysis, I have written about issues of public and private behaviour and belief, as articulated visually.

The book deliberately, indeed necessarily, covers work in a wide range of media. Although paintings of various size, style and purpose predominate, the following pages touch on monumental sculpture and cane handles, song sheets and furniture, photographs, posters and caricatures. It seems to me that this is an entirely appropriate range for the 1890s. This was, after all, the decade when young artists such as Denis, Pierre Bonnard or Toulouse-Lautrec made little or no hierarchical distinction in their production of paintings, posters, book illustrations or stained glass. The SNBA, from its schismatic foundation in 1890, vaunted its modernity by displaying the decorative as well as fine arts, unlike its more conservative rival, the Salon des Artistes Français (SAF). New technologies allowed photographs and coloured images to be printed in books and periodicals alongside the usual line drawings and lithographs, and art dealers such as Boussod & Valadon made it their business to have interests in magazine publishing as well as picture galleries. More than ever, imagery was everywhere. While one must acknowledge that a sculpture requires to be looked at differently from a painting, and a large-scale mural has a different physical presence and evokes different aesthetic responses from a cartoon in a newspaper, widely varied kinds of visual experience could and did contribute to an understanding of the modern world. In terms of how French men and women during the 1890s absorbed and articulated a great diversity of opinions about the debates of the day, the image in its multitudinous forms helped shape their view of the world. For images, after all, were manifestations of *mentalité*, and their very plurality of visual language, size, price, rarity or universality ensured that issues articulated visually reached across all levels of society.

My arguments thus implicitly but emphatically understand the making, dissemination, interpretation and comprehension – or miscomprehension – of images of all kinds as central to the functioning of a modern society. Art in its multiple forms was part of the currency of communication, like the newspapers, which enjoyed higher circulations than ever before owing to France's impressive levels of adult literacy. As such, both print and picture performed diverse roles in public life as education, investment, entertainment and opinion-formers. Given that the Republic – however friable and flexible an entity – was the embodiment of the national identity, one might expect its ideology to act as a determinant in the production of imagery. And, of course, governments acted to mould art to republican ends. This was apparent across a range of gambits. Ministerial speeches outlined preferred policies; public commissions spot-lit favoured artists and styles; and official purchases from the annual Salons indicated state approval. There were also informal channels. As I shall show, functionaries of the Ministère des Beaux-Arts such as Bénédite and Roger Marx wrote art criticism regularly in the press. Although this was at arm's length from government, such quasi-detached writing nevertheless gave scope for suggestion about which artistic initiatives and imageries officialdom smiled or frowned upon.

Yet try as the Republic might to use art and imagery as means to promote its ideology, it had to accept diversity of style and motive. Dalou, for example, was a committed republican, his activities during the Paris Commune exiling him to Britain until the Communards were amnestied in 1880. Thenceforth his convictions coincided with the state's, and his neo-Baroque style was well adapted to casting Republican ideology

in three-dimensional rhetoric. Other artists sidled more opportunistically towards the state. By the 1890s Jean-François Raffaëlli had forged himself a position as a semi-official artist, his status accredited by official purchases of his carefully selected imagery of the suburban lower classes and iconic moments in contemporary republicanism. Yet other, very different, artists adopted more equivocal attitudes to the dominant ideology. As will be seen, the old Impressionist Camille Pissarro painted the crowds on the Parisian boulevards in the mid-1890s. But should these pictures be interpreted as celebrations of social harmony under the Republic, as expressions of a more general humanitarianism or as articulating an anarchist distrust of the constrictions imposed on the individual by the modern capitalist city? Maurice Denis conveyed his equivocation towards the Republic in various career decisions. In 1892 he submitted a project to the competition for the decoration of the *salle des mariages* at the *mairie* of suburban Montreuil-sous-Bois, but his too stylised and ritualistic scheme cut no ice in this official contest.[22] His first major public decorative commission was for a Catholic chapel at Le Vésinet in 1899, his religious bent more comfortable in an ecclesiastical than a secular, administrative setting. But, equivocation about the appropriateness of style and of imagery also surfaced within the Republican establishment itself. In 1890 Adolphe Binet won the commission to decorate no less a room than the office of the Prefect of the Seine in the Paris Hôtel de Ville. Binet's subject was scenes from the siege of Paris in 1870–1. But, however patriotic, his scenes of mud, cold and desperation, executed in highly natural-istic detail, proved inadequate as décor and soon after their completion in 1897 were covered by tapestries.[23] Republican ideology might favour the exact and legible, but aesthetic aptitude and painful memory could prove overwhelming counterweights. One should not, then, look for simplistic patterns of political or social determination of how art looked, what it represented and how it was received.

Indeed, to set up a semi-manichaean distinction between artists whose work enjoyed some kind of official sanction, or engaged with issues current in public debate, and those who pursued a more rarefied aesthetic of private expression is to risk an unstable dualism. For all its fractious politics and precarious governments, the Third Republic stood for positively modern ideas. Surrounded by monarchies and imperial states, France in the 1890s was the only major European nation with an elected president, universal manhood suffrage and a republican ideology that was – in theory at least – founded on social justice forwarded by education, secularism and science. At its best, French repub-licanism was progressive, the dominant social movement against forces of conservatism such as monarchism and the Catholic Church. So art, in whatever form, that articulated such ideals formed part of a progressive consensus. We now thus do well to acknowl-edge that styles and imageries which do not look modern to our post-modern eyes might well have appeared emphatically up-to-the-moment during the 1890s. Of course, one should acknowledge too that some artists withdrew their work from the public processes of debate and communication – or so it seems. Claude Monet and Paul Cézanne, neither of whom play a role in this book, might be seen in their distinct ways to have been involved in highly individual creative projects the exclusivity of which centred on notions of *sensation*, itself a private, emotive response to the natural landscape. Yet even two such self-absorbed painters, two such modernist landmarks, might be understood at certain levels to have responded in their work to the susurration of public debate. For might not Monet's series of Rouen cathedral, with their subordination of ecclesiastical identity to ambient atmosphere, as well as Cézanne's return to mass and the medita-

tions on the transience of life that mark his later still lifes and landscapes, be interpreted as different responses to the Ralliement of the 1890s?

For another aspect of this book's endeavour is to try to re-introduce into the mainstream of art-historical debate neglected kinds of work, forgotten artists, discarded images that had great reputations and resonance during the 1890s. Had one asked French visitors to the 1900 Exposition Universelle who were the nation's leading painters of the last decade, most would have answered Puvis de Chavannes, Detaille, Lhermitte and Dagnan-Bouveret rather than Degas, Pissarro, Denis or Lautrec. All these artists take their turn on my stage, though the distribution of starring roles and walk-on parts may come as a surprise, even an affront, to some readers. This is not because I rate Detaille's *Le Rêve* a better work of art than a Degas pastel. I do not. But the aim of this book has been to site imagery within social debate. That has, I hope, allowed contemporaries to have their say, often pictorially, in as even-handed a way as I could. On those terms artists relatively unfamiliar today, such as Cottet, Carabin and Adler, are significant figures here. Pissarro, Degas, Renoir, Bonnard and Rodin all rightly feature, at the junctures when their work engaged with the debates in focus. Yet this is neither a conventional art-historical survey of French art in the 1890s nor a privileged account of the canonical avant-garde: Monet's series, the emergence of the Nabis, Cézanne's search for *sensation*. Accounts of these already exist, and my next book will directly address issues of style and avant-gardism in the 1890s. In conventional art-historical parlance, one might expect a book about French art in the 1890s to be a book largely about Symbolism. But *The Troubled Republic* is not such a book, nor does it privilege élite or youthful culture. Those peripheries have their place here but this is more an account of the centre, about works of art that – by virtue of being a war memorial, an exhibition picture or a poster – spoke to a wide public, a public conscious of debates, fears and ambitions shared by many fellow citizens. The book has turned out, against my intentions, to concentrate almost exclusively on male artists. Research simply did not turn up work by women that engaged with the themes in hand. That itself raises an interesting problem, but one I have been unable to address here. I have also circumscribed my lines of enquiry in focusing largely, but not exclusively, on Paris and by omitting to treat themes such as landscape painting or prostitution in the 1890s, on which I have written elsewhere. This book tries to open up new material and lines of interpretation, based on particular debates and case studies. It points out that contrary styles can articulate the same ideology, and that consistent styles can articulate antagon-istic positions. Above all, I have used it to explore how imagery can help define and deepen our understanding of historical *mentalités*.

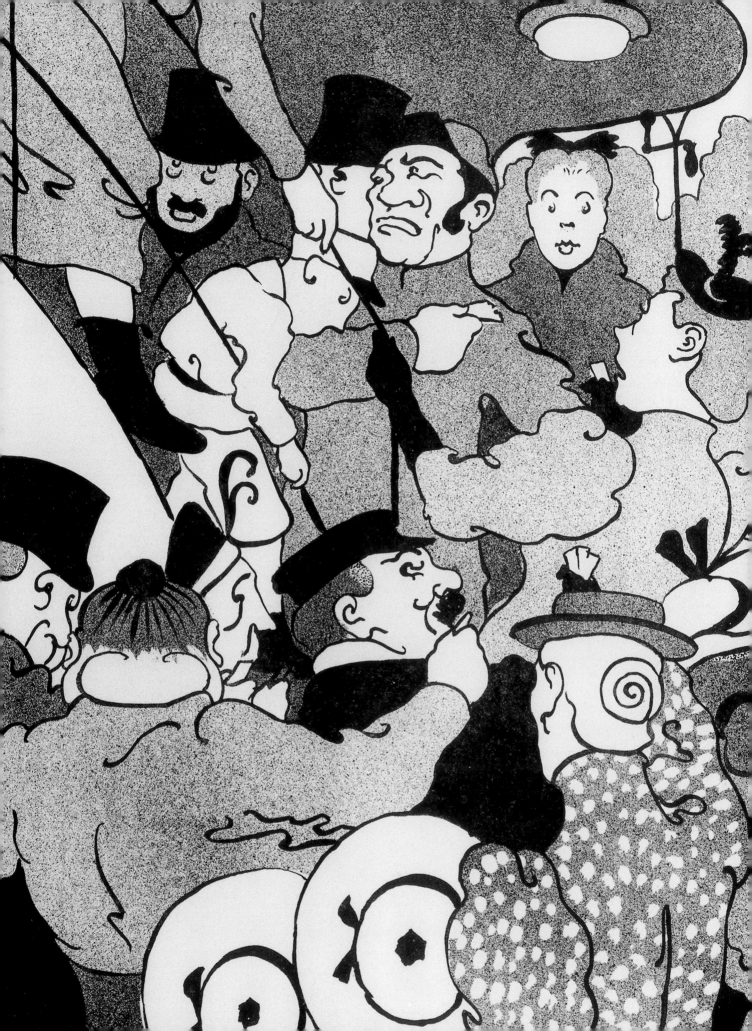

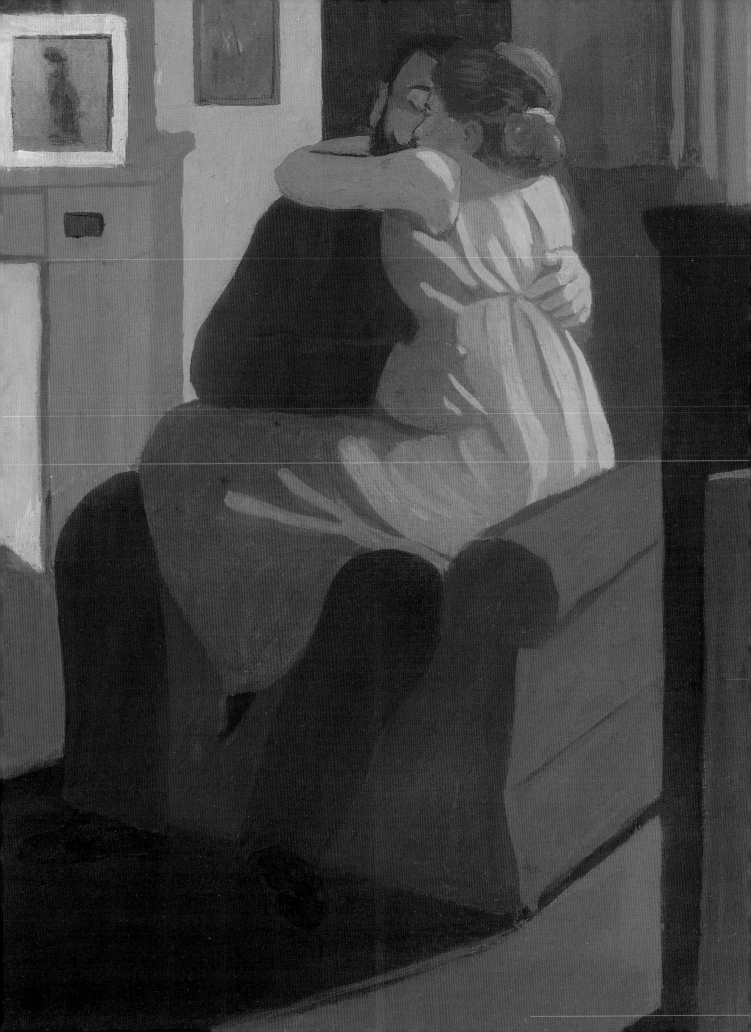

PUBLIC HEALTH AND PRIVATE DESIRE: EXPLORING MODERNITY AND THE EROTIC

The human body was a significant element in many of the public debates in France during the 1890s. Its role may sometimes have been explicit and highlit, at others discreet or downplayed, but its centrality was apparent to all who looked below the surface of everyday discourse about the pressing issues of the moment. The memory of 1870–1, *l'année terrible*, still lingered in the public mind. It raised questions about both the past and the future. How was it that France had been so easily vanquished by the German forces? How could the nation sufficiently recover her position as a Power, and even – a question that preoccupied the nationalist right – one day win a war of *revanche*? The symptoms were apparent, among them an almost stagnant birth rate, a rise in alcohol consumption, enfeebled annual *classes* of conscripts to the army. The diagnoses were troubling: in Darwinian terms France seemed to be degenerating as her rivals thrivingly evolved, adapting to the conditions of the modern world. In essence, many of these problems were physical, afflicting the body of the nation. It was the task of the Republic, in the sense that it was not just an establishment of politicians and functionaries but the intellectual notion around which the majority of French had grouped themselves, to confront and to cure these problems. The Third Republic laid positive emphasis on progress and science. To achieve its goals of social progress, economic stability and improved international status, it needed to encourage a fit and dynamic France.

The physical was necessarily linked to other issues, however. Degeneration was a concept which involved more than bodily decline; morality was integral to it too. The collapse of military might and social order in 1870–1 had been, it was widely held, due to the corruption and decadence of Second Empire France. Moral failure was held responsible for national decline. The Third Republic had to ameliorate this situation by promoting uplifting civic values: the importance of the family, the duty of military service, the responsibility of collective labour for the national good. However, it was also a progressive regime pledged to introduce reforms, if necessary turning over established doctrine. The new divorce law of 1884 is a case in point. What to some appeared apt liberalisation, seemed to others – in particular devout Catholics – a threat to profound moral beliefs. Issues of state concern, such as low rates of natality or rising alcoholism, also had inescapable moral dimensions. The body, and with it that fundamental motor sexuality, had unequivocal links with morality, and social debate had to come to terms with this. At another level, the moral and the sexual are deeply private matters. Indeed, they might either coincide or conflict with public attitudes. An individual's own public

stance might contrast sharply with his or her private beliefs and behaviour. During the 1890s the research of *la psychologie nouvelle* was not only deepening medical science's understanding of the inner mind, it was also permeating the wider social consciousness, giving individuals a greater awareness of their private fantasies and desires. The artist was one such individual. He (for this book concentrates on the male artist) might produce work that was to have a wide public audience, a mural decoration or a poster, perhaps, or that was for private ownership, even for his eyes only. But if his subject was the human body, it would of inescapable necessity have to come to terms with the new debates about the body and sexuality which engaged 1890s France, debates about the public and the private, the overt and the unconscious, the moral and the decadent. Equally, a book that analyses that culture's discourse about social order and control, spiritual responsibility and militaristic nationalism must begin with the body.

Writing about the historical body is fraught with difficulties. In particular, attempting to give some account about how desire and erotic experience found form in the visual arts and the wider culture of representation raises problems. The most immediate of these is that it is difficult to find evidence to reconstruct private, intimate fantasies and feelings, to recreate instincts that went unspoken or urges that stayed unconscious. People remained discreet about such matters. France in the 1890s was a society in which Catholic pudicity, the ideal of the virgin bride as conduit of blood and property, and fear or shame of venereal disease were only several of many forces which encouraged private restraint and discretion. However, this might be offset by very public rhetoric that drew attention to the body and its sexual life. As a nation that made its anxieties about its worrying birth rate and meagre physical fitness a matter of debate, that packaged Gallic *joie de vivre* into bawdy and promiscuous forms such as the can-can and the dirty postcard, France could also parade the physical and the erotic in the starkest public glare. This tension between the public and the private is at the core of French culture in the 1890s. The public, one might say, can speak for itself; that is its function. Political or medical discourse, the painting on display or the sculpture on its plinth, the lubricious can-cans of the dance halls or the posters advertising them, all deal with the body – more or less frankly – in the ways in which they wish it to be understood. The private, sliding from the modest into the subconscious, may be less articulate, even mute, but there still remain shards of evidence – visual, written, observed – which may be brought into play in a tentative reconstruction of ways of feeling, sensing and representing. There is, I want to suggest, more about the sensual, and about sensing, in the imagery of this period than is often suspected. The erotic, that potent and mischievous matrix of the physical and the psychological, was a crucial factor in the modernity of the 1890s.

In Grün's poster for the café-concert La Cigale, *Pour qui votait-on?*, a number of these public issues are in play, in the public format of the advertisement (fig. 11). Printed at the time of the 1898 elections, Grün's image contrived a pun between *pour qui votait-on?* ('who did one vote for?') and *pour qui vos tétons?* ('who are your tits for?'), as the female embodiment of La Cigale bares her bosom for the jovial male electors. But this image of simple bawdy has resonances of wider issues, not that the passer-by would necessarily have dwelt on them as he smirked at the pun. The prostitute selling her body – to which Grün's poster, however genially, necessarily alludes – was a potential transmitter of venereal disease; she posed a medical problem and a social threat. To ply her trade, it was not in her interests to get pregnant; she was therefore a kind of freemartin,

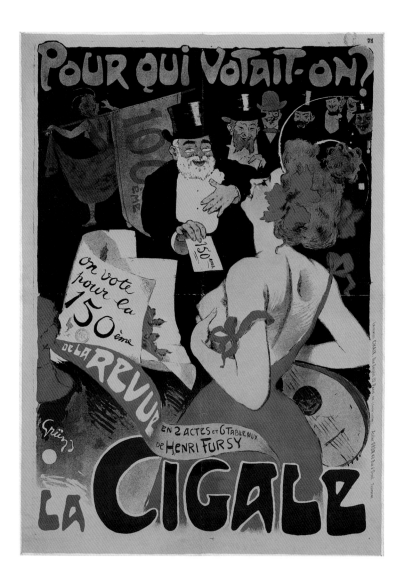

11 Jules-Alexandre Grün, *Pour qui votait-on?* (Who did one vote for?), 1898, colour lithograph, 130.4 × 93.5. Chemnitz, Städtische Kunstsammlungen.

making no positive contribution to the nation's perilously low natality. Both dangerous and useless, the functions she allowed her body to perform were – at least in public terms – immoral. The prostitute was typically working class but would attract a bourgeois clientele, as Grün teased. Her body permitted the crossing of alarming frontiers, between respectability and vice, between socially divided but sexually melded classes, between order and disorder. An image such as this poster strongly suggests that in the 1890s notions about the modern condition could revolve round the body and its sexual functions. This takes on another dimension when one considers reactions to another public, visual form, like the poster a manifestation of new technology and the dynamism of modern life, but this time a single motif: the Eiffel Tower.

Planned to dominate the 1889 Exposition Universelle and its construction begun in January 1887, the Eiffel Tower provoked many reactions, both for and against. The one that concerns me here is the way in which it was read as a physical, even sexual, form. The writer Villiers de l'Isle-Adam scribbled notes on an imaginary adjacent tower of the same three-hundred-metre height but which would be in the form of a man wearing

contemporary costume and a top hat and would bestride the Seine like a modern Colossus of Rhodes.[1] For Louis Gonse, contributing his initial impressions of the 1889 Exposition Universelle to the *Gazette des beaux-arts*, the Tower changed in different lights; in full daylight it seemed to him 'light, grey and sketchy', while 'when the wind blows and . . . its summit plunges into the cloud' it appeared 'male and crude'.[2] Both men took the Tower to be masculine, Villiers in the literal sense of the public bourgeois figure, Gonse in a more allusive, and slightly sexually charged, way. That latter dimension immediately grabbed the attention of Félicien Rops. As early as 1887, while it was under construction, Rops decorated a lubricious letter to a friend with images associating copulating fauns and a drawing of the Tower.[3] It was not only in the male imagination that the Tower provoked such imaginings. Eiffel himself squirrelled away any kind of ephemera relative to his great design. These included two lubricious poems posted to him by a Mademoiselle Massé, written successively in May and June 1889, enflamed by the sight of the Tower and the thought of Eiffel:

> Qu'and je le vois il m'électrice
> Il fais vibrer toutes mes machines et
> m'est tout mon corps en mouvement[4]

A similarly ill-educated but excitable response was contrived by Léon Xanrof in his song *La Tour Eiffel*, which became a standard in Yvette Guilbert's café-concert repertoire from 1891.[5] Its narrative tells of an ingenuous couple from the provinces who take the train to Paris for their honeymoon. The wife is delirious in her desire to see the Eiffel Tower. But she is disappointed by every tall building she sees – the clock tower at the Gare du Lyon, the Tour St Jacques – and every verse ends by her denying that what she has seen is the Eiffel Tower, even the Tower itself. Baffled, her bridegroom takes her to their hotel room, and it is only when he enthusiastically removes his trousers that she squeals with delight that she has found the Eiffel Tower. This piece of bawdy for popular consumption, not dissimilar to Grün's, may have been written by a man but it was performed by a woman, no doubt with appropriate body language, and for a mixed audience. The Eiffel Tower had a vivid sexual presence in the erotic imagination of both men and women, these fragments of evidence suggest. But why should this have been? The Eiffel Tower, broad-based on four legs, pointed, tapering and fretted, does not appear – at least to modern eyes – to have significantly organic, let alone phallic, associations. One can understand Villiers's sense of it as assertive, and therefore male, but less easily both sexes' eroticisation of the Tower. But perhaps it was not the Tower itself, with its ascending form, that inspired such erotic reactions. One might suggest that consciousness of the sexual – the publicly erotic, the bawdy, the decadent, the worthy of censorship – was so much part of the condition of modernity that something which was evidently modern, indeed a beacon of the modern, all but had to be construed in an erotic fashion, however flimsy that analogy was in strictly visual terms. My case is that, as one analyses the visual culture of the 1890s, one needs to be alert to how the body's specifically sexual, as well as its more simply physical, identity was a pressing issue in 1890s France. Flowing back and forth from the public to the private spheres, between consciousness and the unconscious, issues around the sexual body deeply imbued contemporary debate – as threat and delight, provocation and normality – and pulse through the period's image-making.

* * *

A Degenerating Nation?

A central debate in France during the 1890s hinged on the widespread notion of degeneration: *dégénérescence*. Was the nation in decline, went the anxious question, and if so what were the causes and how could they be remedied? The concept was essentially scientific, Darwinian, and it gave the bourgeois – for it was the middle classes among whom the debate was most active – an apparently rational, 'modern' way of discussing perceived contemporary problems. Degeneration was a means of structuring debate about social concerns of grave national import, be they specifically medical – such as the persistence of tuberculosis or syphilis – or more generally medico-social – like falling birth rate or rising alcoholism – and even wide socio-political problems including crime, terrorism and crowd control.[6] France was imagined as a giant abstract body, a conceptualised 'patient' whose health, diet and behaviour had to be monitored and nursed. And like any patient, physical health could not be separated from moral and intellectual wellbeing. From that point of view, art and culture too were considered integral to the national condition. They might be symptomatic of a particular state; and they might also serve as treatment.

In October 1895 the distinguished sociologist Alfred Fouillée published a lengthy article on *dégénérescence* in the *Revue des deux mondes*. Looking into the past, he considered that national vitality had been built on the amalgam of Celtic, Mediterranean and Germanic blood. But he worried that that vitality was being weakened by an influx of foreigners, three per cent in 1886 but by 1895 closer to four per cent. (Reviewers of the Salons worried about the same issue in the specific arena of art exhibitions, with their even higher percentages of foreign participation.) Like many others Fouillée blamed the momentum of the modern city for disturbing moral and physical equilibrium, which suffered from excessive alcohol, coffee, mental exertion, late nights and dissipation. He singled out sexual misbehaviour – *la débauche* – encouraged by an alarming licentiousness tolerated in culture and the media. The decline of the French race, in his analysis, was a question of traditional vices accelerated by modernity and inseparable from demographic issues. Emigration to cities, the rising cost of living, population density, the delay of marriage as a result of military conscription and the legal requirement for equal division of estates among offspring all conspired to lower the birth rate. The upper classes in particular drew Fouillée's contempt for producing insufficient numbers of children because of a truculent 'reverse Darwinism'.[7] Fouillée's responsible if conservative arguments had been preceded three years earlier by Max Nordau's *Entartung* (Degeneration). A German doctor based in Paris, Nordau combined medical analysis – chapter 2 is entitled The Symptoms; chapter 3, Diagnosis – with his cultural knowledge of the capital, dividing his book between a broad diagnosis of the degeneration of France and extended critiques of French authors. Nordau's initial anger was vented at the visual arts, for at the 1891 SNBA Rupert Carabin's furniture incorporating sculpted female nudes and Albert Besnard's floridly painted canvases had seemed to him to typify the French artist's pathological obsession with debauchery to the point of derangement[8] (figs 12, 13). Nordau argued that while only a few genuinely took pleasure in such art, the craving for extreme sensations was contagious, a form of hysteria. He identified the process of degeneration by citing the symptoms common to the debate: the stresses of increasingly urbanised living, the now frantic pace of life (in 1840 the French sent 94 million letters, in 1881 595 million), the increase in alcohol consumption (1.33 litres of

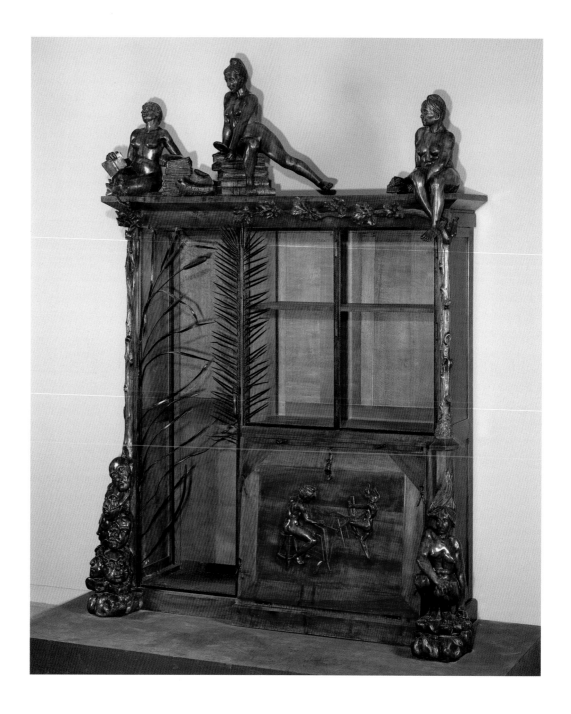

pure alcohol per capita in 1844, 4 litres in 1890), and – a German making a French effect a cause – the humiliation of defeat in 1870–1.[9] Nordau's book itself typified the proliferation of scientific and sociological thought into the wider public domain. Equally typical of popularisation and polemic, its research was not always current; while Nordau followed Lombrosian ideas about how degeneracy and criminality are betrayed by identifiable physical features, recent French studies by criminologists such as Charles de Bierre suggested that a more complex diagnosis involving heredity and environment was in order.[10]

Nordau's book did not hit all its targets – at least one avant-garde Paris periodical took it largely as a critique of the novelist Maurice Barrès rather than an all-out assault

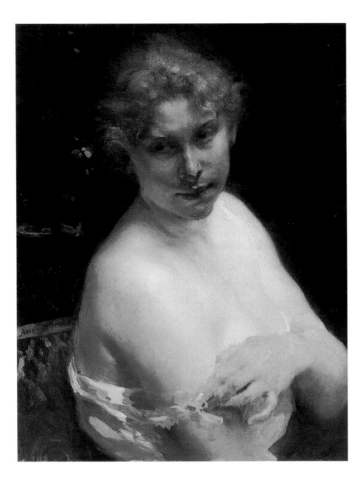

12 (facing page) Rupert Carabin, bookcase, 1890, nut wood and wrought iron, 300 × 210. Paris, Musée d'Orsay.

13 Albert Besnard, *Etude de jeune femme* (Study of a Young Woman), 1892, oil on canvas, 55.4 × 44.5. Private collection.

on modern French society – but its success, with large print runs in French and English translations, was itself symptomatic of the high pitch of the degeneration debate. If many of the problems discussed by a Fouillée or a Nordau were shared by all industrialised nations, one degenerative problem was particularly acute in France. The nation's birth rate had been falling since 1825. By the end of the century this had become critical. In the two generations between 1870 and 1914 the populations of Italy increased by 30 per cent, Austria-Hungary by 38 per cent, Great Britain by 43 per cent and Germany's by 58 per cent. That of France grew by a mere 10 per cent. Marital fertility was critically low. In the half-decade between 1891 and 1895 deaths actually exceeded births in France by three hundred.[11] Such alarming statistics had a knock-on effect on the wider national *mentalité*. Professional ginger-groups such as the demographer Jacques Bertillon's Alliance Nationale pour l'Accroissement de la Population Française (National Alliance for the Increase of the French Population) were established, and in his novel *Fécondité*, serialised in *L'Aurore* and published in 1899, Emile Zola, that literary litmus test of informed concern, addressed the issue. So pressing was the problem of demographic stagnation that it imposed itself from unexpected directions. The Ligue Syndicale pour la Défense des Intérêts du Travail (Syndical League for the Defence of Labour Interests) was an organisation of small businesses competing against highly capitalised department stores. In an article of 1891 in the *Revue indépendante* promoting the Ligue, François de Nion argued that the decline of small patriarchal businesses and precarious employment diminished the likelihood of marriage and children among shopworkers,

thus raising the spectre of *ce péril national* which he spelt out in capital letters: 'IN 18 YEARS IF THE PROGRESSIVE DECLINE IS MAINTAINED, THERE WILL USUALLY BE TWO GERMAN SOLDIERS AGAINST ONE FRENCH SOLDIER.'[12] French anxiety about national decline spilt easily, even bizarrely, from one concern to another. Sexual responsibility, the need for men and women to combine their sexual instincts and good citizenship to produce more babies for the nation, was held up as an ideal of national regeneration. The Republic mobilised physical, moral and aesthetic ideals to encourage the French in the path of positive sexual order.

Anxieties about the nation's physical health – its men's capacity to fight, its women's ability to bear children – were exacerbated by the near-stagnant birth rate. Attempts to address them often had recourse to the classical ideal of the body. The *Revue athlétique*, founded in 1890, published photographs of contemporary French physiques alongside antique sculpture, to the lamentable detriment of the former.[13] Baron Pierre de Coubertin traced his campaign *rebronzer la France*, which led to the foundation of the modern Olympic Games, to his childhood fascination with the Olympiad. At the Exposition Universelle of 1889 he had been delighted by the architect Victor Laloux's painstaking reconstruction of ancient Olympia, and when he lectured on the value of athletic competition he brought into play Greek sculpture such as Praxitiles's *Hermes*, excavated only in 1877. On 16 June 1894 Coubertin launched the modern Olympic movement before an audience of two thousand at the Sorbonne. Coubertin specifically

14 Pierre Puvis de Chavannes, *La Sorbonne* (detail showing central section), completed 1889, oil on canvas adhered to wall, 570 × 2600 (whole). Paris, Grand Amphithéâtre de la Sorbonne.

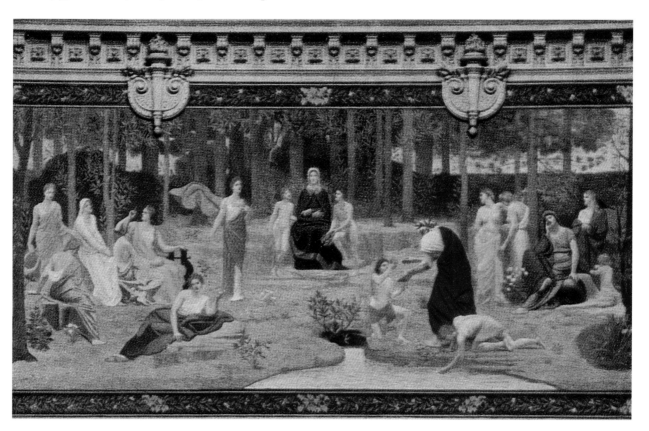

saw sport not only as developing the young French male's body and spirit as an end in itself, but also as a means of revitalising French blood and as a training for future war. His observation published in the *Revue athlétique* in July 1890 – that courage learnt in a rugger scrum will not wilt under German gunfire – made his belligerent projections crystal clear.[14] Coubertin's re-invention of the Olympic Games had various facets. It was the visionary renaissance of a heroic aspect of the ancient world, a channelling of France's virile energies. It was also an expression of modernity, with its vaunting of faster, higher, stronger, and its fascination with performance and time.[15] How appropriate it was that Coubertin launched the modern Olympics in the Grand Amphithéâtre at the Sorbonne, in front of Puvis de Chavannes's modern, classical decoration (fig. 14).[16] This was doubly apt. First, the Sorbonne itself was promoting sport and physical health among its (then exclusively male) students, a *Manuel d'hygiène athlétique* having been produced under Dr Brouardel of the Medical Faculty in 1894.[17] Second, Puvis's work was comfortably accommodated into debates about contemporary decadence, as an antidote. In an article in *L'Image* in 1897 Roger Marx had stressed how Puvis's murals were 'healthy', untouched by 'the contagion of modern neurasthenia'.[18] In the drive to athleticise French youth, the virile body of the ancient Greek hero or hoplite was held up

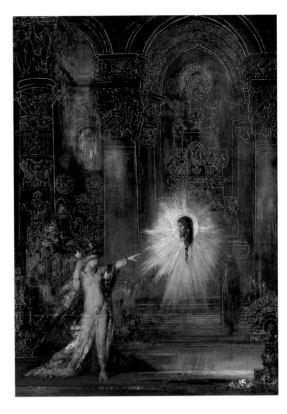

15 Gustave Moreau, *L'Apparition* (The Apparition), *c.*1876 or later, oil on canvas, 142 × 103. Paris, Musée Gustave Moreau.

as an admirable example. For competitive sport, like noble art, was a counter to decadence.

Negotiating the 'healthiness' or otherwise of an artist's work could be a necessary task, especially for a civil servant justifying public expenditure. In April 1899 Bénédite, like Marx a Republican functionary who also wrote art criticism, published an extended article in the establishment *Revue de l'art ancien et moderne* on the work of Gustave Moreau, who had died exactly a year before. In the meantime, in November 1898, the Musées Nationaux had accepted Moreau's legacy: his studio and its contents, in effect the bulk of his life's work, and the responsibility to open it as a museum. As curator of the Musée du Luxembourg, the national collection of recent art, this would come under Bénédite's aegis. Reading the article one senses the bureaucrat walking on eggs. Bénédite argued that Moreau was a disciplined, logical, intelligent artist, who had worked in the French classical lineage of Poussin, La Fontaine and Descartes. He also insisted that literary accounts of Moreau's *inspiration sadique* – he must have had those of Huysmans and Jean Lorrain in mind – were quite unfounded (fig. 15).[19] This quasi-Darwinian argument implying evolution from healthy stock as well as the emphatic denial of perversity were essential. From at least 1895 the reviewers of the annual Salons, among them Roger Marx, had begun to notice the considerable influence that Moreau, a professor at the Ecole des Beaux-Arts for the previous three and a half years, was having on a generation of talented students such as George Desvallières and Georges Rouault.[20] For civil servants like Bénédite and Marx it was important that art taken into the museum

16 (*right*) William-Adolphe
Bouguereau, *Le Guêpier*
(The Wasps' Nest), 1892,
oil on canvas, 213 × 152.5.
Private collection.

17 (*facing page left*) Henri
Martin, *Beauté* (Beauty), 1900,
oil on canvas, 188 × 110.
Toulouse, Musée des Augustins.

18 (*facing page right*) *Venus de
Milo*, marble, Paris, Louvre.

system, in other words into the state's creative metabolism, should not be corrupt, espe-
cially as Moreau's impact on the continuum of the French school was apparently now
so marked. That the Republic's museums should promote healthy, traditional classicism,
yes; harbour a degenerate influence, no.

The classical ideal of physical beauty remained central to art school training. Con-
servative commentators in establishment periodicals such as the *Gazette des beaux-arts*
reminded readers that the study of antique sculpture was essential for students' under-
standing of the nude and drapery, exercises that were the basis of all later artistic prac-
tice.[21] Since the sixteenth century it had been common not only for artists to base poses
on those of prototypes in antique sculpture, but also to 'complete' the bodies of statues
which had come down to modern times only in fragmentary form. This was still prac-
tised in the 1890s. Both William Bouguereau's *Le Guêpier* and Henri Martin's *Beauté*,
exhibited at the 1892 SAF and 1900 Exposition Universelle respect-ively, freely based
their female figure on the *Venus de Milo* (figs 16–18). What would originally have been
an allusion comprehensible only to connoisseurs was by the late nineteenth century an
obvious quotation, the *Venus de Milo* being well known via reproduction and photo-
graph. The physical ideal of the female body that this sculpture was held to embody
had a continuous resonance in French visual and even physical culture. It was promoted
in school textbooks, Pécaut and Baude's 1885 volume on art praising the *Venus de Milo*

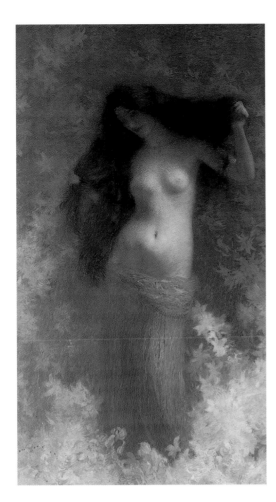
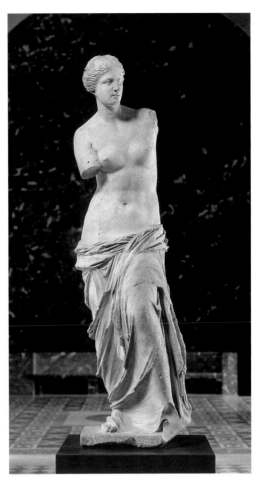

as *parfaitement beau*.[22] Girls educated with that idea might well have later read as young mothers Mme Augusta Weiss's counsel in her 1897 *Guide à l'usage des jeunes mères* that a woman should care for her post-natal body, holding the *Venus de Milo* up as the ideal to which they might aspire.[23] Be it the athletic male or the nubile female, the ideal of the human body derived from the ancient Greeks – fit, noble and well proportioned – had a real presence in late nineteenth-century French culture. It was a physical vision easily translated from the ideological needs of Hellenistic antiquity to those of Republican modernity. Above all, it was free of vice.

The polarity of the healthy, and implicitly moral, on the one hand and on the other the corrupt and decadent was a consistent theme in the figure painting of the 1890s. For many artists, representing the healthy body was a major element of their work, generally as a celebration of physicality but sometimes as an active intervention in the national debate about health. Indeed, some artists took positive steps to keep themselves fit, an expression of both personal pride and public duty. Alfred Roll was an all-round sportsman; Pascal Dagnan-Bouveret had a trapeze in his studio; and Victor Prouvé woke early to a cold bath and rub with a horsehair glove, took brisk walks before working and did weights and gymnastics.[24] This climate of fitness and energy manifested itself in contemporary images of social types and role models. The soldier was one of the most important of these, and images of virile military bodies were common, from

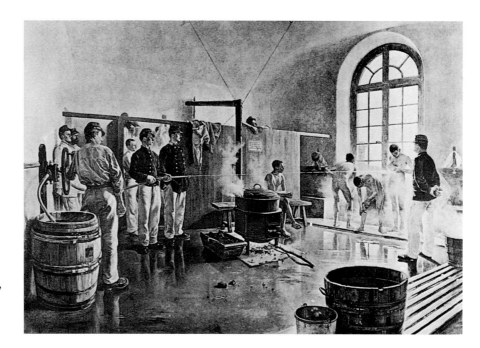

19 Eugène Chaperon,
La Douche au régiment
(The Shower at the Barracks),
1887, oil on canvas,
dimensions and location
unknown.

Charles Crès's rather earnest painting of the *victor ludorum* of one of France's leading officer cadet schools (see fig. 139) to Eugène Chaperon's splendidly blunt depiction of bodily propriety in the other ranks (fig. 19). Such Salon paintings were public statements about the health and hygiene of a public institution, the army; they were made in order to convey that message and example to the nation. Physical fitness also manifested itself in more private images, in particular representations of the nude. Throughout the 1890s Auguste Renoir painted a steady flow of canvases representing the female nude. His motives were typically diverse. Such images were an expression of his own sexual desire. They were also commercially successful, and the painting of three variants of *Baigneuse aux cheveux longs* in 1895–6 is only one instance of an apparently expedient repetition of a marketable motif (fig. 20). In addition, the fecund, passive bodies of these nudes implicitly articulated the typical, socially conservative views of the lower classes from which Renoir came: that a woman's duties were domestic – to keep house, please her husband, produce and nurture children.[25] The young, well-covered and fresh-skinned women that Renoir painted, exemplified by *Baigneuse*, obviously represent his physical ideal. But the values that such images articulate were not just Renoir's; they had widespread validity as, one might almost say, national values, and innumerable artists of very different stamp from Renoir subscribed to them in their own treatments of the nude.

It was not only the female nude that could be treated in this way. Although less common, the male nude also found form. Henri-Edmond Cross painted *Baigneur s'essuyant* in 1893 (fig. 21). In immediate terms it is, of course, a Neo-Impressionist exercise in painting the figure under the fierce sunlight of the Mediterranean, where Cross had lived since 1891. But one of the reasons why Cross, a native of Douai (Nord), had moved south was because of his delicate health. In contrast to the artist himself, the man in the painting is shown as vigorous and *sportif*. While *Baigneur s'essuyant* was not a painting for the mass public of the Salons that Crès or Chaperon addressed,

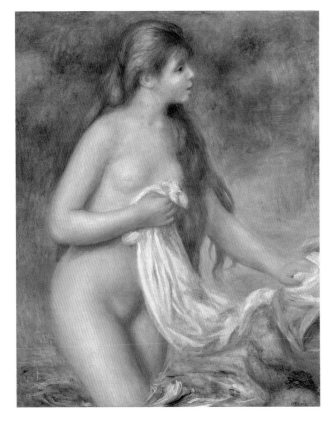

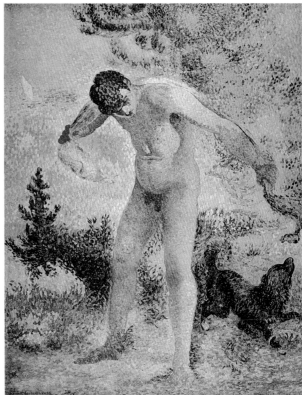

20 Auguste Renoir, *Baigneuse aux cheveux longs* (Bather with Long Hair), *c.*1895–6, oil on canvas, 82 × 65. Paris, Orangerie, Walter-Guillaume Collection.

21 Henri-Edmond Cross, *Baigneur s'essuyant* (Bather drying Himself), 1893, oil on canvas, 147 × 114. Geneva, Musée du Petit Palais.

it nevertheless remained, in the more restricted sphere of the élite audience for Cross's avant-garde work, a paean to robust masculine physicality embraced by the energising sunshine of the Midi. Executed in different styles and directed at different audiences, such diverse paintings were united by their promotion of national health and, concomitantly, their denial of the degenerative diagnosis.

Not all representations of bodies were read, or were intended to be read, in terms of physical health. Georges Seurat exhibited his large canvas *Poseuses* at the 1888 Salon des Indépendants (fig. 22). The capacity of his innovative divisionist style to represent nude figures on a large scale was remarked by most critics, but the actual character of the bodies Seurat had depicted attracted some notice. Writing in the leftist *La Justice*, Gustave Geffroy described the thin limbs 'of skinny girls swiftly grown up, hastily pubescent' and praised the hunched posture of the figure dressing as telling 'the truth about cities and arduous labour'. The anonymous reviewer of the Lillois *L'Echo du Nord* found the models' 'lamentably rachitic skeletons' affecting.[26] It is not known whether Seurat, who was fastidiously discreet about his work, was sympathetic to readings that were overtly critical of the punishment the capitalist metropolis wrought on the proletarian body. With Maximilien Luce, however, one is on surer ground, for his commitment to anarchism was widely known among his contemporaries. During the early 1890s Luce executed a group of paintings of men and women in working-class

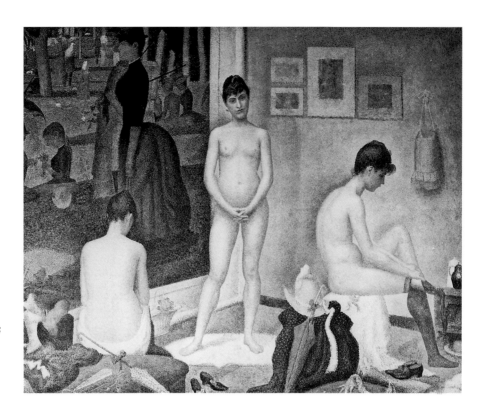

22 Georges Seurat, *Poseuses* (Models), 1887–8, oil on canvas, 200 × 250. Merion, Penn., Barnes Foundation.

interiors. They are radical works both in their divisionist chromatics and in their frank depictions of impoverishment. In a canvas such as *Le Bain de pieds*, made in 1891, it is above all the man's body that strikes the viewer (fig. 23). He appears prematurely aged, his back unnaturally arched by physical strain and his arms and torso meagre from malnourishment. *Musculatures populaires* was the phrase Geffroy, once more, found to describe such images of the proletarian body.[27] However, it was not just radical Neo-Impressionists exhibiting at the Salon des Indépendants who produced gruelling pictures of bodies formed by unhealthy urban conditions. At the 1891 SAF Henri Royer exhibited *Sur la butte* (fig. 24). Naturalist in its detail, scrubby in its touch and dull-toned in its colour, this depiction of an adolescent girl in a proletarian *quartier* is hard-hitting. The anonymous art critic of *Le Progrès de l'Est*, from Royer's native Nancy, wrote:

> This is truly a girl from our great Paris; she is still ugly, having the angular features and, throughout her whole person, the slightness of her awkward age. But when the scrawny back-street girl reaches eighteen she'll be pretty – or worse. For what finery will she abandon her linen pinafore and her pitiful boots, those badly buttoned boots, and where will her little feet dance? That's what she is no doubt confusedly thinking about, with the immense city spread out in front of her where she should find the revenge that the future keeps in store for her.[28]

This account is more forceful than Geffroy's readings of Luce or Seurat's work, regret-fully accepting the price paid by the workers' bodies. For the leftist *Le Progrès de l'Est*'s reading of Royer's painting is couched in terms of social Darwinism. This disadvantaged girl will eventually use her womanly sexuality to advance herself; she will succeed in

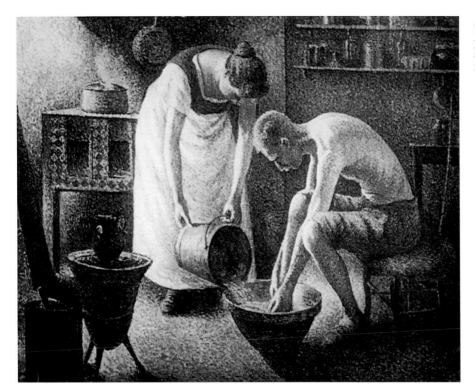

23 Maximilien Luce,
Le Bain de pieds (The Foot
Bath), 1891, oil on canvas,
81 × 100. Private collection.

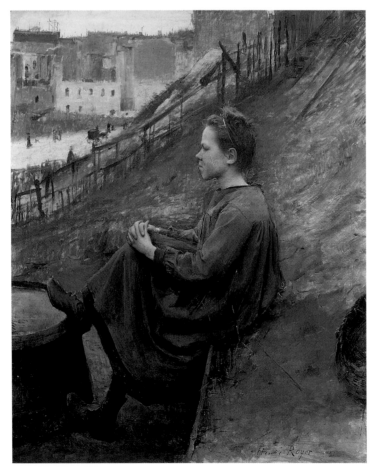

24 Henri Royer, *Sur la butte*
(On the Slope), 1891, oil on
canvas, 72 × 60. Rio de
Janeiro, Museu Nacional de
Belas Artes.

the struggle for life. But the writer imagined a sting in the tail. He implied that her finery would be earned by prostitution, by her body, winning her some, perhaps temporary, prosperity. And in speaking of her 'revenge' does he not insinuate that by milking her clients of money or by spreading venereal disease she will exact some retribution for the grim childhood to which her class has condemned her and which Royer evocatively represents? What may be learnt from such images of the body is that representations were loaded not only in their depiction of the physical – here fit and healthy, there under-nourished and enfeebled – but also in a moral sense. The body was a vehicle of vice as well as of virtue. Royer's young woman, in the prognosis of *Le Progrès de l'Est*, may move up the scale in terms of material gain, but by sinking into vice she will become decadent.

Decadence and Transgressive Sexuality

A combination of new psychological research, filtering down to the wider public, anxiety about the national birth rate, and public prurience geared to the discourse of degen-eration engendered a fascination with what were understood to be sexual extremes. Degeneration was part of common parlance. The press was swift to draw attention to anything that might be considered excessive or perverted. During the show shared by Auguste Rodin and Claude Monet at the Galerie Georges Petit during the Exposition Universelle of 1889, for example, much criticism of the sculptor's work revolved around notions of decadence. The critic of *La Liberté* berated Rodin for taking as a subject for sculpture erotic frenzy of a kind so deranged that it should be treated at the Salpêtrière (fig. 25). The traditionalist Auguste Dalligny agreed that Rodin's pieces deliberately manifested 'heightened libidinousness' to delight 'unhealthy curiosities'. In *L'Evénement*

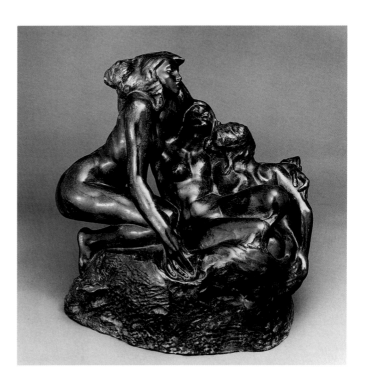

25 Auguste Rodin, *Les Sirènes* (The Sirens), c.1885–9, bronze (cast after 1901), 43 × 45.5 × 32.5. Paris, Musée Rodin.

Roger-Milès countered that Rodin's work represented 'passion in physical love, and not in vice: it is the genetic formula of all species, and absolutely not the unhealthy cliché thought up by some'.[29] These conflicting responses to Rodin's work typify the way in which the national debate about decadence and health coloured people's responses to works of art, and also how artists might deliberately produce work that pitched itself into that contested arena.

Whereas a generation earlier medical publications, let alone novels and the popular press, had only occasionally dealt with the sexuality of minorities, by the 1890s this was the stuff of gossip and popular diversion. Homosexuality is a case in point. A dangerous topic in a France obsessed with national virility, it was convenient to brush it off as a foreign problem. Because doctors such as Richard von Krafft-Ebbing had been at the forefront of research on the fringes of sexuality Germany could be spuriously identified as homosexuality's home. Unsurprisingly, one of Armand Dubarry's 'serious' smutty novels was entitled *Les Invertis (Le vice allemand)* (1896).[30] Although writers such as Octave Mirbeau wrote articles in defence of Oscar Wilde, arguing in support of the individual against mass middle-class prejudice, his case was a British one, and French homosexuals such as André Gide found it easier to discover their sexuality in the Arab colonies. Until the mid-1890s even French doctors writing about the subject characteristically categorised homosexuality as a form of insanity incorporating hysteria and frequently criminal behaviour. No wonder that even an author as frank as Emile Zola, when sent an intimate dossier of homosexual memoirs by an Italian aristocrat with permission to fictionalise them, turned the offer down, fearing public uproar.[31] In such a climate, the homosexual, while a figure of distrust and disdain in the public mind, remained a rare presence in mainstream literature and imagery. When he appeared, as in Forain's caricature *Le Troisième Sexe* (fig. 26), it was to be categorised according to the typology of the time as physically and socially dysfunctional, a furtive marginal figure.

The same was not so true of the lesbian. Whereas the homosexual was seen as a misfit in a society determined to vaunt its military prowess and colonising energies, the lesbian woman did not jolt national certainties (or uncertainties) to the same extent.[32] Lesbianism was commonly understood to have a particular class identity. Julien Chevalier's *Inversion sexuelle* of 1893 was convinced that it flourished among the rich and aristocratic, was rare among the middle classes and was abhorred by the proletariat; he added that it was unknown in the country, being a chic urban vice.[33] Léo Taxil claimed that in high-class brothels all the prostitutes were lesbian; fewer were in middle-ranking establishments; while in working-class *maisons closes* the only lesbian girls were those who had worked in a smarter place.[34] Chevalier was a professional follower of Charcot whereas Taxil was a seedy journalist, and evidence on such delicate matters is difficult to confirm or corroborate. Nevertheless, both writers concurred that lesbianism was an upper-class vice, a useful expedient for explaining it away as linked to the modishness of the neurotic, leisured *femme du monde*. This fitted a

26 Jean-Louis Forain, *Le Troisième Sexe* (The Third Sex), illustrated in *Le Courrier français*, 14 October 1888.

27 José Roy, cover
for *Zé'Boïm* by
Maurice de Souillac,
1889, 19 × 12.
New Brunswick,
Jane Voorhees
Zimmerli Art Museum.

MAURICE
DE SOUILLAC

ZÉ'BOÏM

Paix : **3** fr. **50**

PARIS
F. BROSSIER
ÉDITEUR

par
MAURICE DE SOUILLAC

FÉLIX BROSSIER, ÉDITEUR
PARIS

28 (*facing page*)
Henri de Toulouse-
Lautrec, *Au lit: le
baiser* (In Bed: The
Kiss), 1892, *peinture à
l'essence* on cardboard,
42.2 × 56.2. Private
collection.

decadent stereotype and also a prurient fascination with that chic world. Racy novels on the subject flourished, the fashionable magazine *La Vie parisienne* dubbing the prolific writer Catulle Mendès 'the Jules Verne of Lesbos' in 1891.[35] The publisher Félix Brossier made the stereotype something of a speciality in the later 1880s, printing lurid novels often with women's names: *Phoebé, Daphné, Fusette*. One of these, *Zé'Boïm* by Maurice de Souillac, told the tale of upper-class girls who set up a lesbian hotel, the Téton de Vénus. This trivial stuff, in fact written by a woman surnamed Lefèvre, was riddled with double standards. Not only do the characters finally return to husband and motherhood, but the preface justified a novel about *un vice monstrueux* because it raised a 'serious' social question and was based on 'authentic' documents: the 'scientific' and the return to 'normality' were used to mitigate prurient sensationalism. First published in 1886, *Zé'Boïm* went unnoticed; reprinted three years later with a new cover by José Roy which explicitly alluded to female orgasm, the censorship authorities stepped in and Brossier and 'Souillac' were both fined and briefly imprisoned (fig. 27).[36] It was not the text – slow-burning, requiring to be read – that attracted attention; it was the cover, immediately and provocatively challenging taboos.

Fear of the transgressive clung to the image of the lesbian. For all the quasi-covert treatment of the subject in pulp fiction and the gossip columns exposing or alleging relationships between this actress or that society hostess, lesbianism was not illegal and could be considered a marginal vice. Yet when it took public visual form, in such cases as Roy's cover to *Zé'Boïm*, it became more dangerous. In November 1892 the police required the art dealer Le Barc de Boutteville to remove one of Toulouse-Lautrec's paintings of lesbians from open display in his gallery window (fig. 28). Perhaps in response to this warning, when Lautrec staged a one-man show at the Galerie Manzi-Joyant in 1896 the brothel pictures and lesbian subjects were displayed in a locked first-floor room opened only for friends and trusted clients.[37] This caution was both a safety-first decision in the face of a censorship which sought to protect the morals of the Republic's citizens from the potentially contagious symptoms of decadence, and also a ploy on Lautrec's part to reserve his seedier paintings for initiates. The gentlemen (surely the primary audience) who saw them took on an identity similar to the criminologist or psychologist, becoming in a skewed way professional experts on hidden aspects of human behaviour. And Lautrec's lesbian subjects were purchased in the 1890s by men who, while no doubt admiring them as paintings, presumably chose such subjects because at some level they articulated the collector's own sympathetic liberalism or instinct for the erotic extremes: Charles Maurin and Roger Marx had one each, and the wealthy bibliophile Paul Gallimard and the risqué print dealer Gustave Pellet two each.[38]

The lesbian had other clandestine manifestations. In 1891 Lautrec's friend Louis Anquetin made an important submission of ten works to the Indépendants. One of these, under the curt title *Soir*, was probably the large pastel made in 1889 which represents the *rond-point* on the Champs-Elysées (fig. 29).[39] With stylised elongation and linearity it depicts the dark, veiled silhouette of a woman, accompanied by her poodle, just as they pass prancing horses pulling a carriage across the picture plane. At first sight this is a cloisonnist, slightly caricatural image of a momentary encounter at an intersection in central Paris. However, in his book *La Corruption fin-de-siècle*, also of 1891, Taxil noted that

> A *tribade* [lesbian] in search of one of her kind has a distinctive sign: it's a magnifi-cent poodle, curled, pompommed, frizzed, sometimes beribboned, which accom-panies her on her prowls, on foot or in a carriage. In the Champs-Elysées the observer easily notices elegant lesbians riding around in search of a partner in vice. Here is a superbly harnessed team: in the carriage, a woman alone, in a more or less luxurious costume, with the inevitable poodle next to her. This woman, driving down from the place de l'Etoile, looks carefully at the women on foot, principally between the *rond-point* and the place de la Concorde. A stroller sees the woman with the poodle and catches her eye, while making a rapid movement with her tongue and lips: it's the standard signal used among lesbians to say: 'I go for women'.[40]

At the turn of the decade Anquetin treated this specific theme on a number of occa-sions, representing the woman in her carriage on the lookout, the eye-contact from car-riage to pavement, and the pedestrian woman using her tongue to signal to a passing vehicle.[41] These images are all fairly discreet. Without Taxil's corroborating evidence even a contemporary would have been hard-pressed to realise that they represented more than the surface subject of Parisiennes going about their business. What is of interest here is why Anquetin or Taxil thought it worth their while to uncover and expose such goings-on. Taxil lived on the frontiers of legality throughout the period. In 1884 he and his wife had been found guilty of peddling obscene prints, and between 1895 and 1897 he published for a gullible, awe-struck public the serial 'revelations' of the American Diana Vaughan, victim of Masonic Satanists – and entirely his own invention.[42] Anquetin, like Lautrec later, was being cagey with censorship. But by making pictures that were allusive and codified, he was also colludingly repeating the clandestine lan-guages of the lesbian demi-monde. An initiate to their codes, he was a man with insight into the decadent underbelly of the bourgeois Republic. Through their canny manipu-lation of the covert and marginal on the one hand and the public's appetite for sensa-tion on the other, the controversialist and the avant-garde artist both claimed an insider's knowledge of social decadence.

Looking at the Body: Diagnosis, Voyeurism, Desire

Jean-Martin Charcot, a physician before he turned to psychology, firmly believed that the body gave the doctor important clues to the mental condition of a patient. In an article published with his pupil and colleague Paul Richer in *La Nouvelle Iconographie de la Salpêtrière* (The New Iconography of the Salpêtrière) during 1888 Charcot stated his view that the body was as interesting to the medical as to the artistic gaze. He argued

29 Louis Anquetin, *Le Rond-Point des Champs-Elysées* (The Roundabout on the Champs-Elysées), 1889, pastel on paper, 153 × 99. Saint-Germain-en-Laye, Musée Départemental Maurice Denis.

30 (*above*) Félix Vallotton,
Etude de fesses (Study of
Buttocks), 1887, oil on
canvas, 38 × 46. Private
collection.

31 (*right*) Charles Maurin,
Femme nue (Nude Woman),
oil on canvas, 195 × 78,
location unknown.

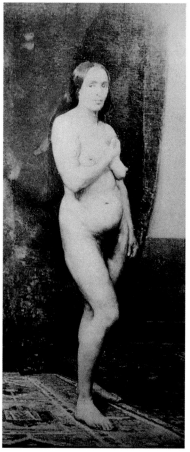

32 (*facing page*) Vincent van
Gogh, *Nue allongée* (Reclin-
ing Nude), 1887, oil on
canvas (oval), 59.5 × 73.
Merion, Penn., Barnes
Foundation.

that by studying the naked body of a patient he could learn about that individual's interior life.[43] One might draw a useful parallel between this kind of scrupulous medical practice and a canvas exhibited by Charles Maurin at the 1887 Salon des Indépendants (fig. 31). This painting, now lost, represented a naked woman standing on a rug, in front of drapery. But Maurin deliberately pulled away from the conventional *académie*. As he wrote to a friend in June 1886: 'I have begun a portrait of a naked woman, but absolutely true, and not a pink or powdered nude like Lefebvre, Carolus-Duran, but flesh, blood, colour, hair, life: no banal head, but my model's head, no feet that follow convention, after the antique, but her real feet.'[44] Interestingly enough, the correspondent to whom Maurin thus explained himself was a doctor, Régis Reynaud. Maurin's life-size figure presents the body with clinical precision, as he claimed. Far from being idealised *à l'antique*, the body has lank hair, heavy arms, distended stomach, profuse pubic hair and inelegant flat feet. Maurin's gaze was pitiless. In his stated determination to avoid aesthetic contrivance, his painting became almost the equivalent of a medical examination, the model scrutinised with the objective eye of the artist or doctor in a manner of which Charcot would surely have approved. Indeed, one of the critics reviewing the Indépendants insisted that it was *une belle anatomie* rather than a picture (*tableau*).[45] But it was precisely that 'scientific' accuracy that caused a scandal. The police insisted that the figure should be covered, so Maurin tactfully painted on a Japanese fan.[46] This was not an aesthetic judgement by the authorities. It was the imposition of order on the body and the gaze, for the female body was considered dangerous in its natural state. At a time when emergent Neo-Impressionism was the radical avant-garde style on view at the Indépendants, it is significant that it was a painting that was by no means progressive in its means of representation but was observed with scrupulously objective precision that caused much controversy.

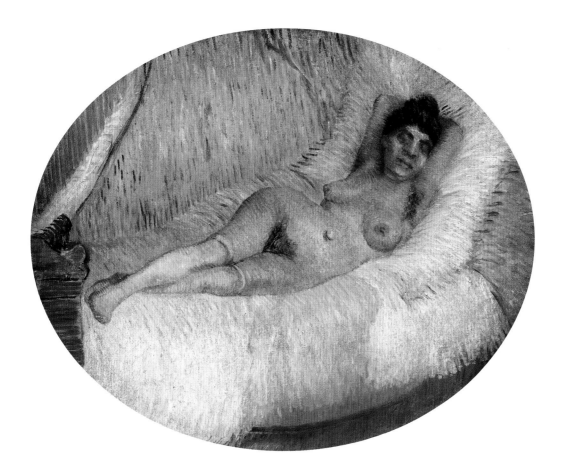

Maurin's naked woman was not without impact on other painters, I suggest. Also in 1887 his younger friend from the Académie Julian, Félix Vallotton, painted a canvas which represents nothing but a female model's buttocks (fig. 30). Like Maurin's canvas, it was life-size and attentive to every physical feature of dimple and crease. A display of student virtuosity in precise naturalism, Vallotton's study of buttocks was not, however, for exhibition, and later in life he refused to sell it. As a private painting, it raises uncomfortable questions in its verism. In particular, the image's blank matter-of-factness reflects interpretation back to the viewer. How did Vallotton, and how do we, cast ourselves in looking at it? – as doctor, lover, voyeur, artist? The frankness of this painting's actuality and the unanswerability of the questions it raises demonstrate how alarming naturalism might still be at this period, especially when the physical, and implicitly moral, stakes were deliberately heightened in this way. Another painter who seems to have realised this in the wake of the exhibition of Maurin's naked figure is Vincent van Gogh. Also in 1887 he made a drawing and a couple of paintings of a mulatto woman reclining on a bed (fig. 32).[47] As distinct from Maurin and Vallotton's naked figures, van Gogh painted white stockings on his model, playing up her undressed state. She is thus presented as prostitute or mistress, not patient. The gaze to which she is subject, as well as the role she plays, thus operates ostensibly within the nexus of desire. Nevertheless, with her broad nose, slack dugs and ample body hair, this too is an assertively naked and unidealised figure who subverts conventional expectations of the painted nude to function in a quasi-'scientific' manner.

This kind of painting revealed the body to be a uniquely contentious motif. Transgression of aesthetic norms could be dismissed or ridiculed; in 1887 Huysmans, for one, condemned the new Neo-Impressionist style in the *Revue indépendante* as being soulless and intellectually vapid.[48] But what were taken as transgressions of both social and moral norms had to be censored, even if that meant – as in the case of Maurin's figure – the absurd addition of a bibelot. Excessive exactitude appeared alarming; it had to be spurned or denied. But for doctors like Charcot the reverse was true. To his trained eye the body in its nakedness offered useful clues to the patients' condition, be it hysteria, promiscuity or some other form of mental illness. For Charcot and his fellow psychologists, the revelation of the naked body did not expose social dangers; rather it revealed inner problems. The coincidence of such paintings and such medical methods was hardly haphazard. Vallotton pursued his search for anatomical exactitude by the traditional means of doctor and artist: the scrupulous study of the cadaver.[49] Maurin avidly observed the sexual behaviour of the monkeys at the Jardin des Plantes. This unusual fascination seems to have been at once both a quasi-Darwinian 'scientific' study and also, perhaps, some form of psychological exercise for the artist. He would recount to male friends intimate experiments he had conducted on himself, upsetting Vuillard, embarrassing even Vallotton and thrilling Lautrec.[50] This was a decade in which art and medicine were in close dialogue, as the words of Charcot and practices of Maurin evince. However, it would be ingenuous to take such paintings at their objective, 'scientific' face value. Such work was energised by the sexual instincts of the artists, whether in the raw desire resonating in van Gogh's canvas, the prurient suggestiveness of Vallotton's or the crude self-analysis in which Maurin indulged and to which his representation of the naked female body may have related.

There is also evidence of various kinds to hint that there was another way of perceiving and representing the body which, though scarcely novel to the 1890s, took on a new deliberateness, even a new barefacedness. As *la psychologie nouvelle* infiltrated

the wider culture it brought with it a growing awareness of the unconscious workings of the mind. Ideas of suggestion and fantasy became increasingly part of how the educated classes understood their world, and so part of what they were prepared to record and represent. Something of this consciousness and, more importantly, the willingness to write it down as a process of self-examination of one's inner life, emerge in the private journals of the young poet Henri Hertz. After the horrific fire at the Bazar de la Charité in May 1897, a conflagration which killed many dozen helpless aristocratic and upper-class women including the wife and mother of Etienne Moreau-Nélaton, the artist and collector, Hertz noted that hitherto he had been intimidated by grand ladies, but that now he could not see them without imagining their bodies burned, equalised by death. But his musings had an erotic as well as class edge. He imagined death as a rapist, the flames reaching under their clothes and into their private parts.[51] The point here is that Hertz was conscious of his own grotesque fantasies, and was willing to record his inner psychological reflections and imaginings, however unpleasant. Given such a climate, fantasy and voyeurism took on an enhanced role in representation. In Jules Renard's ironic novel *L'Ecornifleur* ('The Sponger'), published in 1892, the spurious decadent poet Henri holidays with the guileless Vernet family on the Normandy coast. Henri, thinking that adultery is expected of him, fatuously plans it, lying flat with his ear to the floor in his room above Madame Vernet's and interpreting the sound of her invisible movements 'like a text'. She only uses cold water; the advice of a doctor, he surmises. Henri imagines her body. In his mind's eye her shoulders and breasts do not appeal to him, but he thinks she has attractive legs, imagining her uncovering them with her bedclothes slowly, like a workman removing the covering from a statue at a presidential unveiling ceremony.[52] Renard's shift from private fantasy to public ritual is an effective comic device, of course, but it suggests something of the ebb and flow between exterior fact and inner fantasy with which contemporaries were becoming increasingly familiar as a way of making sense of the modern world.

Voyeurism was quasi-institutionalised in the less salubrious forms of public entertainment. It was a fundamental motive behind the success of the *chahut*, the most licentious and revealing variant of the can-can, as both prurient and condemnatory commentators made quite clear.[53] (It was probably through this kind of dancing that the writer in *Le Progrès de l'Est* envisaged the girl in Royer's *Sur la butte* working her way out of the slums.) Voyeurism was also common in the *maisons closes*, especially the more expensive ones, where lesbian acts might be staged for customers and clandestine peep-holes could be hired.[54] With such gross behaviour as part of the admitted vernacular of viewing, it comes as no surprise that something of the kind found its way into pictorial representation. Toulouse-Lautrec, painter of both *chahut* and *maison close*, seems to exemplify this in two paintings of a model in his studio made in 1889 (figs 33, 34). In one, *Rousse*, exhibited at Les XX in 1890, the artist sat behind the model, herself seated on the floor. The painting's purpose was chiefly that of a straightforward study, to practise a foreshortened pose. But in a second painting, made at much the same time and on a support of similar size, Lautrec stood behind another model seated in a chair. This too is an exercise in foreshortening but the provocatively exposed nipple suggests less the objective gaze of the artist than the furtive glimpse of the lecher. One suspects that Lautrec was deliberately playing with two different modes of viewing.

There are, of course, many different kinds of looking, among them the appropriative gaze of desire, and artists have been aware of them. But at this period one might suggest that there was a heightened consciousness of this, even an active competitiveness among

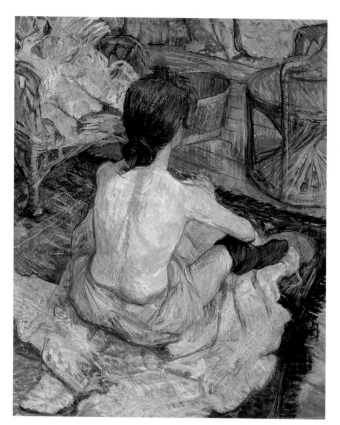

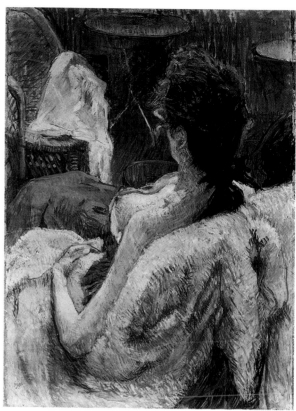

33 Henri de Toulouse-Lautrec, *Rousse (La Toilette)* (Red-head), 1889, *peinture à l'essence* on cardboard, 67 × 54. Paris, Musée d'Orsay.

34 Henri de Toulouse-Lautrec, *Le Repos du modèle* (The Model's Break), 1889, *peinture à l'essence* on cardboard, 64.5 × 49. Los Angeles, J. Paul Getty Museum.

painters about the ways in which they looked, performed by the process of making pictures. Also in 1889 Lautrec painted a model called Hélène Vary, seated in his studio on the same cane chair which features in the two paintings just discussed (fig. 35). (Indeed, Hélène bears a plausible resemblance to the unidentified model for *Rousse*.) It is a picture of strict propriety, the model wearing prim street clothes and posed in expressionless profile to display her pertly defined features. The following year Lautrec's friend Anquetin also represented Hélène (fig. 36). He also showed her seated, head in profile. But Anquetin painted her stripped to the waist, her bare torso half-turned towards the spectator, her left hand very particularly touching the arm of the chair, and the extravagantly florid wallpaper on the rear wall almost seeming to reach like an arm around her shoulders. One might have expected figure and background to have been reversed in these two paintings. The half-naked model in the studio would have been a simple *académie*, the clothed figure in front of the wallpaper a portrait. But Anquetin seems to have wanted to go beyond his friend's stock treatment. In a somewhat incongruous domestic space he stripped Hélène – out of competitiveness with Lautrec? as a conquest? – and filled his canvas with tactile associations: her gentle clasp on the wooden arm, the implied grope of the wallpaper, the longing to touch implicit in his subtle rendering of her skin's sheen. That tactility was promptly interpreted as an expression of Anquetin's desire by critics who saw the painting at the 1891 Indépendants. Adolphe

44

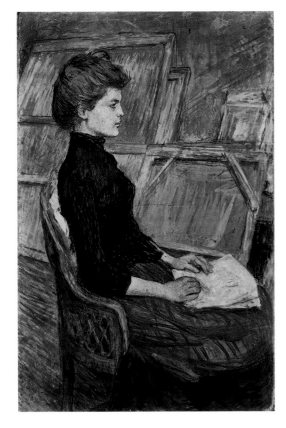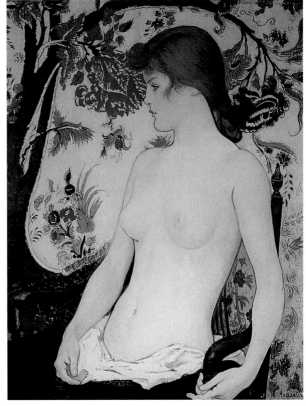

35 Henri de Toulouse-Lautrec, *Hélène Vary*, 1889, *peinture à l'essence* on cardboard, 75 × 50. Bremen, Kunsthalle.

36 Louis Anquetin, (*Hélène Vary*) (Torso of a Young Woman), 1890, 75.5 × 60.3. Private collection.

Retté found the breasts 'amorously painted' while for Henry Gauthier-Villars (or whomever he paid to write his article for him) Anquetin 'caresses with love [the] undressed virginal body'.[55]

It was instinctive and, one might argue, increasingly permissible for the male viewer to respond to such images in relation to the artist's and his own desires, and to write frankly rather than surreptitiously in those terms. I have just cited Retté and Willy. One might add Geffroy, who, reviewing the objets d'art at the 1893 SNBA, unselfconsciously slipped into this mode when he described the two peasant women which decorated Jean Baffier's *Coupe à fruits* as having bodies 'so palpable under the blouse and the skirt of rough fabric'.[56] This kind of writing was symptomatic of the modernity of the erotic that I have been arguing was typical of the *mentalité* of the 1890s. That modernity was traceable in, and influenced by, *la nouvelle psychologie*, but it can also be detected in humour: a symptom that Charcot's pupil Sigmund Freud would have swiftly recognised. In February 1896 *Le Rire* published Lucien Métivet's clutch of comic silhouettes *Rayons indiscrets* (fig. 37). These made use of the new technology of the x-ray to poke fun at the exaggerations of current fashions and the opacity of the drama critic Françisque Sarcey. The risqué was an inevitable element of such humour, be it the couple 'exposed' carrying on in a cab (subject too of a comic song by Yvette Guilbert) or the voyeurism which looks beneath the clothes of two women, both the *mondaine* and the ballet

37 Lucien Métivet, *Rayons indiscrets* (Indiscreet Rays), reproduced in *Le Rire*, 22 February 1896. New Brunswick, Jane Voorhees Zimmerli Art Museum.

dancer. Métivet here harnessed an absolutely new way of seeing – notably one linked to the medical understanding of the body – to the predilection for fantasy and voyeurism that seems to have been current in the contemporary visual imagination. Yet another medium shows something similar. Just after the turn of the century a photographer, probably Charles-François Jeandel, about whom little is known, took three photographs of a woman in a garret room (fig. 38).[57] In one she is fully clothed, in another wearing her underwear and in a third almost completely naked. Strictly speaking, they do not make a sequence. In each photograph she is in the same pose but in the most 'proper' image the objects around her are arranged differently. It is not as if she is active, stripping titillatingly before the viewer. Rather, she is passive and it is our imagination that is active, by implication removing her clothes, once again, in the mind's eye. We, as the implied spectator, sit away from her, out of reach and at the same level. We do not threaten her. We look, and imagine, reading the images like a text, an imagined sequence, in the way that Renard's sponger imagines Mme Vernet in the room below his.

At first sight Benjamin-Eugène Fichel's *Femme au bain* seems a conventional Salon nude, the figure smooth and idealised according to academic formulae, the setting plushly modern (fig. 39). But this painting too requires a similar kind of looking to Métivet and Jeandel's images in their very different media. The painting is only superficially about class: the standard, socially appropriate motif of the maid serving the mistress. Fichel represented the women as similar in height, physique, even hairstyle. One he painted

38 Charles-François Jeandel, *Trois études d'une femme* (Three Studies of a Woman), *c.*1905, cyanotype photographs, 17 × 12, Paris, Musée d'Orsay.

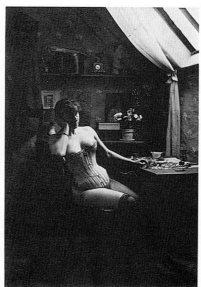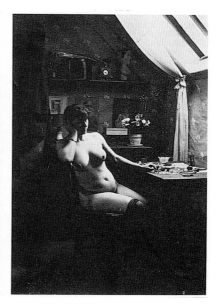

39 Benjamin-Eugène Fichel, *Femme au bain* (Woman bathing), 1891, oil on canvas, measurements and location unknown.

40 Edgar Degas, *Petit déjeuner après le bain* (Breakfast after the Bath), *c.*1895–8, pastel on tracing paper, 121 × 92. Private collection.

naked, the other clothed. By showing those two states, especially closely adjacent, Fichel was complicit in voyeurism and titillation. Although a serious, signed exhibition painting, it actually functions in a similar way to Métivet's *Rayons indiscrets*. In the fiction of his picture of an upper-class bathroom Fichel seems to present the spectator with a visual proposition: with her clothes on the woman (not any woman, but this physical type) looks like this, and without clothes she looks like that. As with Jeandel's photographs, the viewer is asked to compare different states. Further than that, the bodily similarity of the two women implicitly breaks down the class distinction explicit in their roles. Indistinguishability from her mistress was a state to which the maid aspired, wearing her cast-off clothes and hats on her afternoons off. In Octave Mirbeau's novel *Le Journal d'une femme de chambre* (Diary of a Chambermaid) the maid Célestine explains how she enjoys dressing and undressing the women for whom she works, getting to know them from head to toe so that the mistress becomes 'almost a friend or an accomplice, often a slave'.[58] (She might have added, like a patient to her doctor.) Seen from this perspective Fichel's painting is less socially reassuring. For, despite the lavish bathroom with its oriental tiles and modern plumbing, he presents two women who are physical equals, as his x-ray vision implicitly, and almost certainly unintentionally, reveals. The subject of bathing mistress and clothed attendant maid was stock in Degas's repertoire during the 1890s (fig. 40). As works of art, with their sinewy draughtsmanship and skeins of pastel in arresting chromatics, these are far superior to Fichel's plodding effort. However, Degas's variants on the theme tend to counterpoint the two figures, contrasting them in pose, movement and colour. They are not repre-

sented as interchangeable. Degas's work is much more modern and personal in its execution. But its representations of this subject are more conventional in their promptings of how to read the human body. For all its deficiencies as a work of art, Fichel's *Femme au bain* makes intriguing allusions to various means of encoding the female body during the 1890s.

Finding Forms for Sexual Experience

One might step back from images for a moment and consider how people learnt about, and articulated their desires about, the bodies of the opposite sex. These are private matters, often unshared and unrecorded. I can offer only some fragments of an enormous and complex mosaic. These samples, however, emerge from the educated and bourgeois classes, the people who made, purchased and lived with art that dealt with the raw physical and erotic facts of the human body. It would be foolish to take these tiny and partial tesserae of varied evidence as anything resembling an ultimately intangible totality. But let me take them for what they are: a fragmentary archaeology of private desires.

The middle-class woman's knowledge of the male body prior to marriage was frequently, and intentionally, rudimentary. Social factors such as bourgeois propriety, confession and convent education would have militated against fuller knowledge. Once again one comes across the tension between public and private. In national terms it was expected that women should produce babies, to improve France's dire birth rate and inject new vitality into the Republic. And yet in the privacy of many homes, especially among prosperous families in which blood and property were required to flow unsullied from one allied generation to the next, information about reproduction seems often to have been scant or oblique. A girl might learn from what she observed from such diverse sources as male family members or from sculpture, but there was still scope for horrified surprise in the detail. In 1897 Julie Manet, aged almost twenty, saw Renoir with his shirtsleeves rolled up, and was shocked that unlike an animal the hair on his arm showed the skin beneath. 'It's horrible!' she confided to her diary: 'When you take that into account, it takes courage to marry!'[59] The Paris morgue, where unclaimed bodies were laid out naked for public view, was a practical if grisly forum for rudimentary sex education, and in 1892 *L'Evénement* railed against mothers who took their daughters there.[60] A rare fictional account of a young woman's gleaning of sexual information comes in a novel by a woman, Rachilde's *La Marquise de Sade* of 1887. The manipulative protagonist Mary Barbe, now of marriageable age, asks her rigid uncle Célestin, a celebrated obstetrician, to explain the facts of sex. He is initially shocked at her forward request, but agrees to do so scientifically, thinking this better than the tangential half-truths she would pick up from women's magazines. Célestin's account is as cynical as it is clinical. Virtuous women are too witless to know how they have conceived, he proffers, while libertines drift from liaison to liaison, getting nothing out of them but serious infections.[61]

What evidence has survived about male attitudes to sex does not always make pleasant reading. In the correspondence and journals of men of letters, one of the few places where evidence can be gleaned, one detects a degree of posturing among peers, of male rivalry. When private material of this sort turns up, it is often in the form of an exchange

of some kind. Hugues Le Roux, for example, told Maurice Barrès how after mating a stallion will habitually lash out at the mare he has served, prompting Barrès privately to question in his *cahier* whether man also secretly bears his female partner ill-will.[62] The upper-class Edmond de Goncourt used the pages of his journal to scorn his fellow novelist Honoré Rosny's fantasy of sleeping with an aristocratic woman. How typical of the vulgar (*gens peuples*), he mocked, to try to ennoble themselves with their genitals![63] Pierre Louÿs lavished upon his friend Jean de Tinan descriptions of his sexual indulgences in the most ungentlemanly detail, both titillating and crushing.[64] There were of course more generous and affectionate attitudes. One instance occurs in *Double*, the innovative stream-of-consciousness text Francis Poictevin published in 1889. Devotedly married to Alice and a pious Catholic, Poictevin described how natural it felt for his body during sexual intercourse to be in a kneeling position, as if in prayer.[65] What this somewhat arbitrary cross-section suggests is a perhaps not unexpected combination of competitiveness, self-confidence and self-doubt, class rivalry and downright misogyny in men's attitudes towards the female body. These attitudes, voiced by *littérateurs*, were surely not ubiquitous, as Poictevin's more reassuring reflection proves. What links them all, I think it can be argued, is the consciousness with which these observations were made and shared. The evidence about the sexual behaviour of artists such as Degas, Lautrec and Maurin leads one to believe that artists held not dissimilar views. An acute awareness of male rut, however posturing, however exaggerated by contemporary anxieties about national virility, infiltrated image-making and image consumption.

As a starting point from which to explore the visual realisation of this kind of consciousness one might usefully examine a pastel by Degas, publicly exhibited in 1888 but little considered in critical writing then or since. A work of modest scale, it was drawn from a model kneeling on the floor, her back angled down to her head resting on her folded arms (fig. 41). At the eighth Impressionist exhibition in the spring of 1886 Degas had shown what the catalogue titled a *Suite de nuds* [sic] *de femmes*, seven highly finished pastels which mostly represent the figure in a domestic setting but two of which are set out of doors.[66] These attracted considerable critical attention, which may have encouraged him to exhibit another group eighteen months later at the branch of the *galerie* Boussod & Valadon at 19 boulevard Montmartre managed by Theo van Gogh. Nine works can be identified from the telegraphic review Félix Fénéon wrote for the *Revue indépendante* and from a page of copies that Paul Gauguin sketched in a *carnet*.[67] There was no catalogue, the exhibition lasted only a few days in January 1888 and there was minimal critical attention. In the exhibition Degas included his pastel of the woman kneeling. Like the other works known to have been on view at Boussod & Valadon, this pastel was smaller than the 1886 exhibits. And while the earlier 'suite' was all in pastel alone, some of the 1888 works were in pastel worked over a monotype base. In his mixed media works, of which *Femme sortant du bain* is an example, Degas tended to develop the schematic monotype into a cogent naturalistic subject, replete with appropriate actions and everyday setting (fig. 42).[68] But the motif of the woman kneeling was not handled in this way. Firmly and even rapidly drawn in charcoal, it was then heightened in pastel: chestnut brown hair, a pale violet blue for shadows round head and arms, a pink glow on flushed cheeks and a scrubbed flurry of deeper red around the figure to offset the modelled form of the pose. With a mushroom grey tone used round the contours of the figure, and the white paper left bare on the strongly lit hip and flank, the posture has a powerfully sculptural presence, a compact combination of

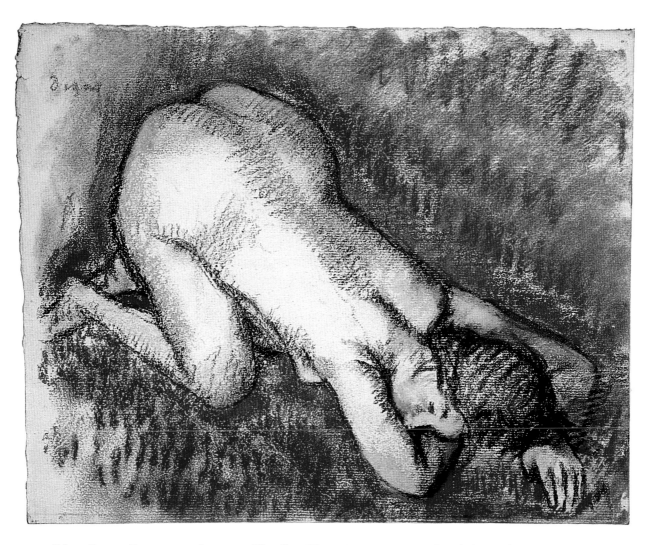

41 Edgar Degas, *Femme nue, à genoux* (Kneeling Woman), 1887–8, pastel and charcoal, 24 × 31. Private collection.

curves and angles. Unlike his worked-up monotypes, Degas here made no attempt to add a domestic setting. The pose, one might say, holds its own as a sculptural form.

Yet, is that a sufficient account of this pastel? After all, the posture represents a sexual position, described as *en levrette* in the pornographic tales of Pierre Louÿs and for which particular courtesans were recommended in guidebooks for upper-class British visitors to Paris.[69] Degas was surely aware of this. A sexually active bachelor in his mid-fifties, the following year he was instructing his friend Boldini to purchase prophylactics at a *maison close* at 21 rue Beaujolais for the adventures they both expected on a forthcoming trip to Spain.[70] The provocative positioning of his signature is a more than allusive indication of the artist's consciousness of the erotic potential of this posture. Other decisions seem to bear this out. Domestic background had no place, one might suggest, in a pose that concentrated the artist's desires. The eroticised gaze is evoked, acted out one might even say, by the agitated strokes of deep red and crimson pastel which form a hot, frantic aura round the figure. The very handling of the pastel evinces an almost physical engagement with the subject of the kneeling woman. Why did Degas leave the

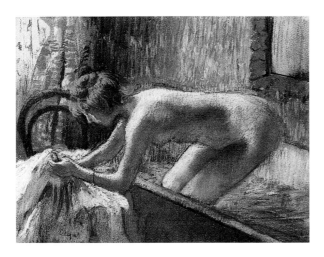

42 Edgar Degas, *Femme sortant du bain* (Woman leaving her Bath), *c.*1885–8, pastel over monotype, 27.5 × 37.5. Private collection.

body merely monochrome and choose red to surround it and give it relief? Red was commonly understood by contemporaries to be the colour of sexual desire. His eye falling on a shop window's display of wine-red corsets, Goncourt muttered that red is 'a colour which heralds wicked things', while in his novel *L'Abbé Jules* Mirbeau described blood-red couplings of clouds at sunset to set the scene for his corrupt priest's attempt to rape a peasant girl.[71] Nordau recorded recent medical experiments that demonstrated the results of different colour stimuli; red appealed to the hysterical, pleasure-driven artist.[72] Red was the conventional colour of the plush used in the public rooms of *maisons closes*, Lautrec's paintings of such places rather wanly playing off the lassitude of the waiting prostitutes with the warm and ostensibly sensual atmosphere of their surroundings.

Given the torrid handling and explicit pose of this pastel, let alone the recent furore over Maurin's standing figure, it is remarkable that Degas offered it for display and that Theo van Gogh was prepared to hang it publicly. The group of pastels was probably exhibited not on the ground floor where Theo presented his primary stock, but on the *entresol* above where he could control the visitors. It was there that he showed more radical art, such as Monet's views of Antibes in June 1888. As seen, dividing the clientele in this way was both a means of protection from controversy or censorship and also a way of making the initiates allowed to the upper floor feel complicit in the work displayed there. Very little is known about the no doubt complex relations between the eroticised representation of the body, censorship and the art market during the 1890s. But once again shards of evidence – both from reading the works themselves and from collecting practices – can be brought into play to provide a provisional picture. This suggests that there was some kind of collusion between how men wanted to represent, to own and even handle women's bodies as art.

Rodin's sculpture known as *Iris, messagère des Dieux* was initially made in the early 1890s as one of the muses for Rodin's planned monument to Victor Hugo (fig. 43).[73] In the cluster around the poet's head, she would have embodied the erotic inspiration for his work. However, in the second half of the decade the half life-size figure took on an independent role. Exhibited at Rodin's one-man show during the 1900 Exposition Universelle, it was entered in the catalogue as *Autre Voix, dite Iris*, both alluding to its initial function as inspirational figure and to its independent status. Despite the fact that

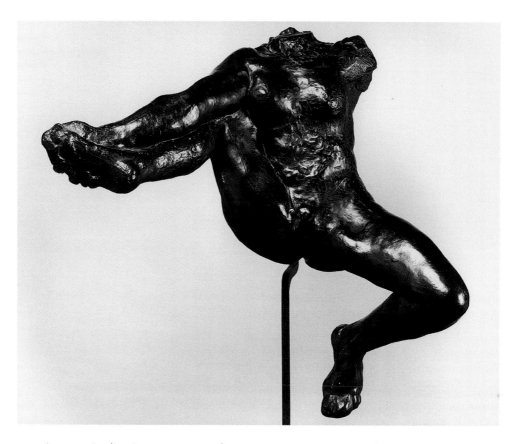

43 Auguste Rodin, *Iris, messagère des Dieux* (Iris, Messenger of the Gods), *c.*1890–5, bronze, 82.7 × 69 × 63. Paris, Musée Rodin.

bronzes of *Iris* were mounted on a metal stand that gives the impression that she is leaping though the air, the figure was undoubtedly made from a model who posed lying on her back. This is evident both from the irregular and sometimes irrelevant modelling on the dorsal surface, and also from the fact that such a pose – legs splayed wide apart, one extended foot clasped in an outstretched hand – would have been impossible for a model to sustain unless she was lying down.[74] Reclining, the pose unswervingly represents the energies of sexual passion (fig. 44). Before the 1900 Exposition Rodin had already authorised and sold several casts of this figure mounted on iron stands. Thus presented vertically, the eroticised female addresses the spectator frontally and assertively, as a leaping, fragmented embodiment of female sexual arousal. By moving his figure through ninety degrees and fixing it confrontationally on a stand, Rodin transformed what had originated as a prone quasi-naturalistic, quasi-prurient pose of everyday sexual experience into an almost mythic vision, ritualised and dance-like. This metamorphosis denied to the collector the fuller erotic experience that must have been Rodin's. Modelling the figure, with the tactile medium of plaster under his fingers and the model spread out before him, placed the sculptor more than ever in the place of lover or voyeur, involving him in an extremely intimate meditation on looking, desiring and making. Owning the bronze, with the figure prancing in a frozen moment of erotic frenzy, would have been a far less charged experience. Nevertheless, the

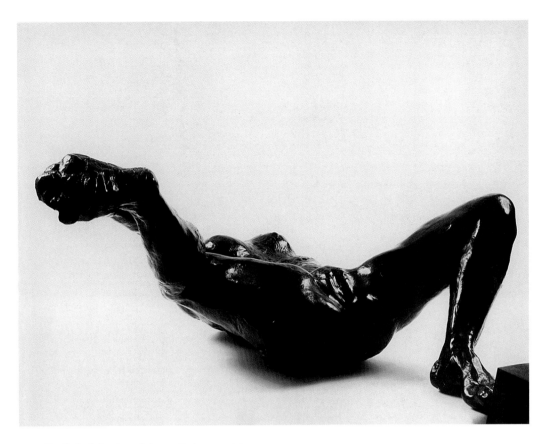

44 Rodin's *Iris* placed in reclining position.

presence of such a sculpture on display in one's domestic space, a tangible icon of desire and delight, must have been disconcerting. It would have been an admission, in the privacy of the home, of one's conscious awareness of, one's explicit collusion in, the *mentalité* of the erotic that I have argued was a powerful undercurrent in 1890s France.

There is still little information about collectors and their motivations in this period, but one can begin to tease out some tendencies and patterns and then draw together the threads of evidence. In 1889 Maurin introduced his friend the sculptor Rupert Carabin to the wealthy engineer and collector Henry Montandon. A sequence of commissions followed. The first, a wooden bookcase with carved allegorical figures of naturalistic female nudes (see fig. 12), was refused by the Salon des Indépendants in 1890 (shades of the furore over Maurin's *Femme nue* three years before), though it was exhibited at the SNBA in 1891.[75] This was the piece that Max Nordau had found symptomatic of the decadence of contemporary French art. Carabin went on to create a group of extraordinary pieces of carved furniture for Montandon. Choosing nut wood, warm-toned, smoothly modelled and shaped into flowing forms, Carabin used the female figure as the basis for these pieces. Remarkable as these objects are in their inventiveness and craftsmanship, they present uncomfortable images of women's bodies. In 1890–1 Carabin created an armchair for which a kneeling woman forms the base. Supported

53

45 Rupert Carabin, chair, 1893, nut wood and wrought iron, 122 × 66 × 72. Strasbourg, Musée d'Art Moderne et Contemporain de Strasbourg.

on her shoulders and bowed head is a pile of books, on which the seat rests.[76] In 1893 he carved another chair, this time with two female figures. One kneels, back bent low to support the seat; the other also kneels, with her upstretched body supporting the back of the chair. Two cats form the chair's arms (fig. 45). Carabin's equation of female and feline, both supple and sensual, played with a topos traceable in French culture at least as far as La Fontaine's fable *La Femme transformée en chat*. It was a cliché current in the 1890s. Jean Champaubert's story *La Femme au chat*, for instance, published in *Gil Blas illustré* in February 1896 with an illustration by Théophile-Alexandre Steinlen, described the dancer Liline Ablette crawling on the floor to play with her cat, the 'adorable curve of her back [and] . . . the mysterious shadows of her thighs' displayed in a way that would enflame her protector Baron Silberstein (fig. 46).[77] Here is more than a longstanding and not altogether flattering association with female physicality. The notion of woman as feline rendered her animal, excessively natural and beyond

46 Théophile-Alexandre Steinlen, illustration to Jean Champaubert, *La Femme au chat* (The Woman with a Cat), cover of *Gil Blas illustré*, 16 February 1895. New Brunswick, Jane Voorhees Zimmerli Art Museum, Rutgers, The State University of New Jersey. Acquired with the Herbert D. and Ruth Schimmel Museum Library Fund.

reason. In Huysmans's *Là-bas* (Down There) (1891) the protagonist Durtal muses that recently a young woman had been brought to the psychologist Charcot believing she was a cat.[78] Whether the novelist's invention or an actual clinical case, the psychological dimension is significant here. It relates less to women, whose physical behaviour or mental state might be considered feline, than to the men who were prepared to entertain such notions. To think of woman as a domestic animal, given to languor, sensuality and caresses, was to reduce her to an inferior stereotype, to suggest, in Darwinian terms, a greater irrational physicality and a lesser intellectual development than men.

That physicality comes out in Carabin's carvings. The figure that forms the base of this chair is in a similar pose to the kneeling figure that Degas exhibited in 1888, a pose of physical submission at the least. In that sense it is a posture both servile and functional, able to support a seat or give sexual satisfaction to a man. The order embodied in Carabin's chair counterbalances the flagrant, one might say hysterical, sexuality, the

47 Auguste Rodin, *L'Ecclésiaste* (Figure on a Book), before 1899, plaster and book, 26 × 28.3 × 26. Paris, Musée Rodin.

lack of erotic or moral discipline, demonstrated by the figure of *Iris* or by another piece Rodin showed in 1900. This was a small plaster figure of a woman reclining on her back, feet clasped in her hands in a posture of agile sexual display. Such a pose is highly reminiscent of the drawings of patients at La Salpêtrière that Paul Richer had made for Charcot's lectures and had published in 1881 (figs 47, 48). Rodin placed his plaster figure writhing on a real book, as if to contrast abandoned female physicality with the scientific rationality of male culture. Carabin used a similar conjunction. In the first chair he had made for Montandon the female figure had supported books on her back and a seat on top, while a table made for another collector in 1896 took the form of an enormous volume upheld by two life-size carved women.[79] Consistently in his sculpted furniture, pieces made for display and for practical use, Carabin represented women's bodies as both sensual and strong. This implied a double function: on the one hand, a frank, vital sexuality and on the other the dutiful capability to support man's world of work, books, ideas. In such pieces of Carabin's – which one should remember were put on public exhibition at Salons and then had a substantial presence in domestic spaces as objects of practical purpose and aesthetic value – the female body was represented as having a double submissiveness.

Fig. 95. — Contorsion. Attaque démoniaque.

48 Paul Richer, *Contorsion: attaque démoniaque* (Contortion: Demonic Attack), from *Etudes cliniques sur la grande-hystérie ou hystéro-épilepsie*, Paris 1881 (2nd edn, 1885, p. 199). Manchester, John Rylands University Library.

Those submissive postures raised a moral discomfort among some. Nordau, typically enough, feared that Carabin's 'naked furies and possessed creatures' would introduce 'a nightmare' into the home.[80] Even Emile Gallé, doyen of French applied artists and friend of Carabin, was troubled that women's bodies, 'the body of sister or wife', should be rendered as 'degraded slaves'.[81] Both were reacting against Carabin's treatment of the female body in a mode common for millennia: in decorative forms for domestic display. What particularly troubled Nordau and Gallé seems to have been what they perceived as an excessive rendering of the female body as instinctual and sexual, the overt eroticisation of the body that appeared to be a characteristic of modernity in visual culture. That overtness was evident not just in the making but the collecting of such works, the motives for which Nordau and Gallé found reprehensible. Collecting in the 1890s, one might speculate, was more than usually imprinted with the male's desires for female submissiveness and malleability, with his fantasy of a regular, undisputed right to touch and own the female body. It was a fantasy readily realisable by the proxy of the art object. We find this in a pastel of a man by George Desvallières, perhaps identifiable as the *Portrait de M.J.K.* that he exhibited at the 1891 SAF (fig. 49).[82] Wearing top hat and overcoat, and clasping gloves in one hand and cane in the other, the man is caught either returning to or departing from what one takes to be his apartment. He is flanked by the accessories of a comfortable, cultured life: to his left a piano, and to his right a table with writing materials, an elaborate inkwell and a bronze of Alexandre Falguière's *Nymphe chasseresse* (Hunting Nymph).[83] Just as monsieur has been posed frontally by the artist, so the bronze has been placed – by artist or collector? – at a provocative angle for the spectator. If such a bronze was manipulable according to the whim of its owner, other objects were literally made to be held in the hand. Carabin crafted several silver or bronze handles for gentlemen's canes in the form of the female nude (fig. 50).[84] These were representations whose purpose was to be a regular presence in the grasp, to be fondled and held when the owner was outside, mixing with women on the city street. As a gentleman like Desvallières's sitter looked at or talked to real women, he could hold one, via the artifices of the sculptor, in his hand. There is no doubt that this was the intention of such objects. Writing about the sculpted key-holes and door-handles made by Alexandre Charpentier, the critic Dan-Léon dwelt on the sensual forms of the

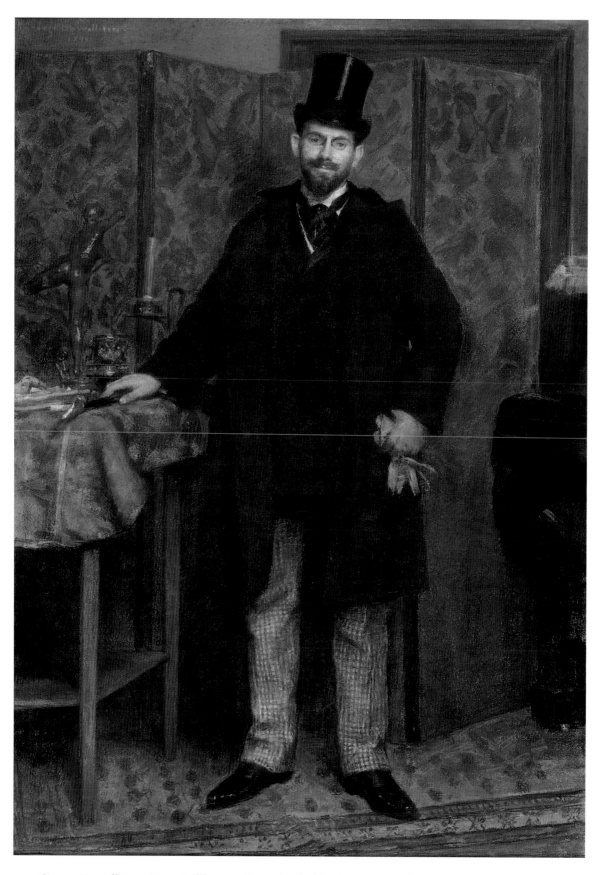

49 George Desvallières, *Portrait d'homme* (Portrait of a Man), 1891, pastel, 117 × 89. Paris, Musée d'Orsay.

50 Rupert Carabin, handle of a cane, *c*.1903–4, silver, agate and wood, 13 × 11. Paris, Musée du Petit Palais.

female figures which decorated them, insisting that Charpentier's purpose was 'to give our hands, our fingers, the same joy as our eyes', thus constantly granting the male the sensual privileges of touch and gaze.[85]

The Female Body and Psychological Narrative

Let me turn for a moment to a history painting, Paul Jamin's *Le Brenn et sa part de butin* of 1893 (fig. 51). Although a scene set in the ancient world, it inferred multiple contemporary allusions for its public in the nineties. The canvas represents the Gaul Brennus, whose forces conquered Rome in 390 BC. Jamin's blood-bespattered hero functions as an image of military triumph, of the ability of the *furia francese* to topple opponents – and as such could be read as having *revanchard* allusions. His triumph is due to his virility, conveyed by Jamin in the swaggering pose, lusty smile and manly grasp on his weapon. Although Coubertin idealised a more noble aspect of the classical world, this figure of Brennus corresponds to his vision of fit, competitive and victorious French manhood. Jamin's painting imagines the moment when Brennus's virile energies switch from physical to sexual violence. The artist, whether consciously or not, set up his painted story of the distant past in thoroughly contemporary terms. Leaving the outer, male world of war, Brennus enters the enclosed female space of flesh and sensuality. This is an imagined space, to which the spectator has already been granted privileged access, to imagine and share Brennus's desires. That said, *Le Brenn* deals with an immediately legible narrative. Facial expression and body language establish the protagonists' dramatic parts, the setting conveys the historical moment. The psychology of the story is simple – confrontational and cruel – and the roles of the two sexes stereotyped. The scene is so conventional, both as a kind of historical or fictional narrative and as a piece

51 Paul Jamin, *Le Brenn et sa part de butin* (Brennus and his Plunder), 1893, oil on canvas, 162 × 118. La Rochelle, Musée des Beaux-Arts.

of staged or painted theatre, that it has limited emotional impact. The canvas reads more as a well-rehearsed performance than as an intense psychological moment. It was against such limitations, and in response to a new and I believe deliberated alertness to the workings of the inner mind, that independent artists developed in the 1890s a revised and more acute means of representing pictorially the interplay of physical behaviour and mental state. Like Jamin, they often recognised that a sexually charged moment could provide particular drama; unlike him they preferred to present their narratives allusively and to use their means of representation as a suggestive device.

During the 1890s Degas posed his models in various ways. Sometimes they were treated almost like conventional *académies* (except that Degas's handling of pastel was hardly conventional): arranged so the artist could study the form or movement of their body. In other cases Degas required poses that would contribute to a more 'lived' plausibility, so the model might be asked to take up a position as if she were washing or towelling herself, or in relation to another figure, such as the maid serving her mistress (see fig. 40). One can establish a third category. In these Degas posed his model as if to suggest some incident, something not quotidian or banal. In these the positioning of the body has a significant role in suggesting the psychology of the moment represented, as does the play of his pastel on the paper. A pastel made in the mid-1890s of a young woman on a bed is a case in point (fig. 52). The posture is slightly ambiguous. She may be asleep but the position of the lower body – hips on the edge of the bed, one leg on the floor and the other cocked up behind it – seems uncomfortable enough to preclude that reading. That very precarious discomfiture of the body, together with the half-naked torso and the face pressed against the pillow, half-hidden by hair and seeking the reassurance of the hand, suggests a troubled state of mind. One can imagine this hunched, protective, irregular posture as the physical manifestation of emotional instability; it brings to mind shame or self-defence, perhaps after a sexual encounter, as the discarded clothes at the end of the bed hint. In comparison with a more conventionally naturalistic treatment of a similar scene of a young woman in emotional distress, Jean Béraud's *Après la faute*, the extent that Degas's handling of the medium adds to his image is apparent (fig. 53). Béraud's deep plush furnishings and the woman's grey dress contribute towards that mood of distress, but in a merely descriptive way. Degas seems wilfully to have employed what one might call chromatic irony. The pastel's colouring – lavender and pale green, petrol blue and warm ochre – is soft and appealing, in stark contrast to the body language which conveys shame, regret, hurt or vulnerability.

That pastel can usefully be contrasted with another, dated 1894, thus close in date. They are about the same size: the motif of the figure on the bed measures 50.5 by 65 centimetres, the second pastel of a young woman braiding her hair 61 by 46 centimetres (fig. 54). They share a similar palette; indeed, the same sticks of pastel might have been used for both works. Moreover, it is even possible that the same model with long brown hair could have posed for both. There comparison stops. The first pastel is a horizontal design, structured round the bed. It is an armature for disorder: heaped linen, discarded clothing and the precariously hunched young woman, cramped in the picture space, half-naked, even pathetic. By contrast, the second is structured round the vertical of the figure as she arranges her hair. Although filling only half the picture space, she dominates it. The room is represented as tidy and clean, one might almost say virginal. In that sense, one could argue that there is some kind of moral distinction between these two narratives that Degas contrived round the representation of the female body.

52 (*above*) Edgar Degas, *Jeune femme sur un lit* (Young Woman on a Bed), *c.*1894, pastel, 50.5 × 65. Private collection.

53 (*right*) Jean Béraud, *Après la faute* (After the Misdeed), *c.*1885–90, oil on canvas, 38.1 × 46. London, Tate Gallery (on loan to the National Gallery, London).

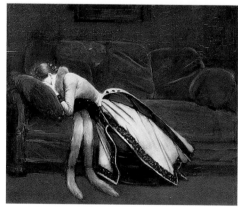

54 (*facing page*) Edgar Degas, *La Toilette* (Young Woman braiding her Hair), 1894, pastel, 61 × 46. Private collection.

Behaviour and body language tally with different emotional, and moral, states: on the one hand remorse, on the other self-possession. Above all, that contrast is articulated by touch. The woman on the bed was crafted in gestural, agitated, almost aggressive markings, whereas the woman braiding her hair was made with controlled, harmonious, even docile strokes. Pastels like these were the result of posing the model and making

marks, of creative decisions in the studio. They were also made by a sexually active bachelor of sixty, who was fascinated by how women lived their lives and who was given to taking moral positions about them. He justified peering down the cleavage of a woman seated next to him at dinner by arguing that the low cut of her dress meant she invited it and deserved no better, and with a belief in the proper social role for the

haute bourgeoise did his best to engineer Julie Manet's engagement to the eligible Ernest Rouart. Making works of art that in body language and touch contrived readings of different emotional states, Degas operated as moralising bourgeois, inquisitive heterosexual male and artist acutely conscious of modernity's discomfiting and deepening fascination with the interstices of the erotic and the psychological.

That artists' own intimate relationships should contribute in some way to their work should come as no surprise. But in the 1890s there are instances in which the interchange between an artist's sexual relationship with a woman, his own inner response to this and the making of pictures took on a particularly intense and, I shall argue, deliberate form. This was a manifestation of the new awareness of psychology and unconscious human motivation. It found exquisitely elaborate literary expression in Pierre Louÿs's novel *La Femme et le pantin* (The Woman and the Puppet), published in 1898. Set in contemporary Spain, the novel describes a wealthy Frenchman's sexual obsession – driving, ridiculous, humiliating and destructive – with a ravishing working-class Sevillian woman.[86] Louÿs's text is more than a racy story about a *femme fatale*. It concerns behaviour rather than action, behaviour that is tortuous and repetitive, and the accounting for that behaviour both in one's own mind and to an interlocutor. The protagonist explains himself to another man, who is at once confessor, psychologist and reader. Similar kinds of exploration of the psychology of sexual relations, I shall show, can be traced in the contemporaneous painting of Vallotton and Bonnard.

In the middle and late 1890s Vallotton, the son of a prosperous business family from Lausanne, was involved with a young working-class Frenchwoman named Hélène Chatenay. This kind of relationship – sexual, across the class divide and ultimately transitory – was common and often passed off obscurely, but in this case there exists some evidence that throws light on both Vallotton's painting and wider social attitudes. In 1899 Vallotton decided to marry Gabrielle Rodrigues-Henriques. He explained his reasons with unflinching clarity in a letter to his brother Paul. Gabrielle was the daughter of the important art dealer Alexandre Bernheim, a connection which offered obvious commercial advantages. She was a widow 'with whom I get on without trouble' and whose three children aged from seven to fifteen Vallotton blithely believed to be already grown up. He expected to live without either needing to change their habits: 'me at my work, she in her interior, it will be very reasonable'.[87] Vallotton's self-interested new arrangement necessitated ditching Chatenay. In the same letter he explained to his brother that both he and Hélène would be hurt by this, but that he had always told her he would one day marry. In another letter he added that she would not be surprised as he had prepared her for the eventuality.[88] Vallotton's use of the word *préparée* suggests that he expected to be able to manipulate his less advantaged mistress. During their relationship in 1897–8 he had made a number of small paintings of female nudes, alone or in pairs, set in interiors. It seems likely that the figure represented asleep on a pile of cushions in 1897 was posed by Hélène, as well as the figure on the right in the picture of two women playing with cats that he painted the following year (fig. 55). Other paintings in this informal group show a woman dressing by a bed, watched by a lapdog, or two women seated on the floor playing draughts.[89] These small, simply painted pictures were relatively rapidly produced, saleable items. They bespeak an easy intimacy with women and their willing participation in Vallotton's play with posing their bodies in absurd (the draughtsplayers!) or allusive ways. Posing Chatenay with the cats was punning, ludic. A sketchbook drawing Vallotton made of her dressed in man's clothes

56 (*right*) Félix Vallotton, *Hélène Chatenay*, *c*.1897–8, pencil, dimensions unknown. Private collection

55 (*below*) Félix Vallotton, *Nues aux chats* (Female Nudes with Cats), *c*.1898, oil on board, 41 × 52. Private collection.

further suggests that he treated her and her body as something malleable or puppet-like, adaptable to his fantasy (fig. 56). After his 'reasonable' marriage he never depicted the matronly Gabrielle nude; she appears in his work as the respectable bourgeoise pre-occupied in 'her interior'. The nudes Vallotton painted after 1899 were from models, hired to pose. Never again would his work have the intimacy and rather one-sided play-fulness that his relationship with Chatenay allowed. Social and sexual domination gave scope for a particular kind of painting.

If Vallotton's paintings featuring Hélène Chatenay are at some level a pictorial equivalent of his manipulation of her in life, in Pierre Bonnard's work one can find a less objective, more internalised painted engagement with a sexual relationship. In 1893 Bonnard also started an affair with a young working-class woman, Marie Boursin. The fact that she styled herself Marthe de Méligny suggests that she had airs; upwardly mobile, she set up with a senior civil servant's son. As soon as their relationship began Bonnard painted some small paintings of Marthe naked or dressing: markers of their newly discovered erotic intimacy.[90] Five years later Bonnard produced another group of paintings, tightly focused on their sexual relationship. These pictures are no longer about the thrill of novelty. Rather, it seems to me, they deal with a more profound, and darker, assessment of Bonnard's desires and his entanglement with Marthe.

In 1898–9 Bonnard painted several versions of a particular pose: Marthe lying, legs splayed, on a bed. He used the same pose in one of the lithographs he was making at this time to illustrate Paul Verlaine's volume of erotic verse *Parallèlement* (1889). But while Verlaine's torrid poetry resonated in Bonnard's imagination, it did not drive it. Indeed, this pose is not an exact visual transcription of the poem, 'Séguidille', which it

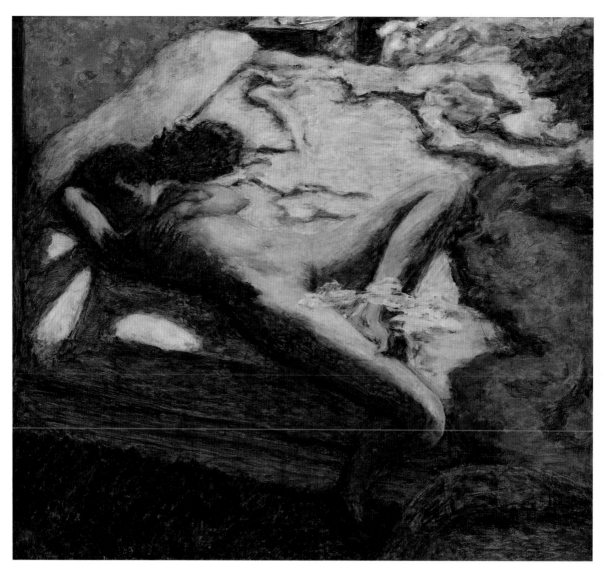

57 Pierre Bonnard, *Femme assoupie sur un lit* (Woman langorous on a Bed), 1899, oil on canvas, 96 × 106.
Paris, Musée d'Orsay.

adorns in the illustrated edition Amboise Vollard published in 1900.[91] Bonnard's most
intense engagement with this pose came in two substantial canvases, one of which is
dated 1899 (figs 57, 58). In both canvases the woman lies on her back, one foot dan-
gling on the floor, the other leg angled outwards. She cradles her head with her right
hand, and with her left pushes her breasts gently upwards. Her tactile awareness of her
own body is enhanced by the detail of her foot on the right thigh, its toes taut and
curled. The woman seems acutely aware of her own physicality, both as something she
can touch for herself and display to us, with her *Iris*-like posture. The flesh is not
realistically painted, in the manner of Maurin's *Femme nue*. Instead it is evoked by the
undisguised visibility of the brushmarks, running over the warm forms in irregular,
fingertip-like strokes. This makes the viewer aware of the man's role, of Bonnard's
looking and making. For this is his view down on his lover Marthe; his body has rumpled

66

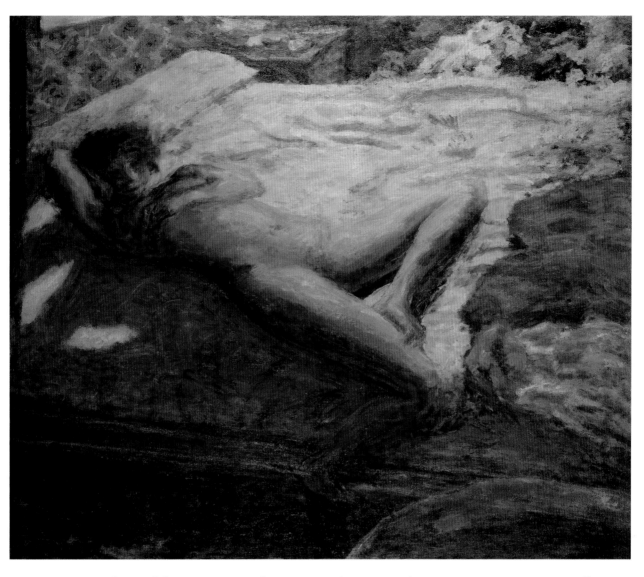

58 Pierre Bonnard, '*L'Indolente*' (Woman reclining on a Bed), *c.*1899, oil on canvas, 92 × 108. Private collection.

the sheets on the other side of the bed; the intimacy, provocativeness and sexual con-
fidence that her body exudes is beamed at him; the smug, shadowy face is to the viewer
any woman, but to him it is that one. Yet this is not an explicit painting. The eroticism
I have described has to be sought by the eye, gradually. That Bonnard himself proceeded
in such a way is suggested by his going back and back to the pose. He made adjust-
ments. The painting dated 1899 includes a cat by the woman's head, making the feline
analogy that was common in 1890s iconography, and the dark rumpled blankets at the
bottom of the bed seem to form a monstrous voyeuristic head and shoulders. In the
other canvas Bonnard drew attention to the rim of the tub beside the bed, at his feet,
ready for post-coital ablutions.

These are surprising paintings. Surprising in their sultry, sluggish evocation of both
object of desire and the desirous gaze; surprising in Bonnard's obsessive repetition of

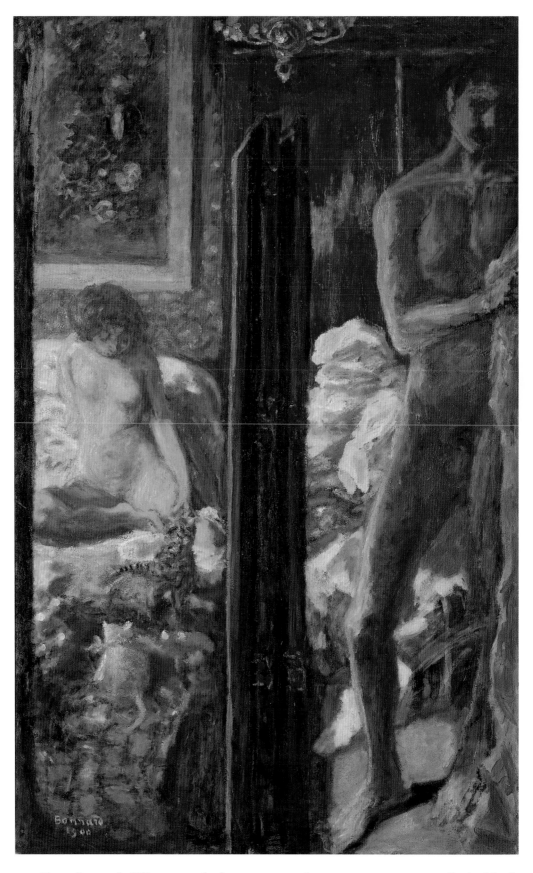

59 Pierre Bonnard, *L'Homme et la femme*, 1900, oil on canvas, 115 × 72.5. Paris, Musée d'Orsay.

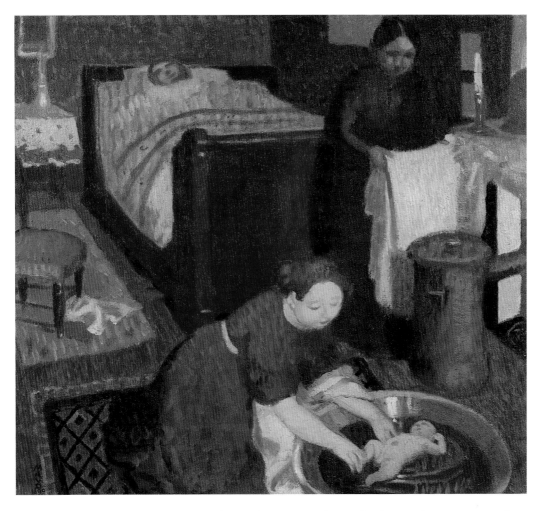

60 Maurice Denis, *La Première Toilette* (The First Wash [Birth of Bernadette]), 1899, oil on canvas, 44 × 49. St Tropez, Musée de l'Annonciade.

this personal business; surprising that in the painted recreation of such intimacy he must have been aware that – once the canvases had left his studio – he was putting the spectator in his own place. One can be certain of that awareness when one looks at another painting from this time, dated 1900: *L'Homme et la femme* (fig. 59). This again is one of several canvases in which Bonnard represented not only the naked Marthe but also himself.[92] These paintings form a pictorial meditation on male and female sexuality, on coupledom and on the specific relationship between Bonnard and Marthe. *L'Homme et la femme* is set in their flat at 65 rue de Douai. Marthe is represented as relaxed, 'natural', in her naked state, playing with the cats; Bonnard begins to hide his nakedness. She lingers on the bed; he does not. She is self-absorbed, frank, in full light; he occupies a darker space, head turned away. For all the apparent openness of their sexual difference and emotional partnership, they are divided by the folded screen. Are we meant to read this caesura across the canvas as simply the stereotype of male and female worlds: as Vallotton put it, 'my work, her interior'? Is the painting about rift, incompatibility? Or does it discreetly deal with the tension in this relationship between sexual

desire and habit on the one hand and on the other irresolvably polarised social and cultural division?

One might contrast *L'Homme et la femme* with a smaller painting of a very different subject painted by Maurice Denis the year before (fig. 60). Made to record and celebrate the birth of his daughter Bernadette, the canvas shows order in a woman's world. All is as it should be. Marthe Denis rests in bed, her fatigued body completely covered, while other women care for the newborn baby and the domestic needs. The design is crisp and clear; three women in three separate spaces do three different things: rest, wash the child, warm towels. The comforting tonality of browns and greys evokes a sense of the physically protective and the emotionally joyful. Denis's painting, consistent in touch and tone, is harmonised, pictorially unified round a single moral ideal, for his painting is about the creative, Catholic, dutiful result of sex. By contrast, Bonnard's canvas may be consistent in tone, in the glowing ochres and browns that give a sensual aura to flesh and décor, but it is equally unready to settle to a particular touch. With dabbed pattern here, rough marking there, it revels in its instinctiveness, its untidiness. Just as Denis's touch implies the moral order of the marital home, so does Bonnard's the ramshackleness of the 'irregular' relationship. Denis's painting is an affirmation of social and religious beliefs, and while highly personal has an appropriately general value. Bonnard's painting too is based on lived experience, but it is concerned with the exploration of private emotions and anxieties. Denis's faith and marriage allowed his painting to deal with certainties, while Bonnard's *L'Homme et la femme* and the other paintings of 1898–1900 that weigh up his relationship with Marthe seem to have acted as a process of self-analysis, even of therapy, at a time of inner uncertainty.

Adultery: Bourgeois Fear, Bourgeois Fantasy

The public imagination in 1890s France nursed a feverish preoccupation with adultery. As in any society, there were many takes on adultery: a passionate or guilty thrill to the participants, a wounding humiliation to the jilted, a mortal sin to the Catholic Church, or a criminal act to the lawyer. Adultery was an uncomfortable subject at the intersection of public and private life. It threatened marriage, in Republican France a civil contract signed in the *mairie*. Marriage created family, and together they formed the stable social foundations that the nation – anxious to preserve collective order, protect wealth and inheritance, and increase the rate of natality – greatly needed. Adultery was a manifestation of that natural instinct for *la débauche* that Republican commentators such as Fouillée diagnosed as symptomatic of national degeneration. Worse, it subverted from within the structures of marriage that the majority of society – on the surface at least – sought to uphold, as just seen in Denis's proprietary canvas of childbirth in the family home. Adultery's centrality in public debate – in legislation, journalism, sociology and humour – paralleled its proliferation in the creative media. Changes in the law, introduced by Republican governments during the 1880s, opened the way for new attitudes, new openness and thus new representations. The legislation liberalising divorce, passed in 1884, essentially protected the family rather than the married woman. A woman could now sue for divorce, but only if her husband kept another woman in their home. A wife's adultery was always a crime, even punishable by prison. Some politicians, such as Alfred Naquet, a promoter of divorce reform, worried that the new

law came close to promoting male adultery. However, the practicality of case law rarely punished female adultery more than male in the ensuing years, and in fact during the 1890s money and mistreatment were the prime causes of divorce suits rather than adultery.[93] Although divorce, separation and scandal were hardly invented in 1884, nevertheless with divorce in the open – in the courts, in the boulevard theatres, in the *faits divers* columns and serialised stories of the popular press – its causes became increasingly common coin in the public imagination. Steinlen's weekly covers for the widely read *Gil Blas illustré* had an adulterous theme almost once a month in 1896.[94] Adultery wormed its way from surreptitious experience and shameful exposure to the forefront of the bourgeois imagination because it seemed to have become specifically modern. Symptomatic of contemporary 'degeneration', crucial to reformist legislation, meat and drink to the daily press and popular culture, target of Church and moralists, threat to social order in its most fundamental manifestation, *chez nous*, adultery seemed to be an insistent expression of modernity. Nowhere does that become more apparent than in a specific case about which – thanks to hoarded evidence – there is unusually ample evidence. Pierre Louÿs's affair with Marie de Régnier, wife of a friend and fellow poet, was conducted, as it were, via the gadgetry of contemporary popular culture. In letters to his brother Louÿs recounted conversations between the protagonists with stage directions and dialogue as if scripted for the boulevard theatre; he and Marie commu-

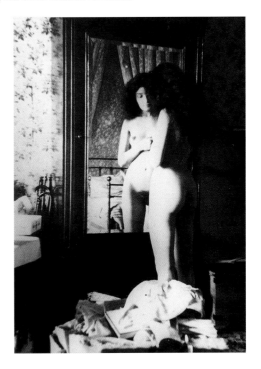

61 Pierre Louÿs, *Marie de Régnier*, 1896, photograph, dimensions unknown. Private collection.

nicated surreptitiously through the small ads column in *L'Echo de Paris*; and Louÿs used his convenient new model Kodak camera to take instantaneous photographs of his lover naked (fig. 61).[95] Here age-old lust and modern forms colluded as never before.

Public and private attitudes to adultery no doubt covered the spectrum of human responses. In February 1899 President Faure died, in his Elysée Palace office in the arms of Mme Steinheil, an artist's wife who was swiftly and surreptitiously smuggled out by civil servants. Immediately before her fatal tryst with Faure she had been at the grand establishment painter Léon Bonnat's studio, sitting for a portrait commissioned by the president. Bonnat relished the cynicism of her attempt to use him as an alibi; for that evening Mme Steinheil had sent him a note apologising for leaving the sitting abruptly, particularly as in the event she had not been able to see Mme Faure at the Elysée.[96] Faure's death provoked much blasé journalistic shoulder-shrugging: 'Why can't the President of the Republic have his little weaknesses like everybody else?' asked Jean Bernard.[97] Of course, others had nobler standards. The composer Ernest Chausson, for one, wrote affectionately to his wife while visiting Prague in 1897 that his braggart fellow musicians had claimed that every married man had had some extra-marital adventures; Chausson was delighted to plead innocence.[98] Some could separate private and public aspects of their lives. At the beginning of the decade Zola had begun an affair with Jeanne Rozerot, his wife's maid, and fathered two children. Yet in *Paris* (1898), a *roman à thèse* designed to examine the metabolism of the metropolis quasi-sociologically, there is a powerful note of censure

in the ways he has the character *abbé* Froment appraise the rich Duvillard family: 'He seemed to hear a terrible sundering as the bourgeois family split apart: the father off with a tart, the mother in the arms of a lover, the brother and sister knowing everything', all leading to 'tortures, physiological and moral miseries'.[99]

Zola's novel was a hybrid of fiction and improving literature, and that kind of cross-fertilisation of the creative and the criminal, the moralistic and the sociological, was typical of the period. Nowhere did this become clearer than with the infamous Chambige affair. In 1888 at a villa in the Algerian town of Sidi-Mabrouck, the naked corpse of thirty-year-old Mme Grille was found next to her lover Henri Chambige. Eight years younger and an admirer of decadent literature, Chambige was accused by the prosecution of being 'suggestible' to corrupt aesthetic notions and of 'suggesting' criminal violence to Mme Chambige, the lawyers borrowing the terminology of hypnosis and psychology as a tool for analysing a *crime passionnel*.[100] Paul Bourget adapted this story for his novel *Le Disciple*, published the following year. Warning young men to adhere to traditional values while simultaneously exploring their perilously emotive and erotic relationships with women became a stock in trade for Bourget's adept pen. A critic in 1892 described his later novel *La Terre promise* as about 'the ugly perspectives of life', 'the principal psychological states' of which this 'delicate anatomist of the soul bares and displays with his scalpel-like pen.'[101] Medical grounds could be used to repudiate as well as praise such topics in literature. Romain Coolus's adulterous comedy *Le Ménage Brésil* (The Brésil Marriage), staged at the Théâtre Libre with Strindberg's *Miss Julie* in 1892, was dismissed as being nothing more than 'the pathological manifestations of a deranged mind'.[102] This kind of interplay with fiction, moralism and the sciences formed an integral part of wider debates about the state of the nation. Baron Charles Mourre's analysis of France's feeble birth rate, published in the *Revue bleue* in 1900, even went so far as to diagnose one aspect of national 'corruption' in what he described as the deification of adultery in the theatre: a cause of economic weakness, late marriage and thus low natality.[103]

Adultery was indeed a common theme in boulevard theatre just as it was in the popular novel, providing artist and audience alike with an opportunity to indulge in two pastimes crucial to the fin-de-siècle *mentalité*: to scoff and to diagnose. The tone in which it was presented combined the blasé and the titillating. In 1895 the engaging *littérateur* Maurice Donnay prefaced his little book of witty dialogues, *Chères Madames*, with the disclaimer: 'This book isn't immoral because it's only about adultery.'[104] The same year Alphone Mucha's poster for Donnay's play *Amants* suavely encapsulated the comedy's themes (fig. 62). The central motif is flirtatious, with an intricately flowing graphic frieze of provocative body language and disloyal eye contact. However, a more critical tone is conveyed by two monochrome panels in the upper corners. The right is the tragic figure of an abandoned woman, while to the left children watch a puppet play featuring a figure with cuckold's horns, head bowed. The poster thus hints at wider problems, about social conditioning and moral exclusion, cause and effect. Public representations of adultery veered between the flippant and the dangerous. On the one hand there were plays such as Ernest Feydeau's farces with their hiding in cupboards and rushing out of doors, or *Le Ménage Brésil* in which monsieur thinks that the 324 anonymous letters tipping him off about madame's infidelity are an amusing joke; Alfred Jarry even wrote a play in which *père* Ubu is cuckolded. On the other there were instances in which artistic form was used to expose vacuity and pain. In his novel *Là-bas* (1891) Huysmans brought out the pointlessness of his protagonist Durtal's affair with Mme

62 Alphonse Mucha, *Amants* (Lovers), 1896, colour lithograph, 99 × 130. Prague, Mucha Museum.

Chantelouve, and also sent up the devices of anticipation so clichéd in the stock adultery novel, by his description of a meal the waiting lover eats: 'a fish no longer fresh, cold soft meat . . . in a sauce with dead lentils killed by insecticide no doubt . . . finally old prunes whose juice tasted of mildew'.[105] Naturalism's descriptive mode was used ironically, creating an antidote to the expected crescendo of appetite and lust. Irony was also a common device of caricature, Forain titling a cluster of bitter cartoons *Les Joies de l'adultère* and Hermann-Paul using the similar *Les Ivresses de l'adultère* as subtitle to the seventh in a series of prints on *La Vie de Madame Quelconque*, in which madame and her mundane lover wait passionlessly for the servant to light the fire in their dismal hotel room (fig. 63).[106]

The use of form to operate as irony found its sparsest visual realisation in Vallotton's series of ten woodcuts *Intimités* (Intimacies) of 1897, published by the *Revue blanche* in 1898. Described there by Thadée Natanson as using only 'the tragic violence of a black patch' to convey 'the naiveté and the ridicule, the hypocrisy and the deceit, the cruelty and even that taste for oblivion that is in our conception of love', *Intimités* use just man and woman, black and white, zones and curves, bourgeois interiors.[107] *Le Mensonge* melds the figures together, as the woman curves around the man, her mouth close to his ear (fig. 64). But what does she whisper? And whose is the lie? The print raises these 'literary' questions by the strictly puritanical means of simple form, a combination enhanced by the cage-like rigidity of the wallpaper. Elided figures set

63 Hermann-Paul,
*La Vie de Madame
Quelconque. No. 7:
Les Ivresses de l'adultère*
(The Life of Madame
Somebody. No. 7: The
Intoxications of Adultery),
1894, lithograph,
33.5 × 24.2.
New Brunswick, Jane
Voorhees Zimmerli Art
Museum, Rutgers,
The State University of
New Jersey, Herbert
Littman Purchase Fund.

64 (*below*) Félix
Vallotton, *Le Mensonge*
(The Lie), from *Intimités*,
1897, woodcut, 18 × 22.5.
The Art Institute of
Chicago, Gift of the Print
and Drawing Club.

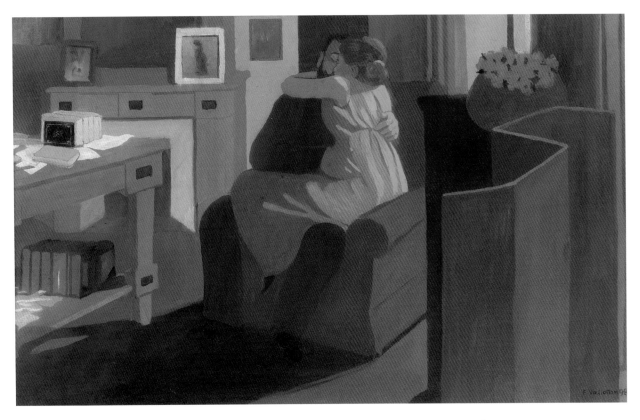

65 Félix Vallotton, *Intimité* (Intimacy), 1898, tempera on board, 35 × 57. Private Collection.

against harsh verticals: the visual clash creates the moral lie. Vallotton followed up his prints with a display of six suggestive paintings on the same subject in 1898. The pictorial space he used for both prints and paintings was planar, as if he imagined his male and female protagonists on stage. There is nothing to prove their relationships exactly. They are physically close, sometimes embracing, at others engaged in dialogue; the overall tone is furtive, snatched, provisional. Geffroy's review recognised that the furniture had a comic function.[108] In *Intimité* the jarringly angled screen masking a large, apparently unsupported bowl suggests precariousness and dysfunction (fig. 65). The inclusion of a woman's photograph on the mantelpiece in that picture, and the woman's belongings discarded on the table in *La Chambre rouge* (The Red Room), hint in both cases that she is an intruder into these spare, intellectual, male spaces, bringing different desires and moods. In both Vallotton uses practical description to prompt our reading, the empty grates – like Hermann-Paul's – suggesting warmth-less passions, as did Huysmans's dreary food. But Vallotton's surreptitious little dramas depend less on descriptive detail than on formal decisions. What tells are the torrid vulgarity of juxtaposed vermilion, apricot and magenta, the spatial voids and aggressive intrusiveness of furniture, the leaps from colour to gloom, and the rimming of shapes which break continuities and create stark frontiers. Simplicity of form was the watchword, as it was for Vallotton's friend Jules Renard. On 9 June Renard made a cryptic note in his journal: 'Letter. I need a little adultery, yes, a brief pash for a charming woman. Shouldn't one have that, from time to time, either at one's friends' house, or at home?'[109] If one takes

this to be a neat encapsulation of a literary idea rather than a private desire, it shares the formal economy, the surgical precision and the ironic note of Vallotton's work. There are no winners in this claustrophobic ecology of bourgeois peccadilloes, just the survival of the fittest in Vallotton's ruthlessly efficient typology of negotiation, passion and void.

<p style="text-align:center">*　　*　　*</p>

Piecing together these fragments of evidence and example can only recreate partial, staccato patches of a complex mosaic. The erotic archaeology of a historical period, with all its layers of practice, convention and psychology, can only ever be suggested, drafting in the lines between tiny clusters of certainty. After all, embarrassment, shame and hypocrisy – let alone the passage of time – are particularly effective barriers to historical enquiry. Nevertheless, what I have tried to explore here is how different aspects of the sexual *mentalité* of the 1890s manifested themselves in visual form. Public discourse was very conscious of the body and its physical and generative functions. Through different channels the Republic made appeals to its women to be fertile and responsible mothers, its men to be virile but continent, its soldiers to be strong and its youth to be abstemious. Writers as varied as the sociologist Alfred Fouillée or the museum curator Léonce Bénédite transmitted the Republic's diagnoses and prognoses to their diverse audiences. By such means the Republic sought to encourage a state of moral citizenship, the better to promote national values, to foster France's vigour. Such a drive to physical improvement also required condemnation of any threat to it. This was the perceived, and also painstakingly diagnosed, condition of decadence.

Decadence, however, like many forms of self-analysis, can become obsessive and fascinating. For some it was not a condition to recognise and avoid. Rather, it was a means to probe aspects of the modern condition that the dominant bourgeoisie and its Republic preferred to ignore. Decadence not only questioned bourgeois morality, sharply in the hands of a Vallotton or Renard; it also exposed bourgeois hypocrisy and ridiculousness. This too was tied to the momentum of the modern. For the realisation that there were ever more complex layers of human behaviour and ways in which they could be described and understood – through *la nouvelle psychologie* in particular – challenged the creative spirit. If psychology was providing new analytical insights and languages, the artist and the writer sought to use them for his and her own ends. In addition, if the Republic was promoting certain codes of behaviour which related in one way or another to how people thought about or used their bodies, and specifically their sexual instincts, artists and intellectuals might well want to acknowledge more flexible, individual roles for men and women. Making images of the sexual body both engaged with, and struggled against, the control of a centralising state founded on persistent structures of class. The Republic might promote certain public norms, ones that set particular store by the regularity of marriage and family. But artists and writers, notably those who had grown up under the Republic and were sceptical of its values, were tempted to use new forms – from caricature to the Kodak – and new sensibilities about their inner lives to explore more deeply the nature of the modern. This chapter has touched on several facets of modernity in the 1890s – the scientific and the erotic, the caricatural and the psychological – in relation to the national and the individual body. Both of those, it was feared in the 1890s, were precariously close to dysfunction.

facing page　Pierre Bonnard, *L'Homme et la femme* (detail of fig. 59).

TWO

PICTURING AND POLICING THE CROWD

Cycles of Violence, Systems of Control

During the 1890s the crowd was a phenomenon which generated fear and fascination. This was the case throughout Western industrialised countries and was the product of a combination of changes that to contemporaries seemed to have accumulated through the nineteenth century. The process appeared alarmingly sequential: the growth of cities, and within them urban proletariats attracted by the prospect of work but rootless in their new environments; the potential in the various voices of the left for rallying those vast forces beneath a flag of insurrection. The choices open to regimes based on class hierarchy and capitalism were stark: control or collapse. The structures that had well served the dominant bourgeoisie – the factory system, the agglomeration of the workforce around the means of production, a transport network able to move large numbers – paradoxically appeared to jeopardise their masters. The crowd embodied another paradox. It threatened social disruption by the crudest of political forces: sheer physical mass. And yet this threat had been created by the momentum of progress. The crowd was both a product of and a danger to modernity. Herein was the fascination of the crowd, and at the end of the nineteenth century the debate about the constitution, aims and responses of crowds had a substantial place in contemporary discourse.

There were particular reasons why Third Republic France was so embroiled in this debate. That involvement was not just the professional province of the politician or lawyer, policeman or sociologist. It was widespread in the public mind, and the purpose of this chapter is to ask in particular how visual culture during the 1890s articulated attitudes to crowds, shared their aspirations or articulated anxieties about them. There was a historical sense that throughout the century then drawing to a close France, and in particular Paris, had functioned in twenty-year cycles, with revolution and bloodshed every two decades. It had been the crowd that had either toppled the regime, or so threatened it that the crowd had to be repressed, in 1830, 1848 and 1871. By this reckoning, the likelihood that the 1890s would see a similar reaction seemed sure. The Commune of 1871 was a painful recent memory in the Parisian mind. In the fighting between the *fédérés* and the Versaillais army during the *semaine sanglante* of May 1871 well over 20,000 insurgents and troops had been killed in the city streets. Central Paris had been significantly damaged, with many buildings emblematic of authority, such as the Palais des Tuileries and the Hôtel de Ville, torched by the retreating *fédérés*. As the years passed the root causes of the Commune came to be understood in the bourgeois mind as twofold. The first was the rise of the radical left, which the Third Republic's amnesty of exiled Communards in 1880 especially rekindled. The second was the aware-

facing page Jean Béraud, *La Salle Graffard* (detail of fig. 68).

ness that urban conditions, notably among the fast-growing population of the capital, provided fertile ground for subversive ideas and movements. As the elderly and conservative Edmond de Goncourt, who had lived through both 1848 and 1871, remarked in April 1890, 'the Barbarians' had been replaced by 'the workers . . . as agents of destruction in modern societies'.[1]

These were the kinds of insurrectionary force, and fears of it, that the Republic had to control. Its rhetoric of *Liberté*, *Egalité* and *Fraternité* had to mollify a hard-pressed proletariat while calming the bourgeois opinion Goncourt voiced. Reminders of the Commune were an effective method of control, in the viewpoint of one outsider, Theodor Herzl, Paris correspondent for the *Neue Freie Presse*. Noting that in 1895 the charred ruins of the Cour des Comptes still disfigured the left bank opposite the Jardin des Tuileries, he wondered whether this was not a constant if discreet caveat from the government: this is what revolution brings.[2] Herzl's speculation was perhaps too subtle, but there was no subtlety in the physically present and politically dangerous crowds which sporadically massed in Paris and threatened the Republic at this time, from the Boulangists who almost toppled the government to install their dashing hero in January 1889, via the 20,000 leftists the police found it expedient to charge in the place de la Concorde on May Day 1891, to the Ligue des Patriotes fronted by Paul Déroulède that attempted to launch a coup in February 1898 (see fig. 137). With this spectrum of mass unrest in mind, it is as well to remember that it was not just conservatives such as Goncourt who felt threatened by the crowd, for the emergence of Boulanger in the late 1880s had caused the left to fear that the mob could impose a Caesar. The crowd was both a weapon of, and an anxiety for, left and right.

Crowds were by no means always formed by political imperatives. One of the great centrepieces of the Third Republic, inherited from the Second Empire, were the regular Exposition Universelles. The first staged by the Republic, in 1878, served to show that under its new regime France had recovered from the *année terrible* of 1870–1. But if that year drew sixteen million visitors to the capital, the next Exposition Universelle, staged in 1889 to celebrate the centenary of the French Revolution, attracted twice the number. Albeit spread over a lengthy summer period, these were enormous crowds. Lured by the spectacle of the electrically lit Eiffel Tower and the Galerie des Machines and transported to the capital by the train, these crowds were generated by modernity, by a drive to participate in progress. That, of course, was what the Republic promoted. If the ruins of the Cour des Comptes were, by Herzl's shrewd account, the regime's oblique admonition of revolution, the Eiffel Tower was its overt celebration of Republican France's success: a beacon of progress to unite the nation and impress the world. Jean Béraud's painting of the Exposition crowd at the foot of the Tower implies as much (fig. 66). The Tower's startling height is implied by the picture space's inability to contain it, its nationality proudly proclaimed by the flanking *tricolores*. The crowd is a various but delighted body of people – encompassing bourgeoises and cripples, peasants and a *curé* – impelled along the tram tracks to the new spectacle, like iron filings towards a magnet. The kind of energy his painting implies parallels the joy many writers described in the crowds at the 1889 Exposition Universelle. Huysmans characterised the 'physiognomy of the crowd . . . as a *je m'enfoutisme*', a wilful joy, while Goncourt also detected a 'vast bestial joy' in the masses.[3] Mirbeau was less dismissive, charmed by 'a tumult of joy'.[4] But beneath this intense and demonstrative delight, all three sensed a more sinister undercurrent. Huysmans mentioned unspecific 'cataclysms to come',

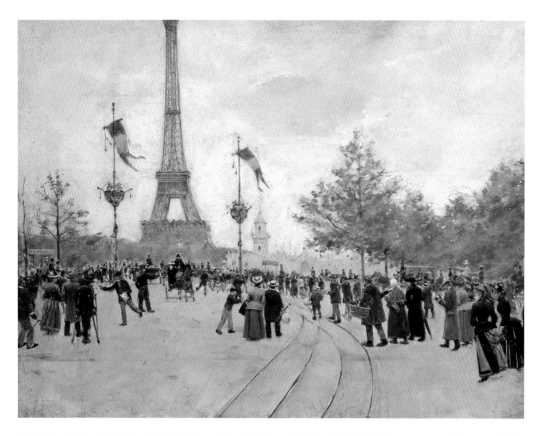

66 Jean Béraud, *L'Entrée de l'Exposition Universelle de 1889* (The Entrance to the 1889 Universal Exhibition), 1889, oil on panel, 30 × 40. Paris, Musée Carnavalet.

Goncourt was reminded of *l'année terrible* and suspected an imminent revolution.[5] Their thoughts were private, but Mirbeau, whose politics increasingly swung to the anarchist left, voiced his in *Le Figaro*, fearing that the crowd could still be swayed to Boulanger. Form as it might around a state-sponsored event staged to demonstrate the stability of the regime, from whichever way one gauged it the crowd seemed inconstant, inscrutable. Even apparent cultural success and social cohesion could not dispel the undertow of political fear for some, opportunity for others.

The crowd was a social formation and a political force that was not only commonly experienced, widely debated and often feared. It also made an emphatic visual impact. As a phenomenon of the modern metropolis, as an instrument of – or against – the democracy on which the Republic staked its ideological modernity, the crowd demanded pictorial attention. The ways in which it found its way into imagery immediately suggest some of the constructions that could be put upon it. Raffaëlli's 1890 canvas of the place de l'Hôtel de Ville, like Béraud's *L'Entrée à l'Exposition Universelle*, represents the kind of assembly of citizens of which the Republic and its bourgeois power base would have approved (fig. 67). Recently restored after its destruction during the Commune, the city hall serves as a backdrop for the passing populus, mixed in class, calm, and harmonious. There are no significant clusterings of people; this cross-section of Paris goes about its diverse business with general purposefulness, but not as a homogenous mass.

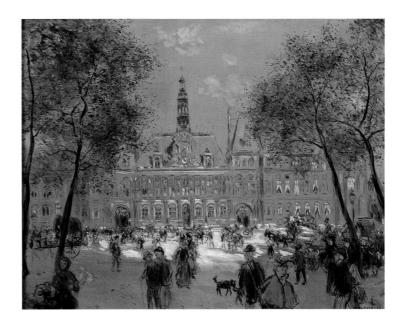

67 Jean-François Raffaëlli, *La Place de l'Hôtel de Ville, Paris*, 1890, oil on canvas, 46 × 58. Paris, Musée Marmottan.

There are many people here, but not a crowd. It is a different matter in Béraud's *La Salle Graffard*, exhibited first at the Salon of 1884 and again in the Décennale section of the Exposition Universelle five years later. Gathered at a left-wing meeting, this is a politicised crowd caught up by the rhetoric of the orator, his public's passions offset by the nonchalant transcribing of the journalists (fig. 68). Teetering on the brink of caricature, this was an image of the kind of crowd the Republic needed to monitor and control. The final sheet in Pissarro's *Turpitudes sociales*, an album of pen-and-ink drawings he made in 1889 in reaction to the Exposition Universelle and sent to a niece in England, is a visualisation of how this anarchist artist expected social change might have to come: his insurrectionary crowd is fighting on the barricades (fig. 69).[6] The anarchist's vision would have been the Republican's nightmare. These three pictorial constructions of the crowd, varied in medium, ideology and audience, by their very diversity give some sense of the engagement of artists and their publics with the image of the crowd.

Theorising the Crowd

The 1890s saw the burgeoning of several new scientific disciplines, psychology, sociology and criminology among them. A hybrid from this flowering, forced somewhat in the hothouse of political anxiety, was crowd psychology. Intellectuals across Europe contributed to its development, because the crowd was a phenomenon industrialised countries had in common. French writers were among the most important within the wider debate, and it is on them that this discussion focuses. Crowd psychology was of particular concern to the right, not least because it was social conservatives who could define with most discomfort the conditions in which the crowd had come to such prominence. Among conservatives there was widespread regret at the passing of the 'natural' structures of the *ancien régime*, hierarchical systems such as monarchy, aristocracy and

68 (*above*) Jean Béraud, *La Salle Graffard*, 1884, oil on canvas, 86 × 120. Private collection.

69 Camille Pissarro, *Insurrection*, folio 28 of *Turpitudes sociales*, 1889, pen and ink, 31.5 × 24.5. Geneva, Skira Collection.

the Church, which the French right had tried to sustain as recently as the 1870s. These had been displaced by new systems and mechanisms – among them political parties, trade unions and newspapers – which the left was better equipped to manipulate.[7] Such mechanisms were modern and essentially urban. Geared to centres of population, they could be used for controlling and even inciting crowds. These new forces, being concentrated in cities, drew attention to the discomfitingly dangerous proximity of the crowd to the centres of government, law and finance: the levers of power of the dominant bourgeoisie. Memories of the Commune and its destructive impact on civil order were thus structural in French crowd psychology.

This was the case with the most important single volume on the subject, Gustave LeBon's *La Psychologie des foules* (The Psychology of Crowds), published in 1895. LeBon's text encapsulated and popularised much of the right's thinking on the subject. Born in 1841, LeBon had a vivid memory of the Commune, which he saw as the quintessential example of how menacing the masses, torn from their roots, could become in the alienating habitat of the metropolis. Removed from their ancestral environment, which had been ordered around traditional structures, people reacted badly to the loss of the controlling presence of continuity and hierarchy.[8] LeBon's account of such profound social problems, how they manifested themselves and might be treated, was effectively a diagnosis. He had trained as a doctor.[9] During the late 1870s LeBon had attended Charcot's lectures on *la nouvelle psychologie* and had become interested in hypnotism. His earlier book *L'Homme et les sociétés* (Man and his Societies) (1881) had argued that the effect of a powerful leader on a crowd could be similar to that of a hypnotist on an individual subject.[10] However, LeBon drew his ideas from various sources, and his increasing commitment to the notion of universal susceptibility to suggestion was closer to the ideas of Hipployte Bernheim and the Nancy school of psychology than to Charcot.[11] Indeed, in 1890 Bernheim himself had published his own views on the impact of suggestion on crowds in the *Revue de l'hypnotisme*, an indication of the contemporary dialogue between the medical and sociological communities.[12] LeBon was also conversant with the language of clinical medicine, in particular epidemiology. In *La Psychologie des foules* he argued that once an idea is instilled in a crowd like a microbe it spreads as a contagion does.[13] By appropriating the methodologies of medical science and borrowing its terminology for similes he was approaching a modern issue with modern means, however reactionary his analysis and solutions may have been.

The fundamental argument of *La Psychologie des foules* is that the late nineteenth century was 'a period of transition and anarchy' propelled by the collapse of the residual structures of the *ancien régime* and the effects of industrialisation. The crowd had enormous potential power – LeBon cited the mass support for Boulanger as the latest example – and society had entered, he announced in apocalyptic upper case, the 'ERA OF CROWDS'.[14] The problem was how crowds could be understood, and therefore controlled, in order to prevent their manipulation at the hands of those who wanted to return, as he put it with Darwinian insinuation, 'to the dawn of civilisation'. This he specified as the reduction of working hours, the nationalisation of public utilities, the equal distribution of wealth and the removal of class hierarchies, because for LeBon the enemy – envisaged as a kind of primitivism and exemplified in the excesses of the Commune – was socialism.[15] The crowd was dangerous because within it the individual loses rationality and personality, becoming part of the collective, a mass that has its own being: in other words, 'a psychological crowd'.[16] By such an account, the people

represented in Raffaëlli's *Place de l'Hôtel de Ville* clearly do not form such a crowd; they are individuals differentiated in their purposes.

For LeBon, like Bernheim, all individuals are suggestible, and can be hypnotised *en masse*. In this hallucinatory state the psychological crowd can easily be led, especially by a single, dominant leader. Such characters LeBon dismissed, again using the language of mental illness, as typically 'morbidly nervous, excitable, half-deranged persons who are bordering on madness'.[17] Crowds can only absorb simple ideas, but once instilled with them, will commit appalling crimes of murder and pillage at the instigation of the leader.[18] LeBon counterpointed this psychological phraseology – the neurotic leading the suggestibly hypnotised – with the language of epidemiology. His metaphor of contagion was not original. An idea current in crowd psychology, it had been used by another theorist in the field, Gabriel Tarde, a magistrate from Sarlat (Dordogne), in his *La Philosophie pénale* (Penal Philosophy) (1890), where he had written of the crowd being susceptible to homicidal contagion.[19] During the 1890s this kind of thinking, and in particular this term, spilt out from the narrow professional world of doctors, lawyers and sociologists specialising in crowd psychology and was gradually absorbed into the wider intellectual mainstream. For example, in 1892 Zola published *La Débâcle* (The Debacle). The penultimate novel in the Rougon-Macquart series, it covers both the Franco–Prussian War and the Commune, providing ample scope for Zola's celebrated handling of crowd scenes. However, nowhere in the novel did Zola employ the term contagion. Yet in 1898 when he published *Paris*, the final volume of his trilogy *Les Trois Villes* (The Three Cities), Zola used it frequently. The execution of the visionary anarchist Salvat, for instance, inspires a *folie contagieuse* among his sympathisers in the crowd.[20] Another example of the proliferation of the notion occurs in Camille Mauclair's essay 'Du Symbole', published in 1894. In a disquisition on the nature of Symbolist literature and its tensions with naturalism, Mauclair imaginatively drew parallels with crowd theory and medical terminology. The Symbolist writer, he suggested, shifted from concrete fact to mysterious idea just as a crowd slid from individual opinion to mass *psychose*.[21] The adoption of these forms of analysis by, in these instances, a naturalist novelist in his fifties and a Symbolist critic in his twenties, gives some indication of how during the 1890s the new discipline of crowd psychology, successfully broadcast by LeBon and others, had infiltrated the intellectual *mentalité*.

With this in mind, one can pursue LeBon's further definition of the psychological crowd, enquiring how such thinking elided with the forms and phrasing of visual culture. One of the worst characteristics of the crowd, LeBon made explicit, was what he implied about socialism; it necessitated a descent to the primitive. 'By the mere fact that he forms part of an organised crowd, a man descends several rungs in the ladder of civilisation ...He possesses the spontaneity, the violence, the ferocity, and also the enthusiasm and the heroism of primitive beings.'[22] With Hermann-Paul's lithograph *L'Escargot d'omnibus*, published in *L'Escarmouche* in December 1893, one wonders how conscious the artist was of current ideas about the crowd (fig. 70). The scene shows the urban mob struggling and shoving on the twisting staircase of an omnibus. In their drive to get on or off, the types display alarm, aggression, stupefaction and even lust. Was this just a caricaturist's observation on Hermann-Paul's part, or the subtler intrusion of a more theorised notion of the crowd's primitive impulses? One can get closer to answering such questions about the resonance of crowd psychology in the visual arts with another, far different work. Paul Buffet's oil painting *Le Défilé de la hâche* was exhib-

70 Hermann-Paul, *L'Escargot d'omnibus* (The Staircase of the Omnibus), 1893, lithograph, 27.3 × 22.2. New Brunswick, Jane Voorhees Zimmerli Art Museum, Rutgers, The State University of New Jersey, Herbert Littman Purchase Fund.

ited at the 1894 SAF (fig. 71). The catalogue entry identifies it as a scene from *Salambô*, the historical novel about ancient Carthage that Gustave Flaubert had published in 1862. The incident Buffet selected comes in chapter XIV, in which the mercenary army in revolt, having been lured into an arid confined valley by Hamilcar's troops, is trapped there and left to starve. Three Iberians die and the godless Garamantians are the first to eat the corpses, provoking widespread cannibalism. In its ghastly naturalism, Buffet's vast painting presents a Darwinian thesis; it is about the struggle for life, the survival, if not of the fittest, of the most pragmatically bestial, the morally lowest. Privation, followed by this grim example, leads the crowd into hideous behaviour. Thus *Le Défilé de la hâche* deals, in the Darwinian parlance current in the 1890s, with degeneration and forms a close parallel to the diagnosis of the 'primitive' crowd that LeBon put forward in *La Psychologie des foules*. The book was published the year after Buffet's painting was exhibited, so no direct link can be established. But LeBon's Darwinism had been consistent in his writing at least since *L'Homme et la société* of 1881, and was fundamental to much contemporary social analysis, especially on the right. This was the kind of conservative intellectual orbit which Buffet, who later became a Catholic missionary in Africa dedicated to raising his converts from their primitive state, would have found sympathetic. The specific Flaubertian scene involving the mercenaries that Buffet chose, interestingly enough, was treated by several other artists at this period, which was noticed by Paul Adam, reviewing the Salons of 1896. He approved Flaubert's 'splendid and pioneering study of the soul of crowds' as a subject, no doubt because Adam himself had written about crowd psychology in *Le Mystère des foules* (The Mystery of Crowds) which he had published the year before.[23]

71 Paul Buffet, *Le Défilé de la hâche* (The Defile of the Axe), 1894, oil on canvas, 400 × 284. Nantes, Musée des Beaux-Arts.

Another metaphor current in the analysis of the crowd was that it was female. That was an assumption that fitted neatly within the commonplace patterns of patriarchal thinking, of course, but it also had the gloss of psychological authority. For LeBon, crowds were always primarily feminine in their characteristics, by which he meant inclined to extremes of sentiment, irrationality and impulsiveness.[24] This conventional contemporary male construction of the female was echoed by other specialists. Addressing the Third Congress of Criminal Anthropologists in August 1892, Tarde opined that the crowd, 'even in the most civilised populations, is always a female savage . . . , an impulsive and maniacal plaything of its instincts and its mechanical habits, often an animal of the lower orders, a monstrous worm'.[25] For such a metaphor, intended as it was to illuminate the invisible workings of psychology and behaviour, to find visual form might seem unlikely. However, political allegory had for a century provided France with the image of the Phrygian-bonneted and sometimes bare-breasted Marianne, who not only exemplified the militant energy of the Republic but was also closely associated with the crowd which she was frequently represented leading.[26] Marianne was as constant an image in the 1890s as she had been in previous decades, and equally subject to various interpretative slants. To the left she was a heroine standing for the continuity of the ideals of 1789; to the right she was more likely to invoke the fears of 1871 and confirm the diagnoses of a LeBon or Tarde. During the decade she had a particularly regular role in the work of Steinlen, for example in his covers for Gérault-Richard's *Le Chambard socialiste* (The Socialist Upheaval), where her function was to remind a regime manifesting sluggish reformist tendencies of the egalitarian radicalism deep-rooted in Republican ideology.[27] But on occasion Steinlen developed the female figure beyond Marianne. A striking instance of this is the poster he was commissioned to design advertising the serialisation of Zola's *Paris* (fig. 72). The design incorporates the vista of the capital, dominated by the scaffolded Sacré-Coeur round which much of the action revolves. Within this, hordes are locked in a fierce physical battle for supremacy, the combination of modern metropolis and primitive struggle redolent of the literature of crowd psychology. Above the fray a giant female figure, no longer Marianne but some kind of feminine genius of tumult, gestures – alarmed and retreating – towards the rising

72 Théophile-Alexandre Steinlen, *Paris, par Emile Zola*, 1898, colour lithograph, 140 × 200. New Brunswick, Jane Voorhees Zimmerli Art Museum, Rutgers, The State University of New Jersey, Gift of Norma B. Bartman.

73 Jules Adler, *Le Grève à Le Creusot* (The Strike at Le Creusot), 1899, oil on canvas,
228 × 298. Pau, Musée des Beaux-Arts.

light that seems to herald the end of struggle and a new dawn of harmony. That, indeed,
is the message at the end of the novel, which had yet to be written when Steinlen designed
his poster, though Zola may have hinted at a climax of hope. This, it seems to me, is
an image broadly from the left – by an anarcho-socialist artist, promoting a text by a
Republican which makes a sincere if ultimately unpersuaded attempt to come to terms
with anarchism – which makes use of the metaphor of the femininity of the crowd
common in the diagnostic warnings of the right. Consciously or not, Steinlen appro-
priated the imagery of his ideological opponents to promote a novel with whose
material he would have felt more, but perhaps not entire, sympathy.

If Steinlen was able to make play with the feminine metaphor of the crowd, other
artists brought the female into play with the crowd by more naturalistic means. Jules
Adler's large canvas *Le Grève à Le Creusot* represented an industrial confrontation
during which working women had played a notably leading role (fig. 73).[28] His repre-
sentation of the strikers in procession shows women as participants, parading with babe
in arms, shoulder to shoulder with the menfolk, and – saliently – a woman at the head
of the demonstration, holding aloft the red flag and either singing or chanting a slogan.
This committed but anonymous woman takes the part which in different contexts one
would expect other, equally inspirational but named, women to play: Marianne,
perhaps, or that multivalent heroine Joan of Arc. Anonymous she may be, but Adler's

74 Jean-Jacques Scherrer, *Charlotte Corday à Caen*, oil on canvas, 208 × 133. Remire-mont, Musée Municipal Charles de Bruyères.

flag-bearer typifies the radical actuality, not the mere symbolism, of the French proletariat on strike. Leading the forces of the oppressed, of social change, rather than the forces of a unified nation, of social order, she is the opposite of Joan of Arc. A socialist, Adler was sympathetic and engaged; the canvas is inscribed 'Le Creusot' as a gauge of authenticity. By painting a crowd led and swelled by women, Adler was turning the right's use of the feminine to impugn the crowd into a specific reminder of the practical support and moral force working women provided for the left. Such an approach might have its ideological inverse. While Adler's *Le Grève* was a record of a contemporary incident, Jean-Jacques Scherrer's *Charlotte Corday à Caen* was a historical reconstruction (fig. 74). But it was more than a mere costume-piece. Scherrer chose to paint not Corday's assassination of Marat in 1793, as for instance Paul Baudry (1860; Nantes, Musée des Beaux-Arts) and Jean-Joseph Weerts (1880; Musée de Roubaix) had done. Instead, he selected the incident which provoked Corday to act: her witnessing in the streets of Caen of a clash between rival revolutionary crowds, the Girondins and Marat's Montagnard supporters. Charlotte de Corday d'Armont was of noble blood and a descendant of Corneille.[29] Scherrer represented her looking down with disdain at the violent irrationality of the mob and making a rational decision to act. It is an image of breeding and culture differentiating itself from baser instincts. Although the protagonist is a woman, and her chosen course of action criminal, Scherrer's painting surely sides with the willed act of counter-revolutionary self-sacrifice to come.

Controlling the Crowd

Crowd theory accepted that there were different kinds of crowd. In *La Psychologie des foules* LeBon took trouble to make this point. For him, the crowd was capable of being swept up by lofty ideas as well as perverse ones; he cited the Crusaders and the volunteers of 1793 as noble examples. And while a crowd might veer towards the intolerant and the fanatical, the 'religious sentiment' by which it might bind its beliefs to its superior could be channelled in positive ways.[30] Not always in agreement with LeBon's notions, Tarde, who resisted such rhetorical flourishes as 'the era of crowds', drew his own distinctions between different 'publics'.[31] And even the satirical leftist periodical *L'Assiette au beurre*, in a 1904 issue devoted to the crowd, made play with its different types, such as the procession, the riot and the flock.[32] Understanding the diversity and the responses of the crowd were, of course, aids to controlling it. Given the significance and the potential of the urban crowd in modern society, it was essential for the regime to have in place mechanisms which allowed it to influence mass opinion, to unite it

around key ideas and encourage its loyalty to them and, if necessary, to impose order physically if mass opinion became mass discontent. In sum, the crowd needed control, and by depicting positive or admonitory examples visual culture provided the regime with one mechanism for achieving this end. Equally, as part of the systems of the state, that establishment visual culture prompted ripostes in kind.

The opposite of the disorganised crowd, of the mob, was the disciplined army, with its hierarchy of command, unit and rank. Military paintings of parades and ceremonies – I put to one side scenes of action and barrack life – proliferated at this period. Such images promoted the important idea of national military *gloire*, as I shall discuss in the final chapter. But they also presented an example. A canvas such as Loustaunau's *Présentation de l'étendard aux recrues, janvier 1887*, exhibited at the 1892 SAF, is a case in point (fig. 75). It is an image that works at several levels. Set in the parade ground of the Ecole Militaire, with the dome of Les Invalides in the wintry background, it evokes the continuing traditions of the French army.[33] With the colonel gesturing with his sword to the tricolour, the painting echoes his lesson of loyalty and duty to *la patrie* (although perhaps not, in the case of officers from Catholic aristocratic families like Colonel Thibault de la Rochethulon represented here, as enthusiastically to *la République*). The discipline of the army, with its ordered ranks, synchronised salutes and smart uniforms, is presented as a noble contrast to the casual gathering of civilians Loustaunau allows one to glimpse in the background. Inducted into the 6th Cuirassiers, the recruits are somehow ennobled by discipline and duty, the painting suggests. In terms of crowd psychology, they form an ordered crowd, motivated by an elevated idea and a responsible leadership. LeBon admiringly cited Napoleon's adage that repetition fixes ideas in the mass mind, and so serves as a means of control.[34] Nowhere is this better experienced, or visualised, than on the parade ground. Loustaunau apparently lauded the army's driving will to submit the individual to its collective service. By contrast, Bonnard, who loathed his military service, derided it in a small, quasi-caricatural painting which makes comic play of men reduced to two-dimensional cyphers (fig. 76). Both pictures give the spectator a sense of presence on parade; one proudly, the other resentfully. The army of course evoked many different responses, but that which both the army itself and its political masters strove to promote pictorially through canvases such as Loustaunau's was one of noble discipline and patriotic duty. For those with a vested interest in social control, the army was an ideal crowd. It was at once an example of positive order and, when coupled with the gendarmerie, a means of enforcing it.

Another traditional system for controlling the crowd was the Church. This was not just by preaching the good example of Christian behaviour and subservience to authority. Virtue, both individual and collective, could be given pictorial form. During the 1890s the Church was renegotiating its place in the world, as the next chapter will discuss. Part of that process involved coming to terms with some of the same social forces that crowd psychologists such as LeBon equally found uncomfortable, for instance the perceived collapse of hierarchy and the rise of socialism. In this confrontation with an often distasteful modernity, those on the side of the Church could usefully employ the languages of their colleagues on the right. At the 1894 SNBA Béraud exhibited *Le Chemin de la Croix* (fig. 77). The painting is a modernisation of a traditional biblical subject, using contemporary dress to give the painting's message more immediate impact. The picture divides the crowd into two halves. To the rear the crowd combines *mondain* types who jeer and proletarian figures who grimace or lash out at

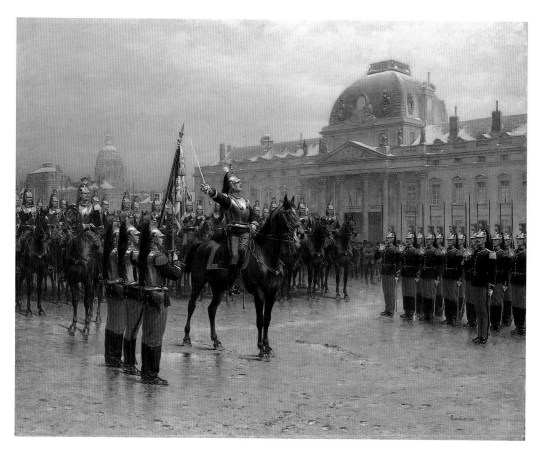

75 Louis Loustaunau, *Présentation de l'étendard aux recrues, janvier 1887* (Colonel de la Rochethulon presents the Standard of the 6th Regiment of Cuirassiers to the Recruits, January 1887), 1892, oil on canvas, 143 × 177. Versailles, Musée National du Château.

76 Pierre Bonnard,
L'Exercise (Drill), 1890,
oil on panel, 23 × 31.
Private collection.

77 Jean Béraud, *Le Chemin de la croix* (The Way of the Cross), 1894, oil on canvas, dimensions and location unknown.

the stricken Christ labouring under the weight of the Cross. In the foreground another crowd – the dying man supported by his *curé*, a first communicant, a nun protecting orphans, a wounded soldier, a widow and other faithful and afflicted – pray and genuflect before their Saviour. The division that Béraud set up in his painting was easily legible, but legible in terms not just of Christian teaching but also of contemporary thinking about crowds. The mocking and violence of the unchristian mob parallels LeBon's conception of the crowd's primitivism, its inclination to sink to a baser level of behaviour.

 The Republic too needed to articulate its position on the phenomenon of the crowd. As a parliamentary democracy with universal manhood suffrage, the Republic was – on the surface at least – a regime whose strength and raison d'être was based on mass opinion. Yet as its leading politicians knew only too well, the Republic was balanced in the centre between two opposing forces both of which were skilled in the manipulation of the crowd, whether they be strikers and May Day protestors on the left or the Boulangists and the Ligue des Patriotes on the right. The Republic thus needed to gather crowds itself, proving its presence as the central national idea and worthy of the people's loyalty. It would also help the regime to record and perpetuate such moments, a task painting could perform. During the summer of 1889 a grand fête was held in the gardens

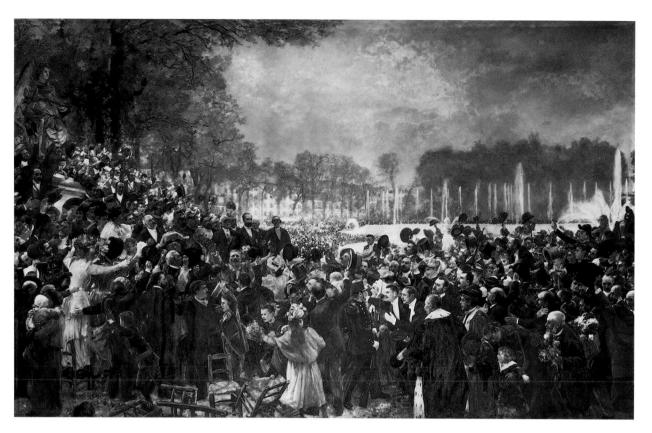

78 Alfred Roll, *Fête du centenaire des Etats généraux au bassin de Neptune à Versailles* (The Fête of the Centenary of the States General), 1893, oil on canvas, 610 × 930. Versailles, Musée National du Château.

of the Château of Versailles to celebrate the centenary of the calling of the Estates General, a key moment in France's historical journey from the monarchical *ancien régime* to the modern Republic. The state commissioned Alfred Roll to paint the event, and his vast canvas was displayed at the SNBA in 1893 (fig. 78). Roll's painting, whose landscape had been executed by his friend Emmanuel Damoye, made it clear that the event took place at Versailles, with its great gardens and extravagant fountains. But within that space, so associated with France's monarchical past, the enormous crowd revolves round the figure of President Sadi Carnot, the embodiment of the Republic that – both event and painting implied – has harmoniously and definitively replaced the *ancien régime*. President Carnot was the grandson of Lazare Carnot, one of the heroic figures of 1793 and the First Republic, so this apotheosis (of a humdrum little man) resonated with Republican heritage, with a new continuity in French history. The crowd is mixed in its social constituents – lawyers, ministers and chic *bourgeoises* mingle with excited urchins and a nonchalant soldier – as befits an image of the egalitarian Republic. Enthusiastic the crowd may be, but it is shown as civilised in its behaviour, its gestures expansive and celebratory, the brandished tophats far from the 'primitivism' of Béraud's unchristian mob or Hermann-Paul's aggressive bus passengers. Above all, Roll represented a crowd preoccupied by a single idea: the Republic. This echoed LeBon's insistence that the crowd requires one concept, and responds to a master. Carnot was no Caesar, but as president he embodied the unifying idea of the Republic.

94

The problem for Republican politicians and civil servants was how to keep a positive image of the Republic and its ideology uppermost for the urban masses. How might it ensure that the crowd was 'hypnotised' by appropriate ideas and not infected by an impure 'contagion'? Public decoration was one means. The large-scale mural was a convenient vehicle the establishment could use to convey its ideology. Its location and its style could be controlled, so that it was seen by the maximum number of people and articulated its ideological ideas in the most legible form. There was a bonus. Because such decorations covered great stretches of wall, they required the artist to employ many figures, often of life size. The mural thus mutely but insistently preached lessons about the behaviour of the crowd, in direct relation to the citizens who gathered in the *salle des mariages* or *salle des fêtes* it decorated. During the 1880s and 1890s the Third Republic had a programme of public decorations in full swing. In Paris the restored Hôtel de Ville and the *mairies* of the Parisian *arrondissements* and outer suburbs were systematically decorated, as well as other major public buildings. Similar projects were undertaken throughout the provinces, one of the largest being the decoration of the Capitole in Toulouse, the vast Salle des Illustres being decorated entirely by artists of regional origin.[35] In broad terms, these decorations were intended to promote the ideology of the Republic, giving life to the abstract notions of *Liberté*, *Egalité* and *Fraternité* by manifesting them in scenes lauding civic virtues of family, labour, military service and celebration of the Republic itself. By painting the crowd manifesting these virtues, the regime intended to inculcate the citizen with them, so that the image of the crowd itself became a form of crowd control.

79 Hippolyte Berteaux, *Souvenir de la fête nationale* (Souvenir of the National Holiday), 1895, oil on canvas, 380 × 180. Paris, Musée du Petit Palais.

In 1895 the *commission de décoration* of the Paris city council agreed the scheme by Hippolyte Berteaux for one of the panels in the Galerie Lobau of the Hôtel de Ville (fig. 79).[36] Although the scene may have been spurred by the public celebrations in October 1893 fêting the Franco–Russian entente, in the event Berteaux's light-filled image of festivity, with its luminous yellow lanterns and drifting pink firework smoke, functions as a generic representation of a *fête populaire*. Its specificity lies in the *tricolore*, billowing across the centre of the picture space, surrounded by the crowd, which salutes it with cheers and waves. Liberty, equality and fraternity are all implicit in this image, but the painting conveys more than public joy in the Republic. The crowd depicted is made up of children and adolescents. They stand for the future of the Republic and – a good crowd unified by a positive idea – their continued coherence will ensure its long-term stability. A very particular demonstration of public decoration representing the crowd as participants in a scene of civic virtue occurred with the decorations by Pierre Vauthier for the *salle des fêtes* at the *mairie* of suburban Bagnolet, completed in 1895 (fig. 80). In 1882 a local woman, Mme *veuve* Chastel, had given money to the *commune* for an annual prize to be awarded to a meritorious girl from a poor family. One of Vauthier's panels depicted Victorine Colas and

80 Pierre Vauthier, sketch for *La Fête de Bagnolet, le jour du couronnement de la rosière* (The Fête de Bagnolet, the Crowning of the Laureate), 1895, oil on canvas, 40 × 155. Mairie de Bagnolet, Salle des Fêtes.

her father entering the *mairie* to collect the 1894 prize.[37] Specific as the event may be, the implicit lesson to the citizens of Bagnolet lies in the representation of the crowd. Consisting chiefly of women, clearly from various *couches sociales*, Vauthier's painting is a commendation and celebration of virtuous female citizenship under the aegis of a benign Republic. In his acknowledgement of the pluralistic nature of crowds, LeBon credited the 'virtuous' crowd.[38] Like the other artists I have been discussing, Vauthier was by no means 'illustrating' LeBon's ideas. But I have shown with Zola and Mauclair how the discourse of crowd theory had entered wider intellectual debate and, with Paul Adam, how it could be spliced into art criticism. At a time when the crowd could commonly be constructed as having 'female' characteristics, considered quintessentially unstable, a painting such as Vauthier's representing a substantially female crowd as a civic community offered a reassuring lesson.

The crowd had a presence in various kinds of imagery that were outside state control. In this more independent sphere the ways in which it might be read tended to be more ambiguous and contested, though still revolving round the contemporary languages and analyses of the crowd. At the SNBA in 1895 Carrière exhibited a major canvas, almost five metres long, on which he had been working for several years, commissioned by the wealthy bibliophile Paul Gallimard. Entitled *Théâtre populaire*, the painting represented the theatre in Belleville, the working-class quarter in eastern Paris where Carrière lived (fig. 81). The performance is not represented, the artist opting to look across the auditorium to the spectators packed within the sweeping curves of the balconies. The subject gave Carrière the welcome opportunity to paint an ambitious multi-figure picture of the ordinary people *en masse*. For Carrière was a radical Republican, friend of Georges Clemenceau and his ally the art critic Gustave Geffroy, both stalwarts of the reformist paper *La Justice*. *Théâtre populaire* is emphatically about the populus, about the lower classes of Paris, their culture and diversions. These same people were potentially the mob of the barricades – Belleville had been one of the last redoubts of the *fédérés* in 1871 – but Carrière represented them rapt by the imaginative world of the theatre: hypnotised, one might say. The painter's hazy warm-toned *envelope* and the embracing parapets give the vast gloomy space an organic quality, the audience unified by the illusion they share. As the eye scans the canvas one can pick out particular faces and gestures, though one is mostly aware of a mass that cannot be made out but is there, present

81 Eugène Carrière, *Théâtre populaire* (Working-class Theatre), 1895, oil on canvas, 220 × 490. Paris, Musée Rodin.

in the darkness. In his review of the SNBA for the *Gazette des beaux-arts* Roger Marx explained that for him Carrière had shown the lower classes, *le peuple*, with their characteristic emotional candour. He had captured 'the very soul of the crowd', wrote Marx, as it formed 'a single being'.[39] It may not have been entirely coincidental that Marx, as an *inspecteur des beaux-arts* a Republican civil servant, here used exactly the same phraseology as LeBon's *La Psychologie des foules*, published that year. For a state functionary like Marx, the proletarian crowd represented as calm, occupied and controlled was an instinctive matter of note, a reassuring image of culture and contentment under the Republic. Geffroy's review took an edgier, less establishment angle. He himself lived in Belleville, had watched the painting in progress and was the biographer of the revolutionary Auguste Blanqui: Geffroy saw the picture differently. He was, like the crowd psychologists, aware of the crowd's credulity, its fascination with 'mirages'. For Geffroy, Carrière had captured the crowd's collective identity, although he did not see this as unified but rather as multi-faceted. Within *Théâtre populaire* were simultaneously 'the joyous crowd of the street party' and 'the steamed-up crowd of revolution'. From Geffroy's more radical vantage, the crowd could never entirely lose its dangerous aspect. The words he used to describe this – 'instinctive, fierce, dark' – might well have been part of the vocabulary of LeBon, ideologically his opponent.[40] But both writers, one seeing this force as a threat to established hierarchies and the other as an impetus to future change, recognised it as an energy to be channelled.

The Physical and Psychological Spaces of the City

During the second half of the nineteenth century cities were increasingly adapted and upgraded to cope with growing populations, with crowds. Paris was in many ways the archetypal example of this. Under the Second Empire in the 1850s and 1860s,

two decades which had seen the city's population almost double from 1 million to 1.8 million, Paris had been transformed by Baron Haussmann. Although most of Haussmann's projects had been completed by 1870, the Third Republic continued and developed the process to keep in step with demographic growth. Much of Haussmann's urbanist strategy had been to ameliorate conditions and make the city more efficient: installing effective sewerage and lighting systems, planting trees and creating parks, improving the circulation of traffic and building a central market. Yet he and his political masters had been acutely aware of public order; after all, there had been insurrection on the streets of Paris twice in 1848 and the Empire itself had come into being via a coup in December 1851. The wide thoroughfares that Haussmann laid out were elegant in their regularity and provided vistas within the urban fabric. They were also designed to be difficult to barricade and easy to move troop reinforcements along. (Ironically, during the suppression of the Commune those same boulevards were found to offer ideal fields of fire for the defenders of the barricades, which the army had to suppress by flanking movements through the very narrow side streets that had been thought to favour the insurrectionists.)

The Expositions Universelles swelled the capital's population enormously with temporary visitors. The efficiency of their progress towards and around the exhibition sites had to be assured. This could usefully be coalesced with an orchestration of their impressions of the great event. Maps of the sites show this clearly. But photographs, often taken for picture postcards, tell the story more fully. A view taken in 1889 shows the Trocadéro, built on the right bank for the previous Exposition Universelle in 1878, through the great girdered arch at the base of the new Tour Eiffel on the left (fig. 82).

82 View of the Trocadéro through the legs of the Eiffel Tower, *c.*1889, postcard photograph. Private collection.

213. PARIS — Le Trocadéro vu sous la Tour Eiffel C.

That vista was the spine of the exhibition, along which the great crowds were meant to pass. It was a route planned to funnel crowds from one side of the river, one cluster of spectacles and exhibits, to the other. But it involved more than the efficient flow of masses. It pointed in which directions to look; it suggested the architectural and cultural progress between the conventional *palais d'exposition* of 1878 to the engineering marvel of 1889. This kind of urbanism instructed the crowd. It told it which way to move; what to see and be impressed by; what to remember. Paris did not merely house or entertain its crowds. Its very structure, the cold rationality of stone and iron, the ordered insistence on progress this way and closure that, served to control the crowd. That control, I suggest, was of a psychological as well as a physical nature.

Artists responded to the tension between the spectacle of the urban spaces and the collective moods expressed by the masses that lived within them. There was a rich conversation to be observed between several elements, and this drew artists in the 1890s to the street scene, to the dialogue of crowd and city. There are a number of considerations here. First, there was the actual vantage point that the artist took. A view from pavement level, as Béraud used for his painting of the 1889 Exposition Universelle, placed the artist in the crowd as participant and close observer. A view from above, such as Pissarro chose for his series of canvases of the Parisian boulevards, made the *populus* a generic mass rather than a horde of disparate individuals, and allowed the painter to counterpoint the crowd with the play of architectural blocks and voids. Second was the particularity of the urban environment that the artist chose to represent. Raffaëlli's canvas of the Hôtel de Ville was one of a large informal series of views of celebrated public buildings and spaces which he exhibited at the SNBA during the decade, typified by their reassuring emphasis on architectural grandeur and popular purposefulness. Among many contrasting approaches to the specific, Pissarro's highly focused campaigns on particular locales allowed him only more measured shifts of angle or responses to the shifting life on his chosen thoroughfare. To work from memory, so that the street represented hovered between evocation and imagination, and particularity counted for little or nothing, was another point of departure, as will be seen in the work of Charles Lacoste. A third way in which the artist could orchestrate his and his audience's response to the metropolis and its masses was by the conventional devices of natural effects: thus a sunlit scene implied sunlit mood. And a fourth element in the dialogue was ideology. A painter like Raffaëlli, who had systematically courted the patronage of centrist Republicanism, would in all likelihood evince a different response to the population and streets of Paris from an anarchist such as Pissarro. With the discourse about the crowd prevalent, the subject was as likely to engage painters as different as Pissarro and Lacoste as it was writers as different as Zola and Mauclair.

Pissarro's most concentrated group of cityscapes is made up of sixteen canvases he painted in 1897 from a room in the Grand Hôtel de la Russie. Fourteen look north-east up the long boulevard Montmartre, while two look more steeply downwards onto its extension, the boulevard des Italiens.[41] Pissarro's motives for painting series of Parisian views were mixed. In the wake of the success Claude Monet had enjoyed with series, commercial ones were important.[42] In 1897 Pissarro was sixty-seven, aware that his time as the family breadwinner was limited; the campaign can be seen at one level, therefore, as building up pictures as capital. He was also acutely conscious, as an Impressionist whose artistic instincts had for decades been attuned to his *sensations* in front of nature, of the natural interest of the motifs his room afforded. As he wrote to his son Georges

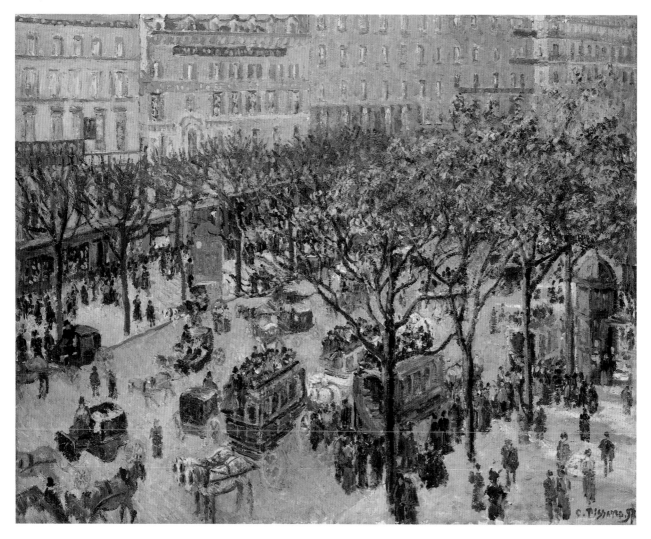

83 Camille Pissarro, *Boulevard des Italiens, matin, effet de soleil* (Boulevard des Italiens, Morning, Sunlight Effect), 1897, oil on canvas, 73.2 × 92.1. Washington, D.C., National Gallery of Art, Chester Dale Collection.

on arrival in February 1897: 'I have begun my series of Boulevards, I've got an amazing motif that has to be interpreted in all the possible effects.' Pissarro's enthusiastic use of the landscapist's jargon *effet* shows how his response to this urban scene was driven by his aesthetic as a painter of nature. And yet he definitely registered the urban character of the locale, continuing to Georges: 'I have another motif which is terribly difficult, it's almost a bird's-eye view, vehicles, buses, people between large trees, big buildings which have got to be set right, it's tough!'[43] Pissarro was as good as his word, and over the following weeks he painted the canyon-like boulevard under various different weather effects such as fog and rain, in full sunlight and at night, and – as time passed – with the trees bare and in leaf.[44] Just as the weather and seasons changed, so too did Pissarro's depiction of the to and fro of the *populus*. Some of the canvases show the boulevard hectic with traffic and pedestrians, others are freer and more leisurely, while a sketchily executed nocturne marks in the thinner night-time throng and lines of *fiacres*

84 Camille Pissarro, *La Mi-Carème sur les boulevards* (Mardi Gras on the Boulevards), 1897, oil on canvas, 64.9 × 80.1. Cambridge, Mass., Fogg Art Museums, Bequest-Collection of Maurice Wertheim.

85 Camille Pissarro, *Mardi Gras, soleil couchant, Boulevard Montmartre* (Mardi Gras, Sunset, boulevard Montmartre), 1897, oil on canvas, 54 × 65. Winterthur, Kunstmuseum.

queuing for custom along the pavements. Even when Pissarro tackled the more 'difficult' motif looking steeply down from his window, his fascination with light prevailed (fig. 83). Closer to the urban crowd, he isolated a few types – a bourgeoise dressed in chestnut brown crossing the street; the tight formation of the bus queue far more restrained than Hermann-Paul's – but none of them stands out as individuals in the democracy of the urban mass and the enveloping unity of a warm grey light. In the views up the boulevard Pissarro registered different kinds of crowd, and must have been aware of doing so. Necessarily more distant, the people are most frequently represented in disparate forms: individuals, couples, small groups, larger clusters queuing or gathered around a window display. On three occasions Pissarro painted the crowds at the Mardi Gras parade (fig. 84). The two largest of these in fact represent two distinct crowds: the mass of spectators jamming the pavements and the spectacle itself, with its packed procession of floats and costumed ranks. Even though the volume of spectators spills them over the gutters and into the roadway, a controlled line is held. These canvases represent images of civilian order, of respect for traditional rituals and of harmless collective enthusiasm of which LeBon would surely have approved. The third, smaller, canvas represents a different scene (fig. 85). The crowd now fills the whole street, an amorphous dark mass, no longer channelled but discharged, spewing into the space probably just vacated by the procession, while the coloured streamers still wave in the breeze overhead. Sketchily executed, this canvas seems to be Pissarro's recognition of the volatility of the crowd, of the way in which, in an instant, control becomes chaos. Yet there is no threat here. Pissarro's Mardi Gras paintings, like the rest of the boulevard Montmartre series, seem consistently – and in commercial terms appositely – good-natured. Whether he dealt with the daily bustle or the masses at a public event, Pissarro's representations of the crowd show it responding to, and not jarring with, the confined, funnelled spaces of modern Paris. For Pissarro in 1897, the psychology of the

86 Maximilien Luce,
*Le Percement de la rue
Réaumur* (The Construction
of the rue Réaumur), 1896,
oil on canvas, 73 × 100.
Private collection.

crowd was, in the main, well balanced and harmonious, though – like many others –
he could intuit its other moods.

That was the way with the crowd. It was fluid, changeable, unpredictable. Pissarro's
boulevard Montmartre series is more than his promised study of a range of *effets*. As a
group, it can also be seen as an informal, and not complete, inventory of different kinds
of crowd: the population of office and shop hours, evening theatre-goers, the mass public
of an annual parade both tidily behaved and shambolically relaxed. He did not paint
the politically agitated or the insurrectionary crowd; as a matter of fact they were not
there to be seen and experienced during the time he was at the Grand Hôtel de Russie.
That did not mean he was unaware of the pressures that might smoulder within a crowd,
or that the unruly could quickly be generated from the inert. For another feature of the
crowd was its fickleness, its swift change of mood and allegiance, its rapid shift from
presence to absence and vice versa. The previous year, in 1896, Pissarro's friend Luce
had painted a number of canvases of the building work to develop the rue Réaumur,
another east–west axis just a few blocks to the south of the boulevard Montmartre.
Luce's paintings also show the funnel of a thoroughfare, though its flanks are less firm
that those of Pissarro's boulevard, with heavy timbering shoring up the buildings weak-
ened by the necessary demolitions (fig. 86). Like Pissarro's paintings Luce's show a busy,
varied populace of workers and bourgeois going about their business. But what if one
brings in another kind of historical evidence about the rue Réaumur at the end of the
nineties? Gyp – the comtesse de Martel, successful comic novelist and extreme nation-
alist – used her wealth to hire thugs and demonstrators during the Dreyfus Affair. 'I
always chose those who seemed to me the worst, the most "hooligan"', she boasted
later. 'They could be found . . . inside the barricades made of planks that extended along
the end of the rue Réaumur, then under construction. The "forty sous" worked for us
or for the Dreyfusards.'[45] So what underlay the apparently genial surface of Luce's
painted fiction of the rue Réaumur was a more violent reality. What he represented as
bustling individuals could be transformed, for a price, into an aggressive crowd con-
trolled not by belief but by cash, motivated not by – in LeBon's terms – its own 'idea'
but by the ideology of its immediate paymaster. For that was one of the ironies of the
urban crowd: that by coming under the sway of one dominant idea and then another,

by its very malleability, the crowd might actually elude control. However rational and channelled the physical structures of the city might be, however urbanism was ordered to influence the progress and pace and even the mood of the metropolitan population, the crowd retained its irrationality, its susceptibility to suggestion.

Some of the most remarkable paintings of the urban experience and – as I see them – of the visualisation of crowd psychology were made during the 1890s by an artist whose experience of the city was not Parisian, and who came to have a presence in the capital only at the very end of the decade. Charles Lacoste was born in 1870 in the Gironde. He was educated in Bordeaux, undertook his military service in the south-west, and his longstanding friends the poet Francis Jammes and collector Gabriel Frizeau were also from the region. Between 1894 and 1897 Lacoste made a number of trips to London, to visit friends and paint. It was only towards the end of the decade that Lacoste gradually gravitated towards Paris, and he settled there in spring 1899.[46] Essentially non-Parisian his early experience may have been, but Lacoste's ability to give pictorial form to urban space and mood was acute.

Lacoste's paintings were typically small, sometimes painted on paper rather than canvas to give them a duller texture, with the medium applied in matt, muted tones with little demonstrative play of the brush. The suppression of *graphisme*, of apparent individuality, was a deliberate result of this process. Unlike Pissarro's direct observation, Lacoste worked from pencil sketches, notes and memory, so his paintings have a sparse simplicity, devoid of detail and resonant as a dream. *Longue rue, soir de fin d'automne. Dimanche* is quintessential Lacoste of the mid-1890s (fig. 87). The artist described it himself on the back of his preliminary drawing.

> Ochre-gold dusk-light, yellow and soft at the end of the street in a gap towards a horizon with a drained slate-blue sky mixed with some dull pink clouds. The houses are in a thick soft black velvet, a bit blue, but lit with a trace of pink-gold which the eye brings in there. The mud is blue, blue-lilac, mysterious in the distance. The shadow in the distance is dotted with greenish bright lights that have come on. It's a Sunday evening when the families come home. A young girl coughs among the black passers-by in the black street. The figures in the dawning dusk are blanched, velvety and soft. The weather is gentle, humid like sweat.[47]

This highly literary description of his painting recalls Lacoste's friendships with poets such as Jammes and Henri de Régnier. But it also makes clear how his imagination inter-sected colour and texture – key elements in the business of making – with the specificity and complexity of urban experience. He is aware of vista and distance, of the natural spectacle of sunset far away, dully framed in the exaggerated X. He deals with the grim physicality of urban life, with sweat and sputum. And he wants to conjure up contra-dictions: hard surfaces of street and stone become velvety, grey-tinted gold, *l'aube crépusculaire*. Although painted in Bordeaux, *Longue rue* is a scene in any city. The painting is not about particular topography; its masses and tones drone like an urban threnody. The crowds pass along the pavements as if in funeral processions, the figures dark and faceless, the mood monotonous. The dying light just manages to instil a lingering optimism in an image of physical compression and dreary psychological uniformity. The following year Lacoste painted *La Main d'ombre*, set more obviously at Bordeaux and representing workers streaming across a bridge over the Gironde at the end of the day (fig. 88). The title comes from the eerie finger-like fan of cloud that

87 Charles Lacoste, *Longue rue, soir de fin d'automne. Dimanche* (Long Street, Late Autumn Evening. Sunday), 1895, oil on paper, 34 × 20. Private collection.

stretches up from the dying sunlight. This form dominates the shadowed city and its silhouetted population, the hand suggesting either benediction or curse on the crowd below.

In both paintings Lacoste used the pathetic fallacy to set mood, reducing the built environment of the city to spectral natural presences: sublime cliffs in *Longue rue*, deserted panorama in *La Main d'ombre*. By no means all Lacoste's cityscapes had the disconcerting mood of these.[48] But his combination of pictorial means such as silhou-

88 Charles Lacoste, *La Main d'ombre* (The Shadow Hand), 1896, oil on canvas, 40 × 68. Paris, Musée d'Orsay.

ette, muted tone and sharply perspectival simplicity with poetic devices like anonymity and the pathetic fallacy gave these paintings a particularly 'psychological' character, which Lacoste's notes suggest was consciously contrived. One might draw in here some other verbal accounts of urban experience. Interviewing Gustave Geffroy for his 1891 *enquête* on contemporary literature, the journalist Jules Huret visited the art critic and novelist at his Belleville apartment, and in the evening they strolled through the working-class quarter together. 'Look,' indicated Geffroy: 'here is life and art. This backstreet poetry, it's the literary lesson that one can get every day just leaving one's home, by putting oneself in contact with these surroundings, this sky, these pavements ... with these people who appear and dissolve like shadows, with this world of passions and sufferings which palpitates there in front of you.'[49] With his deep-seated humanitarianism and left-wing convictions, Geffroy drew from the grim realities of the proletarian *faubourg* some optimism, which he couched in metamorphic and metabolic imagery. Such optimism was harder to come by for the socialist Jean Jaurès, writing in *La Dépêche de Toulouse* the same year. 'You go into the street: you only meet mute, sad shadows which circulate in the fog avoiding collisions ... they glide past close to you, but separated from you by one of those strange gulfs that one sees in dreams.'[50] Both these men of the left, keen to sense vitality in the urban *populus*, recorded discouragement. What they intuited on the streets was described in psychological terms, of desire and pain, mutism and the unconscious. Both reached for the same visual metaphor of the shadow, like the dark ciphers that populate the urban spaces of Pissarro or Lacoste's paintings. Painters and writers alike dealt with the city as an environment in which people lived, like creatures in a habitat. One is drawn back to an image

like Buffet's *Défilé de la hâche*, in which the pre-Roman crowd descends down the evolutionary scale. In Lacoste's *Longue rue* the contemporary crowd is likewise trapped, not in an arid mountainous gulch but in the gas-lit, apartment-lined chasms of the modern city. Evolution, progress, has brought his figures not to cannibalism but to a modern state of disjunction and anonymity.

Riot and Repression

The state's ultimate means of controlling the crowd were the forces of order: the police and, if necessary, the army. It was understood within the authorities that, faced with a belligerent crowd, it might be necessary to shoot first to retain or regain a grip on the situation. The poster designed by Henri-Gabriel Ibels in late 1893 to advertise the new illustrated journal *L'Escarmouche* implied this threat (fig. 89). As a unit of armed soldiers (not in very good order, it must be said) march past a working-class café, staff and customers look warily out of the window. For a consciously avant-garde journal launched at the height of the anarchist campaign of 'propaganda by deed', such an image of the weight of the state and the ordinariness of the opposition was apt.

89 Henri-Gabriel Ibels, *L'Escarmouche* (The Skirmish), 1893, colour lithograph, 61 × 44.7. New Brunswick, Jane Voorhees Zimmerli Art Museum, Rutgers, The State University of New Jersey, Gift of Herbert D. and Ruth Schimmel.

The working class had a right to be fearful of the wrath of the authorities when the Republic seemed threatened. In 1890 the International Congress of Socialist Workers called for a mass demonstration on 1 May to demand an eight-hour day. Frightened that this might trigger a proletarian insurrection, the government garrisoned Paris with thirty thousand police and soldiers, stood extra guards on the Bourse, Banque de France and the Senate, delayed the opening of the Salon, and arrested rabble-rousers such as *la vierge rouge* Louise Michel and the proto-fascist Marquis de Morès.[51] On the day, crowds of only a few thousand gathered, and even as disdainful a snob as Goncourt was appalled by their rough treatment at the hands of the police.[52] Such repression showed the other side of the coin: how much the Republic feared the threat – perceived or real – of the mob. Nor was it confined to Paris. On May Day the following year, in the textile town of Fourmies on the Belgian border, troops of the 145th Infantry Regiment, ordered in to control a crowd of two hundred who were demonstrating for the release of two of their number who had been arrested, answered some stone-throwing by opening fire. More than eighty in the crowd were wounded and, worse, nine killed, four of whom were female and six aged less than twenty-one.[53]

If Fourmies provides a tragic case of the forces of order at their most violently repressive, they too could be on the receiving end. An example of this was the chain of incidents that took place in Paris in July 1893. It began when two thousand students demonstrated in the Sorbonne area over the objections of Senator Bérenger, head of the

Ligue contre la License des Rues (the League against Public Licentiousness), to a naked artists' model who had participated in the recent Bal des Quat'z Arts festivities. Charged by the police, the students reacted; a café was wrecked and a student shot. Rioting continued for a couple of days. Students marched onto the Ile de la Cité and stoned the Préfecture de Police on 3 July and on the following day of prolonged street-fighting in the Latin Quarter shots were fired. Twenty-five or more police and eight *gardes républicaines* were injured. By then, it seems, the crowd had been swelled, even taken over, by workers who, according to *Le Temps*, looted and chanted 'Vive la Commune!' On 7 July the government closed the Bourse de Travail on the place de la République, which it identified as a centre for insurrection, but by then twenty thousand troops swamped the demonstrators and by Bastille Day, when the red flag had to be removed from the statue of Vercingetorix in the place Thiers, calm had been restored. The fortnight's unrest had seen casualties on both sides, as Draner's caricature in *Le Charivari* ironised (fig. 90). It had also shown how trouble could quickly spiral, and how a specific grievance from one group could become hijacked by other, potentially more dangerous, groups with different imperatives. However, like May Day in 1890, the riots in July 1893 had come to little, and establishment journals such as the *Revue des deux mondes* and the *Nouvelle Revue* could reassure their readership that the crowd had posed no major threat to political or social order.[54] Nevertheless, the deployment of such large numbers of police and troops on such occasions, as well as the alarmist tone into which papers such as *Le Temps* could slip, is indicative of how seriously the Republic and its bourgeois power base took the dangers implicit in the crowd.

As a final approach to the phenomenon of the crowd and the ways in which it found visual forms, it may be useful to bring together two of the elements already discussed. The physical order of the urban space and the legal order guaranteed by the police were both means of controlling the urban mass, as remarked. They were also both means by which the crowd could be pictured. In a rash of images from across the range of visual culture – from photographs and journalistic illustrations to large-scale exhibition paintings – there was a loose consensus about the distribution of physical forms and associative features to convey notions of control. Informally, but in sufficient numbers and variety to create a persuasive consistency, image-makers colluded in their depictions of the urban crowd. Take a photograph and a large canvas a decade apart. An anonymous photograph of the Bastille Day parade taken in 1885 from the island in the place de la Concorde shows the array of troops marching down the Champs-Elysées (fig. 91). The pavements are thronged with people, and the photographer positioned himself within the crowd, taking his shot from a raised vantage to clear the hats of those in front of him but nevertheless still contriving to give the viewer a sense of being among the crowd, albeit with a privileged view. The soldiers

90 Draner, *Moralité à tirer* (The Moral to Draw), cartoon from *Le Charivari*, 15 July 1893. John Grand-Carteret, *L'Année en images*, 1893, Paris, 1894, p. 90. Manchester University, John Rylands University Library.

form their disciplined ranks, under the command of an officer on horseback. Equally the crowd on the pavements mass in orderly fashion, marshalled by a policeman. In 1896 Pierre Vauthier executed a large canvas representing the ceremony in which Tsar Nicholas II, on a state visit to France, had laid the first stone of the pont Alexandre III, which was to be one of the key thoroughfares for the 1900 Exposition Universelle (fig. 92). Although working in quite another medium, Vauthier, like the photographer, also contrived a vantage above the crowd gathered along the quays. From there people gaze upstream to the sunlit ceremonial, the clusters of dignitaries and the boats bedecked in bunting and *tricolores*.

In both these widely different images the scene is manipulated by photographer and painter to fit together the architectural order of the urban framework – quayside, pavement edge, lines of lights and avenue of trees – with the gendarme saliently placed on duty. The physical structure of the city acts as a constraining mould for the urban crowd, so that the people take a shape consistent with the structure of the city. Thus the city serves as a metaphor for order, the moral authority of which is embodied by the police. In both images the gendarme stands between spectacle and the massed spectators, picked out as guardian and guarantor of order. For these are images of rightness and hierarchy. They do not represent the 'natural' order for which LeBon and other reactionaries pined, but a modern order apt for the new phenomenon of the late nineteenth-century metropolis. Crowd theory preferred the mass to be directed towards appropriate 'ideas', such as celebrating the Republic on Bastille Day, cheering the army or welcoming the Franco–Russian alliance. What the image-maker could do was to find pictorial forms – shapes, metaphors, protagonists – which emphasised that rightness, which gave a visual identity to appropriate suggestion.

The authoritarianism usually articulated implicitly by such motifs was writ large in a woodcut by Félix Vallotton. *La Foule à Paris*, made in 1892, represents no specific event; it just shows a moment of crowd control (fig. 93). Vallotton had strong anarchist sympathies and a sharp eye for police heavy-handedness. He was also Swiss, and his work was noticed by his native newspapers, giving them an opportunity to comment on French police methods. The Paris correspondent of the *Journal de Genève* described *La Foule à Paris* simply as depicting 'a street, like others, half-cropped, where an obviously

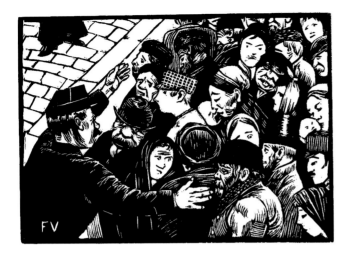

93 (*left*) Félix Vallotton, *La Foule à Paris* (The Crowd in Paris), 1892, woodcut. Paris, Bibliothèque Nationale, Département des estampes.

91 (*facing page left*) *La Revue des Champs-Elysées, le 14 juillet 1885* (The Military Parade on the Champs-Elysées, 14 July 1885). Photograph. Paris, Bibliothèque Nationale de France.

92 (*facing page right*) Pierre Vauthier, *Inauguration de la première pierre du pont Alexandre III* (The Laying of the First Stone of the Alexander III Bridge), 1896, oil on canvas, 170 × 226. Private collection.

proletarian crowd swarm beneath the outstretched arms of a conscientious policeman'. Here again, albeit in what the same writer described as 'the coarse, naive and powerful art' of the woodcut, the artist is employing those typically twinned elements: the solid structure of the city and the gendarme, his commanding arm parallel to the emphatic perspective of the pavement, form and instruction combining pictorially in an image of controlling order.[55] The following year Vallotton's friend the poet Mathias Morhardt shrewdly analysed another woodcut, *La Manifestation*, in the *Gazette de Lausanne* (fig. 94):

94 Félix Vallotton, *La Manifestation* (The Demonstration), 1893, woodcut, 20.3 × 32. New York, The Metropolitan Museum of Art, Rogers Fund, 1922. (22.82.1–9).

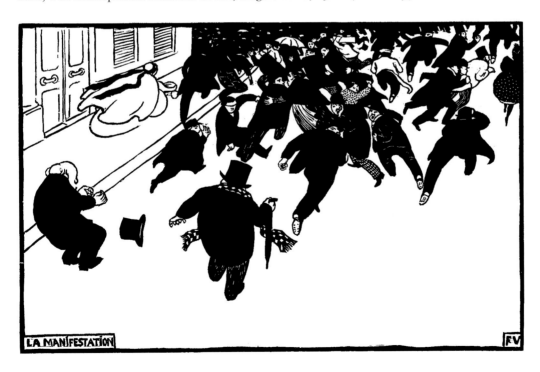

La Manifestation will hardly please anyone except Parisians. I think it will please them greatly. Imagine a very wide boulevard. The crowd flees in a fan-shape, into the distance, in very diverse attitudes which evoke in a surprising way memories of scenes that we've often witnessed over the last five years. However, nobody pursues this crowd. Yet it scatters in a frantic flight. Near the front just one bloke, half-kneeling, turns round, and his expressive silhouette indicates that he expects the regulation kicking from the police, which is the very ethos of these demonstrations.[56]

Morhardt enjoyed the opportunity his compatriot Vallotton's woodcut allowed him to ironise about public order in Paris. But he did not quite read the image correctly. The man who fearfully turns his head is not kneeling but sprinting away, and he is not the only one who casts a terrified gaze behind him. The crowd manifests only one expression – terror – and one action – flight. However, the range of types – elderly bourgeois, chic young women, *prolos*, pastry-cook and nursemaid – militates against unanimity of motive on the part of the crowd, and thus against the justice of the unseen but implicitly repressive police. Morhardt also missed the meaning of Vallotton's high viewpoint, for it is the vantage of mounted gendarmes at the charge. It is that insinuation, together with the innocence of many of the imminent victims and the sense of the fragmenting crowd still held together in their bruising fate by the ungiving structure of the street, which makes *La Manifestation* a curtly troubling image of oppressive control. LeBon wrote emphatically about how crowds are servile and need to be mastered. From an opposing ideological position, Vallotton made images in regretful concurrence with such theories, exposing the practicalities of controlling the crowd by command or violence.

Crowd psychology put great stress on the suggestibility of the mass, on how many minds could be made to think and act as one by concentration on a single idea. That idea could effectively take visual form. LeBon was explicit about this, arguing that 'a crowd thinks in images' and has a 'fetish-like respect' for established concepts.[57] For the politicians of the Third Republic, keen to provide their constituents with imagery that would help bind them loyally to the regime, this was a given. The key image of Republicanism was the figure of Marianne, and successive governments' determination to impose her image on national consciousness had seen the proliferation of statues and busts in public spaces and buildings in the two decades prior to 1890.[58] One of the most intentionally strategic of these was the vast plinth topped by Marianne designed by the Morice brothers and inaugurated (in maquette form) in the place de la République on 14 July 1880 (fig. 95). It is with this image – not the sculpture itself but what it could be made to stand for and how it could be resisted – that one might close this analysis of the crowd and its representation.

The Morices' *Marianne* was planned as an image round which crowds would circulate and form. The decision to erect this massive monument in the place de la République was deliberate. The site is at a frontier in Paris, where the eastern edge of the city centre – the historic core, seat of government, hub of commerce and consumption – meets the outer *faubourgs* – the workforce's dormitories, the expanding proletarian *quartiers* where the Commune had finally been extinguished. An image of Republican unity at this junction, passed by tens of thousands daily, was strategic propaganda, a grand and permanent reminder of the binding litany of *liberté*, *égalité* and *fraternité*.[59] So embedded an image was this *Marianne* intended to be in the consciousness of the capital that she was from the outset repeatedly given pictorial form. Alfred Roll was commis-

sioned by the state to paint a large canvas recording the celebrations at the monument on Bastille Day, 1880. His vast treatment of this event was exhibited at the Salon of 1882 (fig. 96). Roll did not make much of the city's structure. Apartment blocks on the far side of the square give some sense of the size of the urban space and the monument at its centre. Rather, he focused on the crowd which, set forward from the spectator, addresses itself with enthusiasm to the procession of passing troops. The crowd is appropriately represented as mixed in class. To the lower right, for instance, one sees a worker about to raise his cap and a flower-girl trying to sell a bouquet to a *grand bourgeois* in his carriage, to the left of which a woman has her hand on the shoulder of Roll himself, brandishing his tophat. Diverse as the individuals may be in class, as a crowd they are unified in their energetic salutation of the Republic, embodied in the massive, benign presence of *Marianne*. Although in the early 1880s Roll would probably not have used these terms, his crowd is 'hypnotised' by a positive idea, its commitment to the Republic is 'contagious' and concentrated on a dominant image. Significantly Roll included the army, a contingent of which is glimpsed marching past directly beneath the statue of *Marianne*. The army is depicted in its role as protector of the Republic, disciplined, central. Roll's *14 juillet 1880* thus effectively summarises the 'good' crowd, its fetish and the systems of imagery, ideology and force which control it. As such, it was an image that remained in circulation. Although too big to be easily brought out for the Expositions Universelles of 1889 and 1900, the painting's afterlife as an official manifestation of Republican values was long. As late as 1912 it could be found as a black-and-white slide in a set circulated by the Ministère de l'Instruction et des Beaux-Arts for use in schools.[60]

In the intervening period, however, the Republic, at least as far as the left was concerned, showed itself dilatory or disinclined when it came to tackling *la question sociale*, to facing structural issues about work, pay and conditions of employment of the kind that brought out working-class crowds to demonstrate on May Days. The Republic tended to lurch between power struggles, corruption scandals and ideological schisms, a process that threw up other images – Boulanger, Panama, Dreyfus – that rivalled or tarnished Marianne. These 'ideas' also fomented the crowd, so that Paris, to the fascination of foreigners such as Morhardt or the German journalist Herzl, became the city associated with the regular, surging tide of mass momentum.

Artists on the left, grieved by the state of things, might articulate their resentment of the Republic by using its imagery against it. At the 1897 SAF Jules Adler exhibited *Les Las* (The Weary) (fig. 97). This substantial canvas, two and a half metres across, was purchased by the state, whose functionaries soon after included it in the 1900 Exposition Universelle. Such apparent acknowledgement of the picture by the establishment might be taken as an acceptance of the painting's grim theme of fatigue and fatalism. Yet this process of state benediction might have been a decoy tactic, under a smoke-screen of frankness about images of lower-class fellow-*citoyens*, to absorb and negate the impact of such an image. Impact *Les Las* certainly has. The life-size figures give the canvas a real immediacy and elicit a powerful empathy. None of the faces is idealised or sentimentalised. The painting functions as a 'scientific' typology of the Quartier de la République at the end of the day. To the left of the weary figures plodding home Adler presents a widow and on the other flank a felt-hatted clerk or teacher. Between are manual workers of three generations, carrying tools and lunchboxes. Their drawn features and dogged stride find their chromatic equivalent in the dark-toned browns and

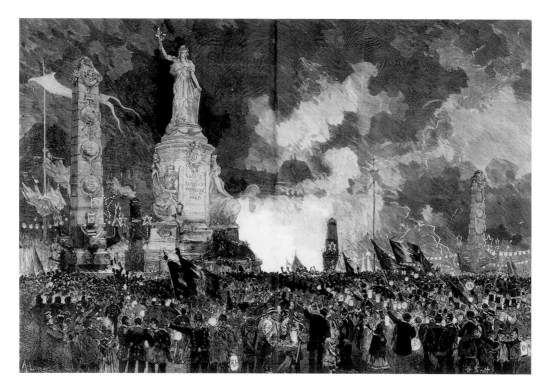

95 *The Illumination of the Place de la République on the installation of the maquette of 'The Republic' by Léopold and Charles Morice*, illustration from *Le Monde illustré*, 24 July 1880. Paris, Bibliothèque Nationale de France.

96 Alfred Roll, *Le 14 juillet 1880*, 1882, oil on canvas, 650 × 980. Paris, Musée du Petit Palais.

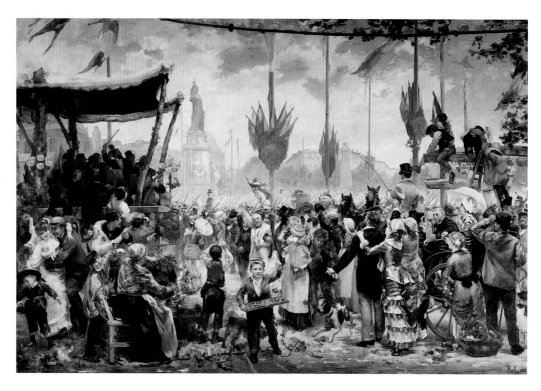

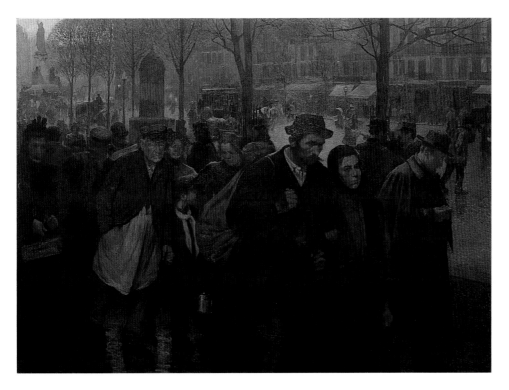

97 Jules Adler, *Les Las* (The Weary), 1897, oil on canvas, 181 × 251. Avignon, Musée Calvet.

blue-greys, for this is a painting about psychology more than action. As with many of these images, Adler set his crowd in the tight grip of the regulated urban environment, inventorying its uniform features: trees every ten metres, less frequent gas lamps, the

statutory *pissoir* – and the necessary gendarme giving directions. Like Lacoste in his far different *Longue rue*, Adler employed the pathetic fallacy. Rain shines on the roadway, and to the upper left – towards which one's eye is drawn by the receding trees – the dying sun pinkens the sky. Against it is silhouetted Léopold Morice's *Marianne*. That ostensibly hegemonic symbol of the Republic's benevolent patronage of Paris Adler contrived to diminish by placing it in the distant corner of his picture. It is not towards her in expectation but away from her in resignation that the procession of workers trudges. He made something of his oppositional position clear by quoting under the entry for *Les Las* in the 1897 SAF catalogue some lines from Zola's novel *L'Assommoir* (1876) which described the Parisian labour force dully walking to work.[61] But the hard irony of *Les Las* is lodged in the construction of the painting itself. Adler's crowd is oppressed but still orderly, not

98 Maurice Radiguet, *Le Dieu votant* (God Voting), 1894, frame for shadow play from Le Chat Noir cabaret. New Brunswick, Jane Voorhees Zimmerli Art Museum.

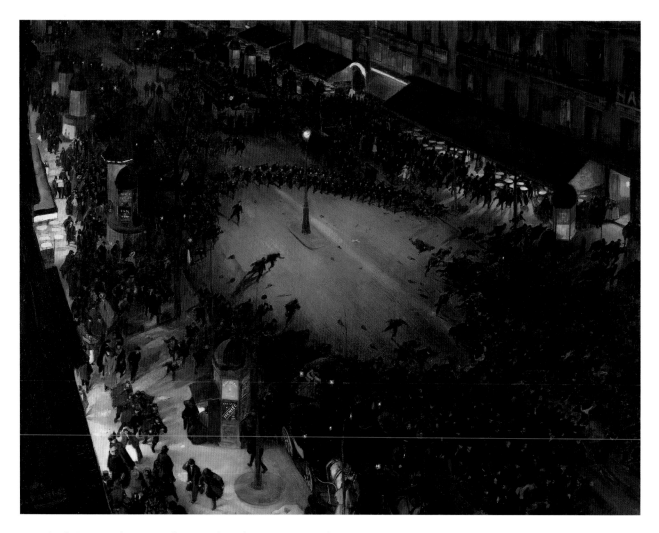

99 André Devambez, *La Charge* (The Charge), 1902, oil on canvas, 127 × 162. Paris, Musée d'Orsay.

insurrectionary. This is no longer Roll's jubilantly loyal crowd but – a decade and a half on – a subversion of that enthusiasm. These figures turn their backs on *Marianne*, their repudiation of the Republic perhaps one pace from a riot.

In 1894 the Chat Noir cabaret had staged as one of its shadow plays a piece by Maurice Radiguet entitled *Le Dieu votant* (God Voting).[62] One of the *tableaux* in this represented a scene similar to Vallotton's *La Manifestation* (fig. 98). A line of gendarmes, regular in step and under command, charge a less orderly crowd. The crisp silhouettes of Radiguet's design leave no doubt where the scene of repression takes place: beneath the shadow of *Marianne* in the place de la République. This motif, created for a venue renowned (and profitable) for its purportedly anti-establishment attitudes and made in a less conventional medium, takes this irony further than Adler's major exhibition painting would do. In Radiguet's *tableau* the figure of the Republic oversees not just oppression but repression. The highly simplified forms of the shadow play bring into sharp focus the combination of the city's structure and the ranks of the police. Order matches order, under the aegis of the Republic. The crowd is rendered subject; contagion is prevented.

One final image encapsulates picturing and policing, and their intersection: André Devambez's *La Charge*, exhibited at the SAF in 1902 (fig. 99). Here LeBon's lessons, one might say, have been learnt and are being applied. The crowd is represented as ragged and disorganised. Its lack of structure implies its lack of rationality, in LeBon's terms its femaleness. Facing it is a triumphant phalanx of gendarmes, formed into a rank, led by an officer in front, a disciplined force standing for an ideal of social discipline. To each side, along the pavements which parallel the buildings that structure the city, cafés function and good citizens try to give a sense of normality. The street is a rational space in which rationality is being restored. The theatrical arena in which this is played out has a single gas-lamp, which illuminates the forces of order. The laws of perspective tip the splintering crowd into chaos, into darkness.

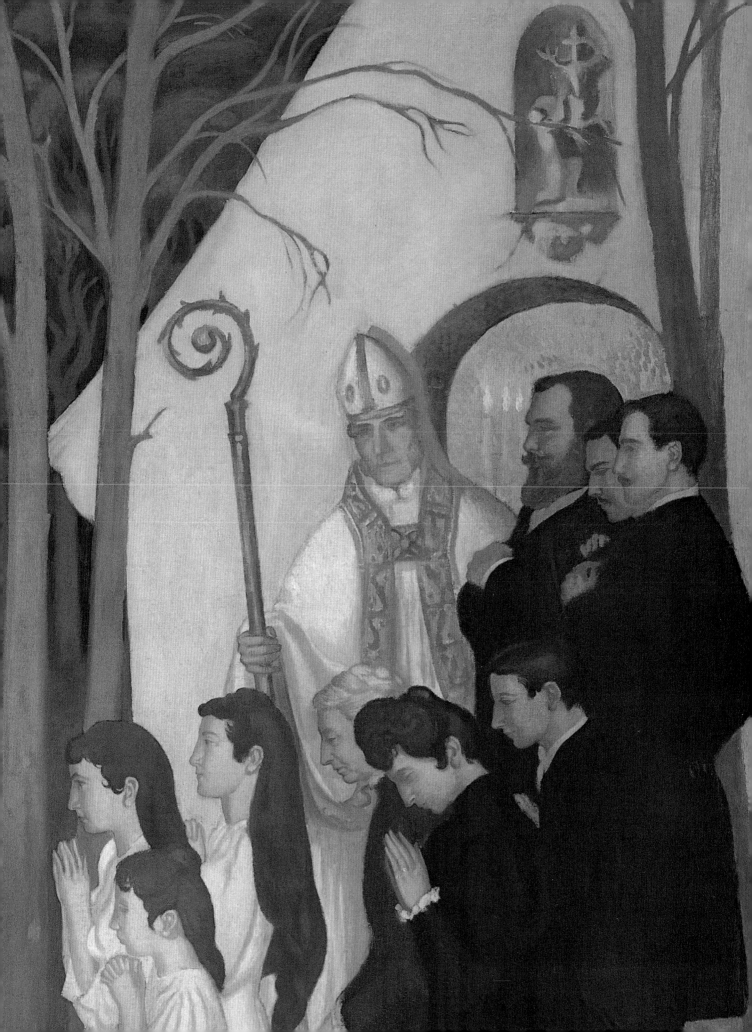

THREE

THE RELIGIOUS DEBATE: REPRESENTING
FAITH, DEFINING MODERNITY

Religion and the Republic

In March 1891 the young critic Albert Aurier published an extended article on the recent work of Paul Gauguin in the *Mercure de France*, praising his startlingly innovative work such as *Jacob luttant avec l'ange* (*La Vision du sermon*) (fig. 100). The piece riled Pissarro, both for its underestimation of the emotive aspects of Impressionist painting and for its promotion of Gauguin, who for some time had seemed to Pissarro to be unscrupulously opportunist. Writing to his son Lucien the following month, Pissarro took Gauguin to task not for his radical style – 'a vermilion background' – but for his rejection of 'our modern philosophy which is absolutely social, anti-authoritarian and anti-mystical'. For anarchists such as the Pissarros it was a credo that progressive art should go hand in hand with progressive ideology. Gauguin's crime, in Pissarro's view, was to have 'sensed a backwards turn among the bourgeoisie in reaction against the great ideas of solidarity which are flourishing among the people'.[1] Tensions and rivalries of this kind, jockeying for position about style and significance, were endemic among an avant-garde contesting precarious territory on the fringes of taste and commercial viability, and this particular incident is a paradigmatic example.[2] Pissarro's suspicions about Gauguin's manœuvrings were long-standing, but his diagnosis in spring 1891, based as it was on a social analysis of a tectonic shift in class relations, was new and specific. It went beyond exploratory style and critical nuance – with which in retrospect art history might immediately concern itself. Pissarro was writing at a particular juncture, when two hitherto implacable enemies – the Catholic Church and the

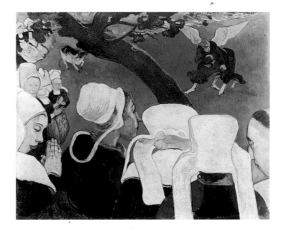

100 Paul Gauguin, *Jacob luttant avec l'ange* (*La Vision du sermon*) (Jacob wrestling with the Angel (The Vision of the Sermon)), 1888, oil on canvas, 74.4 × 93.1. Edinburgh, National Gallery of Scotland.

Third Republic – were edging towards rapprochement, a movement he and many on the left sensed had been encouraged by a mutual fear of the growing power of the people, manifesting itself in seats for socialists in the Chambre des Députés and – as shown earlier – in mass demonstrations. His letter to Lucien was straddled by an initial gesture of conciliation from Cardinal Lavigerie to the Republic in November 1890 and the publication of the Papal encyclical *Rerum novarum* alerting the Church to the need to recog-

facing page Maurice Denis, *L'Arrivée à l'ermitage* from *La Légende de Saint Hubert* (detail of fig. 110).

nise social change. For the purposes of this chapter, then, I shall take as given the innovative significance of the *Jacob luttant avec l'ange*, the creative importance of debating the merits of *sensation* and *synthèse*, and Aurier's claims for *le symbolisme en peinture*. Rather, let me investigate the underlying assumption of Pissarro's diagnosis. How did French art during the 1890s come to terms with the changing climate of relations between Church and state? To what extent were the tensions between the forces of conservatism and modernity articulated visually?

Religious art produced in nineteenth-century France has attracted few historians. There are many reasons for this. Among them must be the increasing secularism and materialism of the twentieth century, and Protestant-educated art historians' anxiety about being ill-equipped to handle Catholic art. Another would be prejudice about the quality of the art, at its worst slick, sentimental, overdemonstrably pious. But force one's way through those barriers, and one finds oneself surveying a remarkably different panorama, particularly in the 1890s. That decade presents religious art in complex and fascinating patterns. In the first place, the role of Christian belief and the Catholic Church in contemporary society was in the forefront of public debate. A combination of factors – among them a pope conscious of the need to confront modern issues, a Republic eager to consolidate its middle-of-the-road constituency, and malaise with a changing social order – brought religion centre stage. The idea of an aggressively *laïque* Republic in conflict with the ancient edifice of the Church presents too simple a polarity. Social and political currents of allegiance, prejudice and antagonism were subtle and shifting. In such an environment religious art was far from monolithic. The representation of Christian subjects in painting during the 1890s was richly diverse in style, scale and purpose. Above all, religious art was a field in which artists, knowing the subject was in the public eye, could present their contributions to the greatest tradition of representation in western pictorial culture.

Religious art was a field for the ambitious. Just as the great question for the Church and, perhaps ironically, for the Republic was how traditional belief could be adapted to the modern world, so artists sought to resolve it in their work. The making of such art overlapped with crucial professional decisions that faced the artist. How might style and imagery be articulated to satisfy, or perhaps spurn, the Republican status quo? To what extent did contemporary society and its modern pressures require a new kind of religious art, perhaps more avant-garde than academic, and how might that be phrased? Religious art in the 1890s offered possibilities for the *salonnier* and the *indépendant*, and for the *catholique avant tout*, the opportunist, the *fumiste* and the blasphemer. Therein lies another obstacle for the art historian. Often one does not know the individual religious beliefs of artists, rather as one does not know their sexual mores. This is hardly surprising, since such knowledge of others' private inner beliefs is usually obscure, even to contemporaries, as Louis Morin admitted about his fellow illustrator Louis Legrand in 1894.[3] The historian may sometimes have to rely on informed guesswork, as I shall do here, but that is part of the challenge of trying to empathise with the problems and beliefs of past cultures. So rich is the material at hand, however, that the risk is well worth taking.

Before examining the evidence of visual culture, one needs to outline the debate between the deep-seated authority of the Catholic Church and the recently established Third Republic. French Republicanism had long taken a hostile attitude to the Church. The Church's commitment to Christian dogma contradicted *liberté* of thought and even

expression. Its hierarchical structure and traditionally close allegiance to monarchy jarred with the concept of *égalité*. And the setting of priest apart from people skewed the ideal of *fraternité*. For centuries the Church had played a central role in education, influencing young minds in ways which would sustain its authority from generation to generation. For Republicanism to deepen and perpetuate its own roots in the consciousness of the French people, it needed to emulate this practice, removing clerical influence on education and replacing it with the Republican faith. This was the process known as 'laicisation'. Various broader, less ideological currents had been running through French society that pushed along that political momentum. A burgeoning belief in social and industrial progress, the impact of Darwinism and a creeping indifference to organised religion were symptomatic of a modern secularism.[4] But as the Third Republic took a firmer ideological grip following the election of Grévy as president in 1879, legislation began to be introduced that systematically eroded clerical influence in schools. That year the Paris municipal council banned priests from teaching in public schools, and Jules Ferry passed a law banning them from educational supervisory bodies, moves opposed by Catholics. In 1886 the tension was ratcheted up again, the law of 13 October requiring that all clergy be replaced by lay teachers within five years.[5] Marcel Pagnol's father was trained as a teacher at this time, and Pagnol wrote with affectionate irony about how his father believed and instructed his pupils that the Church was nothing more than an instrument of oppression and ignorance, while the French Revolution had been a golden age of fraternity.[6] By such intellectual gymnastics it was expected that one orthodoxy would be replaced by another.

If education, and thus the shaping of further generations, was the primary field in which the Republic strove to best the Church, the confrontation had other battlegrounds. The passing of legislation in 1884 liberalising the divorce laws was a manifestation of the Republic's commitment to social progress and, to a lesser extent, women's rights. It flew in the face of the Church's teaching about the sanctity of marriage. The Church's traditional role in the care of the sick was also undermined. In 1890, for instance, crucifixes were banned from Paris hospitals with a few exceptions such as the Hôtel-Dieu and the Hôpital Saint Louis.[7] If this was a *laïque* gesture of almost spiteful orthodoxy, Republicans had other means of subverting the Church's health care, notably the concept of scientific progress. Dr Désiré-Magloire Bourneville used the pages of *Le Progrès médical* to campaign for the laicisation of hospitals, claiming to counter the incompetence and proselytising of the nuns.[8] Books such as Dr E. Monin's *L'Hygiène des sexes* (1890) also condemned nuns for their professional failure to teach intimate hygiene to adolescent girls in convents, and in a much publicised trial the nuns of the Bon-Pasteur orphanage in Nancy were taken to task for teaching that it was a sin to wash oneself.[9] Popular anti-clericalism took various forms. During the 1882 strike at Monceau-les-Mines one way the miners demonstrated their anger against authority was to destroy six crucifixes and attempt to dynamite the vast statue of Notre-Dame-des-Mines.[10] Such inflammatory popular protest was matched by more deliberate and genteel gestures among the bourgeoisie. Daniel Wilson, Grévy's son-in-law (and ultimate nemesis), set up a regular fencing school at the Elysée Palace at which senior Republican functionaries would exercise; it was timed for the hour of the Mass on Sunday morning. The practice continued under President Félix Faure in the later 1890s.[11] (Such provocations had their counters. One Legitimist *baron* had the cesspit at his estate near the Belgian border emptied annually on *quatorze juillet*.[12])

Although the antagonism between Church and Republic during the 1880s had been intense, and clerical and anti-clerical positions remained fiercely held throughout the 1890s and beyond, there were other forces in play. For the situation was complex and nuanced, and something of the difficulty of interpreting images and the role of visual culture can be grasped by exploring this. By the later 1880s the anti-clericalism of Republican governments began to mollify. After all, substantial gains in educational and social reform, such as divorce, had been made. In foreign policy the Republic was moving towards an alliance with autocratic Russia, and needed to appear less radical. Additionally, colonial expansion gained advantage from Vatican support for France as the protector of missions. At home, election results taught centrist Republicans not to be complacent about mass support. Strident *laïque* policies might alienate significant tranches of potential voters in the middle ground. In the 1885 elections conservative groupings had doubled their seats in the Chambre des Deputés, while the Republicans had lost almost a fifth of theirs. The Republic's rivals could sense opportunity. General Boulanger, who had been anti-clerical and numbered few Catholics among his prominent supporters, telegrammed the Catholic newspaper *La Croix* on 11 August 1888 to stress that he would not support religious persecution, thereby seeking to win conservative and clerical support. At the 1889 elections the Republicans secured victory, and the threat of being out-manoeuvred by Boulangist nationalism was seen off. Nevertheless, on the left the socialists made gains, and the importance of consolidating the political centre-ground remained acute.[13] Political considerations also informed the Vatican's position. Leo XIII, pope since 1878, recognised that after two decades of the Third Republic the restoration of monarchy in France was a lost cause. He wanted both to protect the state subsidy for organised religion and to encourage French missionary activity. He was also keen to garner French support to try to recover something of the Vatican's lost temporal power. The pope had thus come to favour a Catholic rapprochement with the Republic that would ensure broadly conservative government with an awareness of social issues, a bulwark against socialism.[14] The climate was right for some form of reconciliation.

Prompted by the Vatican, Cardinal Lavigerie, archbishop of Algiers (see fig. 101), used the opportunity of a speech to monarchist officers of the Mediterranean fleet in November 1890 to call for unreserved loyalty to the Republic and opposition to dangerous forces of social change. His speech raised the banner of the Ralliement, the initiative to encourage Catholics to rally to the Republic. As the Ralliement gained strength during the early 1890s different interests took different positions. Within the Church, the majority of French bishops had reservations about this shift of policy away from their deepest convictions. Cardinal Richard, archbishop of Paris, retorted in March 1891 with a stern attack on laicisation. Parish priests, who bore the brunt of local anti-clericalism, were largely suspicious of the Ralliement. Among senior lay Catholics, some liberals who might have been expected to concur, such as the monarchist comte Otherin d'Haussonville, objected, while some ultramontanes who might have been expected to resist, such as comte Albert de Mun, accepted the Ralliement because the pope had given it his support. Indeed, Leo XIII had even taken the exceptional step of issuing in French an encyclical accepting the Republic, *Au milieu des solicitudes*, so keen was he to win the nation's Catholics to the Ralliement. However, de Mun's colleague in the Social Catholicism movement, René de la Tour du Pin, could not agree. In broad terms, support for the Ralliement among Catholics was divided. Some, such as businessmen, saw the

advantages of steps to consolidate social order, while more liberal Catholics considered the Republic insufficiently committed to social reform; some wanted the end of *laïque* legislation, while for others a degree of laicisation was tolerable. Many Catholics were appalled when the explosion of the Panama Scandal in September 1892 revealed the levels of corruption within the Republic to which they had been urged to rally. On the Republican side laicisation was for many the non-negotiable term of any rapprochement with Catholicism. And for the more combatively anti-clerical, the whole initiative was a ploy of the right to win seats in the Chambre and alter the constitution to restore monarchy.[15] That threat, however, faded with the elections of 1893. The Ralliés fielded ninety-four candidates but only thirty-six were elected; even the eminent de Mun lost his seat in Morbihan. The Republican share of the total vote, on the other hand, rose from the fifty-three per cent of the 1889 election to eighty-two per cent. Centrist Republicanism could now deal with religious issues on its own terms, without the taint of complicity with the right or excessive anti-clerical pressure from the left.[16]

It was in this spirit that the leading Republican Eugène Spuller made an important speech in the Chambre on 3 March 1894 in which he argued strongly that the Republic must now show a much greater tolerance in religious matters. Spuller, a close associate of the late Léon Gambetta, had impeccable Republican credentials; his new position registered an important ideological shift. He was also the minister for education, the fine arts and religious affairs, thus at that moment one of the officials most responsible for the shaping and broadcasting of Republican ideology. The tone he set had an impact on what concerns me, visual culture. Of course, not all Republicans responded favourably to this change of tone. In the radical *Le Phare de la Loire* Marcel Schwob waxed sarcastic, telling his Nantais readership: 'We have a Messiah. He has returned to preach us the holy word. He has been reincarnated again. He has taken the name Spuller.'[17] But Spuller, a typical politician, was as much responding to a changing public mood as he was trying to create one. This shift found articulate and authoritative voice in intellectual circles in January 1895 when Ferdinand Brunetière, editor of the conservative *Revue des deux mondes*, used his pages to revalidate the intellectual and social position of the Catholic Church. Despite its claims, he argued, science had not provided universal solutions; mysteries remained mysteries. 'Science has lost its prestige; and religion has reconquered part of its own.' Leo XIII had astutely addressed modern concerns by encouraging the rapprochement with the Republic and expressing anxiety about the dangerous divide between social classes. The divinity of Christ, Brunetière went on, could not be disproved, and why try to do away with religion in any case? Democracy needs a morality, and for France Catholicism was well suited. *La question sociale*, he concluded, could be solved neither by natural history, as sociologists want us to believe, nor by state control or the destruction of the state, the solutions of socialists and anarchists respectively. The answer, in his view, lay in the morality of the individual.[18] Brunetière's argument tried to square some uncompromising circles, but it was symptomatic of a powerful momentum towards at least a constructive dialogue between Church and Republic, science and religion, and the forces of social conservatism and social unrest.

Of course, ideological opponents of this consensus still found strident voice themselves. On the left, a paper such as Gérault-Richard's *Le Chambard socialiste* railed against what it saw as the Republic's traitorous volte-face in abandoning its core anti-clericalism – worse, making up to the pope – in order to identify a new enemy: the hydra

of socialism.[19] On the right, a fanatic like the Dominican Père Didon could fulminate dangerously as he did in his published speech to a school prize-giving in July 1898, when he urged the army to mount a coup to prevent the re-opening of the Dreyfus case.[20] What such arguments and counter-blasts indicate is how central religion was within public debate during the 1890s. The point is further demonstrated in the decision of Zola, that cultural lodestone, to devote a sequence of three novels – *Lourdes* (1894), *Rome* (1896) and *Paris* (1898) – to issues of morality and belief. In *Paris*, the dynamic and subtle Monseigneur Martha explicitly stands both for the reconciliation of science and Catholicism and for the Ralliement.[21] Zola's use of his characters to articulate these modern concerns bears witness to the significance of such issues not just among an intellectual and cultural élite but also among the mass readership that consumed his novels *en feuilleton*. The elections held in the year *Paris* was published, 1898, showed that the Ralliement had failed politically. Only thirty-eight *Ralliés* were elected, and the right as a whole lost a dozen seats while the socialists gained five. In effect, the Ralliement had not succeeded in infiltrating the Republic, but it had pushed monarchism to the far sidelines of French politics, replacing it with Catholicism as a major cause for the right to defend.[22]

Political failure the Ralliement may have been, but perhaps its greater impact was in opening wide debate about religious and moral issues in the public – and thus intellectual and creative – sphere. It needs to be stressed that the arguments and opinions which swirled around religion during the 1890s, stirred further by the Ralliement, touched French life widely. This meant not just upper-echelon discourse about educational policy or relations between the Quai d'Orsay and the Vatican, or strident newspaper articles, speeches and sermons demanding one course and damning others. One finds it too in the indoctrination of students for a lifetime's schoolteaching, the character of the classroom's daily cycle, the nature of pastoral care for the sick, even instruction in sexuality and personal hygiene. The religious debate also affected how images were made, who looked at them, and how.

Given the shifting politics, varied regional and class loyalties and kaleidoscopic profusion of individual belief, it would be imprudent to lay down strictly defined attitudes to the Ralliement or patterns linking religious observance to the crafting, patronage and appreciation of the visual arts. Nevertheless, one might give some sense of a broad picture by sketching in some generalities and pinpointing some particularities. Lavigerie himself had a detached attitude to the Ralliement, despite being its instigator. For him it was a useful method of protecting the Church, but he had little belief in the durability of the anti-clerical Republic, so the Ralliement was little more than a temporary expedient.[23] He made at least one gesture, it seems, to promote his cause pictorially. In 1888 the eminent portraitist Léon Bonnat had exhibited his grand effigy of the cardinal at the Salon (fig. 101). Lavigerie is presented in his red robes of office as a man whose physical bulk partners his moral and political authority, his expression forthright yet gentle, even visionary. Four years later, in 1892, when in the wake of his Algiers toast Lavigerie's reputation had become national, Bonnat requested that the state purchase the portrait, which was owned by the cardinal. Both men made sacrifices to this end. Lavigerie, who died later that year, was prepared to let the painting go back to Bonnat merely for the original purchase price, while the painter had to accept deferment of the state's payment until the following year.[24] Both seem to have calculated advantages: for Bonnat the kudos of having painted the initiator of the Ralliement, for

101 Léon Bonnat, *Cardinal Charles Lavigerie, l'archevêque d'Alger*, 1888, oil on canvas, 239 × 164. Versailles, Musée National du Château.

Lavigerie impetus accrued to his initiative by having his portrait prominently within the public domain.

Catholicism's strength varied from region to region. In particular it was well rooted in Brittany, the Vendée and the west, and also in Flanders to the north. Such patterns had been created, and were adapted, by forces such as regional history and cultural tradition, the quality of the clergy and the support the Church received from outside, from land-owning notables in the west or industrialist *dévots* in the north. The Church's authority can to a certain extent be measured by church attendance figures, which had been in decline since the Second Empire as the pressures of modernity took their toll on traditional practices. Increased literacy, medical advances diminishing the fear of death and agricultural developments assuring the success of the harvest via fertiliser and machinery rather than prayer were among the forces of change. By the 1880s the number of men attending Easter Mass in left-wing Narbonne (Aude) was as low as 9 per cent, while Breton dioceses such as Rennes (30–40 per cent), Saint-Malo (40–50 per cent) and Redon (50–60 per cent) registered much higher proportions.[25] But church attendance did not necessarily connote deep conviction, even among the classes expected to be strongly Catholic. The daughter of the Prince de Broglie, estate owner and deputy in Anjou, remembered that she was regularly taken to Mass without any explanation of religion being offered to her until she was twelve. Indeed, her family and their ilk rarely

102 Jacques Aymer de la Chevalerie, *Sainte Radegonde*, 1899, oil on three canvases in shaped frame, 71 × 138; 233 × 133; 57 × 137. Poitiers, Musées de la Ville. Musée Sainte-Croix.

discussed religion, their loyalty to throne and altar being a question of inbred tradition rather than committed practice.[26]

Contrary to the example of the Broglies, however, there were many regional notables who were pious Catholics, some of whom expressed this through the visual arts. Jacques Aymer de la Chevalerie came from an old family in the west of France, whose ancestors had included Knights of Malta, senior officers under the Bourbons and distinguished mother superiors. Owner of the Château de Piloué at Chiré-en-Montreuil (Vienne), Aymer was a notable in the Poitiers region. He trained at the Ecole des Beaux-Arts under Gustave Moreau in the early 1890s and at the 1899 SNBA he exhibited a substantial devotional painting of Sainte Radegonde (fig. 102). The canvas was rich in local significance. Its main panel represents St Radegonde, patron saint of Poitiers, standing in front of a panorama of the city and holding a model of the Abbey of Sainte-Croix. Beneath is a predella in grisaille depicting St Euphronius, bishop of Tours, presenting St Radegonde with relics of the True Cross, while above a hemispherical panel shows Christ Pantocrator with St Radegonde and a male saint, perhaps St Medard or St Pient.[27] The painting brings into play both the archaic – the Romanesque arch of the frame; the hieratic frontality of the figure of St Radegonde in her pink dress and white cowl, like a sculpture on the portal of a cathedral – and the modern, for the viewer is presented with contemporary Poitiers, with a factory by the river. That dialogue extended to the painting's purpose. In donating it to the church of St Radegonde in Poitiers, Aymer must have felt that its image of a sixth-century saint continued to hold meaning for the modern city, and that it was his duty as a Catholic notable to do what he could to sustain the faith of his region.

Among the pressures of modernity, creeping secularisation and Republican opposition to the Church, a leading churchman such as Lavigerie and a provincial layman like Aymer took steps to protect their faith as they saw fit, both in their different ways involving visual culture. Within their different contexts, these men were senior figures, taking particular responsibilities. At far less esteemed levels, on the ground floor of Catholicism, in parishes and families, patterns of support for the Church were as diverse as might be expected. One consistency, however, does stand out and it had particular impact on the production of art. This is the common division within families, whereby religious observance remained stronger among women than men. The distinction was not necessarily just one of individual belief; it was shaped by established social formation. Among the wide ranks of the bour-

geoisie, women were expected to centre their lives on the home, caring for children and their early education, bringing up daughters respectably to perpetuate that role within the family. For woman's designated role of care, domesticity and resignation, the Virgin provided the perfect example. Men, pushed as boys into competitive schooling and then military service, as adults took on career and political responsibilities, all of which factors provided pressures – whether in the form of temptation or professional expediency – that could draw them away from the Catholic path. The result was frequently a division within family frameworks. Generally women remained closer to the Church than men, taking the lead and often securing the acquiescence of their menfolk in respect of religious observances. One finds instances of this within artists' families. In Monet's case it was clearly Alice Hoschédé, with whom he had lived for more than a decade after his first wife's death, who took the moral decisions within the family. Unprepared to marry Monet until her long-separated husband had died, Alice insisted on marrying the artist, in church as well as the *mairie*, before her daughter Suzanne went to the altar in July 1892. Monet acquiesced in this, as did Renoir when it came to having his children baptised.[28] Carrière too seems to have accepted a compromise. His own beliefs were progressive and Republican, and pantheistic rather than Catholic. Writing to Geffroy from Pau (Pyrénées) in December 1898 he complained about the town being 'an utter quagmire of clericalism', and yet he agreed that his children celebrated their First Communion and that his daughters attend convent schools.[29] Domestic divisions between the sexes might involve not only decisions about religious practices within the family but also political disagreement. In 1889, for example, the novelist Alphonse Daudet and his wife Julia, also a writer, were at odds about the government's anti-clerical policies, for she was strongly opposed to the legislation ordering the removal of crucifixes from schools and dismissal of nuns from hospitals, which he supported.[30] These four cases – all from the cultured bourgeoisie but from various constituencies within that stratum – support the conventional assumption that women felt a closer responsibility to the teachings of the Church than men, and that they were able to win their case within the family circle.

103 Maugean, *La Prière* (Prayer), 1890, oil on canvas, measurements and location unknown.

Women's role as stalwart among the faithful was frequently represented in the 1890s, and by artists of different aesthetics. Pissarro, full of his suspicions about Gauguin's opportunistic playing to the Catholic gallery with the radically simplified and imaginatively coloured *Jacob luttant avec l'ange*, took for granted its inclusion of pious Breton women.[31] By contrast, *La Prière*, painted by Maugean in 1890, is emphatically and conventionally naturalist (fig. 103). The cut-off figure to the left, the child turning to peek at us and the viewpoint which implies that the spectator too is kneeling in this church interior are all contrived to give a sense of actuality. In addition, this is a painting about class. The young woman in the main aisle, probably of leisured family, is wearing simple but smart costume, a little less practical than the correct, *institutrice*-like figure near her. In the foreground both the older woman and the maid accompanying her mistress's child are working-class types. Although there are male figures represented within this partial congregation, the majority are women, differ-

104 Maurice Denis, *Sancta Martha*, 1893, oil on canvas, 46 × 38. Private collection.

ent in age and class but shown as dutiful to their religious responsibilities. Painted three years later, Maurice Denis's *Sancta Martha* is an entirely different kind of painting (fig. 104). Executed with the synthetic simplicity of Denis's Nabi style, the painting is reductive in both its generalised forms and subdued tones of blue-greys and browns. Although the viewer is placed close to the main figure – Denis's bride Marthe, painted on their honeymoon – the picture's fiction plays off her physical presence and intimate gaze with the imaginary scene of Christ with Mary and Martha in the further room, personal emotion and religious belief harmonised within a single canvas. The figure has a dual

role, as Denis's Marthe and the New Testament's Martha. In essence, *Sancta Martha* is a painting about duty – to husband, household, faith – in which sobriety and balance of pictorial design echo their moral equivalents. Both these paintings, so different in style and allusion, centre on women: women in interiors involved in the traditional round of housekeeping, childcare and prayer. Such images, presented to different publics and no doubt executed by artists of different ambitions, could be multiplied with many other examples. What they convey is the presence of a lively and diverse imagery sustaining traditional religious values, an imagery that articulated a deep-seated domestic Catholicism at odds with Republican ideology, and the ways in which women's roles within the virulent debates about religious observance and anti-clericalism were crucial to the way the discourse was articulated.

Different and divided readings of paintings with religious subjects were inevitable when opinions – based on ideology, belief, class, region or sex – were widely divergent. The exhibition of Dagnan-Bouveret's *Le Pardon en Bretagne* at the 1887 Salon and again at the 1889 Exposition Universelle stimulated contrary reactions. On the one hand, critics such as Pierre de Soudeilles and Henri Dac, writing in the monarchist *Le Monde* in 1887 and 1889 respectively, used explicitly Catholic language to extol, as they saw it, the piety of the Breton peasants' devotion to the Church and the Virgin. On the other, the critic of the leftist Republican *Le Radical*, Paul Heusy, damned the same painting as a representation of superstition, irrationality and fanaticism.[32] It is not known how Dagnan himself responded to such antagonistically opposed positions over his painting. But Joris-Karl Huysmans's wry response is recorded when he found himself in a similar position following the overnight success of *Là-bas*, his novel about Satanism, in 1891. Writing to a friend, he explained that the Church's position was divided. The ultramontane *L'Univers* wanted him prosecuted, but *L'Observateur français* – the Vatican's mouthpiece, Huysmans noted – was content that the book was Catholic and mystical, so should not be attacked. It was, however, precisely those characteristics that had got him into trouble with Charcot and his acolytes, arguing from a scientific and Republican position.[33] In such a climate, a painting such as *La Leçon de catéchisme*, exhibited by Dagnan's friend Jules-Alexis Muenier at the 1891 SAF, could be interpreted in multiple ways too (fig. 105). In Catholic eyes it could be seen as the dutiful country *curé* undertaking his pastoral duty of instructing the village children in the liturgy, whereas for anti-clericals it might be read as a cretinous priest inculcating the credulous with superstition. Whatever Muenier's own intention, of which I have no documentary evidence, his detailed naturalism does invite close reading. How, for example, does one interpret the careful depiction of the soutane greyed with age and splashed with mud: as indicative of the priest's noble impoverishment or his indifferent hygiene, or perhaps neither, merely as demonstrating Muenier's descriptive skills with the brush?

Painting the Faith

From within these complex and contradictory patterns one can extract some consistencies in religious art, though it would be true to say that diversity was among them. There was no monolithic 'Catholic' painting in the 1890s. Church decoration is a case in point. In 1889 Joseph Aubert began the major project of decorating Notre-Dame-des-Champs, in the sixth *arrondissement*, with a cycle of scenes from the life of the Virgin, a task

105 Jules-Alexis Muenier, *La Leçon de catéchisme* (The Catechism Lesson), 1890, oil on canvas, 68 × 92. Besançon, Musée des Beaux-Arts.

which took eighteen years (fig. 106). Aubert was a devout Catholic who stated, when quizzed by the older artist Jean-Jacques Henner, that he believed everything he painted.[34] He made decisions appropriate to decorative work to be seen from a distance: he reduced the number of figures in the narrative scenes from the Bible, grouping them round the central incident, paid attention to the changing direction of light in the church during the course of the day and related his tones to the architecture. But his primary decision was to render the figures in naturalistic detail, so that faces, gestures and costume could be easily read and understood by the congregation. The large decorations may have been harmonised in their execution, but that stylisation was entirely at the service of legibility, of naturalism. That was what his public expected. The senior painter William Bouguereau, who numbered church decorations among his wide range of work, typi-fied that audience when he was invited to see some of the Notre-Dame-des-Champs paintings before they were inaugurated. He drew attention to what Aubert, so close to his work on the scaffolding, had missed: seen from the choir the pivotal image of the Almighty in the apse looked as if He was picking his nose.[35] Aubert had hastily to revise the figure to avoid misunderstandings that the public eye, attuned to the apt and accu-rate, might make. Bouguereau, with his well-honed instinct for popular taste in art, had provided a useful litmus test. Nevertheless, Aubert's decorations for Notre-Dame-des-Champs – lucid and conventional in both style and piety – were the kind of monumental

106 Joseph Aubert, *La Sainte Famille se reposant en Egypte* (The Holy Family at Rest in Egypt), 1890s, oil on canvas, dimensions unknown. Paris, Notre-Dame-des-Champs.

religious painting that the fervently Catholic press such as the Assumptionist *La Croix* particularly favoured. As early as 1891 the paper's art critic, citing one of the canvases for the church that was on show at the SAF, proclaimed that Aubert was almost the only substantial religious painter currently showing.[36] Combative Catholic taste, one might say, seeking to coalesce the widest possible constituency, sponsored an aesthetic that was moderate and legible.

That kind of taste offended those of less convinced religiosity and more adventurous culture. Edouard Vuillard, for one, complained about the feeble level of clerical taste, indicative in his view of the collapse of religion. His opinions were registered by his friend Denis in his journal, Denis being forced to agree with the first point. Although a *catholique avant tout*, Denis acknowledged that the clergy shared the taste of the bourgeoisie – 'clerks, civil servants, soldiers, engineers, tradespeople'. After all, he admitted, a *curé* might order a 'Gothic' altar for his church just as a bourgeois might order reproduction Henri II dining room furniture. If congregations had poor taste, Denis instructed himself, the solution was to win round the clergy to good art.[37] Vuillard's critique and Denis's reflections were occasioned by the inauguration in March 1899 of the chapel the latter had decorated in the Collège de Sainte-Croix in Le Vésinet, in the western suburbs of Paris. Denis owed the recommendation for this commission to his friend *abbé* Bergonier, a rare priest who would have escaped the two painters' criticisms, for he next confided in Denis the decoration of his own church in Le Vésinet, the modern Sainte-Marguerite.[38]

For this larger project, two separate chapels in the church, Denis was given freedom of style and iconography. The chapel of the Virgin, completed first, was executed in a style derived from Fra Angelico, the painter whom Denis had admired from the very beginning of his career and whose work he had recently been able to study in depth on a visit to Florence in 1897. The subject matter of this chapel, centred on an Assumption, involved scenes such as the Visitation, the Finding of Christ in the Temple and the Wedding at Cana. They celebrated the life of the Virgin, and conventionally adopted themes which associated her with family values. The second chapel, not completed till

107 Maurice Denis, *La Glorification de la Sainte Croix* (The Glorification of the Holy Cross), 1899, oil on canvas in six sections: *Préparation de l'encensoir* (Preparing the Censer), 250 × 115; *Anges et enfants aux encensoirs* (Angels and Choirboys with Censers), 225 × 225; *Paysage* (Landscape), 115 × 164; *Anges et enfants lançants des pétales* (Angels and Choirboys throwing Petals), 225 × 225; *Préparation des courbeilles des fleurs* (Preparing Baskets of Flowers), 250 × 115; *L'Exaltation de la Sainte Croix* (The Adoration of the Holy Cross), 220 × 597. Paris, Musée des Arts Décoratifs.

1903, was dedicated to the Sacred Heart. Not only did it differ from the earlier chapel in its more strict, linear style, which reflected Denis's later interest in the pupils of Ingres, but its iconography was different. New Testament subjects such as the Good Shepherd and the Good Samaritan were side by side with images of Christ bringing together employers and workers, with the painted injunction *Aimez-vous les uns et les autres*. The chapel of the Sacred Heart thus articulated a more assertive Catholicism than the gentler chapel of the Virgin, in tune with the more conservative and authoritarian position that the right had adopted and which was endorsed by the new Pope Pius X, elected in 1903. When the Le Vésinet ensemble was completed that year Denis's decorations inevitably received an ideologically charged reception in the press. Right-wing papers such as *La Liberté* and Action Française's mouthpiece *La Revue universelle* praised them, while the leftist *Le Réveil* condemned the artist for his membership of the Ligue de la Patrie Française.[39]

Denis's Le Vésinet work was determinedly Catholic, socially conservative and supported by allies on the right. Motivated by ideology as well as faith, it fell victim to the rival ideology of the Republic. For with the passing of Combes's law separating Church and state in 1905 the chapel at the Collège de la Sainte-Croix was closed, and only six years after their completion Denis had to dismantle his decorations. But for all the inherent conservatism of Denis's projects at Le Vésinet, they were a genuine attempt to reviv-

ify religious painting, to endow it with the aesthetic quality that Vuillard and he could agree was frequently missing. Take the lower panels from the *Glorification de la Sainte Croix*, painted for the chapel at the Collège (fig. 107). These paintings are a striking combination of opposites. The repetitive profiles and insistently perspectival tiles look back to the Italian *quattrocento* Denis admired, but the vivid contrast of reds and greens gives the frieze a modern immediacy. The choristers are idealised and angelic, while the altar boys are naturalistic and easily diverted; the ritualistic meets the recognisable. Simply executed with symmetry and strong forms, the processional design serves its function in relation to the panel above, which represents the Adoration of the True Cross. The upper scene tells of the duty of those on earth to celebrate divine revelation, while the scene below – pitched at the level of the congregation and drawing its attention – shows how this may be done. For the choristers and altar boys process beneath a vine-hung pergola and in front of a cornfield, providing between them the bread and wine of the Mass. The middle panel, with its central track leading to an illuminated city on a hill, leads the worshipper's eye in, along the path of Christian duty to the promise of salvation. In iconographical or liturgical terms none of this is difficult to grasp. Denis was fulfilling his dual aim of using his decorations as an accompaniment to the congregation's devotions and of raising their level of aesthetic appreciation. For by discarding the frankly illustrative naturalism of an Aubert for a fusion of *quattrocento* hieraticism, *Ingriste* austerity and singing modern chromatics, Denis created a style combining tradition and new energy, the purity, probity and contemporaneity of which generated a positive ambience of worship apt for a Catholicism determined to assert itself in difficult times.

While such projects continued the great Catholic tradition of grand public works to stimulate the devotions of the faithful, at the other end of the scale images were produced for more private purposes. Of course, the so-called imagery of St Sulpice proliferated in many Catholic households: mass-produced painted plaster saints, vulgar chromolithographs, or indifferent reproductions of great works of religious art. But one can trace instances in which more radical expression was employed for private devotion. Aged twenty or twenty-one, Denis painted a little landscape from which he was never parted (fig. 108). Painted in austere purple-greys, this missal-sized picture represents a high-walled road winding through a dark landscape of tall trees. In the distance, at the top of a long slope, the road disappears over a horizon illuminated by a pale blue glow. Loosely based on the undulating landscape of his native Saint-Germain-en-Laye (Yvelines), the image evokes an interior landscape: the winding path of life, surrounded by uncertainty, along which we all tread, with the hope of a better beyond.[40] Denis's little painting was an aid to prayer and meditation made for himself. Marie-Charles Dulac made such images for others. Trained as a painter during the late 1880s, Dulac's piety led him to take the Third Order of St Francis in 1890, and on his early death in 1898 he was buried in his monk's habit.[41] Although Dulac also painted small, simple landscapes with religious undertones, perhaps the most significant work of his short career is the sequence of albums of colour lithographs that he produced. While the *Suite de paysages* of 1893 set the tone with minimal motifs employing much repetition and reflection, by *La Cantique des créatures* of the following year Dulac had moved on. The natural motifs are illumined by heavenly light and sometimes transformed by invented elements. The religious dimension of *La Cantique des créatures* was overt, with the album including a text by St Francis of Assisi and the individual prints given titles such

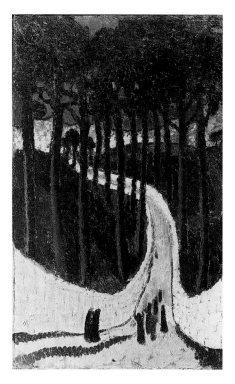
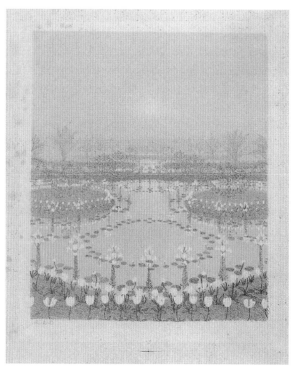

108 Maurice Denis, *Le Chemin dans les arbres* (Path in the Trees), *c.*1891, oil on board, 28 × 19. Saint-Germain-en-Laye, Musée Départemental Maurice Denis.

109 Marie-Charles Dulac, *Parterre et pièce d'eau* (Flowerbed and Pool), from the album *Le Credo vivant* (The Living Creed), 1896, colour lithograph, 37.5 × 44.5. Paris, Bibliothèque Nationale de France.

as *Sancta Trinitas Unus Deus* and *Jesu Via et Vita Nostra*. In 1896 Dulac worked on *Le Credo vivant* (The Living Creed), in which the process of stylisation went yet further. A lithograph such as *Parterre et pièce d'eau* employs Dulac's instinct for the symmetrical, in deliberate opposition to the disordered natural, with his personal use of colour symbolism, here yellow representing the embracing love of God just as violet meant humility and the earthly life of Christ (fig. 109). Dulac also associated natural elements with specific religious meaning, for example water with purity.[42] *Parterre et pièce d'eau* (Flowerbed and Pool) thus offers the viewer a harmony of balanced repetitions, circling forms and all-embracing illumination conducive to tranquil meditation. For this was the work of a monk, reaching out to the faithful through his art, expecting the peruser of his images to use them for private devotion. Dulac adapted the devices of the modern – the medium of colour lithography; a synthetic, decorative style; the collectable print album – to the purposes of prayer. His goal as an artist, he wrote in a letter from Assisi in 1897, was 'to serve, to praise God', and the circulation of prints was a contemporary form of visual preaching.[43]

Dulac's lithographic albums, or the modestly scaled paintings of religious subjects that Denis painted during the 1890s, were intended for a cultivated public, middle class and Catholic. There were also a few instances of Catholic grandees supporting religious art, not as public figures but as private individuals. Baron Denys Cochin is a case in point. The Cochin family were Legitimists, whose fortune had grown in mid-century with

investments in the railways and other industries. They were politically active: Denys Cochin's grandfather had been mayor of a Paris *arrondissement*; so had his father, as well as a *préfet* under Thiers's first presidency of the Republic; and Cochin himself was a deputy who spoke for the liberal right. A devout Catholic and admirer of Leo XIII, he continued the family tradition of social responsibility by supporting the scientific research of the Curies and Louis Pasteur, publishing his own *L'Evolution de la vie* in 1886. His moderation later led to his becoming, in 1915, the first Catholic in a Republican cabinet.[44] Cochin's Catholicism emerged discreetly in his art collection. The sale of nineteenth-century paintings held in 1919 three years before his death included one Corot of Rome, another of Castel Gandolfo and a third featuring the cathedral of Saint-Lô; the Courbet was a study for the choirboys in the *Burial at Ornans*; and one of the four Delacroixs was a Christ on the Cross.[45] Cochin also commissioned new work. In 1895 Besnard designed him a stained-glass window, *Les Animaux sauvages* (St Germain-en-Laye, Musée Départemental Maurice Denis), divided into a triptych of farm animals, thoroughbreds for hunting and racing, and game, an allusively aristocratic piece for the proprietor of an estate near Melun. There Cochin participated in the revival of hunting to hounds which was a gesture of privileged reaction under the Republic. Thus when in late 1895 he commissioned Denis to paint decorations for his study, the theme of St Hubert, patron saint of hunting, was an apt choice. Completed in 1897, the seven panels form a sequence from the departure of the huntsmen to the final chase.[46] But it is not merely descriptive. The central panel on the end wall of the study represents St Hubert's vision of the Crucifix between the horns of the stag he pursues, and the moral undertone of the pursuit of good and the dangers of evil is implicit in scenes of losing the scent and the frantic chase. The initial *Le Départ* leaves no doubt that the Cochin family are notables, and the appearance in intermediate panels of the coachman Forget and even the busily sketching Denis leaves no doubt either of their subsidiary social roles. The final *L'Arrivée à l'ermitage* returns to the Cochin family, praying in disciplined submission to revealed truth, the figures in profile like donors in a fifteenth-century altarpiece (fig. 110). The conscious archaism of Denis's style (he had illustrations of Gozzoli's processional *Journey of the Magi* from the Medici-Riccardi chapel in Florence to hand) implies continuity: in Christian faith, traditions of artistic expression, or in the Cochin lineage with its proper respect for male and female roles.

Secularisation, Anti-Clericalism and Blasphemy

Different in style, purpose and patronage as it may have been, the work of artists such as Denis, Dulac or Aubert was overtly Catholic, intended to support the Church and its faithful in an unfavourable climate, ranging from the indifferent to the aggressively anti-clerical. With the Church on the defensive, the modern and increasingly secularised culture, aided and abetted by the policies of the Republic, created something of a scorched-earth terrain, from within which new manifestations of visual culture could sprout. The Republic tried to make the most of such opportunities. The figure of Marianne, for instance, as typified by the Morice brothers' massive monument in the place de la République, was deployed as a secular, ideological counter to the image of the Virgin, just as *quatorze juillet* served as an alternative festival, Republican not religious (see figs 95, 96). The decorations commissioned for *salles de mariages* in town halls,

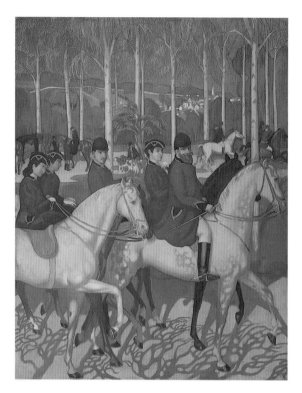

where the compulsory civil marriage ceremony was performed, rivalled the altarpieces of churches, where an optional religious service might take place. Such decorations systematically promoted secular values such as family, labour and *patrie*, articulating the conventional understanding of gender roles. These were notions to which the Church would take no exception, but they were usually couched in unswervingly *laïque* terms. In this strange cultural environment, where an ancient ideological tradition struggled for survival while a newer one strove to take root, there was, it seems, a process of cross-fertilisation, of unusual graftings and hybrids. For where the religious ended and the Republican began was by no means always clear, as the changeable climate of the Ralliement decade would lead one to expect.

Where an artist stood was by no means always certain and could lead to confusion. In an interview for *La Semaine de Paris* in January 1895 Paul Gsell put it to Puvis de Chavannes that many considered him 'a devout and mystical primitive strayed into the nineteenth century'. As an answer, Puvis showed the journalist reproductions of his decorations for the Musée des Beaux-Arts in Lyon, completed in 1886, insisting that *L'Inspiration chrétienne* (Christian Inspiration) was counter-balanced by the pagan *Vision antique* (Classical Vision) on the opposite wall.[47] Unwilling to be tarred with a religious brush, Puvis preferred to see the iconography of his Lyon scheme as non-committal. The decorations that he painted in two stages for the Panthéon on the theme of the life of St Genevieve also convey an equivocation. Painted in 1877 on commission from a Catholic minister of fine arts, the marquis de Chennevières, the painting of the child saint at prayer depicts her with a halo. Puvis executed two more decorations between 1893 and 1898, this time working under a ministry more doctrinaire in its Republicanism. These represent the patron saint of Paris in later life bringing supplies

110 (*left and facing page*) Maurice Denis, *La Légende de Saint Hubert* (The Legend of St Hubert), 1897, oil on canvas in seven sections: (i) *Le Départ* (The Departure), 225 × 175; (iv) *Le Miracle* (The Miracle), 225 × 212; (vii) *L'Arrivée à l'ermitage* (The Arrival at the Hermitage), 225 × 175. Saint-Germain-en-Laye, Musée Départemental Maurice Denis.

to the besieged city (see fig. 152) and watching over it by night. In neither does she have a halo, and in the descriptive cartouches beneath the paintings she is named simply as 'Geneviève', whereas the descriptions of the 1870s had given her the title of saint. To what extent Puvis was operating in these two instances according to instruction, or adjusting the details of his work in response to his ideological antennae, is not known. But whereas Genevieve in the earlier decorations had been explicitly a saint – praying before a crucifix in one painting, being blessed by St Germain d'Auxerre and St Loup in the other – in the later paintings she registers instead as the benign aegis of Dark Ages Paris, Christian associations expunged. Whatever Puvis's own role in this, it is an example of the complex relationship between the religious and the secular at this period.

At times the ebb and flow between those two poles seems inconsistent and even unfathomable. How might one account for Lhermitte's posthumous portrait of the celebrated chemist Sainte-Claire-Deville (fig. 111)? Commissioned for the Ecole de Chimie in the new Sorbonne, the canvas represents the scientist as a contemporary hero. He is made salient by means both narrative and formal: his colleagues and students closely attend to his teaching, while his strongly lit head stands out against a darkened window. Sainte-Claire-Deville is presented as an authoritative modern figure. He has been rewarded with the Légion d'Honneur for his scientific discoveries and teaching; his reputation is based on intellectual merit rather than social position. As a scientist – man of logic, rigour, clarity of mind – he stands against superstition. In all this, one might say, Sainte-Claire-Deville appears an ideal Republican role model, commanding an important social role based on intelligence and dissemination of knowledge. (Perhaps he had been a devout Catholic.) On the other hand, Lhermitte's composition has a familiar ring to it. The central figure gesturing frankly as he talks about what he has

111　Léon Lhermitte, *Henri-Etienne Sainte-Claire-Deville*, 1890, oil on canvas, 180 × 280. Paris, Ecole de Chimie.

before him on the table, the attentive male audience, one in the background somewhat isolated: is this not a Last Supper, secularised and shifted from the upper room into the modern laboratory? Given the frequency of Lhermitte's treatment of religious themes, both scenes of regular village observance and more imaginary pictures, this transformation can hardly be taken as disrespectful, let alone blasphemous. Yet it can scarcely have been disingenuous, so transparent is the Last Supper design. Perhaps Lhermitte, whose Republican credentials seem to have been as sound as his Christian, was trying to effect some kind of equivalence between scientific and religious revelation. Lhermitte did not insist upon the conjunction (there are thirteen onlookers, not twelve), but the relationship between the apparently naturalistic group portrait in a chemistry laboratory and the conventional Last Supper composition is too inbuilt to be accidental. However one reads the Sainte-Claire-Deville portrait, it seems to be the work of an artist finding a path through terrain bordering on both the secular and the religious.

With Charles Cottet one finds a slightly different pattern. Born in 1863, and so two decades younger than Lhermitte, Cottet grew up under the Third Republic. It was during the 1890s that his career blossomed, from modest founder member of the SNBA in 1890 and co-exhibitor with the Nabis at Le Barc de Boutteville's gallery in 1893, to the triumph of a gold medal at the 1900 Exposition Universelle. During the second half of the decade Cottet emerged as an artist of high ambition. Exhibiting Breton themes year on year under the rubric *Au pays de la mer* (In the Land of the Sea) he gave them a cumulative identity, at once ethnographical and epic. The most remarkable of these was the large triptych exhibited at the 1898 SBNA (fig. 112). In the central panel, *Le Repas d'adieux*, the men and women of a Breton fishing village gather for a final meal before the men go to sea. The figures are grouped in a ritualistic way, movement and gesture limited, lit by a central lamp. In harmony with the human expression, the colour is muted, only the mustardy table, red apples and a few blue or violet ribbons discreetly raising the sombre tone, as do the touching hands, quiet conversations and grave faces. The two side panels, *Ceux qui s'en vont* and *Celles qui restent*, are also placid, the men working calmly on their vessel, the women scanning the sea from the rocky shore. Both wings are lit by the meagre light of nature, and the triptych is bound together by the vast horizon of the ocean. In its evocation of the farewell meal, with its agonised anticipation of *adieu* and the loneliness of separation and longing for safe return, Cottet's

112 Charles Cottet, *Au Pays de la mer: les adieux* (In the Land of the Sea: The Farewells), 1898, oil on canvas in three sections: *Le Repas d'adieux* (The Farewell Meal), 176 × 237; *Ceux qui s'en vont* (The Men who go), 176 × 119; *Celles qui restent* (The Women who stay), 176 × 119. Paris, Musée d'Orsay.

triptych is one of the most moving paintings of the 1890s. It deals with states of mind, locked into a repeated cycle that can only be broken by death. The numbed faces set in ceaseless bereavement, as well as the grim eternity of the ocean, discomfort the spectator with a sense of the *longue durée* of grief and loss.

Is this a work locked into a dreary, fatal pattern of danger, drowning and the lingering pain of loss? Perhaps there is consolation as well as distress. Bénédite, an admirer of Cottet who had the triptych purchased by the state, noted in his review of the 1898 SNBA that the composition reminded him of a Last Supper.[48] That sacramental, ritualistic character is easy enough to make out, but its embeddedness in the architecture of the picture suggests that it was primary to the painting's emotional conception, not merely expedient. Cottet's *Au pays de la mer* canvases frequently chose religious subjects such as pardons and *veillées* over the dead, which could be taken as images of empathy with Breton Catholicism or as ethnographic records of Finisterre folkways. But with the grand triptych *Les Adieux* one is on more certain, and yet more suggestive, ground. Although no explicitly religious story or ritual is depicted, the tripartite format carries its traditional resonance of the altarpiece. Cottet had been educated in the 1870s at the Collège des Maristes at Thonon (Haute-Savoie).[49] The Marists, as their name suggests, particularly venerated the Virgin and trained their pupils in quiet self-examination, requiring part of each day to be spent in such exercises. This spiritual and intellectual formation seems to underpin the triptych. Its great themes are Marian: the acceptance of suffering, and the values of patience and passivity. It balances the roles of men and women; if the men risk more, pain lingers with the women. Just off-centre in the main panel, beneath the light emanating from a lamp which hovers over the table like the dove of the Holy Spirit, a man makes to leave, placing his hand gently on the arm of a woman in a trance of anxiety whom one might take to be his mother. The right-hand panel could almost represent the women at the foot of the Cross, while the left could be compared to images of the disciples asleep in the Garden of Olives. Both panels deal with waiting and suffering. The overall stillness of *Les adieux* requires the spectator to be still, to reflect on the relationships in the painting, to meditate on passing

113 Jean Geoffroy, *La Consultation* (The Consultation), 253 × 304, central panel from *L'Oeuvre de la Goutte du Lait au dispensaire de Belleville* (The Drop of Milk Project at the Belleville Dispensary), 1903, oil on canvas in three sections. Paris, Musée de l'Assistance Publique.

time, the insecurity of earthly existence, the immensity and eternity of the sea and the comfort of light. The triptych is not an overtly religious painting. Indeed, although it may have suggested a Last Supper to Bénédite, it cannot represent one, as there were no women present. But the triptych uses the subject of the Breton fishing community to evoke powerful emotions about the great questions of human existence, in which Christian belief – if not explicitly represented – resonates profoundly.

Another triptych requires to be approached in a different way. This is *L'Oeuvre de la Goutte de Lait au dispensaire de Belleville*), exhibited by Jean Geoffroy at the 1903 Salon (fig. 113). Geoffroy had established his reputation as a painter of children in the 1890s and this ambitious painting was a climax of that work. The subject allied his skills in representing babies and toddlers with a particularly contemporary theme. An important aspect of the degeneration debate, as remarked before, was the virtual stagnation of the French population in the 1890s. Not only were insufficient babies being born to make the population grow in proportion to its Western European neighbours and in particular its rival Germany, but the death rate among the newborn was also troubling. Infant maladies, poor hygiene and nutrition, and inadequate health-care were all to blame. Dr Gaston Variot was a central, and somewhat controversial, figure in trying to ameliorate these circumstances. Initially trained as a military doctor, Variot, fired by patriotism, switched his specialism to childcare. His particular concern was the nurture of babies. This he insisted should be monitored with scientific rigour. To practise what he preached in his *Journal de clinique et de thérapeutique infantile*, founded in 1893, the previous year he had established a clinic, La Goutte de Lait, in working-class Belleville. There Variot developed the clinical procedures represented by Geoffroy in his triptych celebrating a decade's work. In the central panel the seated Variot and his colleagues consult with nursing mothers, who happily clutch plump offspring. In the left panel a mother presents her child to be weighed, a precautionary measure on which Variot insisted, and in the right another mother collects a bottle of the sterilised or concentrated milk that the doctor negotiated from companies such as the Société Gallia and Nestlé to ensure that the infants of working women were not deprived of nourishment.[50]

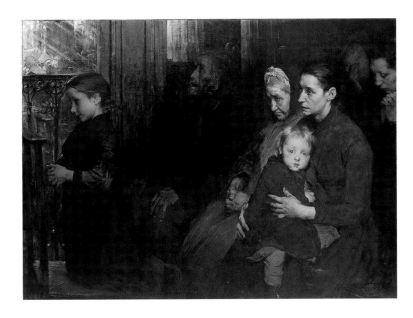

114 Jean Geoffroy,
Les Résignés
(The Resigned), 1901,
oil on canvas,
110 × 150. Paris,
Musée d'Orsay.

Once again, this seems a work that operates in an ambiguous middle ground between the religious and the secular. Geoffroy's triptych, like Cottet's, accords with a conventional format of religious art and its central panel parallels representations of 'Suffer the little children to come unto me' (Luke 18 : 16). And yet it could be argued that the triptych was a functional device for showing the different aspects of Variot's practice. Indeed, the central scene – far from implying a Christ-like role for the doctor – suggests a different, even antagonistic, reading: the man of science not superstition, the egalitarian Republican working for social progress among the proletariat, the patriot building up the nation's future physical force. However, it is not known for certain whether Variot was *laïque*; the fact that one of his sons attended an ecclesiastical college might suggest not.[51] Nor is Geoffroy's position known. Paintings such as *Les Résignés* (fig. 114) – a group of working-class figures in church – might suggest one thing, while his appointment in 1893 as Membre de l'Imagerie Scolaire, a grouping under the presidency of the art historian Henri Havard and devoted to secular education, suggests another.[52] The lack of clear evidence in such cases necessitates cautious interpretation. But perhaps the very ambiguity of people's positions indicates an ambiguous cast of mind. After all, in the 1890s the majority of mature French men and women had undergone a Catholic education. Knowledge of the Bible and a general acknowledgement of Christian moral values were generic, even if church observance and a commitment to clerical interests in one's politics were not. The variously faceted nuances of interpretation I have been considering may have been calculated on the artists' part. It is more likely that they were arrived at by improvisation or instinct in a period when many were uncertain or uncomfortable about where they stood. If that was the perceived mood of the public, it might suit the painter to keep his images multi-valent.

<center>✻ ✻ ✻</center>

Images of Anti-Clericalism

Alongside such ambiguous attitudes, and going beyond mere indifference to the Church and Republicanism's ideological secularism, was the extreme of anti-clericalism. This form of reaction was as diverse across regions and classes as Catholicism itself, flourishing among the artisans and labourers of the large industrial cities, the peasants of the Massif Central and the disaffected bourgeoisie of particularly religious localities. Of course, for anti-clericals the Church made an easy target. Viewed over the long perspective of traditional resentments or from a progressive utilitarianism, the Church could still be seen to have excessive influence in both social and political spheres. In addition, anti-clericalism had a democratic character; all classes could subscribe to it, though it had particular appeal to *petits gens* in traditionally Catholic provinces who felt oppressed by the established hierarchies.[53] In such circumstances, anti-clericalism had obvious appeal to socialists and anarchists who wanted to replace or destroy existing social structures, but it also had its uses in mainstream politics. In a speech given in Château-Thierry (Aisne) in 1897, for example, Léon Bourgeois asserted that the lists of candidates designed to ensure a right-wing victory in the forthcoming elections would be drawn up in the Vatican. Such an extravagant claim of interference by the Catholic hierarchy was downright political posturing, an anti-clerical gambit calculated by a progressive Solidarist to put pressure on the perceived tolerance to the Church in the more conservative Méline government.[54]

Political in its intent, Bourgeois's slur took the exaggerated form of caricature. That was probably the primary means of articulating anti-clerical views in visual terms. Caricature operated at different levels in the hierarchy of images. The work of Jehan-Georges Vibert was celebrated for its high finish, sumptuous surfaces and anecdotal subjects. These little narratives made much of facial expression and gesture – Vibert was also a playwright – which could be contrived into a form of sophisticated pictorial lampooning. A pastel made in the early 1890s encapsulates this well: a sleek cardinal gazing into a mirror, smug-faced but too coy even to meet his own gaze, and musingly titled *Si j'étais le Pape* (fig. 115). How anti-clerical is such an image? Again, it is difficult to gauge. With such pictures Vibert poked fun at the peccadilloes of senior clergy – pomposity, gluttony, vanity, even anger at anti-clerical newspapers such as *L'Intransigeant* – but the caricature is humorous, not bitter. Vibert's political stance is unknown. Such pictures did, however, have considerable market success. The *feinmalerei* and the gentle, well-staged gibes sold well to wealthy, and assuredly Protestant, collectors in the United States, *Si j'étais le Pape* entering the collection of the Union League of Philadelphia in 1894.[55]

At the other end of the caricatural scale was imagery that was sharper, even vicious in its anti-clericalism. Hermann-Paul, son of a doctor and staunch Dreyfusard, was an illustrator whose works typified a more acutely radical imagery in the 1890s. His lithograph *La Sortie du séminaire* has a more cutting edge than Vibert's pictures.

115 Jehan-Georges Vibert, *Si j'étais le Pape* (If I were Pope), *c.*1890–4, pastel, 48.9 × 54.6. Philadelphia, the Union League.

116 Hermann-Paul, *La Sortie du séminaire* (Leaving the Seminary), *c.*1895, colour lithograph, 31.5 × 23. New Brunswick, Jane Voorhees Zimmerli Art Museum, Rutgers, The State University of New Jersey, Herbert Littman Purchase Fund.

117 Auguste Roubille, *L'Education chrétienne*, 1899, lithograph, 57 × 45.7. Private collection.

The moral value of its gossiping priests, effete and malevolent, is hinted by the notice on the wall behind: *Défense de uriner* (fig. 116). Of course, in contrast to Vibert's elaborate techniques Hermann-Paul was here using a graphic medium more conventional for caricature, with its simplifications, exaggerations and implicitly disposable nature. But his colour lithograph was not exactly as ephemeral as a line cartoon in a newspaper. It involved *crachis*, trial proofs, several printings. His print was, in other words, a collectable item and would have been intended for amateurs who found merit in both its craftsmanship and its anti-clerical imagery. So would a book of satirical verse like Laurent Tailhade's *Au Pays du mufle* (In the Land of the Lout), published in 1894. Tailhade was a poet of anarchist sympathies who fancied himself as a modern Juvenal, pouring scorn on the corruption of the contemporary world. The clergy were, again, an obvious target and a poem such as 'Vendredi Saint' (Good Friday) poked malicious fun at digestive disasters brought on by fasting and at *abbés* ogling schoolboys outside Saint-Sulpice. The poem was illustrated with a drawing by Hermann-Paul representing a priest with two boys.[56] What Tailhade and Hermann-Paul implied Auguste Roubille represented forthrightly in *L'Education chrétienne*, a lithograph published by the anarchist periodical *Les Temps nouveaux* in 1899, where a priest abuses a boy while glancing guiltily at an image of the Virgin (fig. 117). This kind of imagery was unpleasant and was intended to be. It was preaching to the anti-clerical converted: anarchists, radical intellectuals, a young public brought up under the *République laïque*.

118 Jean-Paul Laurens,
*Saint Jean Chrysostome et
l'Impératrice Eudoxie*
(St John Chrysosthome and
the Empress Eudoxia), 1893,
oil on canvas, 127 × 160.
Toulouse, Musée des
Augustins.

Anti-clericalism had a strident voice not only in the scabrous sub-cultures of the pic-
torial hierarchy but also had a hearing at the highest level. At the Salons of the 1890s
visitors were faced by paintings intended to raise, or even force, the issue of the role of
the clergy. Jean-Paul Laurens, one of France's leading history painters and art school
professors, was a dedicated Republican whose career had flourished for two decades
under a regime which he had served well, notably by executing mural decorations for
the Panthéon and Hôtel de Ville which promoted the state's ideology. Laurens's Repub-
licanism encompassed anti-clericalism. He believed in God but opposed the doctrinal
authoritarianism of the Church, a position probably shared by many. The doctrine of
Papal Infallibility particularly offended him, though he was tolerant enough to admire
Archbishop Darboy for having disagreed with it.[57] At the 1894 SAF Laurens exhibited
Saint Jean Chrysostome et l'Impératrice Eudoxie (fig. 118). Purchased by the state and
assigned to the museum in Laurens's native city of Toulouse, the painting had official
approval, though many art critics found the composition excessively rhetorical and
severe.[58] But for critics writing for a readership inclined to anti-clericalism, Laurens's
image of the fourth-century saint lambasting the Byzantine empress could easily be
interpreted to suit their prejudices. As Félix Fénéon put it in the backstreet parlance
used by the anarchist *Le Père Peinard*: 'What's he going on about, the little rat? At least,
back then, she didn't shit on the proles.'[59] The same sentiment, expressed in civil service
tones, might well have crossed the minds of the functionaries at the Ministre des Beaux-
Arts who recommended its purchase and dispatch to Toulouse. The south-western city
had a strongly Republican tradition and had been swift to secularise municipal educa-
tion in the 1870s. What better destination for a canvas which, with the authority of a
history painting, could be interpreted as criticising the dangers of clerical dogmatism
interfering in the affairs of state?

If Laurens questioned the function of the clergy through the prism of the historical
past, other artists chose to do so by representing the immediate present. This was Jules-

119 Jules-Gustave Besson, *Devant Saint-Sulpice* (In Front of St Sulpice), 1896, oil on canvas, 198 × 151. Remiremont, Musée Municipal Charles de Bruyères.

Gustave Besson's tactic in the canvas he exhibited at the 1896 SAF, *Devant Saint-Sulpice* (fig. 119). Besson's painting is emphatically naturalistic, its devices of passing movement and obscured faces contrived to give a sense of a moment registered in the to and fro of the square outside one of Paris's great churches. Indeed, this square, as many of his viewers would have known, was flanked by a major seminary and the shops selling the vulgar religious imagery that Denis disliked. Writing in the *Gazette des beaux-arts* Paul Adam, ex-Boulangist and experimental novelist, described the picture. 'On a bench next to the church of Saint-Sulpice, M. Besson groups . . . the embrace of poor lovers seen from behind with a balding woman hallucinating with hunger who breast-feeds a baby clasped against her rags. Past the church goes a procession of surpliced seminarists incapable of offering the consolatory certitude of heaven.'[60] Adam's tone is only discreetly judgemental, but he evidently read the painting as registering a gulf between the Church and the poor, and this seems to have been the way that Besson had composed it. Besson's representation of the procession of priests in his Salon painting is by no means as condemnatory as Hermann-Paul's in his caricature. But both, in their different media, were using modern forms of visual communication – the naturalist painting and the caricatural lithograph – to score points off the Church, to accuse it of being self-interested and neglectful of its obligations to its flock. The roles of the Church in the Republic and of Catholicism in the contemporary world were matters of the moment. So too was anticlericalism in its various forms. As part of the texture of modernity, it was up to artists to find them modern visual form.

* * *

Modernity and the Picturing of Religion

The rivals or antagonists of Catholicism in the 1890s were various. Among them one should count intellectual developments as well as political opponents. The publication of Darwin's *Origin of Species* in 1859, with a French translation in 1862, questioned the nature of the creation of humankind and with it the veracity of the Old Testament. Ernest Renan's *La Vie de Jésus*, which appeared in 1863, emphasised the historical Jesus, a man who lived in first-century Roman-occupied Palestine, rather than Christ, the Son of God, who wrought miracles. By insisting on scientific and historical evidence, both books put pressure on mere faith. Two generations on, in the 1890s, such ideas had spread beyond the restricted scope of scholarly enquiry to be current in mainstream thinking. To these could be added the political forces already considered: the momentum of Republicanism, using its parliamentary majorities to erode the Church's traditional areas of influence, and, in the offing, socialism, with a more dangerous attitude to hierarchical structures. All these pressures were modern. They had been generated by the post-Enlightenment drive for intellectual, ideological and social progress. By the end of the nineteenth century it was clear to many Catholics that to face these forces the Church had to adapt, to address modernity itself. Once again, Leo XIII was to the fore in recognising the need for change. His encyclical of 15 May 1891, *Rerum novarum*, went beyond condemnation of the socialist enemy, urging Catholics towards greater social responsibility, encouraging better relations between employers and workers and promoting the formation of Christian associations. The pope's call to action, already adumbrated in the Social Catholicism of de Mun, Frédéric Le Play and others, generated results. Trade unions, newspapers, co-operatives and rural banks sprang up to sustain Catholic interests, to the extent that socialists like Jaurès and Gérault-Richard felt threatened by the reaction.[61] With this new social impetus developing in parallel to the political initiative of the Ralliement, Catholicism was coming to terms with the modern. This process manifested itself in various ways in visual culture.

One of these was in an increased concern for historical accuracy. Since earlier in the century French artists had travelled to the Middle East in search of material to make their representations of biblical scenes more precise. Horace Vernet had first visited Algeria in 1833 and in 1839 had taken daguerreotypes in Jerusalem, while Jean-Léon Gérôme, still painting detailed biblical canvases in the 1890s, had made his first trip to Egypt in 1856. This process was in part a response to a growing anxiety that the 'modernising' progress of colonialism would eventually diminish the resonance of the region's historical past. It was accelerated both by the impact of Renan's book and also by nineteenth-century positivism's fascination with material fact, the very culture that had produced Renan's original enquiry. By the end of the century naturalism was entrenched as the dominant form of representation, the public expecting to be instructed by images that were exact and informative. Illustrated magazines, with precise drawings, such as *La Nature* and *L'Illustration*, proliferated and the photograph, itself commonly understood to be the epitome of accuracy, increasingly began to be used as the visual component in books and periodicals. If the Church was to reassure the faithful and counter its rivals, their 'scientific' precision would have to be turned against them.

In 1882 the Dominican Matthieu Lecomte had proposed establishing a school for biblical studies in Jerusalem. Papal approbation was soon granted and in 1890 the Ecole Biblique was opened, accompanied by its own publication, *La Revue biblique*.[62] The

120 Etienne Dinet, *Golgotha*, 1891, oil on canvas, 158 × 193. Nice, Musée des Beaux-Arts Jules Chéret.

school's aim was to foster the study of the Bible on site, within the geographical environs and surviving historical remains of the biblical world, and using new and systematic methods such as archaeology. The Ecole Biblique proved a stimulus to artists with analogous goals. Thus Joseph Aubert, engaged in his decorations for Notre-Dame-des-Champs, paid a useful visit there in 1892, accompanied by another Dominican, Antoine Sertillanges.[63] In such a climate, the illusion of actuality became an increasingly admired quality in religious painting. At the SNBA in 1892 Etienne Dinet exhibited *Golgotha*, typical of this trend (fig. 120). The painting employs many of the devices which naturalist painters of modern life, and indeed Gérôme, had been using for two decades, adapting them to a climactic moment in the New Testament. As Christ dies on the Cross, a storm breaks and an earthquake strikes (Matthew 27 : 51). Dinet evoked the tragic drama of the moment by representing the terrified crowd fleeing down the hill, leaving only the three Maries, St John and Joseph of Arimathea, with some hard-bitten Roman soldiers, still beneath the Cross. Dinet's removal of the key incident to an upper margin, his central void, cut-off figures breaking into the spectator's space and detailed observation of flying hats and swirling dust all add to the vivid immediacy of his painting. The artist's precise treatment of the arid terrain and livid lighting appeared to at least one critic as too alien and African.[64]

Nowhere was the search for scrupulous accuracy pursued more obsessively, and rewarded with more public impact, than in James Tissot's project to illustrate the life of Christ. Following a highly successful twenty-five-year career as a *peintre mondain* in Paris and London, Tissot had been reconfirmed in his Catholicism by a vision he had in Saint-Sulpice in 1885. Subsequently he made two trips to Palestine in 1886 and 1889, painstakingly gathering material for his illustrations. At the 1894 SNBA Tissot was given special exhibition space on the ground floor of the galleries on the Champ-de-Mars and a separate catalogue for the 423 works he showed.[65] The secretary of the SNBA, charged with the hanging arrangements, was Guillaume Dubufe, a devout Catholic who may well have calculated that such a privileged display was propitious in the new climate of *Rerum novarum* and the Ralliement. Two years later, in 1896, the book was published in two volumes by A. Mame et fils of Tours, with an English translation appearing the following year.[66] Lavishly illustrated by the standards of the day with 365 gouache drawings reproduced in fine colour and many monochrome drawings, the book was not simply an illustrated New Testament (fig. 121). Texts from the Gospels were extensively quoted, sometimes giving different Evangelists' accounts of the same incident, but these were interspersed with exegesis by Tissot himself, citing other authorities, describing specific locations and customs, and even criticising past painters who – working from imagination rather than observation and research – failed to get 'facts' right (Tintoretto is one rather unfairly admonished[67]). While Tissot's watercolours concentrated on scenes from the New Testament, his line drawings provided a wider material context with their depictions of archaeological specimens such as sarcophagi and Jewish ornaments and even later Islamic architecture. In his introduction, the artist insisted that his objective in this enormous project was to restore 'the evidence of history' and to respect 'topographical accuracy' in his illustrations to the Gospel stories.[68] But while appealing to the modern fascination with the 'scientific' there was a reactionary cast to his work. Among the authorities acknowledged in the introduction Renan is not to be found. Indeed, the very title of Tissot's volumes – *La Vie de Notre-Seigneur Jésus Christ* – seems to have been deliberately chosen as a *Catholique avant tout* counter-blast to the ostensible atheism of Renan's own title, the minimal *La Vie de Jésus*. Tissot's thanks extended to two Dominicans, *père* Didon and *père* Ollivier, whose instincts were hardly modernising or *ralliés*. Didon I have already introduced, urging an anti-Dreyfusard coup against the Republic. For his part *père* Ollivier , preaching a sermon at Notre-Dame in 1897 at the funeral of the 117 victims of the Bazar du Charité fire (the first time the president of the Republic and senior colleagues had attended a religious ceremony in a quarter of a century), would fulminate that as men had put science before God, so God had used science – in the form of an electrical short-circuit – against men.[69] It was another Dominican, *père* Sertillanges, who welcomed the two Mame volumes in *Le Correspondant* on their publication in 1896, praising them for their factual reliability.[70] For all the apparent certitudes of Tissot's books, they emerged into a world in which the modernising and the reactionary were in intricate dialogue.

Tissot's *La Vie de Notre-Seigneur Jésus Christ* was an act of private faith deliberately designed to address a modern debate. By giving previews of the work in progress to figures such as Ernest Meissonier and Edmond de Goncourt Tissot was marshalling support among the senior echelons of the Paris culturati. The exhibition at the 1894 SNBA presented his work to a far larger public than a dealer's show could have done, while alliance with Dubufe's organisation ensured its chic. Mame's employment of the

latest colour printing presented the 'facts' of Christ's life twenty centuries ago with the immediacy of modern technology. The whole project, then, was orchestrated to bring the story of the New Testament into the 1890s in the most arresting and contemporary way. But behind that mask of modernity, I have suggested, Tissot's *La Vie de Notre-Seigneur Jésus Christ* disguised a more conservative than contemporaneous Catholicism. The perceived character of the work, and the levels of its acceptability to its various publics, can be detected in the reviews of the 1894 exhibition, in which positions about ideology and faith were often voiced in code or undertone. Marcel Schwob, himself Jewish and writing for the *Le Phare de la Loire*, briefly accounted for Tissot's project as 'the story of Jesus patiently reconstituted and placed in its milieu, minutely studied throughout a decade's work.'[71] Schwob's telegraphic tone made the associations that his Republican readership would have immediately understood: Renan, naturalism, historical interest. As an Inspecteur des Beaux-Arts, Georges Lafenestre instinctively took a civil service line. His review in *La Revue des deux mondes* pointed out that Tissot favoured moments such as Christ's childhood, the parables and Holy Week, because of their familiarity and humanity. That was a similar emphasis, Lafenestre added, to Renan's. He acknowledged that Tissot's work was based on faith and should be treated with respect, whatever might be the spectator's attitude to 'des légendes religieuses'.[72] Whether in daily journalism or a more elevated review of record, the writer of Republican bent was inclined to add to his opinions an element of distance, a tone of disparagement far from overt anti-clericalism but laced with a dash of Renan's scepticism. If Republican opinion was by no means entirely dismissive of Tissot's project, Catholic opinion was no more unanimously in favour. *La Revue Thomiste* had enthusiastically proclaimed that, led by Tissot's example, painters should no longer paint the imagined but only the 'true' Christ. This view was derided by the neo-Catholic *Le Coeur*, which considered that the artist had done nothing more than produce an illustrated Baedeker of the Holy Land. That, it objected, was typical of modern rationalism and the public's slavish craving for exactitude: *le document est tout!* According to *Le Coeur*, such materialism was of Semitic origin, at odds with the idealism of the Aryan-Hellenic tradition which, in terms of religious painting, found glorious expression in the mystical work of Fra Angelico or Leonardo.[73] That Tissot's *La Vie de Notre-Seigneur Jésus Christ* could provoke such widely divergent reactions as the gently dismissive tolerance of *Le Phare de la Loire* and the flagrantly anti-Semitic and élitist rhetoric of *Le Coeur* is a trenchant reminder of the uncomfortable tensions generated by religion during the 1890s.

Perhaps the strangest illustration to *La Vie de Notre-Seigneur Jésus Christ* is the gouache in which Tissot imagined, as its caption says, 'Ce que Notre Seigneur a vu de la Croix' (fig. 123). The scene is dramatically foreshortened, so the angle of vision looks down from a position about six metres above the ground. Immediately below are Christ's bloody feet and the praying Magdalene. Further out are the stricken Holy Women and St John, and beyond them to the right are Pharisees and rabbis most of whose expressions mock but some of whom appear troubled. On the other side are the Roman soldiers, mostly bored by yet another death, though the face of the sternly positioned centurion reveals a conscience beginning to wake to revelation. This crowd of varied people and reactions is spread out as if Christ had lifted his head to survey them. The image strives for extreme naturalism: what it is like to look directly down from a height, who was there, how we know or can reliably construe how they would have

121 James Tissot, *Le Jeune Homme riche qui s'en allait tout triste* (The Rich Young Man who went away sorrowful, Matthew 19:22), *c.*1890–4, gouache, 12.5 × 18.7. The Brooklyn Museum of Art. Purchased by public subscription.

122 James Tissot, *L'Annonciation* (The Annunciation, Luke 1:26–38), *c.*1890–4, gouache, 16 × 21.5. The Brooklyn Museum of Art. Purchased by public subscription.

123 James Tissot, *Ce que Notre Seigneur a vu de la Croix* (What our Saviour saw from the Cross), *c.*1890–4, 25.2 × 22.9. Brooklyn Museum of Art. Purchased by public subscription.

reacted. It was the very naturalism of the crucifixion scenes that Goncourt, visiting Tissot's studio in February 1890 in company with Alphonse Daudet and his wife, found moving.[74] But for all Tissot's apparent exactitude, the image was entirely contrived. In one glance it would be impossible to see the person immediately below one and those

further away, impossible to take in so much detail at once. What the gouache represents, of course, is not what Christ actually saw but what Tissot wanted to believe, and make his public believe, that Christ saw. Tissot's illustrations necessarily included scenes with fantastic elements, such as the Annunciation (fig. 122). To a dedicated naturalist like Goncourt, these were far less interesting. *Ce que Notre Seigneur a vu de la Croix* is a curiously hybrid image: at once insistent in its actuality and entirely imaginary. Goncourt had first heard of Tissot's project in December 1889, from Charles Yriarte (like Lafenestre, an Inspecteur des Beaux-Arts), who had already seen the work in train. The novelist had written in his journal that the illustrations had been executed in 'a state of mystical hallucination', following Tissot's own gloss on his creative process. For in the introduction to the two volumes on their publication in 1896 the artist explained how by following the very paths Christ had trodden 'hyperaesthesia' had intuitively brought such images to his mind. Tissot's interpretation was complex and tactical. Exactitude made his work modern because it was in tune with the dominant naturalism of late nineteenth-century culture. Because it was legible, and appealed to the lowbrow taste that *Le Coeur* derided, it served the Church's strategy of outreach and modernisation. No wonder the book was praised for its actuality in *Le Correspondant* by *père* Sertillanges.[75] The more mystical and miraculous aspects of the New Testament, of course, required Tissot to transgress the limits of naturalism. But fantastic elements such as angels and visions were woven seamlessly into his work by his naturalistic representation, and justified intellectually by using the terminology of suggestion associated with modern psychology. Nevertheless, for all these modern gambits, Tissot's project was shot through with contradictions. Support from a Dominican was equivocal, given the reactionary utterances from others in the order. Naturalism, although the aesthetic on which Tissot had based his whole career, was by the 1890s very much the visual language of the Republic, and to use it could be seen less as fighting the forces of the *laïque* on their own ground as rank capitulation. *Le Coeur* in particular damned the clergy's support of Tissot's naturalism as a surrender of principle, a weakness to a modern contagion.[76]

If 'scientific' exactitude was one means by which the Church tried to reassert the importance of faith in the modern world, another was by reinforcing the notion among the faithful that Christ's teachings continued to have a daily significance, even in the hurly-burly of the late nineteenth-century world. The practical Social Catholicism of Albert de Mun and others, with its organisation of Catholic banks and unions, was an articulation of this, given new momentum in the 1890s by *Rerum novarum*. One might also see a phenomenon in the decade's visual culture in the same light. The decade saw an extraordinary wave of works that sought to represent Christ in the modern world. These paintings were highly varied, and the fact that this imagery drew in painters of diverse style, ideology and – in all probability – faith reminds one how live an attraction religious painting was for the ambitious artist during the 1890s. The Church had often called on the evocative power of the visual to support its new initiatives in the past. The emotional impact and physical immediacy of Counter-Reformation art is the most salient example. Albeit on a smaller scale, artists' efforts during the 1890s to picture biblical revelation in the modern world might be seen in a similar light.

One of the earliest of such paintings to make a significant impact on the consciousness of the Parisian Salon-goer did so because of its apparently outrageous treatment of an incident in the New Testament. Jean Béraud's *La Madeleine chez le Pharisien* (The Magdalene at the House of the Pharisee) attracted large crowds at the 1891 SNBA

124 Jean Béraud, *La Madeleine chez le Pharisien* (The Magdalene at the House of the Pharisee), 1891, oil on canvas, oval, 95.5 × 127.5. Paris, Musée d'Orsay.

(fig. 124). The artist, already celebrated for his scenes of everyday, and often chic, Parisian life, had taken the story of Christ explaining to Simon the Pharisee why he forgave the penitent prostitute (Luke 7 : 37–50), but set it in a contemporary gentleman's club. The expensively coutured Magdalene, despite her face being hidden, was widely rumoured to have been posed by the courtesan Liane de Pougy, while the model for Christ was the journalist Albert Duc-Quercy, an anti-clerical socialist who wrote for *Le Cri du peuple*.[77] In the middle of the gentlemen/Pharisees, few of them sympathetically characterised and several actually recognisable, was seated the portly Renan himself. This highly detailed and somewhat caricatural transcription had, as more than one critic put it, effectively 'Parisianised' the biblical account.[78] For all its public impact as a sensationalising *tableau-clef*, Béraud's painting won few plaudits as a work of art. Periodicals as different as the establishment *Revue des deux mondes* and the avant-garde *Revue indépendante* dismissed the picture as a boulevardier's prank, though Lafenestre, writing in the former, could not resist an anti-Semitic smear in his description of Béraud's onlookers.[79] The *Gazette des beaux-arts* condemned it as in bad taste, while stopping short of speculation about the painter's own religious views.[80] These are, as is often the case, difficult to verify, but the fact that in 1880 Béraud had contributed to the Comité de Souscription Artistique au Profit des Écoles Chrétiennes provides some evidence of his Catholicism.[81] That the painting is, to a degree, caricatural is clear enough from the blasé, combative and even downright lecherous expressions that contemporaries noticed.

125 Léon Lhermitte, *L'Ami des humbles* (The Friend of the Humble), 1892, oil on canvas, 155 × 220. Boston, Museum of Fine Arts. Gift of J. Randolph Coolidge.

But that could be a creative extrapolation perfectly consistent with the tone of St Luke's account and far from the tastelessness, almost the blasphemy, of which Béraud was accused. Indeed, the Gospel story of the Magdalene washing Christ's feet elevates moral redemption over material sacrifice. In that sense, the painting promotes faith over materialism, Christ over Renan.[82] Béraud brought this out pictorially, Renan's napkin white against black to draw attention to his rattled expression, Christ's expansive white-sleeved gesture confidently explaining his doctrine of forgiveness.

The SNBA the following year saw two, notably different, treatments of the supper at Emmaus (Luke 24:28–32) by Lhermitte and Jacques-Emile Blanche (figs 125, 126). Although both deployed life-size figures for scenes of Christ in the modern world, the paintings could scarcely have been more different. Lhermitte's was a relatively seamless adaptation of his typical peasant interiors – with their strongly drawn staffage, drab tones and emphatic lighting – to a religious subject. The one-to-one scale of the figures makes an immediate impact on the spectator, drawing one's instant attention. The sense of surprise, even to the point of fear, is conveyed by the bearded man's shocked gesture, while his companion at the end of the table is rooted to the spot with astonishment as he recognises Christ facing him. The woman and boy, on the other hand, simply do not

notice, involved as they are in a normal human exchange. A soft light emanates from behind the figure of Christ. This device of placing Christ's face in *contre-jour* let Lhermitte off a tricky artistic hook – that of trying to find naturalistic means of conveying the revelation of Christ – while enabling him to use light to suggest a moral dimension: the illumination of the two pilgrims as the light hits their faces. Even a critic who was generally as unsympathetic to this new current in religious painting as Lafenestre could recognise the *noblesse morale* of Lhermitte's lighting effects, while as an art historian he could contentedly place the Emmaus story as an expedient for showing Christ in a contemporary setting in a line of descent from Titian and Rembrandt.[83]

Lhermitte's version of the supper at Emmaus subject made its claim as a naturalist extension of a traditional theme; Blanche's painting could hardly have been more contrasting. Indeed, it was far different from the suave portraits with which he himself had made his reputation over the last decade. *L'Hôte*, as it is called, oscillates between paradoxes. Ostensibly naturalistic in its modern setting and detailed treatment of surfaces, the painting is quasi-symmetrical and ritualistic, centring on the hieratic gesture of blessing made by the Christ figure, posed by Louis Anquetin. Despite this moment of spiritual intensity, some of the figures seem merely curious while others, notably the standing

126 Jacques-Emile Blanche, *L'Hôte* (The Host), 1891–2, oil on canvas, 220 × 290. Rouen, Musée des Beaux-Arts.

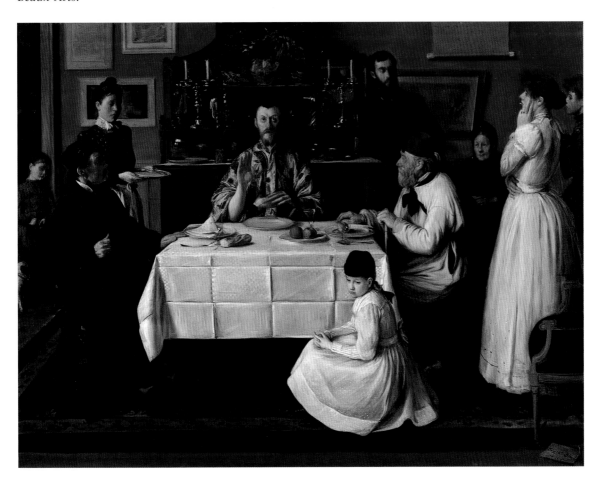

figure of the writer Edouard Dujardin, appear disconnected. The subject conventionally involves peasant figures but Blanche merely flanked his Christ with a neighbourhood artisan and labourer, setting the scene in his own *haut-bourgeois* interior with its Japanese *kakemonos* and chic Maples sideboard.[84] Although the two workers evince some sense of being taken aback – though not the startled demeanour of Lhermitte's men – this is Blanche's only conventional bow to the Emmaus subject. In the end *L'Hôte*, with its psychological disjunctions and pictorial non-sequiturs – is difficult to interpret. Lafenestre could only understand it as a pretext for studies of different modern types.[85] What might seem like a rather half-hearted piece of criticism may well be on the right track. There is no reason to doubt Blanche's sincerity in painting *L'Hôte*; a young painter with an emergent reputation would hardly exhibit such a large painting as a jest. Blanche explained in his memoirs that he decorated Christ's jacket with the motifs of the fish and omega, traditional Christian motifs.[86] He was ambitious in wanting to compete with his peers in painting the up-to-the-minute subject of Christ in the modern world, then, but recast it in highly personal terms. Not for the cultivated and well-connected Blanche the conventional peasant setting, but rather the elegant dining room. Not for the son of a highly regarded psychiatrist a concentrated scene of narrative unity, but rather a tableau of psychologically disjointed responses, each of its own inner validity. A strange atmosphere emanates from *L'Hôte*, carefully contrived to craft a painting that matched the modern fascination with Christ in a contemporary setting with a specifically modern psychology. Small wonder that Blanche made no effort to repeat the experimental formula and that he kept *L'Hôte* all his life.

The representation of Christ in the modern world continued throughout the decade. Lhermitte, for example, exhibited a pastel of the Samaritan woman at the well (John 4 : 7–42) at the 1898 Société des Pastellistes and another version of the Supper at Emmaus in 1905.[87] Painters among the avant-garde were tempted as well, Ker-Xavier Roussel treating the theme of 'Suffer the little children to come unto me' (Luke 18: 16) in the mid-1890s.[88] When Denis decided in 1895 to develop his career beyond the confines of the avant-garde exhibitions by showing at the SNBA he presented himself as a Catholic artist, submitting thirty-two illustrations to *The Imitation of Christ* and two paintings, a *Visitation* and *Les Pélerins d'Emmaüs* (fig. 127). Both canvases were not only set in the modern world but were also emphatically radical in style. Denis, as seen, had been painting such subjects over the previous two years, and had shown a small version of the Emmaus painting at the Indépendants in 1894. But the version he exhibited at the 1895 SNBA was as large as Lhermitte and Blanche's paintings of 1892; it was an aesthetic and ideological manifesto picture. Although substantial in size, *Les Pélerins* is not an overtly demonstrative canvas. The gestures are restrained and the colour subdued. The roughly symmetrical design is held together by deep browns and aubergines, the far landscape a harmony of ox-blood red and buttery yellow. Typically, Denis used natural elements as pictorial equivalents of his religious beliefs. After autumn and winter, spring comes; Christ was crucified but has risen to sup with the pilgrims at Emmaus. Behind Christ's head a yellow path curves into the distance, a visual metaphor for his words reaching out into the world. Even the simple, flat facture that Denis used functions in terms of spiritual meaning, as a denial of materialism. That was also a means of differentiating his work from the naturalist tactility of Lhermitte or Blanche, of staking a claim to a style of greater spiritual purity, an artistic gambit to which I shall return.

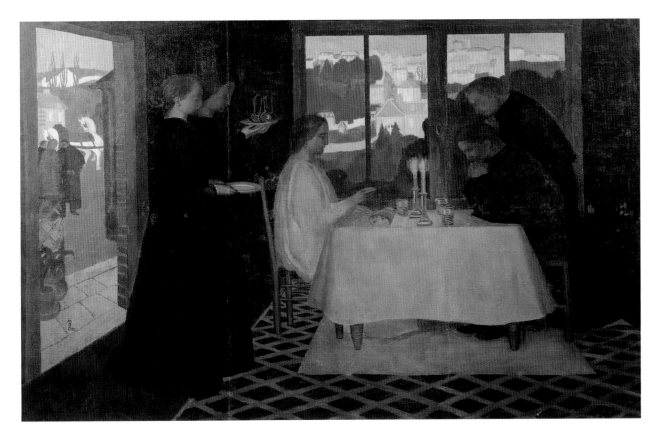

127 Maurice Denis, *Les Pélérins d'Emmaüs* (The Pilgrims of Emmaus), 1895, oil on canvas, 177 × 278. Saint-Germain-en-Laye, Musée Départemental du Prieuré.

As the decade drew on, artists seeking to modernise biblical stories increasingly introduced what they perceived to be modern effects. These efforts to generate a heightened spiritual actuality met with disdain from leftist critics such as Geffroy, unsympathetic to 'a Christ over here emerging from rays of electric light, another over there projecting violet flames.'[89] The most ambitious of such paintings was Dagnan-Bouveret's *Le Christ et les disciples à Emmaüs*, exhibited at the SNBA in 1898 (fig. 128). Another large canvas with life-size figures, the scrupulous exactitude with which Dagnan realised his figures seems, to the modern eye, to jar with the bright yellow and lime green hues that emanate from behind Christ, though this was presumably the effect of supercharged naturalism for which he strove. In certain respects the painting is consciously 'modern': the daring chromatics of yellows and ultramarines, greens and violets, the nervous play of loose touches over more finished areas of paint. By contrast, the draughtsmanship is tightly academic, the composition hieratic and the inclusion of the artist's family on the right reminiscent of donor figures in an early Renaissance altarpiece, as contemporary critics observed. Dagnan was not prepared to go as far in his 'neo-traditionism' as Denis, with whose *Pélérins* of three years earlier his painting surely competed. Like Denis, Dagnan used the ritualism of symmetry, and included himself in the scene as a gauge of his piety, but he vaunted his academic credentials over Denis's conscious *naïvété* and opted for a flamboyantly illuminated frontality as a ploy to draw the spectator into the mystery he was trying to convey. Not all reviewers in 1898 were convinced he had

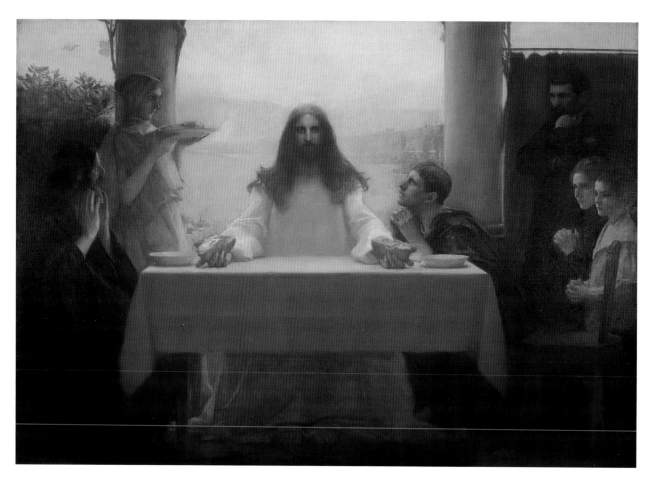

128 Pascal Dagnan-Bouveret, *Le Christ et les pélerins à Emmaüs* (Christ and the Pilgrims at Emmaus), 1896–7, oil on canvas, 198.1 × 280.7. Pittsburgh, Carnegie Museum of Art; Gift of Henry Clay Frick.

achieved this. Geffroy accused him of getting the biblical story wrong: if the risen Christ was so incandescent, how could his fellow walkers have failed to recognise him?[90] For others too, the lighting was overplayed. Bénédite found it artificial, while the painter Azar du Marest condemned it as so bizarre that it contradicted the humanity of the event.[91] And, inevitably, the political correctness of *laïque* Republicanism wafted through the painting's critical reception, the leftist Geffroy talking about the Emmaus 'legend' and the civil servant Bénédite hedging his comments with reference to 'the Christian myth'.[92]

Some explanation is needed for the profusion of images of Christ in the modern world during the 1890s. Competition between artists, as I have suggested, was a vital element. Indeed, the immediate initiative for such subjects was not exclusively French. The Munich-based painter Fritz von Uhde had made a substantial reputation with scenes of Christ among contemporary peasants since the mid-1880s, and the French state recognised his contribution by buying *Le Christ chez les paysans* from the *vente* Charles Ricada in Paris in 1893 (fig. 129).[93] (There was, nevertheless, some xenophobic grumbling about this in the French press, Lafenestre muttering ungraciously in the *Revue des deux mondes*: '*Flight into Egypt* or flight into Switzerland, it's much the same . . . They

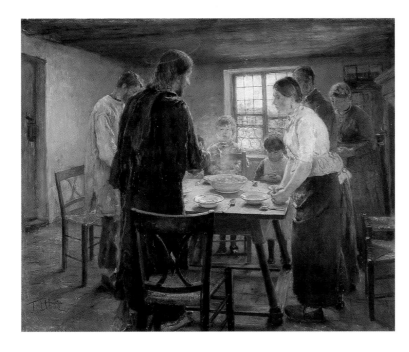

129 Fritz von Uhde, *Le Christ chez les paysans* (Christ in a Peasant Home), 1887–8, oil on canvas, 50 × 62. Paris, Musée d'Orsay.

are Bavarian pilgrims, the village they're looking for is Emmaüsdorf.'[94]) French painters sought to try their hand at the modern pictorialisation of the Christian message in competition with foreigners such as Uhde and the Finn Albert Edelfeldt, as well as with each other. But the fact that there was a drive to modernise religious painting in France suggests that artists were aware that the climate was propitious for work of this kind.

Representations of Christ in the modern world do not seem to have been specifically commissioned by the Church. In his review of Tissot's *La Vie de Notre-Seigneur Jésus Christ*, Sertillanges acknowledged the existence of this kind of imagery, but stated his preference for Tissot's solution of accurately recreating the historical world in which Christ had lived.[95] During the late 1890s Albert Besnard had painted murals, and his wife Charlotte made sculpture, to decorate the chapel of the Institut Cazin-Perrochaud at Berck-sur-Mer (Pas-de-Calais). The work was an expression of gratitude to the hospital for curing their son of tuberculosis.[96] Although the Franciscans who ran the Institut would no doubt have approved the scheme, the iconography of the paintings seems to have been Besnard's own. His scenes of birth, sickness and death all include the image of the crucified Christ, a more iconic image than the naturalistic one of Jesus as a fellow protagonist, to be sure, but nevertheless a reminder of the presence of Christ in our daily lives (fig. 130). Besnard did not exhibit these paintings at the SNBA. Perhaps he saw them as an entirely private project; perhaps he did not wish to be seen as contributing to a highly public pictorial debate about how to paint modern faith. His friend Geffroy, who had his own partis pris of course, later wrote that Besnard was not a religious man, and that his efforts in these paintings to bring out the socialism with which Geffroy was happy to credit the Gospels did not show the true artist.[97] When the Church was directly involved in a commission, it preferred more conventional decorations of the kind painted by Aubert. Rather, this 'new' iconography of Christ in the modern world seems to have been one driven forward by artists, contributing to a public debate as pious individuals or ambitious professionals.

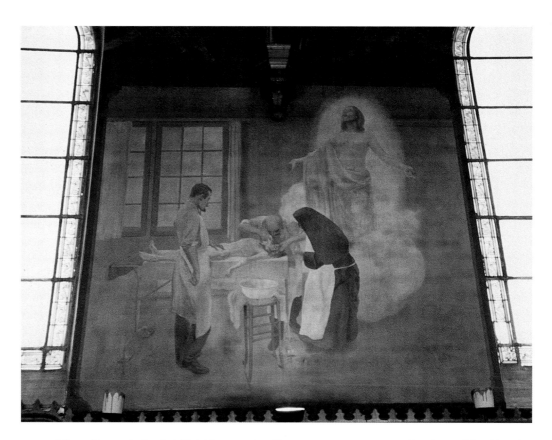

130 Albert Besnard, *La Foi* (Faith), *c.*1898, oil on canvas, 245 × 275. Berck-sur-Mer (Pas-de-Calais), Chapelle de l'Institut Cazin-Perrochaud.

That debate was a political one. Political language infiltrated critical writing about images of Christ in the modern world. P. N. Roinard, writing in *Essais d'art libre* in 1892, was quick to warn that the trend of recent painting 'to democratise the Nazarene' would ultimately result in work as tasteless as the imagery of St Sulpice.[98] Even the Republican Lafenestre saw 'the democratic realism' of this kind of religious painting as merely modish and detrimental to artistic quality.[99] What troubled such intellectuals was that religious painting seemed to be reaching out to a wide constituency through this new form. By giving Christ a contemporary presence it was rendering Christian art less élitist, less pious and more immediately relevant. While from their point of view this was jeopardising aesthetic values, from another it could be seen as working in parallel to the Ralliement. The conjunction of a new initiative by the Church to come to terms with the Republic, a softening of government attitudes and the new inflections in the vocabulary of religious painting must, therefore, be seen in relation to each other. It was in artists' interests to make these changed circumstances work for them. With his painting of the supper at Emmaus, one might argue that Lhermitte was positioning himself tactically. His naturalistic paintings of rural life had been purchased by the state for many years, and he had recently won official commissions for the Nouvelle Sorbonne and the Hôtel de Ville. While an accredited Republican painter, whose work the criticism of a state functionary like Lafenestre was inclined to favour, Lhermitte was also, it seems, a Catholic. In 1892 a painting in his acknowledged naturalist style which intro-

duced a religious theme into a contemporary subject could be seen as a move to respond to the Ralliement, to make a pictorial statement about the possibility of aligning Republican values – family, legibility, fact – with Catholic ones: the presence of Christ in our daily lives. It was surely no coincidence that Lhermitte did not give his picture the conventional biblical title but rather opted for the quasi-*laïque L'Ami des humbles*. By that means he dismantled the need for priestly exposition of a particular biblical text, rendering the story simply as a spiritualised extension of *égalité*. If the painting was intended to play to the Ralliement gallery, it almost worked. The state wanted to purchase it, a gesture that would have brought a religious painting by a leading Republican artist into the national collections. Unfortunately the painting had already been bought by a rich Bostonian to give to his city's museum.[100]

The Parochial and the Anti-Modern

The momentum behind the attempts to bring religious painting into line with the new social and political initiatives of the Church – whether by heightening the actuality of biblical scenes or representing Christ in modern settings – was generally favoured by artists working in naturalistic idioms. Naturalism was associated with the reassurance of scientific fact, with progress and with the democratic instincts of Republicanism. However, if this was the predominant trend, there was a robust counter-balance. A painting such as Denis's *Les Pélérins*, stylistically unusual as it may have been in the pictorial rivalry I have just described, was symptomatic of a reaction against the blatantly material. That there was a competitive, corrective edge to *Les Pélérins* can be deduced from the comments he made in his art criticism in 1892 concerning Béraud's second Christ in the modern world painting (location unknown), a Descent from the Cross set on the hill of Montmartre. While Denis could only notice approvingly that 'a breath of Christianity' was animating recent painting, and stopped short of uncharitably suspecting Béraud's motives, he thought it 'a malaise to hear the Gospel preached in slang'. Paint pictures to make Christ's teaching resonate in contemporary life, by all means, but do not rely on aesthetic vulgarity to convey eternal truths.[101] As we have seen with his decorations for Le Vésinet, Denis sought a religious art that, by apt and economical formal means of the kind typified by the Italian quattrocento, expressed Christian values with appropriate purity and humility (see fig. 107). It would, however, be imprudent to settle for a simple polarity between the naturalistic and the 'primitive' here. Religious art was as complex a field as the religious beliefs that it served. Aubert, to take just one example, occupied an entirely separate position (see fig. 106). While pitched at legibility, Aubert's work was idealised rather than naturalistic. For him, idealisation was necessary to convey religious meaning, while primitivism was deficient because it was an unresolved form of expression. When Aubert condemned the *snobisme* of those who supported *primitifs* he presumably targeted his criticism at the work of Denis and his ilk and at its upper-class collectors such as Denys Cochin, the painter Henri Lerolle and his brother-in-law the composer Chausson.[102]

Denis's position was one of subtle tension between the modern and the traditional. Published in October 1896, his 'Notes sur la peinture religieuse' argued against the current naturalism exemplified by Tissot's illustrations and praised the symmetry of Byzantine art and the emotional purity of Fra Angelico. But Denis was not simply reac-

131 Alexandre Séon, *Sâr Josephin Péladan*, 1892, oil on canvas, 132 × 80. Lyon, Musée des Beaux-Arts.

tionary. He stressed how Symbolism had stimulated sincerity of expression and how the way a picture is crafted is quintessential to the meaning it conveys.[103] In this he was consistent with his first published article, 'Le Définition du Néo-traditionnisme' of 1890, its title's neologism intended precisely to situate Denis's modernity in the dialogue between proven and experimental forms of expression.[104] That searching for a new equation in his art and thought was also symptomatic of the intellectual and political climate in which he matured. Twenty and ambitious in 1890, Denis developed intellectually and artistically during the debates around the Ralliement and *Rerum novarum*. A grudging Republican with monarchist sympathies, his conservatism articulated itself less by opposition to the state than by a determination to optimise what he saw as the most profound aesthetic values for the service of contemporary Catholicism.

Joséphin Péladan, the self-styled Sâr of the Société de la Rose+Croix, provides both parallels and contrasts with Denis. Son of a Catholic theologian, Péladan's extreme Catholicism had its first public manifestation in 1880 when he was arrested as a student in Nîmes (Gard) protesting against the expulsion of the Jesuits. Having made a minor reputation in Paris during the 1880s as an art critic and writer of decadent novels, Péladan relaunched the ancient Rosicrucian movement as a vehicle for his aesthetic, politics and self-aggrandisement (fig. 131). His aesthetic position was autocratically telegraphed in his *Salon de la Rose+Croix: Règle et monitoire*, which he published in 1891, summoning submissions to the society's first exhibition the following year.[105] The ambition was to promote idealism in art. His *Règle* thus specifically welcomed work that articulated Catholic dogma and that was allegorical, decorative or elaborate. Equally, he pronounced strictures on naturalistic art, from scenes of modern life though still life to military painting. The exhibition opened in March 1892 at the Galerie Durand-Ruel (whose owner was a Catholic Legitimist), with the financial backing of comte Antoine de la Rochefoucauld and music organised by Erik Satie.[106] The work on view was extraordinarily eclectic, varying from the medievalising synthetism of Charles Filiger, via the elaborate Christian and Wagnerian allegories of Vincent Darasse and Rochefoucauld himself, to the series of refined drawings by Alexandre Séon which related to Péladan's novels. These last dwelt on perverse subjects such as androgyny, Péladan's ostensible aim being to shame his readers back to a purer path by exposing them to vice. That aesthetic tactic did not convince the clerical authorities. At a Church congress held at Malines in June 1891 Péladan's writings were among those officially condemned for their profanity. This was grist to Péladan's self-promotional mill. Although an ultramontane Catholic, he despised the Church and especially the Ralliement. In the columns of *Le Figaro* in late 1891 he even went so far as to threaten Cardinal Lavigerie and Monseigneur Rampolla, the Vatican Secretary of State,

with excommunication. Inevitably, he detested the *République laïque*. One of the reasons why Denis had refused to show with Péladan's Rose+Croix in 1892 was that he was loyal to the Church.[107]

Péladan was ostentatious, refractory and even downright ridiculous. (He refused to fight a duel with Rodolphe Salis, proprietor of the Chat Noir cabaret, on the grounds that, as a mage, he would have an unfair advantage.) Nevertheless, he had impact. The first Salon de la Rose+Croix attracted a great deal of attention, the thousands of visitors a symptom of the insistent presence of religious issues in the public mind. Although the later shows tailed off in quality, Péladan had drawn around him some fine artists. Even Geffroy, who found the whole event disconcertingly alien from the humble piety of the ordinary Catholic, acknowledged that artists such as Séon, Henri Martin and Armand Point were gifted men.[108] Point was fascinated by the Italian Renaissance, producing paintings and *objets d'art* with which he strove to recreate lost techniques, but his consciously nostalgic work did not typify the Rose+Croix exhibitors. Séon, for one, was not just leftist in his politics but also experimental in his art. Among the pictures he exhibited at the 1892 Rose+Croix was a *Jeanne d'Arc* in which the frontally posed figure stands with her arms rigid and fists tightened, a posture which seems to derive from illustrations in contemporary texts about the physical manifestations of mental illness (fig. 132).[109] So although Péladan's personal position was demonstratively conservative, his Rose+Croix organisation embraced others whose attitudes to modernity were more liberal and adventurous. Taken in that wider perspective,

132 Alexandre Séon, *Jeanne d'Arc*, 1892, medium, dimensions and location unknown.

Péladan's project has points of contact with Denis's, not least in the determination to keep the aesthetics of religion in the public eye at a time when religion was central to the national debate, as well as in working through tensions between the modern and the traditional.

Much of the debate about the future of religious art – with its conservative resistance to modern initiatives, its nostalgia for historical styles in an era of populist naturalism – was centred on Paris. It was in the metropolis, in the shadow of the construction site of the Sacré-Coeur, that discourse about art and religion was at its most intense, articulated through exhibitions, commissions, the press and patronage. However, the regions should not be neglected. Catholicism's strength in the north, west and east has already been outlined. Indeed, by 1890 the Church was stronger in Flandre Intérieure, Haute-Loire and Morbihan than it had been two decades before. This is in contrast to Paris, where from the mid-1870s the number of baptisms fell while the number of civic marriages and funerals increased.[110] A salient example of the vitality of religion in the provinces is the phenomenon of Lourdes. In September 1890 Georges Vanor reported a visit there in *Entretiens politiques et littéraires*. Entitled 'La Nouvelle Jérusalem', one might expect his article to have been ironic, published as it was in a review that gave considerable support to anarchism and the following year printed extracts from the

Communist Manifesto.[111] Far from it. Vanor was staggered that twenty-seven trains could deliver more than thirty thousand people to this out-of-the-way spot from all over France in a single August day. He was impressed by the propriety of provincial Lourdes in contrast to that 'caravanserai' Paris. He was overwhelmed by the five-hour-long torchlight procession of the faithful, with its religious orders, scions of ancient families, Catholic leagues and the White Cross of the Bretons.[112] Not only did Vanor compare Lourdes favourably to the capital, he invoked the traditionalism of its rituals. Provincial and anti-modern this pilgrimage may have been, but he could recognise that it had a powerful validity for many. Regional Catholicism offered a large public which artists wanted to address, especially if they themselves had been formed by it. Henri Le Sidaner is a case in point. Educated during the 1870s at Notre-Dame des Dunes in Dunkirk (Pas-de-Calais), he began his career as a painter of religious subjects in settings characteristic of the *département*. In 1893 he completed a major canvas, *L'Autel des orphelines*, showing orphan girls placing flowers on an altar and learning to sew under the tutelage of nuns (fig. 133). At once naturalistic in style and ritualistic in format, it preached the value of inculcating young women with the virtues of piety and diligence while celebrating the Church's charitable care of the unfortunate. Prior to exhibiting the painting at the 1893 SAF in Paris, Le Sidaner made sure that it was shown at the Exposition des Beaux-Arts in Dunkirk and at the Société des Amis des Arts at Douai (Nord).[113] Such a move was no doubt intended to maximise the possibility of a sale, but it was also the artist's public avowal of Catholic values to a receptive audience in a region of buoyant church observance.

Finally, let me bring together three elements of this complex debate – the tensions among conservative traditionalism, the regional strength of the Church and Social

133 Henri Le Sidaner, *L'Autel des orphelines* (The Altar of the Orphan Girls), 1893, oil on canvas, 262 × 428. Arras, Musée d'Arras.

Catholicism – to speculate about how visual culture interwove with these forces. With his encyclical *Rerum novarum* of 1891, the pope, as already noted, had sought to identify contemporary social problems and positive Catholic responses to them. In France the ground was well prepared for such an initiative. This was due in substantial part to the previous work of the senior Catholic laity. Albert de Mun was a central figure. As with Gustave LeBon, another man of the right but whose diagnoses and solutions were quite different, de Mun's thinking had been shaped by the Commune. An army officer during its suppression, the aristocratic de Mun had been profoundly moved by what he had witnessed, seeing in the tragedy of the *insurgés* the grim effects of industrialisation and the guilt of the upper classes.[114] During the 1870s he had founded L'Oeuvre des Cercles Catholiques d'Ouvriers (the Society of Catholic Workers' Clubs), but for all the movement's good intentions to prevent the proletariat becoming dissociated from the Church, it remained paternalistic, its leaders still regarding the workers as social inferiors and failing to penetrate the urban proletariat. During the 1890s de Mun and his allies continued to press for reformist measures in the Chamber: the reduction of working hours for women and children, the provision of old age pensions, adequate insurance against industrial accident. Behind this programme, the support for Social Catholicism was predominantly regional. Its main impact was in the north around Lille and Roubaix, in the north-east in Reims and Nancy, in the east around Lyon and Saint-Etienne, and in Brittany. The Association Catholique des Patrons du Nord, which set up *syndicats mixtes* of industrialists and workers together, had established 177 groups by 1895. The Congrès Démocratie Chrétienne, a Catholic workers' movement independent of both proprietorial and socialist influence, held its congresses in Reims in 1893, 1894 and 1896, while a Christian Democratic party was formally launched at a congress in Lyon in 1897.[115] If much of Social Catholicism's impact was in such areas, how might this have manifested itself in visual culture?

Evidence of specific links is not easy to find, but one can piece together some traces. Rémy Cogghe was a Roubaix-based artist who specialised in three genres. He painted portraits of local worthies, the kind of industrialists who were involved in the Association Catholique des Patrons du Nord; scenes recording the folkways of working-class Flanders; and anecdotal pictures of proletarian piety.[116] The repertoire identifies a Catholic artist of local loyalty, who would hardly have been unaware of Social Catholicism and public debates about religion. He painted, for instance, the portrait of the Roubaix industrialist Eugène Motte, who in the 1898 elections secured a victory for the Catholic vote over Jules Guesde, the leader of the French Marxist party.[117] One of Cogghe's most celebrated paintings was *Restitution* of 1901, in which a young working woman confesses to a priest her theft of jewellery, presumably from her upper-class mistress (fig. 134). The scene is specifically local, the Tourcoing newspaper identifying the priest as *curé* Vanbockstael of St Christophe, and the anecdote an edifying representation of conscience and redemption.[118] The errant servant's act of contrition, it is perhaps implied, should be met by an equally Christian act of forgiveness on the part of her employer.

While little is known about Cogghe, a good deal is about Etienne Moreau-Nélaton. Son of a wealthy and cultivated family, fellow-student of Jean Jaurès, Henri Bergson and Paul Desjardins at the Ecole Normale Supérieure, collector of contemporary and earlier nineteenth-century art, owner of an estate at Fère-en-Tardenois (Aisne), near Reims, Moreau-Nélaton had no need to work.[119] However, he trained as a painter and,

134 Rémy Cogghe,
Restitution, 1901,
oil on canvas,
172 × 128. Roubaix,
Musée de Roubaix.

following his marriage in 1889 which deepened his religious commitment, devoted much
of his work over the next few years to Christian subjects. His production comprised
both paintings and graphic work. The latter was symptomatic of a desire to reach out
to a wide public with Christian imagery, whether it was a colour poster for the Breton
village of Saint-Jean-du-Doigt (1894), advertising its annual pardon, its sea-bathing and
archaeological sites with an image of Christ being greeted by a Bretonne, or illustra-
tions to a children's book, *Les Grands Saints des petits enfants* (1896).[120] In 1896 he
donated his painting of St Vincent de Paul to the church of Notre-Dame du Travail,
then under construction in the rue Vercingétorix (14th *arrondissement*). He expressed
his further support for this project to extend the Church's presence into a burgeoning
working-class *quartier* of Paris the following year, when he designed a poster urging
travailleurs de France to contribute to the building's completion (fig. 135). By so doing,
Moreau-Nélaton was, I think it can be argued, involving himself in an act of Social
Catholicism, by stepping down from his patronal position to collaborate practically in
the building of a church for the proletariat. The cases for Cogghe and Moreau-Nélaton
as artists consciously committed to Social Catholicism may not be proven, but both indi-

135 Etienne Moreau-Nélaton, *Travailleurs de France: Apportez tous votre pierre à Notre-Dame du Travail* (Workers of France: Bring your Stone to Notre Dame du Travail), 1897, colour lithograph, 128 × 93. Private collection.

cate that there did exist at this period types of art and artist whose beliefs drew them towards an imagery consistent with the Church's efforts to consolidate its influence in working-class communities. In such circumstances, the work was perhaps necessarily somewhat conservative in style, aware, like Aubert's church murals, of the need to address its popular audience legibly. This kind of work flourished in the climate produced by *Rerum novarum*.

A Concluding Paradox: Anarchism and Religion

This chapter began with Camille Pissarro's condemnation of Gauguin's recent painting. The anarchist dismissed what he perceived as his younger colleague's opportunistic and retrograde pandering to the religious debate newly rekindled in French society, blaming Gauguin for ignoring the forward momentum of the people. Whatever his motives, Gauguin's engagement with religious issues in his work at this period was an initiative shared with many other artists, diverse and even competitive as I have indicated their

136 Charles Angrand, *Le Bon Samaritain* (The Good Samaritan), 1895, conté crayon, 84 × 61. Private collection.

solutions to have been. Gauguin's work may have neglected one debate, to Pissarro's distaste, but it engaged with another. From his perspective as an anarchist Pissarro could only see religion as an immutable opponent to radical social change. Curiously, however, this ideologically obvious position was by no means unanimous, from either point of view. Perverse as it appears, throughout the 1890s anarchism and Christianity were often linked in people's imaginations. The relationship seems inappropriate: on the one hand a set of beliefs upheld by a hierarchical establishment, long established, socially conservative and with strong bonds to monarchical and authoritarian government; on the other an ideology committed to the abolition of hierarchies and systems, the better to free individual expression. But links were made. One could cite *père* Didon's sermon, given in the Madeleine in April 1892 before the Archbishop of Rouen and the Duc de Nemours, in which he identified with those who revolted against contemporary hedonism; or Paul Adam's article 'Eloge de Ravachol' which lauded the terrorist as a modern redeemer; or the polarised plot of Zola's *Paris*, with one brother a priest and the other an anarchist.[121] This equation of extremes, too complex to be reduced to right and left, was common enough to be worth unpicking.

Both the anarchist (necessarily) and the Catholic (not infrequently) could find themselves opposed to the Republic. Both had a profound belief in a fundamental morality. For both, the equality of all men before a greater good was preferable to the social and political expediency that the Republic seemed to stand for. With this is mind one might ask why Charles Angrand, a dedicated anarchist and not a religious man, wrote to a friend in October 1893 that he was working on several large conté crayon drawings: a Manger, the Annunciation to the Shepherds, the Pilgrims of Emmaus and the Good

Samaritan.[122] All are subjects which involve ordinary working people, responding to a higher truth. Angrand did not finally sign his drawing of the Good Samaritan until 1895, which suggests that he pondered it carefully (fig. 136). Depicting the Samaritan lifting the injured man onto his horse, it represents an act of charity and good conscience in Christian terms or caring fraternity in anarchist. Either way, it is a moral image. Perhaps there is even an ideological edge. For in the parable (Luke 10:30–37) the men who pass the victim are priests, while for Jews a Samaritan was an outsider.[123] Thus Angrand's subtle drawing, its image of brotherhood glowing from the velvety blacks of the conté, may suggest anti-clericalism as well as selfless charity. In that sense, as in many other images discussed here, religious imagery could engage with not only the teachings of Bible and Church but also with the wider social debates about religion that were contested in France during the 1890s. Pissarro's circle, one might say, could be squared.

'ALWAYS THINK ABOUT IT; NEVER DISCUSS IT': IMAGERY AND THE IDEA OF *REVANCHE*

Revanche *or Regret?*

The war of 1870–1 was a catastrophe for France. In the field her armies were out-manoeuvred, out-generalled and out-fought. Despite operating on home terrain, with her infantry equipped with a far superior rifle to that of their German enemies, the fate of France's two main armies in the summer of 1870 was to be besieged in Metz and to be surrounded and crushed at Sedan. The German forces then imposed a grim siege of Paris over the hard winter of 1870–1, while resolutely holding off the French provincial forces which hustled on their flanks. In January France sued for peace. The victors compounded their triumph by parading down the Champs-Elysées and crowning the King of Prussia as Emperor of a united Germany in the palace of Versailles. By the terms of the Treaty of Frankfurt, signed in May 1871, France had to concede the province of Alsace and much of neighbouring Lorraine to the new Germany, surrendering rich industrial and agricultural territory west of the 'natural' frontier of the Rhine. She also had to pay substantial reparations, effectively subsidising her own defeat. Worse, the siege of Paris was followed by the insurgent Commune, the suppression of which in late May 1871 was in effect a bloody civil war. *L'année terrible* was a national calamity, a severe blow to France's status as a Great Power.

Its ramifications were wide-ranging and long-lasting. How had the nation fallen so low, and how could it raise itself up? The postmortem laid the blame at many doors: the weak leadership of the Second Empire, the incompetence of the generals, the failure of French manhood. The solutions for the future were also various. Ironically but practically, France looked to her conqueror's example, and both the German army and universities served as institutional models for French reformers. By expanding her colonial possessions in such theatres as Madagascar and Tonkin, a policy vigorously pursued by Jules Ferry in the 1880s, France flexed her military muscles and showed herself again a player on the world stage. The continuation of the cycle of Expositions Universelles gave France the opportunity to assert her cultural superiority. For ardent nationalists, however, none of this was enough. Neither internal tinkering nor foreign diversion obviated the need to pursue the ultimate goal: *revanche*, a war of revenge against Germany. Among historians, the common view is that during the 1890s the idea of *revanche* was all but dormant in French public and political life. With the exception of a vocal but very small right-wing minority, the nation had forsaken the dream of

facing page Paul Legrand, *Devant 'Le Rêve' de Detaille* (detail of fig. 176).

a triumphant war of revenge, too preoccupied with more immediately pressing issues to concern itself with a *fait accompli* from the past. However, when the evidence of visual culture is considered this position is far less easy to sustain. But first the historians' evidence.

As the wounds of 1870–1 healed, and before the clamour that climaxed in August 1914 began, the widespread attitude to the lost provinces and *revanche* among the French public was one of 'general indifference', one is typically told.[1] Of course, as I shall show, there were moments of heightened antagonism, for example during the Schnaebelé incident in 1887 or during the Dreyfus Affair a decade later, but these were sporadic interruptions to a normally calm, if grudging, acquiescence. Leading Republican politicians sought to dampen the fires of *revanche*. As early as 1871 the senior Republican Jules Grévy, to be president between 1879 and 1887, told the young Alsatian deputy Auguste Scheurer-Kestner that France had to renounce Alsace.[2] The Republic had other objectives, not least to secure its own future by educational reforms, fending off threats from left and right, and by modernising the French economy through a period of great difficulty, especially during the 1880s. At the elections of 1889 even *L'Alsacien-Lorrain*, a political weekly for *emigrés* founded in 1880, could not bring itself to support the *revanchard* position of General Boulanger and his henchman Paul Déroulède (see figs 6, 137). None other than the candidate for Belfort, a symbol of French resistance to Germany as the fortified town where in 1870–1 Colonel Denfert-Rochereau had courageously withstood a long siege, made only the most insipid reference to fighting under the *tricolore* 'one day'.[3] As for the population of Alsace-Lorraine, they seemed increasingly to acquiesce in their new status as part of the German Reich. In 1879 twenty-five per cent of young men dodged the draft into the German army, a figure that by 1904 had fallen to eight per cent.[4] Of the fifteen Alsace-Lorrainers sitting in the Reichstag in 1898, twelve were content to express their loyalty to Germany.[5] While the passage of time gradually absorbed Alsace-Lorraine into the greater Germany, it gave a consistently unreassuring reading of France's status as a Power. In the years before the Franco–Prussian War, France had been more or less at parity with the North German Federation. However, by 1914 her population and industrial capacity was only about half that of Germany.[6] On these terms, it hardly looked as if France could prosecute a war of *revanche*. With such evidence in mind, recent historians have played down the role of *revanche* in French public life at the end of the nineteenth century. 'Revenge against Germany was talked about after 1870', writes Robert Gildea, 'but only to maintain the illusion of French greatness, never as a viable option.'[7] Eugen Weber has suggested that during the 1890s, and in particular between the confrontation over control of the upper Nile at Fashoda in 1898 and the signing of the Entente Cordiale in 1904, it was Britain that appeared France's primary rival as a Power. Germany, by contrast, had the less confrontational and more prosaic role of 'the official enemy'.[8]

This mood of passivity and indifference was not entirely unchanging. Whereas during the 1893 elections even the right did not use *revanchard* rhetoric, in the subsequent elections of 1898, when the Dreyfus Affair had brought bitterly back to mind France's military rivalry with Germany, that kind of talk necessarily resurfaced. When one moves from the wide field of public opinion to the more circumscribed views of intellectuals, one finds similar shifts and contrasts. In April 1895 the *Mercure de France* published the results of an *enquête* on Franco–German relations. Intellectuals as ideologically disparate as comte Melchior de Vogüe and the anarchist Jean Grave had been polled for

their opinions. Most were cautious or dismissive of nation-
alism, arguing for closer cultural relations between the two
countries. The Alsace-Lorraine question was barely men-
tioned, *revanche* merely whispered, and without using that
explicit word.[9] On the other hand, some nationalist intel-
lectuals were articulating different views. In the *cahier* he
used between May 1897 and February 1898 Maurice Barrès
warned himself that it was through education, especially the
teaching of history, that children in Alsace and
Lorraine were being indoctrinated with the idea of German
superiority over the French.[10] France needed to attend to
such erosion. More publicly, Déroulède, leader of the Ligue
des Patriotes and clamorous voice of the nationalist right,
used his verse as a political and promotional tool (fig. 137).
In *Refrains militaires*, published in 1889 at the height of the
Boulangist momentum, the tone is explicitly *revanchard*.
Not only is the militarism frequently couched in the future
tense – the volume is dedicated to the first *petit soldat qui
... aura versé son sang pour notre France* – but it is overtly
about reconquest: *C'est vers Metz et Strasbourg que j'ai tou-
jours marché.*[11] Ideas about *revanche*, perhaps not neces-
sarily about an imminent call to arms but certainly serving

137 Gabriel Ferrier, *Paul Déroulède*, 1906, oil
on canvas, 114.5 × 96. Paris, Musée du Petit
Palais.

to keep the cinders of resentment smouldering, did circulate in French public life during
the 1890s, and found voice in the cultural sphere. Indeed, and one might even say above
all, they found form in visual culture. The evidence of painting, caricature and sculp-
ture forcefully contradicts the interpretation that the Alsace-Lorraine question, and the
eventual return of the lost provinces to France, was a dormant issue during the 1890s.
How were such notions of *revanche*, taken in its broadest definition, articulated visu-
ally? How was it promoted and received? To whom did it appeal: just supporters of
extremists such as Déroulède? And if it was supported by many, who objected?

Policy and Imagery in the 1890s

The army had a vital position in French life and tradition. Whether one's ideological
preferences led one to remember the royal armies of Rocroi and Fontenoy, the levies of
the First Republic triumphant at Jemappes and Valmy, or the Napoleonic Grande Armée
of Austerlitz and Jena, the past primacy of French arms was one of the cornerstones of
national identity and *gloire*. Humbled in 1870, the army had been forced into a process
of rehabilitation, redefining its character and purpose. By the 1890s it had been signifi-
cantly re-equipped, first with the excellent Lebel rifle which Charles de Freycinet had
introduced during his long service as War Minister between 1888 and 1893. This was
followed in 1896 by the introduction of the recoiling 75-mm gun, developed by Captain
Sainte-Claire-Deville, which gave the French considerable superiority over German
artillery.[12] The Chamber habitually passed the military budget with minimum debate,
sustenance of the army's needs being a political *sine qua non* of its rehabilitation. Such
unquestioning support was, however, increasingly jeopardised in the 1890s. Socialists

such as Jaurès, suspicious of the conservative regular army, became less tractable. In addition, the signing of the defensive alliance with Russia in 1894 meant that the pressure to keep pace with Germany, 'man for man, franc for franc', was significantly eased.[13] Despite the offensive ethos of the teaching at the Ecole Supérieure de la Guerre, French military policy and strategy was fundamentally defensive. During the 1870s General Séré de Rivières (a relative of the Toulouse-Lautrec family), had drawn up plans for the fortification of key towns in eastern France such as Verdun, Toul and Belfort in order to channel armies invading westwards into ground advantageous to the defending forces. Improvements in German *matériel*, notably artillery, and the accession of the ambitious Wilhelm II as Kaiser in 1888 led to his plan being put in train. However, the costs were extremely high and by 1893 most work on fortifications had halted.[14] This was not the profile of a nation preparing for war.

Nevertheless, France did take steps to ensure that, in the event of mass mobilisation, it would be able to call on vast reserves of trained manpower. In 1889 the law on conscription was changed, establishing a standard three-year term and abolishing the privilege of being able to buy oneself out, though students, seminarians and teachers needed to serve only a single year.[15] The reform was intended to make the army match more closely the Republican ideal of the nation in arms. This in turn would reduce the influence of the right, for there were in effect two armies: the cyclically changing mass of conscripts and the relatively fewer regulars, the bulk of whose officers were politically conservative and frequently Catholic.[16] Freycinet, the first civilian Minister of War, insisted that the army should remain apart from politics, attempting to eradicate the dangerous elision between the two that Boulanger had personified. Indeed, until the explosion of the Dreyfus Affair at the end of the 1890s, the army and Republican politicians co-existed well enough.[17] Elements within the army even moved towards the Republic, mirroring the movements of Social Catholicism and the Ralliement. In 1891 Louis Hubert Lyautey, a young captain later to become a Maréchal de France, published an article on the social role of the officer in the *Revue des deux mondes*. During the mid-1870s Lyautey had been an early convert to de Mun's Social Catholicism, and under its banner had opened in the late 1880s a Catholic *foyer* for his troops while serving with the 4th Chasseurs at Saint-Germain-en-Laye. His article argued that officers should respect their soldiers and thus reduce class antagonisms. The new generation of officers needed to be scientifically and socially forward-thinking.[18] Lyautey's was a modest, idealistic gesture, but it was a token of the ways in which the army might recognise its need to respond to the Republic, just as politicians sought to shape the army to their ends.

Imagery had a substantial role to play in the process of the army's rehabilitation. The long tradition of French military painting had, in the main, been centred on heroic reportage: the representation of past or distant engagements to evoke for the noncombatant the glory of French arms. But warfare was an increasingly industrialised business in the second half of the nineteenth century. Hundreds of thousands of troops were moved great distances by railway, their increasingly complicated equipment being manu-factured by a dedicated armaments industry. Because conscription involved the vast majority of young men even in times of peace, the army became a mass presence in the everyday world. Every Jacques Bonhomme did his military service and his annual *28 jours* as a reservist. And he did it publicly. The law of 24 July 1873 made forced marches and manoeuvres compulsory every summer. The army thus became a highly

visible presence in the French countryside.[19] And because the experience was universal, the commonplace existence of the soldier became what people saw and knew, thus gaining credence as a theme for art. While heroic imagery did not disappear, it was increasingly partnered by representations of the *citoyen* temporarily under arms. Eugène Chaperon was only one of a number of artists who became specialists in the frank, even dull, charting of daily army life. A painting such as his *Le Photographe au régiment* of 1899 shows a unit of a cuirassier regiment having their photograph taken (fig. 138). The casual grouping in the stable-yard and the artist's unfussy naturalism suggest a neutral record. But in fact Chaperon took care to include the different trades and, particularly, to mix officers and other ranks, so that his painting is an image of the social inclusivity that Republican politicians and a Social Catholic officer like Lyautey considered ideal. If Chaperon was a semi-official military artist, respected and welcomed by the army, Charles Crès was a serving officer, the drawing master at the Prytanée National Militaire at La Flèche (Sarthe). Crès painted as well as taught. At the 1889 Salon he exhibited a canvas of *L'Inspection générale des exercices physiques au*

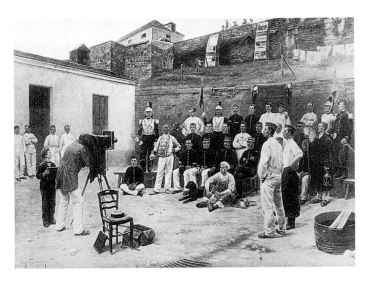

138 Eugène Chaperon, *Le Photographe au régiment* (The Photographer at the Barracks), 1899, oil on canvas, dimensions and location unknown.

139 (*below*) Charles Crès, *L'Inspection générale des exercices physiques au Prytanée Militaire* (The General Inspection of Physical Exercises at the Prytanée Militaire), 1889, oil on canvas, dimensions unknown. La Flèche, Prytanée National Militaire.

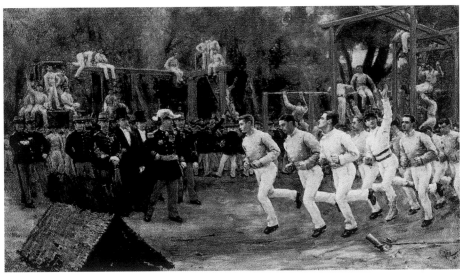

Prytanée Militaire (fig. 139). The painting represents the triumphant procession of the *victor ludorum*, as the officer cadets run past the inspecting general. Once again, it is more than the mere depiction of an event. It is an image of physical fitness, celebrating strength and virility as the antidote to decadence, and also of modernity: the Prytanée Militaire had introduced Swedish gymnastic techniques.[20] While Chaperon's painting apparently represents the conscripted citizen army, Crès's depicts the regular élite. But whereas Chaperon's is set firmly in the present and is about fixing the here and now, Crès's also implies the future, for among these eager cadets are surely generals to be. Both artists tell their audiences about the community and readiness of the French army, but neither deals with *revanche*.

Visual culture was also a lever in the complex machinery by which France negotiated its own national status and its foreign relations. Franco–German relations were competitive in the cultural sphere, whatever the aspirations of the intellectuals polled by the *Mercure*. The French regularly ran down German cultural standards. In 1891 Téodor de Wyzewa published *L'Art et les moeurs chez les Allemands* (Art and Morality in Germany), in which he dismissed France's neighbours in Darwinian terms. In Germans, he opined, the five senses remain in a primitive state, and a violent instinct emanating from Berlin could set back the nation's slow evolution in an instant.[21] Three years later the satirical novelist Victor Joze added to his series *La Ménagerie sociale* (The Social Menagerie) a volume on vice in Germany, *Babylone d'Allemagne* (A German Babylon). His preface denied that the novel was intentionally chauvinistic or provocative (despite suggesting that Germany was guilty of leading an arms race). Rather, he claimed that it was an *étude sociale* intended to expose the gross nature of Prussian vices, so much baser than elegant, fragrant Parisian debauchery.[22] A similar parallel was drawn by the composer Gabriel Fauré, visiting Bayreuth in August 1896. While he was deeply impressed by the scenery, he wrote to his wife saying how he preferred Parisians, despite their faults, to the Germans. 'How tasteless people are here . . . Always pretentious barbarity.'[23] Literary critic, novelist and composer all responded to Germany with cultural prejudice. It was an ingrained reaction that chafed more irritatingly as German prestige as a Power grew while France's stock stayed low.

But if Germany's might lay in size – of population, industry, volume of trade – France had the advantage of cultural kudos. The fine arts could be used as a weapon in a war of taste if not of territory. In 1891 French artists were invited to exhibit in Berlin. Anton von Werner, director of the Prussian Academy of Fine Arts, had approached Edouard Detaille to organise a show of recent French art. The invitation split both the French art world and public opinion. The large-circulation *Petit Journal* and the conservative *L'Echo de Paris* came out vociferously against participation, but neither as vehemently as Paul de Cassagnac, Bonapartist director of *L'Autorité*. Acceptance was impossible, he thundered on 21 February, 'with a bloody wound on our flanks', returning three days later to attack 'the pilferers of our provinces, the executioners of Alsace-Lorraine'.[24] Artists felt obliged to defend their position, first Detaille and then Puvis de Chavannes writing letters to *Le Temps* and *L'Autorité*. Although the project came to nothing (a second invitation in 1895 was successful), it did indicate how closely art was linked to national pride and prestige. *La Vie parisienne* went so far as to imagine the kind of point-scoring works that could make up such a show: paintings of Napoleon at Jena by Meissonier and Detaille, battle scenes from Sedan and the Siege of Paris by de Neuville, Henner's *Alsace. Elle attend!* (see fig. 170), a tricolour still life of poppies, white roses

140 Henri Lévy, *Egalité, Liberté, Fraternité*, oil sketch for the *salle des fêtes* of the *mairie* of the sixth *arrondissement*, Paris, 1887, oil on paper laid down on canvas, 100 × 256. Paris, Musée du Petit Palais.

and cornflowers by Madeleine Lemaire, and by Besnard a *Projet* for a firework display at victory celebrations.[25] The imaginary portfolio thus ran the anti-German gamut from nostalgia through regret to an image of successful *revanche*.

Art could be used by artist and institution alike to convey nationalist and potentially *revanchard* messages. As a successful history painter winning public commissions, Henri Lévy did not forget his regional loyalties. His father had been born in Mulhouse, part of Germany since 1871, and Lévy himself in Nancy, since the Treaty of Frankfurt a frontier city. Lévy won the competition to decorate the *salle des fêtes* of the *mairie* of the sixth *arrondissement* in 1887 with three ceiling tondos representing Liberty, Equality and Fraternity (fig. 140). In the foreground of the latter two female figures, France and Alsace, engage.[26] The iconography was unusual, but it not only satisfied Lévy's personal feelings, it was evidently approved by the Commission de Décoration of the Conseil Municipal of Paris, which awarded the task to him. In 1896 Lévy exhibited a Napoleonic painting of Bonaparte entering the mosque in Cairo, in Mulhouse. Representing the dramatic moment when the young French general courageously rode his horse into the sanctum, scattering a crowd of Mamelukes before him, the painting was more than a historical reconstruction; it was a symbol of French martial power. No doubt it appeared as such to the inhabitants of Mulhouse, who purchased the painting for their museum as part of their policy of patriotic resistance to Germanisation.[27] In both these cases municipal institutions colluded with the painter's personal commitment to *une Alsace française*.

The French state was more wary. Diplomacy had its etiquettes and requirements. In 1891, the year of the Berlin exhibition furore, Gabriel Ferrier exhibited at the SAF the ceiling commissioned from him by the state for the French embassy in the German capital. Representing the glorification of the arts, it was an allegory representing personifications of the fine arts and French poetry with La France and La Liberté. Executed in a vertiginous baroque style with lively warm chromatics, it spoke of national stylishness without the need for more overt or even subliminal political associations. It was,

Georges Lafenestre approved in the *Revue des deux mondes, la formule de bon sens*.[28] The state seems to have followed such a policy in its annual purchases from the Salons. In 1892, for instance, forty-eight paintings were bought from the two Salons. Some twenty of these were landscapes: only one of these represented the 'lost' Alsace, and the two Lorraine motifs matched the number of Mediterranean ones. A single canvas of a scene from the Franco–Prussian War was purchased.[29] This was an expression of the Republic's longstanding policy of remembering but not stirring up the issue. Governments needed to be seen to be patriotic but not sabre-rattling. It was expedient to keep nationalists at home in place, as they threatened the Republic on the right, while on the international stage it was prudent not to provoke Germany. Art was only one of many policy areas in which sensitivity was the order of the day. What, then, could have been less sensitive than the painting Jean Veber submitted to the 1897 SNBA? Entitled *Boucherie*, the canvas represents a street façade, with the butcher standing outside the door of his premises (fig. 141).[30] But this is no ordinary genre scene. Two human corpses hang to left and right, one decapitated, disembowelled and cut off at the knees. Entrails run along the shop-front in a hideous decorative frieze, and on the slab are severed heads. Several of these wear laurel wreaths like the glorious defeated. To the upper right hangs a crest with a sailing vessel, perhaps the coat of arms of Paris, and one of the heads might be that of Napoleon III. *Boucherie*, it seems, is a ghastly allegory of 1870–1, livid and blood-soaked, an association that becomes even more pressing when one recognises in the face of the butcher, his gory hands smeared on his filthy apron, the features of Bismarck. The victor of 1870–1, nemesis of Napoleon III and architect of the united Germany, was still alive. The painting was, of course, and was surely intended to be, an affront to Germany. In response to protests from the German embassy, the painting was removed from exhibition. Jean Veber was consistent in his antagonism of Germany. The following year he acidly illustrated a text by his brother Pierre, a satirical writer, 'Le Voyage du Kaiser Guillaume II en Proche Orient' ('Kaiser Wilhelm II's Voyage to the Near East'), which was published in *Le Rire*. It was banned in Germany.[31] Jean Veber did not surrender over *Boucherie*. He made a lithograph of it that was widely shown, appearing at exhibitions in Nantes in 1900 and Lyon in 1902.[32]

The most important shift in Franco–German relations during the 1890s – and one that in *revanchard* eyes made the recovery of the lost provinces no longer a distant dream but a more realisable proposition – was the alliance France made with Russia. In November 1888 Bismarck closed German banks to Russian loans. As a result, Russia relied more on French banks, notably the Crédit Lyonnais. The renewal of the Triple Alliance between Germany, Austria-Hungary and Italy in May 1891 reinforced the central bloc and left Russia exposed. Gradually she drew closer to France, on 18 August 1892 signing a secret agreement with the French guaranteeing simultaneous mobilisation if the other was threatened. In October 1893 a Russian naval squadron visited Toulon, and the rapturous reception it received encouraged the Tsar to agree to an official relationship, overcoming his reluctance to deal with a republican democracy.[33] The treaty of Franco–Russian alliance was signed in 1894. The rapprochement with Russia had considerable public impact. In 1893 even the non-political Claude Monet took his wife Alice to watch the French and Russian naval manoeuvres off Cherbourg, and when Nicolas II came to France on a state visit in autumn 1896 the crowds were again considerable.[34] Julie Manet, Berthe Morisot's daughter, wrote enthusiastically in her diary about the grand procession through central Paris, the Spahi outriders as colourful in

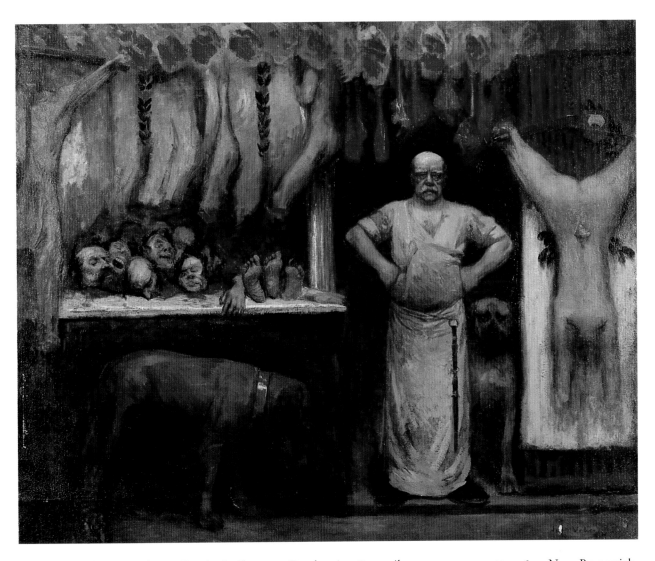

141 Jean Veber, *Boucherie* (Butcher's Shop, or Butchery), 1897, oil on canvas, 100 × 116.5. New Brunswick, Jane Voorhees Zimmerli Art Museum.

their North African costumes as a canvas by Delacroix. Imbued with the anxious instincts of her class towards the Paris crowd, she was relieved to record its good humour at this national celebration, reassuring for an *haute bourgeoise* mingling with the people. Girlishly, she could not resist noticing, during the laying of the foundation stone of the pont Alexandre III, the prominence of the Tsarina's nose.[35] These crowds and fêtes were exhaustively represented by painters, both the events and the works of art that recorded them symptomatic of France's relief at having a partner among the European Powers after a generation of enfeebled isolation.

The state and other national institutions were active in promoting such pictures. There was, after all, no direct affront to Germany. The pont Alexandre III ceremony that Julie witnessed was painted by Vauthier (see fig. 92), and also by Alfred Roll. His vast canvas (Versailles, Musée National du Château), its frame carved by the artist, was shown at both the SNBA in 1899 and the Exposition Universelle the following year, an official

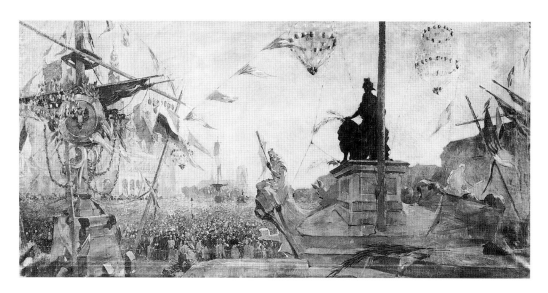

142 Louis-Jules Dumoulin, *Réception de l'amiral Avellan, place de l'Hôtel de Ville, 1893* (The Reception of Admiral Avellan, place de l'Hôtel de Ville, 1893), 1894, oil on canvas, 1500 × 3000. Paris, Musée Carnavalet.

143 Adolphe Willette, *Autre Temps ... Les Cosaques, les Cosaques!* (Another Age ... The Cossacks, the Cossacks!), illustration from *Le Courrier français*, 20 September 1896. Private collection.

monument, energised by the colour and brushwork of painting, to the revivifying alliance.[36] Louis-Jules Dumoulin's large canvas the *Réception de l'amiral Avellan, place de l'Hôtel de Ville, 1893* (fig. 142) was purchased, appropriately enough, by the City of Paris, as it represented the commander of the Russian squadron which had visited Toulon being fêted in the capital. Viewed from a daïs on the north side of the *place*, the painting's high vantage point takes in the massive crowd and celebratory constructions of masts and rigging decorated with the national flags, its broad touches a pictorial equivalent to the animated mass it depicts. Dumoulin was also commissioned by the state to paint an even larger canvas, measuring fifteen and a half square metres, for the Musée National at Versailles.[37] The sheer acreage of canvas the Franco–Russian alliance encouraged met with some scepticism from aesthetes. Wyzewa's deadpan dictum about the delight aroused by 'a considerable quantity of views of Toulon', voiced in his review of the 1894 Salons of the *Gazette des beaux-arts*, was dryly ironic.[38] London-based, *The Studio* had no doubt that 'painting of the patriotic, Franco–Russian, humanitarian type' had noble intentions but negligible artistic quality.[39]

The new alliance had such an impact on French popular opinion that it found form not just in grand exhibition paintings but right across the field of visual culture. In the fourth album of *L'Estampe originale* (1893), a publication aimed at middle-class print collectors, Félix Bracquemond included an etching of the French national symbol the cockerel crowing forcefully *Vive le Tsar!* (fig. 144). Caricatures

144 Félix Bracquemond, *Vive le Tsar!* (Long Live the Tsar!), 1893, etching, 32.9 × 22.9. New Brunswick, Jane Voorhees Zimmerli Art Museum, Rutgers, The State University of New Jersey, Friends Purchase Fund.

and drawings appeared in a wide variety of newspapers and periodicals, from Toulouse-Lautrec's *Au Moulin Rouge: l'Union Franco–Russe*, published in the avant-garde *L'Escarmouche* on 7 January 1894, to Adolphe Willette's *Autre Temps ... Les Cosaques, les Cosaques!* (fig. 143), which appeared in *Le Courrier français* on 20 September 1896 and made fun of an old man, who could remember the depredations of the Cossacks in 1814, reaching for his scythe as France's new allies arrive.[40] So prolific were these images that John Jean-Carteret, a specialist in journalistic imagery, was able to publish an anthology of them, *Les Caricatures sur l'Alliance Franco–Russe*, as early as 1893.[41] This imagery can be found not only in connoisseur's prints and cheap newspaper caricatures, but also in chic fashion accessories such as fans. The leading woman painter Louise Abbéma was only one of several modish artists who decorated fans with allegories and other scenes celebrating the alliance (fig. 145).[42] Of course there were objections to the mass hysteria that the alliance stimulated and this kind of imagery articulated. Huysmans complained cynically about the madness in his government office, while Mirbeau also talked of the mad atmosphere that denied any contradiction when *L'Echo de Paris* turned down an article antagonistic to the alliance.[43] The coruscating neo-Catholic Léon Bloy consistently railed against the alliance in his private journal, furious that in 1896 he had been trapped in the crowd – 'the hedge of patriotic meat' – watching 'that runt' the Tsar pass.[44] Given the role of the pictorial in generating the uncritical enthusiasm of the masses, Bloy's proposed counter-attack was appropriately visual: an electric sign projected into the sky saying 'LA FRANCE N'A BESOIN DE PER-

145　Louise Abbéma, *Souvenir de la visite de l'escadron russe* (Souvenir of the Visit of the Russian Squadron), 1893, fan, 32.5 × 61.5. Paris, Musée Carnavalet.

146 The Imperial Workshops of Ekaterinburg, *Carte de la France offerte en 1900 par le Tsar Nicolas II au président de la République* (Map of France offered by Tsar Nicholas II to the President of the Republic), 1900, *pietre dure*, 100 × 100. Château de Compiègne.

SONNE'.[45] Russian approval of the French alliance also manifested itself via visual culture. Armand Dayot, reviewing the 1898 SAF for Juliette Adam's *revanchard* periodical *La Nouvelle Revue*, as one would expect given its nationalistic readership, drew attention to François Flameng's grand *Vive l'Empereur!*, a painting of doomed French heroism at Waterloo. He added that the canvas had been bought by Grand Duke Nicolas Mikhaelovitch, implying that the purchase was ideological, a Russian gesture of respect for French military *gloire*.[46] Nicolas II made a similar bow in 1900. The Tsar presented the president of the Republic with a metre-square map of France in polychrome *pietre dure*, crafted by the Imperial Manufactory at Ekaterinberg (fig. 146). The different *départements* are depicted by differently coloured stones, and the chief cities named. Plain grey stone, by contrast, indicates neighbouring countries. 'Allemagne' is printed beyond the line of the Rhine, so that Alsace-Lorraine remains a slightly ambiguous space

between the two nations. The design of the Russian map certainly does not go as far as the maps Jules Ferry had ordered for French schools in the 1880s, which marked Alsace-Lorraine in a different colour from either Germany or France, implying an indeterminate status. The Tsar's official gift could not aggressively affront Germany, but its design was nuanced enough for the alert French eye to detect within it a hint of sympathy.

Reading the Imagery of Past War

In all the issues so far considered – the functioning of the French army based on conscription, the use of cultural forms as an assertion of French national status, resentment of German hegemony, and the celebration of the Franco–Russian alliance – visual representation played a crucial role. Across a range of media and at different levels of culture, from caricature via public decoration to diplomatic gift, imagery was a potent and ubiquitous means of conveying national issues and of embedding them in the French consciousness. The image articulated and shaped *mentalité*, acting as a reservoir for collective recollection and aspiration. Equally, it could be deployed as a device to promote a particular *parti pris*. It is to these possibilities and distinctions that I shall now turn, moving closer to imagery that embraced or flirted with *revanche*, that smouldering problem-child of *l'année terrible*.

Revanche does not seem to have been a pressingly active issue in people's private lives during the 1890s, echoing its low status in the priorities of the governing classes. Of course, there were groups of fervent nationalists such as Déroulède's Ligue des Patriotes who sought to keep the issue in the limelight, but in the main *revanche* was discussed, certainly among the articulate bourgeoisie, without enthusiasm or expectation. Julie Manet recorded what sounds like a typical middle-class conversation at the height of the Dreyfus Affair, shortly after the suicide of Colonel Henry. *Revanche* was raised and when M. Baudot, father of one of her friends, dismissed it as impossible, a Colonel Clément retorted that, while that might be his view, he should not be so discouraging as to state it.[47] This sort of attitude, either dubious or half-hearted, was probably commonplace. To it should be added the view that war creates rather than solves problems, the quietist point made by Odilon Redon, veteran of 1870–1, in a reply to an *enquête* on the Alsace-Lorraine issue.[48] Among the working classes attitudes seem to have been different, less reflective and animated by a quasi-visceral chauvinism. In 1895 Henry Leyret, a journalist on Clemenceau's leftist *L'Aurore*, published *En plein faubourg*. This short book was an account of Leyret's recent experience of running a *mastroquet*, a wine shop, for several months in proletarian Belleville, in the east of Paris. Leyret had found that among the metropolitan working class the individual's pride in his regiment ran deep, as did a generic dislike of foreigners, even fellow workers. Nationalist feelings were strong, fuelled by 'the flattering hope of promised *revanche*'.[49] Such patterns of opinion were complex, shifting and impossible to chart precisely. Nevertheless, *revanche* was lodged in the national consciousness, however latent or rarely disturbed.

It was, understandably enough, closer to the surface of those who had been displaced as a result of 1870–1. Following the disruption of the war and the Treaty of Frankfurt, many Alsatians and Lorrainers opted not to live on their native soil under German rule and became émigrés in their *patrie* France. A number of these, who one might take as an informal cross-section, were people who in one way or another played a role in the

art world during the 1890s. Among artists, the painter Emile Friant, son of a locksmith, had been born south of Metz in Dieuze (Meurthe) in 1863, but after 1871 the Friant family moved to Nancy. Similarly, the sculptor Rupert Carabin, born in 1862 in the Alsatian town of Saverne, was uprooted to Paris in 1871.[50] So too was the art critic Gustave Kahn, son of a wealthy Jewish family from Metz, and Louise Weber, better known as the can-can dancer La Goulue, whose parents fled Lorraine for Paris with their four-year-old daughter in 1870.[51] Being an émigré coloured one's view of the world. In 1898 Carabin was approached on behalf of the Grand Duke of Hesse to take a lucrative post in the decorative arts school at Darmstadt. He refused.[52] The art critic Camille Mauclair, another son of Jewish émigrés, recollected that while he was intellectually drawn to anarchism's ideal of individual freedom during the early 1890s he could not subscribe to its anti-militarism, given *les sentiments naturels à un fils d'Alsaciens-Lorrains*.[53] Such sentiments found expression in works of art, especially when the temperature was raised by political tensions. In April 1887 Schnaebelé, a French police official, was arrested at the frontier by Germans who suspected him – correctly, in fact – of espionage. For some tense days war loomed, fuelled by the self-serving nationalism of General Boulanger, but was eventually averted. For those on the border territories it had been a chilling moment, 'a monstrous nightmare' in the words of *Nancy-artiste*.[54] An incident such as the Schnaebelé affair was a salutary reminder of national frictions for artists in Nancy, close to the frontier. It raised an uncomfortable paradox. While *revanche* and the recovery of the lost provinces was a common dream among Lorrainers and the dispossessed, war by an unprepared if affronted France on the might of the united Germany was to be avoided.

147 Emile Gallé and Victor Prouvé, *Orphée et Eurydice* (Orpheus and Eurydice), 1888–9, clear-cased vase with red and brown sealed oxides, h. 26.5. Paris, Musée des Arts Décoratifs.

Works of art produced by members of the Ecole de Nancy, which saw a remarkable flowering at this precise period, articulated the contradictions that many felt. Emile Gallé and Victor Prouvé collaborated on two pieces that were exhibited at the Exposition Universelle in 1889. One was a glass vase designed by Gallé and with figures by Prouvé (fig. 147). These represent Orpheus and Eurydice, and the glass is inscribed 'Ne retournez plus/En arrière/Ce serait me perdre deux fois/et pour toujours' ('Do not look behind you ever again. That would lose me for the second time and for ever'). Taken from classical mythology the subject may be, but its allusion to the lost provinces is prompted by the engraved signatures, linking 'Gallé' with the Cross of Lorraine and identifying both collaborators as Nancy artists. Prouvé's father had been an *artiste industriel* who left his work in Dieuze after 1871, while Gallé was a passionate Lorrainer who had served in the Franco–Prussian War and begun signing his glass and furniture with the Cross of Lorraine as early as 1878.[55] If the vase's iconography is suggestive of forced parting and longed-for reunion, the collaborators' second piece was more overt in its nationalistic reference. This was a table made in a rich variety of woods and entitled *Le Rhin* (fig. 148). The base, in a historicising Renaissance style, incorporates the thistle, the

148 Emile Gallé and Victor Prouvé, *Le Rhin* (The Rhine), 1889, table in carved nut wood, inlaid with other woods, 76 × 220 × 109. Nancy, Musée de l'Ecole de Nancy.

symbolic plant of Lorraine, as well as Gallé's usual signature. The complex inlay of the surface follows a design by Prouvé. In the centre is the allegorical figure of the River Rhine. To each side figures in the tribal costumes of the Roman era confront each other; on the right the belligerent Teutons press forward to combat, while on the left the noble Gauls rise to defend themselves. The confrontation is surmounted by a text from Tacitus: 'Le Rhin sépare des Gaules toute la Germanie' ('The Rhine separates the Gauls from all Germany'). Classical authority almost two thousand years old is taken to uphold the natural order ruptured by the Treaty of Frankfurt. The iconography is pellucid in its meaning. The Rhine firmly points the Germans to their own soil, and the French are entitled to take arms to defend what is rightly theirs. The implication is that 'to defend' can be 'to restore'. As a work of art *Le Rhin* does not convey an overtly *revanchard* message. But as a complex and immaculately crafted object it required close attention, and that reveals its iconography and encourages reflection. Like the Orpheus and Eurydice vase, the table stimulated its cultivated public to remember, regret and ponder the future.

By the 1890s the desperate events of 1870–1 were slipping further into the past, becoming history. A new generation was growing up which had no personal recollection of *l'année terrible*; annual drafts of conscripts were being called to the colours with little to motivate their sense of duty. Politics was one means of keeping the past alive, but as seen, overt *revanchisme* was a tactic only of extreme nationalists like Déroulède and opportunists like Boulanger. Mainstream politics, preoccupied with myriad more pressing problems, opted for the more passive rubric of Gambetta, *y penser toujours, n'en parler jamais*: a rubric that became more vacuous as the years wore on. Another means was memory. And memory was effectively provoked by imagery. Sculpture, painting or print could serve as a trigger to recollection and reflection, breathing life into

184

Gambetta's dictum. And the most public and obvious form of propagandist image was the sculpted monument. Placed in the main street or square of a town, a sculpture was a constant and perhaps arresting icon, as evocative of duty and sacrifice, loss and – in the right frame of mind – even *revanche* as a church was of Christian values. Unlike the objects of Gallé, intended for brief public display but ultimately for élite private ownership, the monument addressed the widest possible public: both sexes, all age groups, French and foreign. Given its permanence and its audience, municipal sculpture could have a significant impact. Such monuments could be phrased and read in different ways, as a sampling indicates.

In 1887 the Société du Souvenir Français was established to encourage the erection of monuments to the dead of 1870–1. Motivated by the desire to preserve the memory of *l'année terrible*, the Société was politically neutral, despite having been founded at the height of Boulangist nationalism. But that is not to say that political ideology did not inflect the works it promoted. Jean Baffier surmounted his *Monument des enfants du Cher morts pour la patrie*, commissioned for the place Séraucourt in Bourges (Cher) in 1896, with a powerfully built figure of a Berrichon peasant (fig. 149). The figure is both non-military and timeless. Other than details such as the dates '1870–1871' on the plinth there is little to link this iconic presence to the Franco–Prussian War. Rather, the

149 Jean Baffier, *Monument des enfants du Cher morts pour la patrie* (Monument to the Children of the Cher killed for their Country), 1896–1907, bronze on stone plinth, Bourges, place Séraucourt.

150 Edouard Lormier, *Monument du souvenir français* (Monument of French Remembrance), exhibited SAF 1898 as *Mort pour la patrie*, bronze in stone setting. Boulogne-sur-Mer, boulevard du Prince Albert.

monument is an articulation of Baffier's stridently regional, regressive and anti-metropolitan ideology.[56] The Bourges memorial contrasts strongly with *Mort pour la patrie*, designed for Boulogne-sur-Mer (Pas-de-Calais) by Edouard Lormier, who exhibited the bronze at the 1898 SAF (fig. 150). Modelled in high relief, Lormier's sculpture is divided into two interrelated parts. Below is a battlefield scene, littered with life-size figures of dead and dying soldiers, lying among the debris of war: weapons, equipment, a shattered wheel, a discarded drum. The effect of this is remarkably, and I suspect calculatingly, pictorial, addressing itself to the public eye attuned to the narrative naturalism of military painters such as Detaille and de Neuville (to whose work I shall shortly turn). But above the precision and pathos of the battlefield scene, Lormier introduced a winged allegorical figure bursting into the viewer's space. This adds a striking change of tone. The allegory is more specific than the conventional personification of Glory, for she represents France, and a France helmeted and armed for war. Hence one might be led to interpret the sculpture as *revanchard*. But this was not, apparently, Lormier's intention. In 1897 he wrote to the Boulogne municipal council that

> as our conquerors allow no occasion to pass without loudly celebrating their glorious military anniversaries [and] erect monuments to perpetuate the recollection of their triumph in the most modest villages, we ourselves also have not just the right but the duty to remember, and to offer to those who died for the fatherland the honours which are due to them.[57]

The sculptor's own account of his work, then, was not as a manifesto for *revanche* but as an icon of memory. Nevertheless, he saw his monument in competition, indeed retaliation, to German equivalents, and his image of an armed France flying into the viewer's immediate space could as easily be considered by those so inclined a future desire as a homage to the past.

Neither Bourges nor Boulogne had formed part of the battlefield in 1870–1 whereas the town of Gray (Haute-Saône) had. On the banks of the Saône to the north-east of Dijon, Gray's seizure by General von Manteuffel's II Corps on 18 January 1871 had outflanked Bourbaki's Second Army of the Loire, forcing his eventual humiliating retreat into neutral Switzerland.[58] With the Treaty of Frankfurt, the Franco–German frontier moved appreciably closer to Gray. The monument to the dead of 1870–1 erected in Gray therefore had a particular resonance (fig. 151). Designed by Jules Grosjean, a young sculptor born outside nearby Vesoul, it takes the form of a stone column mounted on a plinth supplemented by two bronze sculptures. The plinth records the names of the war dead from the local communes, while the column is inscribed to the memory of the dead and with the names of the local politicians who organised the subscription and of General André, the minister of war who unveiled it. The column is surmounted by a bronze of a crowing Gallic cock, although the most important element is the group at its foot. Grosjean's cast represents a dying soldier pointing towards the German border with words of encouragement to a schoolboy who stands beside him. The lad has put down his books and picked up the soldier's rifle (now removed) as he listens to what he is urged. Another sculptural element comes into play, for behind the naturalistic bronze group the figure of Marianne is carved in low relief on the column. Thus the three-dimensional sculpture represents the lived ideal of inherited patriotic duty, while the stone relief suggests the abstract ideal which generations of Frenchmen should defend: *la République*. The concept of inherited duty is repeated in a quatrain inscribed

on a tablet below the group. This describes how children, working on a future harvest, will find the buttons from uniforms of heroes who fell in the same field defending their fatherland. The ensemble of the Gray memorial may be too cluttered with forms, imagery and media but it drives home its messages. The enemy is identified; patriotic duty is inherited; and the future beckons.

Born in 1872, Grosjean had not been alive when the Franco–Prussian War was fought.[59] Many monuments commemorating the war's dead had been erected in its immediate aftermath but a large number of municipalities did not put up memorials for a couple of decades, until urged on by organisations such as the Société du Souvenir Français and a more general instinct not to forget. Although the municipal authorities in Bourges began to debate a monument in 1892, it was not until four years later that Baffier was commissioned and 1907 that the sculpture was inaugurated.[60] Lormier's monument in Boulogne dates from 1898, Grosjean's in Gray from 1901. Why many of these public sculptures were commissioned and created in the 1890s, when *revanche* was apparently low on France's agenda, is difficult to explain. The desire to shore up memories before they disappeared, and to influence the younger generation, was evidently strong. That strength, however, was no doubt variable. It would have been subject to local factors. In the Cher, for instance, the Société du Souvenir Français had few members, accounting perhaps, along with the sculptor's known extreme views, for the slow progress of Baffier's project. Geography, and its inevitable effect on memory, would also have counted. As I have suggested, it was likely that the war memorial in Gray, which had been in the front line in 1870–1, would convey more overt *revanchard* sentiments than Boulogne, which had not. The extent to which politics, nationalism or other local influences manipulated individual memorials is a complex question best negotiated in detail. But, considering the matter in the wider perspective, it is clear that such monuments, static and solid as they are, are flexible of interpretation. What stands as, and may have been intended as, a passive memorial, an image in honour of the historical past, could easily be conceptually translated into an active image of present or future intent. Grosjean's monument would need little gloss to make it anti-German; it is, to my eye, inherently *revanchard*. Lormier's allegory too could be simply converted to the dynamic of revenge, and even Baffier's sturdy peasant could be preached into an image of nationalist confrontation. Given the inherent interpretative mutability of such sculptures, their easy alternation between regret and revenge, wistful memory and energetic reaction, one wonders quite how dormant the French instinct for *revanche* actually was in the 1890s. It may not have featured forcefully in the public statements or even the private thoughts of politicians, policy-makers and diplomats, but it found form in the public spaces of towns and cities the length and breadth of France. That form was variable, slow to get put in place, open to various interpretations according to different political climates and ideologies. But nevertheless it made itself present. Public subscription,

151 Jules Grosjean, *Monument aux morts* (Monument to the Fallen), completed 1901, bronze and stone. Gray (Haute-Saône), place Général de Gaulle.

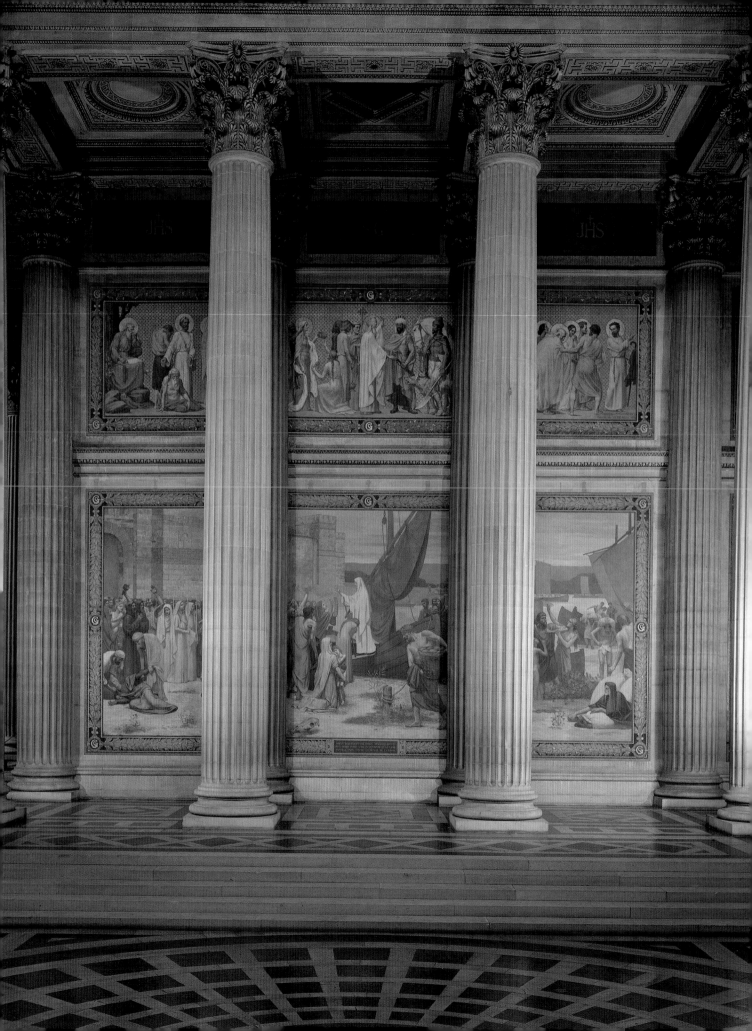

local initiative and ginger groups all went to make these monuments possible. It is difficult to believe that only national pride and respect for the war dead motivated this spate of planning, fund-raising, design and construction.

Such monumental sculpture, overt and often declamatory, was dependent for its maximum impact on its physical location and presence. By contrast, painting – with its range of scale from the mural decoration to the cabinet picture, its suitability for transformation into printed or photographic form – could more easily adapt itself to different publics. It could make an impact both installed in a grand building or displayed at a major exhibition, and in printed form migrate from metropolis to province, from Salon to school, into the hands of nationalist or regionalist, the apathetic or patriotic. Painting could convey attitudes to *l'année terrible* both discreetly and demonstrably. Puvis de Chavannes's *Geneviève ravitaillant Paris*, a large mural for the Panthéon which the artist had completed just before his death in 1898, represents the fifth-century saint bringing supplies to the besieged city at a time when France was in the grip of northern barbarian tribes (fig. 152). While the iconography fitted the building's theme of the city's patron saint, for those alert to the allusion the Gallo-Roman subject would not have hidden the parallel to the 1870–1 siege of Paris at the hands of the Prussians and their German allies. In a national monument, discreet suggestion was apt, the merest whisper of Gambetta's dictum. In a barracks, the matter was handled differently. As minister of war in the mid-1880s, Boulanger had established *salles d'honneur* for regimental depots.[61] These were to be decorated with paintings of the units' actions and glories, serving both as a regimental history and symbol around which to build *esprit de corps*. Aimé Morot was commissioned to paint the Battle of Reichshoffen (known to non-French historians as Froeschwiller) for the *salle d'honneur* of the 3rd Regiment of Cuirassiers (fig. 153). During the battle, on 6 August 1870, an entire brigade of cavalry was launched towards the village of Morsbronn to buy time for the hard-pressed French infantry to retreat and regroup. The charge was across impossible terrain, cluttered with hedges, walls and lines of vines, and German artillery and rifle fire took a horrendous toll. Nine entire French squadrons were annihilated, and probably not a single German killed. Morot chose the moment when Colonel de Lacarre, shown leading

152 (*facing page*) Pierre Puvis de Chavannes, *Geneviève ravitaillant Paris* (Genevieve revictualling Paris), 1893–8, oil on canvas adhered to wall, 462 × 900. Paris, Panthéon.

153 Aimé Morot, *La Bataille de Reichshoffen, 6 août 1870*, 1887, oil on canvas, 430 × 800. Versailles, Musée National du Château.

his regiment at the left of the large canvas, was decapitated by a shell. The catastrophe of Froeschwiller, although it was followed later in the war by other heroic and costly French cavalry charges, in effect brought down the curtain on that form of attack as a military option; henceforth, in Michael Howard's words, 'the only choice before horsed cavalry lay between idleness and suicide.'[62]

Given the nature of such a battlefield disaster, and the exactitude of Morot's depiction, one wonders how it might have functioned as an inspiration to the regiment. Perhaps it was used to prepare soldiers for the ultimate sacrifice that their country might demand from them, perhaps to arouse a lust for revenge. In general, fewer scenes from the Franco–Prussian War were appearing in the Salons in the 1890s. This was noticed by a number of critics. Henri Bouchot, for one, surveying the two 1893 Salons for the *Gazette des beaux-arts*, remarked that 'patriotism seems tired of slaughters'. He wondered hopefully if this decline was due to a renewed confidence in French power, though he feared that the passage of time had dulled the interest of the younger generation and noticed that many paintings representing scenes of 1870–1 were now drawn from literary accounts.[63] Nevertheless, there remained a strong current of interest in such themes. After the Franco–Prussian War the military painters Edouard Detaille and Alphonse de Neuville had led a team which painted a vast panorama of the Battle of Champigny, a sortie during the Siege of Paris. Installed in Paris in 1882, the panorama had enjoyed enormous popularity for many years. As its impact waned, the panorama was toured in the provinces and then, beginning in 1892, dismembered into fragments.[64]

154 Middle-class salon, with reproduction of Alphonse de Neuville's *Le Bourget, 30 octobre 1870*, 1890s, photograph.

155 Jules Monge, *Le Dernier du bataillon* (The Last of the Battalion), 1894, oil on canvas, dimensions and location unknown. Reproduction from *Le Petit Journal*, 1894.

But what looks like the typical trajectory of Franco–Prussian War imagery – created while the disaster was still fresh in the public mind in order to retrieve some glory in defeat, then lapsing into historical oblivion – took another twist. When in May 1892 important fragments of the panorama were auctioned at the galerie Georges Petit, Pierre de Nolhac bid on the part of the state to buy Neuville's *Combat de la platrière* (Combat at the Plasterworks) for the Musée National at Versailles where he was curator. A foreign museum tactfully held back, and when the hammer came down with the words *Adjugé aux Musées nationaux* there was enormous applause.[65] The emotional investment in such images was a matter not only of public but also of private patriotism. A number of photographs of French interiors of the 1890s bear witness to the presence of framed prints of paintings by Detaille and Neuville. One such photograph of a smart middle-class salon at the end of the century, for instance, has a large reproduction of Neuville's *Le Bourget, 30 octobre 1870*, a painting of 1878, hanging over the doorway (fig. 154). It is difficult to know what to make of such evidence. Did that print hang there unnoticed and irrelevant to the inhabitants' lives? Did it commemorate a deeply regretted loss to the family? Might it have been an icon of *revanche* in a fervently nationalist household?

Whatever the answer in individual cases, it seems that such pictures still counted, and that they were made to count. Given that the numbers of Franco–Prussian War scenes were waning at the Salons, those paintings had to have impact. Artists increasingly opted for shock tactics. They chose to paint incidents of high drama and emotion, such as the dying soldier writing on a wall with his own blood 'Vive le 2e Zouaves', in Jules Monge's 1894 *Le Dernier du bataillon* (fig. 155). The fact that this picture was reproduced in *Le Petit Journal*, with its circulation of more than one million, vouches for the continuing popularity and enormous outreach of such patriotic themes. Subjects from 1870–1 also occurred in painting through the filter of literature, artists adapting the naturalist

191

156 Ernest-Jean Delahaye, *Mademoiselle Fifi*, 1898, oil on canvas, 181 × 140. Private collection.

fiction of Zola and his followers.[66] For instance, at the 1898 SAF Ernest-Jean Delahaye exhibited *Mademoiselle Fifi*, a canvas based on the late Guy de Maupassant's eponymous short story of 1882 (fig. 156). Born in 1855, Delahaye was just too young to have served in the Franco–Prussian War, but Maupassant had been conscripted though he saw no action. The tale is of a group of Prussian officers, billeted in a Norman château, who bring in some local prostitutes for their amusement. As the dinner becomes increasingly drunken an aristocratic sub-lieutenant, nicknamed 'Mademoiselle Fifi' for his eccentric pronunciation and contempt for the French, insults French women. At this the whore Rachel plunges a silver dessert knife into his neck and escapes in the mêlée, avoiding capture by hiding in the local church tower, the Jewish prostitute protected by the *curé*. Delahaye chose the split second of the stabbing for his painting, a theatrically staged scene of loot and lust, surprise and violence. The spectator was intended to recognise the literary reference, as Alfred de Lostalot did for the readers of *L'Illustration*.[67] The narrative of *Mademoiselle Fifi* hinges on an insult revenged, whether in prose or picture. Such double-layering of cultural forms was not necessarily a weakness of imagination on the artists' part. By the 1890s many younger painters did not have their own immediate experience of the War to draw upon. Rather, it suggests how deeply embedded *l'année terrible* was in the cultural imagination.

What is less easy to track down is the individual's position about *revanche*. What did this person think, or what kind of affiliations or ideologies did that artist nurse as he

157 Ernest-Jean Delahaye, *Montbéliard: Paul Déroulède entre le premier dans la ville, et enlève la barricade* (Montbéliard: Paul Déroulède enters the Town first, and takes the Barricade), 1899, oil on canvas, dimensions unknown. Metz, Palais du Gouverneur Militaire.

painted a particular picture? After all, in the complex political culture of 1890s France, there were many different kinds of patriotism being invoked, appealing to different constituencies. The example of Delahaye, it seems, offers some answers. Although I have no direct evidence of his political stance, his career offers significant clues. In the early 1880s he had been a painter of modern genre scenes, but from the second half of the 1880s he had begun to focus on military painting, both of the Napoleonic and Franco–Prussian Wars. Delahaye exhibited a portrait of General Boulanger at the 1886 Salon. Ten years later the museum at Versailles acquired his large canvas of the funeral procession of Marshal MacMahon, showing the homage of the foreign delegations to the cortège at the 1893 ceremony.[68] Two such paintings suggest more than a bent for military pictures, hinting at sympathies for the nationalist right. However, the submission of a scene of Jewish ceremonial to the Salon of 1882, coupled with the heroic incident of the fictional Rachel in *Mademoiselle Fifi*, exhibited in 1898 at the height of the Dreyfus Affair, seems to exonerate Delahaye from the anti-Semitism common on the right. At the SAF in 1899 he exhibited a scene from the Franco–Prussian War which is so specific in its hagiography of an individual that it seems inescapably to articulate Delahaye's political commitment (fig. 157). The canvas shows street-fighting in the eastern French town of Montbéliard in January 1871, when Bourbaki's army vainly tried to threaten the Germans' southern flank. The pivotal figure is a young French officer, Paul Déroulède, leading his Tirailleurs Algériens against a German barricade.

Déroulède had indeed had a distinguished war. Having fought bravely with the Zouaves at Sedan in September 1870, where he had been captured in the combat at Bazeilles, he escaped from Germany and rejoined the French army. For his courage at the Montbéliard action he was awarded the *chevalier* de la Légion d'Honneur.[69] As noted earlier, by 1898 Déroulède was leader of the Ligue des Patriotes, a right-wing *revanchard* grouping. Delahaye's painting was surely more than a lauding of Déroulède's courage in battle almost thirty years ago; it was a commitment to the ideology of the Ligue. That commitment was all the more loyal and outspoken during the spring of 1899, when the canvas was on show at the Artistes Français. For on 23 February Déroulède and his Ligueurs, contemptuous of the moderate Republic and hoping to take advantage of the crowds at the funeral of President Faure, attempted to stage a *coup d'état*. The bid failed and Déroulède was arrested. To exhibit a painting vaunting Déroulède soon after this incident was in all likelihood an endorsement of his extreme nationalist position, as was the purchase of the canvas by the Ligue's newspaper *Le Drapeau*. One should also note that the painting was still accepted by the SAF after Déroulède's arrest, was reproduced in the illustrated guide to the Salon and was selected for display in the Décennale at the 1900 Exposition Universelle, to which it was lent by *Le Drapeau*. All these facts suggest that Déroulède's extreme politics, for which Delahaye's painting stood useful proxy, had significant institutional support.[70]

The linkage between war imagery and politics of different extremes is well exemplified by the resonance of a particular painting of the Franco–Prussian War. Neuville's *Les Dernières Cartouches* was made during the immediate shock of defeat, and exhibited to considerable acclaim at the Salon of 1873 (fig. 158). Two decades later the iconic status of the picture and the engagement it represents gave it a crucial identity in debates about nationalism and militarism. *Les Dernières Cartouches* depicts an incident during the morning of the battle of Sedan, on 1 September 1870. In one of the opening moves of the battle the German forces attacked in strength at Bazeilles, a village just to the east of Sedan, where they were bravely engaged for some hours before the French were overwhelmed. Among the defenders the Marines were salient, and Neuville's painting represents in detail the interior of a house in which they made a final, heroic stand. What concerns me here is not the painting's reception when it was first exhibited but its afterlife two decades later. Neuville had died young in 1885, and his friend Déroulède had written his obituary for *Le Drapeau*, republishing it two years later in *Le Livre de la Ligue des Patriotes*.[71] More than twenty years later Déroulède dedicated his memoirs of the Franco–Prussian War, written in exile, to Detaille and the memory of Neuville: *au peintre des 'Dernières Cartouches'*.[72] Neuville's reputation, encapsulated in this memorable painting, was secured by extreme nationalism. But it was also widely promoted among a more moderate nationalist public. In August 1889 *Paris illustré*, a lavishly illustrated magazine aimed at the prosperous bourgeoisie, devoted a whole issue to Neuville's work. There were various angles to this. *Paris illustré* was published by Boussod & Valadon, formerly Goupil & cie, a company that specialised in publishing high-quality reproductive prints of successful Salon pictures. Neuville's work had been one of their staples. The main article on his art was written by Arsène Alexandre, a critic of socially conservative views suitable for *Paris illustré*'s readership. Alexandre wrote at length about *Les Dernières Cartouches*. Reminding his readers of how well it was reproduced as a print, he described how Neuville's extraordinary realism brought this moment 'of smoke and glory' to life, so – and here he slipped into the language of *la psychologie*

158 Alphonse de Neuville, *Les Dernières Cartouches* (The Last Cartridges), 1873, oil on canvas, 108 × 165. Bazeilles, Maison de la Dernière Cartouche.

nouvelle – that one seemed to see the scene like a hallucination. Alexandre took the usual line that the painting showed glory in defeat, and made no allusion to *revanche*. However, he stressed how emotively Neuville's intentions conveyed themselves to his public. Finally, he mentioned how the very house where this engagement took place had recently been turned into a simple museum.[73] Widely distributed in printed reproduction and lauded in the bourgeois press, *Les Dernières Cartouches* had become an icon in the public mind, functioning, albeit with greater national resonance, like a memorial in a town square.

In researching *La Débâcle*, his novel about 1870–1, Zola visited the Maison de la Dernière Cartouche in 1891. Published the following year, the book includes a scene in chapter 4 which is close in many respects to Neuville's painting. Although Zola may have used other sources, such as the recollections of a captain who fought there which *Le Figaro* had published in May 1891, *Les Dernières Cartouches* was so well known as an image that it is highly likely that Zola's visual memory of the picture coloured his prose.[74] *La Débâcle* met with a mixed reception on its publication in 1892. For some it was a painful but exact fictional account of *l'année terrible*, for others a disgraceful attack on the French army. In 1895 an anonymous 'captain of the army of Metz' published a condemnation of Zola, entitled *Gloria Victis!* after Antonin Mercié's celebrated sculpture (1874) lauding the defeated French. While the author did not specifically

159 Hermann-Paul, *En joue . . . Faux!* (Take aim . . . Fake!), illustration in *La Feuille*, 20 September 1898. New Brunswick, Jane Voorhees Zimmerli Art Museum, Rutgers, The State University of New Jersey, Gift of Norma B. Bartman.

mention either the *dernières cartouches* incident or picture, he took Zola sternly to task for insulting exactly what Neuville's image promoted: French heroism in defeat, the upholding of national *gloire*. In addition, the former captain's tone was explicitly *revanchard*. 'The whole nation is destined to fight', for the enemy will reap what he has sown, he asserted, so Zola was traitorous to revel in past defeat.[75] For this kind of aggressively *revanchard* nationalist, *Les Dernières Cartouches* would have represented the typical French bravery which would win the future war.

Yet this icon of the army could be turned against it. On 20 September 1898, at the height of the Dreyfus Affair, Hermann-Paul published a caricature in *La Feuille* entitled with a parody of the military command: *En joue . . . Faux!* (fig. 159). It represented the 2me Bureau, the counter-espionage branch of French military intelligence, under seige from public opinion. The image was apt, appearing less than a month after Colonel Henry, forger of documents to cover up the army's unjust condemnation of Dreyfus, had committed suicide. What was particularly telling was that Hermann-Paul's composition obviously quoted Neuville's *Les Dernières Cartouches*, distorting that ubiquitously known icon of military *gloire* into a critique of the army's duplicity. There is a final facet to this cluster of associations surrounding Neuville's painting. In the spring of 1899 a public subscription raised the funds to purchase the Maison de la Dernière Cartouche in Bazeilles as a permanent museum and memorial. The initiative would never have taken place without the celebrity that particular building had won through Neuville's picture, a telling instance of the power of visual imagery at this period. The subscription was organised by the right-wing newspaper *Le Gaulois*. Its director, Arthur Meyer, was able to put together a remarkable list of subscribers, whose names are listed alphabetically on a board in the house (fig. 160). It includes the reactionary aristocracy (Boni de Castellane, le duc de Doudeauville, le baron de Mackau, la duchesse d'Uzès), bankers and businessmen (Chauchard, owner of Les Grands Magasins du Louvre, the great benefactor Edouard Viel-Picard), artists (Detaille, Forain, Gérôme, Henri Gervex, necessarily Alphonse de Neuville's widow and nephew) and nationalist writers and intel-

160 Board of Honour listing the subscribers for the purchase of the Maison de la Dernière Cartouche, Bazeilles.

lectuals (Juliette Adam, Maurice Barrès, François Coppée, Jules Lemaître, Déroulède of course). There are also the organs of right-wing opinion – *L'Echo de Paris*, *Le Petit Journal*, the inevitable *Le Drapeau* and *La Libre Parole*, even the Goupil art publishing company – and their clients the veterans' organisations. Those gold names and allegiances painted on that black board constitute a veritable inventory of nationalist and *revanchiste* opinion at the end of the decade. What brought them together was less that particular house or that particular engagement, but a single painting which had conferred on them both iconic status in the ambitions and hagiography of the right.

Preparing the Next Generation

Education was central to the politics of the Third Republic. Through schooling citizens were to be trained to sustain the Republic and frustrate its enemies. Education would promote civic virtue and dismiss the superstitions of the Church, just as it would, in theory, advance scientific and democratic thinking. In the regime's eyes, such a modern world-view was rooted in what children were taught at school, but it was nurtured throughout all phases of life and via a variety of media. At all stages visual imagery, from children's comics and song-sheets through to Salon paintings and public monu-

ments and decorations, played a vital role in relaying Republican ideology. It was through education that the Republic sought to control its future. But to what extent could it control the messages that were being transmitted via the complex media systems of the 1890s? The case of *revanche* is of particular interest here. At government level – in the decisions of politicians, the negotiations of diplomats, the planning of the military – *revanche* was of very low priority; it was scarcely a policy, more a dream or even illusion. For these reasons modern historians place it on the sidelines of their accounts of the decade, as has been seen. But if one looks at the Republic's systems of education, including the diverse media via which information and ideology were conveyed to the citizenry, the patterns are somewhat different. When one pans across the range of visual culture, one finds that *revanche* had a far greater currency that might be expected.

In the early 1880s Ferry's Ministry of Education had distributed maps of France which clearly identified the lost provinces as neither French nor German.[76] Their dark, different colouring gave Alsace-Lorraine a deliberately indeterminate quality: not (yet) German and not (any more) French. That cartographical anomaly was a visual means of allowing a situation that was solid in *de facto* political terms a fluidity in the more emotive spheres of nostalgia and nationalism. Like a public monument or a painting, the regulation map could be read variously, according to the bent of the schoolteacher. We do not know exactly what the teacher in Albert Bettanier's *La Tache noire* is saying, of course (fig. 161). But at the Salon of 1883 Bettanier had exhibited a painting of peasants in 'occupied' Lorraine hiding a young man escaping German conscription (whereabouts unknown), and at the 1887 Salon *La Tache noire* was on view with many images of General Boulanger, then at the crest of his nationalist wave during the Schnaebelé affair. Thus it is probably best to assume that Bettanier's image is one of patriotic education, and that the master is instructing his adolescent pupils on – at least – the injustice of Alsace-Lorraine's separation from France, a message that would have been

161 Albert Bettanier, *La Tache noir* (The Black Stain), 1887, dimensions and location unknown.

reiterated when they joined their regiments as conscripts a few years later. Another painting, made just into the twentieth century, took up the same theme. Maurice Denis's *La Vierge à l'école* was begun in November 1902 and shown at the 1903 SNBA, at a time when the determinedly anticlerical premier Emile Combes's *laïque* educational policies were troubling the Catholic artist (fig. 162). Typically, the quattrocento flavour of the composition evoked Denis's equation of pure art and pure belief, in a canvas which upholds the value of religious education by bringing the Madonna into the modern school. Denis's image opposed the Republic's current educational policies, just as it promoted a nationalist cause. For on the wall behind the Virgin the map of the French *hexagone* is marked by the dark scar of German-occupied Alsace-Lorraine, the retrieval of which was the grail for many nationalists.[77] The painting thus includes many touchstones of the right: the centrality of the Church, the unity of the nation, the instinct for *revanche* against Germany. Bracketing the 1890s, these two widely different images of schooling indicate something of the consistency of the idea of *revanche* in the educational *mentalité* of the decade.

162 Maurice Denis, *La Vierge à l'école* (The Virgin in School), 1903, oil on canvas, 158 × 200. Brussels, Musées Royaux des Beaux-Arts de Belgique.

Children were constantly exposed to the imagery and ideology of nationalism. There were, of course, fluctuating patterns in this: sometimes the dosage was stronger, sometimes gentler, depending on the political climate. The prevailing notion of the separate spheres meant that girls were targeted in different ways from boys, on whom I shall concentrate. Nevertheless, nationalism was instilled in the French throughout their childhood, as a variety of evidence indicates. Take an anonymous poster advertising a toy fair in Bordeaux in 1899 (fig. 163). Designed by an adult as an advertisement for adults to bring their children to the event, the image was also intended to enthuse children. Its simple imagery shows a girl with a doll and two boys, one an infantryman blowing a bugle and the other on a hobbyhorse brandishing a toy sword. Such pictures instilled in the two sexes from an early age their respective national duties of motherhood and military service. Once at school, children were likely to be infused with the ideology of *revanche*. They were taught to sing:

163 *Grand Bazar de Bordeaux*, 1899,
colour lithograph, 128.8 × 103.8.
Toulouse, Musée Paul Dupuy.

Pour la patrie un enfant doit
S'instruire
Et dans l'école apprendre à
Travailler.
L'heure a sonné, marchons à pas.
Jeunes enfants, soyons soldats.[78]

Advice to teachers could be specific about what should be taught. In 1884 the professional paper *L'Ecole* recommended that as well as the Marseillaise and the Chanson de Roland, classes should be taught 'L'Hymne à Jeanne d'Arc' and that *après les horreurs de Sédan, nous aurons . . . la revanche*.[79] It seems that some of the pressure of this kind of overt nationalism diminished in the 1890s. For instance the *bataillons scolaires*, local units established in 1882 to teach schoolboys how to march and drill, lost momentum, even in eastern France on the borders of the lost provinces.[80] But *revanche* still found its way into mass-produced imagery aimed at the wide populace. This kept it in the public eye, especially of the young. An interesting example is *Le Petit Français illustré*, an illustrated paper for adolescent boys, aimed at a literate middle-class readership.

164 Alphonse Mucha,
La Mort d'Henri Regnault
(The Death of Henri
Regnault), cover of *Le Petit
Français illustré*, no. 152,
23 January 1892, p. 85. Paris,
Bibliothèque Nationale de
France.

Among its adventure stories, it regularly returned to the Franco–Prussian War. It dwelt
on German iniquities, such as the execution by firing squad in Bavaria of the captured
Sergeant Gombald, and hyperbolised French feats of arms, citing the cavalry charge at
Rezonville – a catastrophe in which two regiments were sacrificed for no gain – as a
French victory because no ground had been lost.[81] It gave a detailed account of the death
of the painter Henri Regnault, with a cover drawing by Alphonse Mucha of his (futilely)
heroic demise (fig. 164).[82] In the 1890s *Le Petit Français illustré* could be utterly frank
about its *revanchard* ideology. A fold-out page published in July 1892 as part of a series
on particular units noted of the Chasseurs d'Affrique that 'the regiment, proud of its
past, waits with confidence the striking revenge – *la revanche éclatante* – which the
future reserves for it.'[83] Identical ideology can be found elsewhere, aimed at a wider,
lower-class public of a slightly older age-group. This is an *image d'Epinal* lithograph to
record an individual's conscription number (fig. 165). A box for that serial to be added
was left blank, as was the exact year – *Classe de 189* – so that the print was effective
for the whole decade. It addressed the young soldier-to-be with rabidly *revanchard*
rhetoric:

> Ecoutez! C'est la Marseillaise.
> Sa voix domine le tambour:
> Elle vous dit 'Je suis française.
> Mon pays natal est Strasbourg!'[84]

In all likelihood the story was not exactly the same throughout France. A teacher with
Boulangist sympathies would be more nationalist than a liberal colleague; the policy in
a school near the Franco–German frontier or in a town with many emigrés from Alsace-
Lorraine, such as Le Havre, would probably differ from a school in Provence or Les

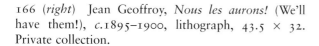

165 Image d'Epinal, card for a conscription number, *c.*1890, colour lithograph, 25 × 25. Paris, Musée National des Arts et Traditions Populaires.

166 (*right*) Jean Geoffroy, *Nous les aurons!* (We'll have them!), *c.*1895–1900, lithograph, 43.5 × 32. Private collection.

Landes. But education, hand in hand with cheap and widely available printed imagery, made sure that *revanche* – whether as fantasy, duty or certainty – was instilled in the young French mind.

It was not just imagery aimed at the young that sustained such notions. Children were also used as images. The child implied the future, and the idea of *revanche*, as it was not a present reality, was a projection into the future. Nowhere is that clearer than in Jean Geoffroy's *Nous les aurons!* (fig. 166) The title – in essence 'We'll have them!' – had been Joan of Arc's shout when fighting the English early in the fifteenth century. It was the war cry of national resurgence, of expulsion of the foreigner from French soil. Geoffroy applied it to an image of three little boys, too young even to be in a *bataillon scolaire*, marching along under the *tricolore*, armed with wooden rifles and home-made swords. The doughy faces and penny-sized eyes were 'Géo's' hallmark, and the naïf fraternity of the boys' game of pretend soldiering was all too easy to read for the public of a widely distributed print. But that was the point of such imagery. Young Jacques Bonhomme was to be encouraged in his martial games. One day he might play them for real, and then *nous les aurons!* That same kind of projection had a discreet but regular place at the Salons. Paul Legrand's *La Leçon de stratégie*, shown at the 1890 SAF, is a case in point (fig. 167). The painting, as its subtitle specifies, shows a grandfatherly old soldier explaining to three boys with their wooden soldiers how cavalry should attack a formation of infantry. As the battles of 1870 had proved, this was pre-

167 Paul Legrand, *La Leçon de stratégie* (The Strategy Lesson), 1890, oil on canvas, dimensions and location unknown.

cisely the kind of action that the modern rifle had made lethal for the cavalry. But the obsolescence of the lesson was not Legrand's point. That was to show the enthusiasm of the boys, and that French military blood ran true through the generations, into the future. The patterns of meaning in these images for children and of children are difficult to unpick. In some cases *revanche* is preached, in others it is perhaps implied but unstated. But that range of possible interpretation, the ambiguity that allows for reading either way, the potential for future projection, is typical of much imagery in the 1890s.

Looking into the Future

One needs to set this kind of imagery, with all its ambiguities, within the context of a *mentalité* that, at different levels of the conscious and unconscious, was aware of, and troubled by, the experience of 1870–1. France in the 1890s was not unlike an individual personality marked for life by a trauma of many years ago. This manifested itself in curious ways. I have already shown that one of the most potent images for France after 1889, although it is not a work of art in the strict sense, was the Eiffel Tower. In his initial proposal to the government in 1884 Gustave Eiffel primarily promoted his scheme on the grounds of the tower's potential strategic value, although on completion it served rather as a symbol of progress and tourist attraction. It could be used, he argued, for observing enemy movements for sixty kilometres around the city and for communicating by relays of optical telegraphs to the rest of France.[85] Such functions were essentially defensive, looking back to the experience of the siege of Paris in 1870–1, but once the Tower had been erected it also stimulated bellicose patriotic poetry which enthusiasts sent to Eiffel. A couple of lines of doggerel by one A. Delayen suffices to set the tone of technological triumphalism some versifiers adopted: *Inclinez-vous Teutons la voice la merveille/Et de tout l'univers à nulle autre pareille*, while the *revanchisme* of others is manifested by a certain Georges Bouret's: *En dépit du Teuton qui bisque/Elle [the Eiffel Tower] démontre/Qu'à nous battre nous sommes prêts.*[86] This kind of *mentalité* that encouraged strangers to send such private poems to a public figure like Eiffel was stimulated by a variety of motives: political and personal, nationalist or

xenophobic, eccentric or trite. Like currents and eddies in a river, without beginning or end but in constant, mutually defining movement, imagery and *mentalité* functioned together in 1890s France. Neither can be identified as the origin or the result, although sometimes a hand can be suspected on the sluice-gate, altering the flow: Boulanger's, perhaps, then Déroulède's. Through the years, this momentum flowed insistently on. At first sight it might barely be identified on the calm surface of the water, which in terms of French official policy was unruffled by any *revanchard* inclination. And yet there was such movement. Imagery was motivated by *revanchard* opinion and designed to communicate and promote it. *Mentalité* drove the image-makers to visualise their ideology, and reminded its viewers that the past made its demands on the future.

As one would expect, this imagery functioned across the range of visual culture, addressing different publics through different media. A similar nationalism can be found in certain café-concert performers, who shaped their stage personae round their politics, articulating their own opinions and appealing to particular constituencies. With 'En revenant de la Revue' of 1886 and subsequent songs, the singer Paulus linked himself to the Boulangist cause. For her part, Eugénie Buffet was sentenced to two weeks in prison in 1889 for yelling 'Vive Boulanger!', and during the 1890s her repertoire conveyed her militant membership of Déroulède's Ligue des Patriotes.[87] The material of such performers was widely available in cheap song-sheets, sold by travelling street-vendors and popular among the working classes. Such sheets were typically illustrated with crudely coloured lithographs on the cover. Among them were patriotic songs about Alsatian lads refusing to submit to German conscription ('Le Déserteur', 'Le Conscrit Alsacien'), Alsatian girls oppressed by lubricious Germans ('Le Précipice d'Alsace', 'La Voix des Sapins') and gestures of defiance such as three Alsatian women wearing dresses in the colours of the banned *tricolore* ('Les Trois Couleurs'). The tone of these songs, and the unpretentious prints in which they were packaged, was closely echoed in the imagery of paintings on show in the Salons of the 1890s. Although ostensibly operating at a more elevated level in the aesthetic hierarchy, the tell-tale or slightly allusive title, easily legible narrative, and sentimentally nationalistic character of such canvases addressed popular patriotism in a similar voice. Many of these were genre paintings, often by native Alsatians keen to keep their province's plight lodged in the national memory, such as Zwiller's *Une Noce à Didenheim (Alsace)* (fig. 168) or Enders's surreptitious celebration of the 14 July '*A la France!*' *En Alsace* (present location unknown), shown at the SAF in 1890 and 1893 respectively.

What is interesting about these paintings is not only the melancholy of their nostalgic nationalism and their rhetoric somewhat at odds with the realities of the 'occupation', to which in its third decade the local populations were becoming increasingly accustomed, as seen. It is also the response they received in Paris publications. Some critics felt called to make nationalist allusions. In his illustrated

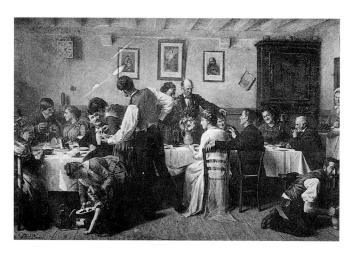

168 A. Zwiller, *Une Noce à Didenheim (Alsace)* (A Wedding at Didenheim (Alsace)), 1890, oil on canvas, dimensions and location unknown.

book on the two Salons of 1890 Louis Enault took Zwiller's wedding scene as a cue for lachrymose comments about the 'bloody hands' that had torn Alsace from us and the 'immortal tenderness' which France feels towards her.[88] Enders's painting prompted Henri Bouchot in his 1893 review for the *Gazette des beaux-arts* to regret 'our hours of inertia', perhaps an implicit criticism of government policy.[89] At other times this kind of picture evoked ambiguous or contrary criticism. If one did not know Auguste Dalligny's conservative position, one might take his cod description of Charles Landelle's *Fleurs de France* (SAF 1890; present location unknown) – representing a young woman in Alsatian regional costume picking a bouquet of red, white and blue flowers – as facetious or ironic rather than patriotic as he probably intended.[90] In his *Figaro-Salon* of 1890 the influential critic Albert Wolff railed against such pictures. For him, scenes of nostalgia or *revanchard* expectation ran the risk of reducing art to the level of the mere expression of patriotic sentiment.[91] More than a century later, our taste, formed around modernism's rejection of the illustrative, finds it easy to agree with Wolff's position. But the typical eye of the 1890s was not accustomed to modernist notions of formal purity and individual invention; it expected imagery to convey values that concurred with popular ideologies. And the imagery of the time often effectively did precisely that. Three years after Wolff's complaint, Jules Huret took a somewhat different line in *Le Figaro*. In an article puffing the newspaper's illustrated publication on the 1893 Salons, Huret wrote that it will open with 'a scene by Jean Berg, *L'Alsacienne* [present location unknown], which represents in the Tuileries . . . a maid wearing an Alsatian coiffe, carrying a baby boy and watching a regiment of *cuirassiers* ride down the rue de Rivoli.'[92]

One can tell from the description alone how effective such illustrative art could be as a conveyor of ideology. At one level it simply described a scene. At another, it made potent allusions. It did much more than remind the readers of *Le Figaro* that Alsace was now German territory. It showed resentment of the occupation being transmitted, from Alsatian to Parisian, from one generation to the next, from the passive sex to the active sex, perhaps to a future *cuirassier* of the *revanche*. In this suggestive sense, such an image elides with the notion of contagion that was current in the social thinking of Gustave LeBon and others. Berg's image both represented the transmission of ideology, and itself acted as an agent of that transmission; it was doubly contagious, doubly virulent.

If such pictures were naturalistic images of expectation and hope, couched in narrative terms, I want now to turn to the different idiom of allegory, looking at two contrasting works. The first is Adolphe Willette's drawing unequivocally entitled *Revanche*, representing a French *cuirassier* wiping the blood from his sword having just beheaded the German imperial eagle on the frontier (fig. 169). Willette had been a pupil of Cabanel at the Ecole des Beaux-Arts, and despite earning his living as a caricaturist and illustrator he remained attached to the allegories and complex compositions of history painting. A fervent right-wing nationalist, he

169 Adolphe Willette, *Revanche* (Revenge), 1890, lithograph, 40.2 × 37.1. New Brunswick, Jane Voorhees Zimmerli Art Museum, Rutgers, The State University of New Jersey, Herbert Littman Purchase Fund.

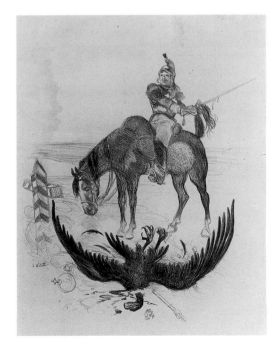

170 Jean-Jacques Henner, *L'Alsace (Elle attend)* (Alsace (She is waiting)), 1871, oil on canvas, 60 × 30 cm. Paris, Musée National Jean-Jacques Henner.

had stood as an anti-Semitic candidate for the ninth *arrondissement* in the 1889 elections and during the First World War would produce scores of acrid anti-German images. *Revanche* was first published in *Le Courrier français* in November 1890, and reappeared in the ninth edition of *L'Estampe originale* five years later. Its continued currency indicates that Willette was content with it as an image that conveyed his passionately *revanchard* beliefs, and it is particularly significant that he used it to air them in two such contrasting outlets: mechanically produced in a salaciously commercial weekly targeted at the bourgeois public of Montmartrois nightlife, and as a lithograph in an album of varied modern prints marketed for the discriminating *amateur*. By contrast, Jean-Jacques Henner's *L'Alsace (Elle attend)* had been commissioned in 1870 by an Alsatian lady, Mme Kestner de Thann, as a gift for Gambetta, the Republican politician then leading the efforts to raise provincial armies to expel the German forces that had just conquered eastern France (fig. 170).[93] Twenty years later this image of a young Alsatian woman in her provincial costume, wearing mourning but with a *tricolore* cockade in her coif, her pose passive and her face calm but determined, had iconic status in France. On taking Henner's *fauteuil* at the Institut the year after his death in 1905, Lhermitte made the traditional speech in honour of his predecessor. He emphasised the importance of *L'Alsace*, which 'had been copied, photographed, engraved, [and] lithographed to such an extent that it was everywhere in France'.[94] While Henner's image was female and passive in contrast to Willette's male and violent motif, it could be read just as unequivocally. Writing in 1888, the critic Claude Vento was insistent that the posture of the figure in *L'Alsace* was 'the attitude of expectation: the expectation of *revanche*!'[95] Different as these two images were, they shared two points in common. Both were multiply reproduced in various media to maximise circulation, and both in their different voices gave allegorical form to the urge for *revanche*.

The contribution of such images to *revanchard* consciousness was to a considerable extent haphazard. A photograph of Henner's painting might or might not hang on a classroom wall, depending on the teacher's nationalism; a collector finding Willette's lithograph in his *L'Estampe originale* album might be delighted or indifferent. But on occasion public agencies acted explicitly to promote actively the idea of *revanche* through allegory. In 1887 François Schommer won the competition run by the City of Paris to decorate the *salle des fêtes* at the *mairie* of Pantin, an industrial suburb to the

171 François Schommer, *L'Avenir* (The Future); *Hardy Pantin, en avant!* (Forward, brave Pantin!); *Le glorieux passé* (The Glorious Past), 1887–9, oil on canvas, dimensions unknown. Mairie de Pantin, Salle des Fêtes.

north-east of the city. His scheme was an allegory based on time and the lost provinces (fig. 171). One of the flanking panels represents *Le Glorieux Passé* (The Glorious Past), embodied by a muscular warrior in winged helmet, an approximately Gallic figure beneath whose seated form a French cock fights a German eagle. The other represents the figure of Alsace, in her provincial costume. Entitled *L'Avenir*, she instructs a boy from a large open book. The generic Gaul and the child under instruction are motifs seen before, but in Schommer's case they were sharpened in their allegorical meaning: *Le glorieux passé* by the addition of the fighting birds and *L'Avenir* by the replacement of the embodiment of education in his competition-winning oil sketch by the specific figure of Alsace in the finished ceiling, her costume instantly recognisable thanks to the ubiquity of images like Henner's. The central tondo of this ceiling, *Hardy Pantin, en avant!* (Forward, brave Pantin!), centres on the rousing figure of Marianne leading soldiers and workers into battle under the *tricolore*, their thrust forward urged on by a proletarian mother and child. As an ensemble, Schommer's ceiling is both easily legible and exactly targeted. Its allegory makes a smooth elision between past achievement and future duty; identifies foe, grievance and objective; and makes military action the central solution. I cannot yet explain why this particular public decoration was honed into such an explicitly *revanchard* message. Was Schommer of Alsatian ancestry? Did Pantin have a particularly large population of *émigrés*? Whatever the answer, this ceiling was undoubtedly designed to promote *revanche* permanently and publicly in the consciousness of the people of Pantin.

Not all allegories read so clearly. Ambiguity could come into play. Take Frédéric-Auguste Bartholdi's *Morts en combattant*, a monument to the National Guard killed in 1870–1 in Colmar (fig. 172). To have one of the twin slabs out of true, from beneath which a bronze arm appears near a fallen sword, was a deliberately dramatic sculptural

172 Frédéric-Auguste Bartholdi, *Morts en combattant* (Died on the Field of Battle), 1898, stone and bronze. Colmar, municipal cemetery.

ploy. But how should it be read? On the one hand it could be interpreted as the last glimpse of a hero slipping into glorious oblivion, but on the other it could be a vision of the fallen rising for a last, spectral battle.[96] Take a work in another medium. At the 1895 SNBA, and again at the 1900 Exposition Universelle, Jean-Joseph Weerts exhibited *Pour l'humanité, pour la patrie!* (fig. 173). Commissioned as an altarpiece for the chapel of the new Sorbonne, this highly finished and vividly lit canvas was presumably intended to inspire in the congregation the thought that at some point in the future the former student might have to fight for his country and be prepared to make the noble sacrifice of his life as Christ had done. But for the cynical or the devoutly Christian student Christ's gaze might be read as one of pity and regret for the vain death of the young *cuirassier*, a condemnation of mere *gloire*, rather than sympathy for his heroic loss. How one read such works and negotiated such ambiguities depended on one's ideological position. This comes out clearly in the response to Edouard Detaille's *La Revue de Châlons, 9 octobre 1896* (fig. 174). This vast canvas was commissioned

173 Jean-Joseph Weerts, *Pour l'Humanité, pour la patrie!* (For Humanity, for Fatherland!),
1895, oil on canvas, 285 × 240. Paris, Musée du Petit Palais.

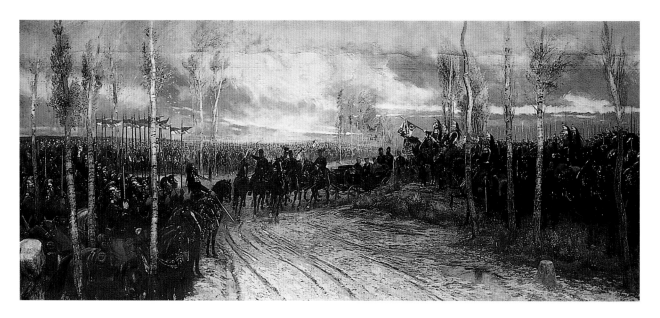

174 Edouard Detaille, *La Revue de Châlons, 9 octobre 1896* (The Review at Châlons, 9 October 1896), 1897, oil on canvas, 225 × 528. Versailles, Musée National du Château.

by the state in 1897 to record an event on the state visit of the Tsar and Tsarina the previous year, during which they had reviewed French troops on manoeuvres. Shown at the 1898 SAF and again at the 1900 Exposition Universelle, Detaille's painstaking canvas of the massed cavalry drawn up under a bleak Champagne sky might seem to some a drab depiction of the routines of diplomacy and to others pregnant with allied military threat to Germany. Unlike the other paintings I have been discussing, Detaille's was not an allegory. But ideology could lead it to be read in such a way. The experienced art critic Dayot covered the 1898 SAF for *La Nouvelle Revue*, whose outspoken nationalist editor Juliette Adam had introduced herself to the young Camille Mauclair as *la cocardière, la revancharde . . . j'ai la haine des Prussiens*.[97] Given that ideological bias it is no surprise that Dayot's account of the painting went beyond simple description. Indeed, he insisted that what is in effect a descriptive painting had *une intention symbolique*, because 'in the distance the dying sun colours the horizon with a kind of dawn glow, the radiance of which makes the sabres, bayonets and forest of lances sparkle.'[98] For a nationalist readership, it became necessary to transform a grandiose pictorial record into an allegory of *revanche*, to change sunset to sunrise, twisting the associations of light to project a positive note of future military *gloire*.

Earlier Detaille had used a kind of allegory in an ambitious painting that was destined to be one of the key works of the period, *Le Rêve* (fig. 175). Day gently breaks over a panoramic landscape unbroken by trees or villages but picketed by stacked piles of rifles behind which the French army sleeps, wrapped in their blankets. In the distance glow the camp-fires of the enemy. Soon battle will commence, but Detaille's painting represents the last moments of sleep. As one would expect of Detaille, even in a canvas measuring four metres across the technique is precise, with the dull light glistening on the bayonets and every chain link on each canteen described. But for all this precision, none of the sleeping soldiers is seen full face. They are not individuals, although in their

175 Edouard Detaille, *Le Rêve* (The Dream), 1888, oil on canvas, 300 × 400. Paris, Musée d'Orsay.

anonymity they are unified in their nationality and duty to *la patrie*. Clad in their uniforms, wrapped in their standard issue blankets, *égalité* and *fraternité* implicitly coheres the army in its defence of *liberté* against the opposing force. The nearest figures are life size and close to us the spectators. Detaille's naturalism embraces us; it is as if we had just sat up and looked around at our sleeping comrades, equal with them. But the canvas is divided into two. Gentle diagonals zigzag along the line of bayonets and the line of grey-violet clouds to a mass of troops who surge across the sky, spectral figures in the tinted heights, tattered flags streaming in the breeze. These are the ghosts of the triumphant French armies of the past, of whom the sleeping soldiers dream before their decisive battle. In loose terms, *Le Rêve* is an allegory. The armies of the dream are, if not exactly an emblem of, then at least an inspiring allusion to, victory, *gloire* and – I think it can be argued – *revanche*. Detaille's use of allusive metaphor includes the pathetic fallacy, for in the context of *Le Rêve* the new dawn has rousing associations, the memory of which may have prompted Dayot's later and somewhat hyperbolic response to the painting of Châlons.

For *Le Rêve* became a highly celebrated painting, the kind of rallying cry that Detaille had no doubt hoped to create. It immediately had considerable public exposure. First shown at the Salon of 1888, from which it was purchased by the state and hung in the Musée de Luxembourg, it was exhibited at the 1889 Exposition Universelle in the *décennale* section. *Le Rêve* also had a widely broadcast life in printed form, as I shall show. From its first public appearance the painting was recognised as both a major work by Detaille and as a painting of national importance. Responses did, however, take on different nuances. Writing in *Les Lettres et des arts*, an expensively produced periodical for a cultivated readership, Henry Cochin queried whether the image was not too obvious. 'Doesn't this dream of battle strike everyone at very first glance? . . . A work of art ought to leave something to the imagination. Could we not have divined the dream of these sleeping soldiers, without having been shown it?'[99] André Michel's review for the *Gazette des beaux-arts* took a similar view, and gently chided the artist for pretending that such an iconography was innovative: the lithographer Raffet had done much the same fifty years before.[100] But these were élitist quibbles. For *Paris illustré*, with its wide bourgeois circulation, *Le Rêve* was a 'magisterial composition which symbolises the nation's hopes . . . the resumé of all France's glories, from the heroic epochs down to our own days . . . an appeal, a lesson, an act of faith.'[101]

What was the artist's own position? *Le Rêve* was a mid-career gambit based on personal ideology and professional strategy. Although the enemy is not identified in the painting, and those writing about it seem to have respected that anonymity, the implication was that it is Germany. For Detaille, himself a veteran of the Franco–Prussian War, this was personal. His brother, a prisoner of war, had died of smallpox in Berlin in December 1870, although the family was informed only eleven months later.[102] Politically, Detaille was a conservative republican, a friend of Déroulède, and the appearance of the painting at the Salon when Boulanger's popularity was at its height was surely no coincidence. In professional terms, Detaille's reputation had hitherto been based on small-scale military pictures and on vast panoramas reconstructing the engagements of 1870–1. He needed to produce a substantial history painting to raise his status as an artist, and the Boulangist tide gave him his moment. In addition, he was engaged in widening his appeal as an artist, and voicing his nationalist ideology, through the popular media. In 1888, the year *Le Rêve* appeared at the Salon, the publishers Boussod & Valadon published a book, *L'Armée française*, richly illustrated with Detaille's drawings, a nationalist project linking art and the army on which he had been working for years. As noted earlier, Boussod & Valadon were the successors of Goupil & cie, whose reproductions of popular Salon pictures included those of Detaille and de Neuville. They were also, by the 1880s, publishers of illustrated magazines. Among these were *Les Lettres et les arts* and in particular *Paris illustré*, which devoted a whole issue to puffing Detaille's book in September 1888. The firm promoted conservative and nationalist social values: Goupil, as seen, was among the subscribers to the purchase of the Maison de la Dernière Cartouche. These values it targeted at the widest clientele. *L'Armée française*, in which *Le Rêve* was illustrated and described, was published in a two-volume deluxe edition at 2,400 francs, but also in a much cheaper popular edition and as a part-work.[103] Thanks to the institutional backing of both the state and this publishing house, Detaille's painting was given maximum exposure.

Nevertheless, the question of how the ubiquitously circulated *Le Rêve* might best be interpreted was a vexed one, varying between ideological standpoints. What were the

soldiers dreaming about? Texts of widely different kinds offered answers. There were oppositional voices, of course, like Octave Mirbeau. From his humanitarian, anarchist position, he ironised in his review of the 1889 Exposition Universelle that though one might expect them to dream of demobilisation and home Detaille insists that they imagine the glories of the past.[104] In their exhibition reviews Cochin understood that the image of past *gloire* had implications for the future battle, while Michel explained that the spectral soldiers represented the recent past, not the vague 'heroic epochs' that had satisfied *Paris illustré*. Herein lay Detaille's republicanism: his ghosts began with the volunteers of Valmy.[105] Wrongly insisting that they went back to Joan of Arc, *Le Petit Français illustré* may have been inexact about the past, but the boys' paper similarly laid emphasis on the future implicit in *Le Rêve*. War was bad, the article devoted to the picture told its young readers in May 1891, but it was 'a sacred duty', necessary for 'the defence of invaded territory'.[106] Just as the enemy depicted in *Le Rêve* is unidentifiable, so *Le Petit Français illustré* resisted naming them. But the reference to the invasion of *la patrie* drew the young imagination back to the humiliations of 1870 – and shaped the *mentalité* that would respond patriotically in 1914. The paper's article ended by telling boys they could see the painting in the Luxembourg. Within a decade the impact of *Le Rêve* through the medium of print and illustration inspired its own painting: Paul Legrand's *Devant 'Le Rêve' de Detaille*, exhibited at the 1897 SAF (fig. 176). Legrand's picture is loaded with associations, as schoolboys of different classes cluster round a colour print of Detaille's icon, itself surrounded by other prints and illustrations – the president of the Republic, the Russian imperial family, the restored Hôtel de Ville, even perhaps the German victory parade past the Arc de Triomphe in 1871. The role of the elderly amputee, possibly a veteran of the Crimea or another of France's mid-century wars, is ambiguous. Whether Legrand intended him as a warning about the costs of war or as an example of worthy sacrifice, his presence does nothing to deter the boys from their enthusiasm for *Le Rêve*.

At the SNBA in 1891 Dagnan-Bouveret exhibited a canvas simply entitled *Les Conscrits* (fig. 177). Although Dagnan discreetly inscribed it 'Ormoy', the village in his native Franche-Comté where he apparently glimpsed the scene that inspired the painting, the moment represented, like the title, is generic. This specific group of young men has just been conscripted into the army, but they typify the way in which their age group throughout France had been called up to the peace-time colours. Arms linked, they march down the village street, past a woman and child in a doorway, led by a drummer – an older man who would have done his military service – and the *tricolore* carried by a lad who will one day undertake his own. The processional pace of these life-size figures, the clumsy fraternity of their linked arms, the confined space of the dark street, all combine to give Dagnan's painting a predictability, an ubiquity, a combination of the ordinary and the universal which was eloquent. The artist seems to have tried not to assert himself in the painting, to allow the work and its cast the semblance of a life of its own. The texture is fairly rough and dense, so that Dagnan's suave draughtsmanship is lodged unobtrusively in the painting's *faire*. Overall, the colour is rather drab, the browns and greys of a dull provincial village, though some of the jackets and shirts have an individual accent, and from the conscripts' collars shine the *boutonnières* they were given when their enrolment papers were signed.[107] True to its generic nature, *Les Conscrits* presents a variety of French manhood. The young men's faces represent different types – the swarthy, the Jewish, the open peasant – and different moods: eager, blank,

176 Paul Legrand, *Devant 'Le Rêve' de Detaille* (In Front of Detaille's 'The Dream'), 1897, oil on canvas, 134 × 105. Nantes, Musée des Beaux-Arts.

177 Pascal-Adolphe Dagnan-Bouveret, *Les Conscrits* (The Conscripts), 1889, oil on canvas, 170 × 148. Paris, Assemblée Nationale.

determined, anxious. The painting does not disguise the uneasy combination of the dutiful and the melancholic. For *Les Conscrits* matches the grand abstractions of Republican rhetoric – *patrie*, democracy, duty – with a sense of the intimate and the personal: the youth leaving the confines of his village to become a man in, and for, greater France.

Contemporaries interpreted *Les Conscrits* in both national and emotional terms. The combination of these two elements was precisely what gave the painting its great qualities, pronounced Georges Lafenestre in the *Revue des deux mondes*. In his view, Dagnan matched *la hauteur morale* and *l'exactitude vulgaire* in an acute formulation of the patriotic sentiment of rural France. The painting had the grandeur of a great mural, of which it seemed a fragment, a grandeur that elided with the peasant figures 'enhanced and ennobled by the soul of the fatherland which breathes before them in the billowing folds of the sacred flag'.[108] Paul Mantz, writing for *Le Temps*, empathised with the feelings of young men torn from village certainties by externally imposed duty.[109] Interestingly enough, the same response came from an entirely different quarter. *Le Spectateur militaire* also recognised how Dagnan's conscripts 'don't leave their *pays* without regret, but once they are with their regiment, they'll know how to do their duty like all their comrades.'[110] If professional art critics like Lafenestre and Mantz admired the way Dagnan had crafted a canvas which combined naturalist observation with patriotic resonance, others nursed doubts. The novelist Edouard Rod, reviewing the 1891 Salons for the *Gazette des beaux-arts*, found *Les Conscrits* somewhat worthy – but then Rod was Swiss. One retired prefect wrote privately to the Ministre des Beaux-Arts, expressing his anxieties about the signals Dagnan's painting seemed to him to transmit. 'One would think that the artist's intention had been to show how French conscripts feel horror as they leave for the army. In buying his painting, the French government makes it look as if it agrees. Is this really the case, when France has finally glimpsed the hope of *revanche*?'[111] The former prefect had no way of knowing that Dagnan himself had been worried about how his picture would be taken, writing to an engraver friend that fellow artists would probably consider *Les Conscrits* too patriotic and the general public not patriotic enough.[112] The prefect was misinformed, too, about the painting's history. It had not been purchased by the state. After its success at the 1891 SNBA *Les Conscrits* had been bought by a Chicago collector. But when several Republican deputies, among them the Gambettist Antonin Proust and Etienne Dujardin-Beaumetz, argued that it should be hung in the Chambre des Deputés as an iconic image of French patriotic duty, the couturier Worth, the portraits of whose family Dagnan had recently been painting, bought the painting back from the American, and presented it to the state.[113] Nevertheless, the retired prefect had good reason to imply that *Les Conscrits* had become a national picture. Painted in the very year in which the laws on conscription were reformed, won back for France, hanging in the Palais Bourbon (where it remains) at a time when the Franco–Russian alliance gave those who dreamt of *revanche* more plausible hopes, *Les Conscrits* was an image of potent national meaning. Indeed, it was used as such. As widely reproduced as *Le Rêve*, *Les Conscrits* was constantly employed as an icon of republican duty. As late as 1912 it was one of a set of slides, also including Roll's *Le 14 juillet 1880* (see fig. 96), distributed by the Ministère de l'Instruction Publique et des Beaux-Arts as visual aids for French schools. The accompanying text echoed the combination of patriotic duty and melancholy that Lafenestre and Mantz had sensed more than twenty years before.[114] *Les Conscrits* had lasted as a republican icon, probably because it allowed that whisper of the personal and emotive

within the louder, more rhetorical and didactic message of its stock iconography: the woman and baby and the fabric of the village itself standing for *la patrie* to be defended, the democratic duty of manhood to fight for France under the flag of the Republic.

Revanchard nationalism, and the flag-waving and imagery that often accompanied it, was disliked by intellectuals, particularly the young. The rhetoric of paintings such as *Le Rêve* and *Les Conscrits*, and of public monuments of the kind I have considered, was intended at very least to keep fresh the disgrace of *l'année terrible*, even to foster the hope of *revanche*, in the minds of the generations that could not remember 1870–1. But the generation who were in their twenties and thirties during the 1890s were by no means convinced of the value of this inheritance. They were troubled by its implications for the future. Nationalism appeared like a mask that hid the threatening visage of autocracy, rather than a noble adornment of republican virtues. The mechanisms by which nationalist feeling was fostered seemed dangerously populist, mobilised to appeal to the mass instincts of the crowd. In addition, the arrangements the Republic was putting in place to shore up its diplomatic positions, structures which made *revanche* conceivable, involved unwelcome compromises of – if one considered it scrupulously – republican principles. The anonymous 'Sarkis' argued this clearly in *La Plume* in May 1897. The official visit of the Russian foreign minister, Count Muraviev, had been heralded by a profusion of images of him – 'a pink, yellow and faded thing, like an abcess' – pinned 'on newspaper kiosks and wine-shop windows, on Parisian boulevards and in the smallest of small villages'. Here was mass-produced imagery being used as a lever of opinion. 'Sarkis' distrusted this device because it worked: 50,000 had welcomed the count at the Gare de Lyon. Slipping into the jargon of crowd psychology, he described how they 'yelled desires and delirium.' That number, he reminded his readers, was the same as had cheered 'Boulanger-la-Victoire' at the same station when, at the height of his popularity a decade before, the government had tried to sideline him by posting him to Clermont-Ferrand. The theme of the president of the Republic's welcoming speech, that the Franco–Russian alliance meant peace, 'Sarkis' retranslated for *La Plume*'s readers as: 'While this Peace exists, we can never take back Alsace and Lorraine.' His account of the event identified the tension between the rabid activism of the Ligue des Patriotes and the entrenched apathy of establishment Republicanism. He concluded by damning them both. *Revanche* was '*aussi bête qu'un poème de Mallarmé*', while alliance with the Tsar, an autocrat with no concept of liberty, was a denial of republican principles.[115]

One point made by 'Sarkis' typifies a specific fear about nationalism among intellectuals: its appeal to the masses. The army was popular. Its colonial successes, such as the subjugation of Madagascar in 1895, brought back some *gloire* to French arms. So constantly was the army made visible to the nation – through the annual *14 juillet* review and regular parades in garrison towns, through Salon paintings and images in the popular press – that it became a physical embodiment of national vigour once more.[116] But this mass popularity, and the loyalty to the regiment that conscription engendered, troubled intellectuals. For them, the army crushed individuality, threatened the *moi*. In the 1 May 1893 issue of *La Plume* dedicated to anarchism, one Mélas condemned the 'imbecile veneration' of the flag promoted by the army, which 'atrophies [a man's] mind, reduces his individual qualities to *automatism*'.[117] Writing in *La Revue blanche* the year before, Ludovic Malquin had made the same point: the purpose of the army was to

make a man obey. His individuality drummed out of him by the army, he became a citizen, ready to be instructed.[118] This was the common experience of the conscript, especially if he was well educated. One has to remind oneself that one is more than 'a number on the regimental roll and that one once led a life different to that of a brute', wrote Pierre Bonnard to his friend the actor Aurélien Lugné-Poe during his military service over the winter of 1890–1.[119] Bonnard's resentment found pictorial form in a small painting discussed earlier, in Chapter 2 on the crowd (see fig. 76): the spectator is given the vantage point of a soldier in the ranks, looking over his comrades' shoulders to the sergeant and another file behind him. The composition employs naturalism's devices for giving a sense of presence in the fiction of the painting, but only to parody it. The flat patterning of Bonnard's Nabis technique is more than just a matter of stylisation. The repetition of the soldiers' pose, their blue jackets and red trousers, provides both pictorial order and a sense of stultification, underlining the reduction of men to cyphers which Bonnard, Mélas and Malquin resented. Vallotton created a similar image in a different medium. His woodcut *A vingt ans*, made in 1894, used his emphatically reductive method to acutely caricatural effect (fig. 178). The repetitive squads in simple shapes of black and white insist on military order, yet this is subverted by Vallotton's intrusion of risible incident such as flabby physiques, shifty glances and unbuttoned flies. One would expect such a response from an anarchist sympathiser like Vallotton. Ironically, a similar stylistic solution could suit an image which carried an ideologically opposite message. Caran d'Ache's drawing *La Révision* was published in *Psst...!* in September 1898, on the day that Mme Dreyfus appealed for the second time to the Chamber of Deputies for her husband's case to be reviewed (fig. 179). His simplified, black-and-white image bears comparison with Vallotton's. But whereas the Swiss used repetitive figures to jeer at the mindless inflexibility of the military, Caran d'Ache used them as an image of imperturbable order, ready to execute the man he, a determined anti-Dreyfusard, considered guilty of treason.

Despite these examples, artists seem to have been less active than writers in opposing or poking fun at nationalism. The decade had begun, in January 1890, with Lucien Descaves taken to court on forty-five charges of defaming the army and seven of moral outrage lodged against his novel of scurrilous garrison life, *Les Sous-Offs* (The NCOs), published the previous year. Although the prosecution opened its case – with nationalist over-statement – by saying that the novel had been well reviewed in *Le Gazette de Berlin*, Descaves was acquitted. In the event, the case backfired on the slighted Ministère de la Guerre, for by 1892 the novel was in its thirty-sixth printing.[120] The decade ended with performances of Alfred Jarry's play *Ubu enchaîné* (Ubu Enchained), written in 1899, which toyed with the idea of individual liberty in a way which his friend Bonnard would surely have approved. The soldiers insist to their corporal that they are free: they are at liberty to be late and, while they acknowledge that they cannot disobey, they have to do it as free individuals.[121] There was no one better than Jarry at playing the giddy goat with cherished values, whether the Republic's *liberté* or the army's obedience. The history of anti-militarism in literature should not detain me here[122] but several points need to be made, because the opposition to nationalism helps set nationalism in relief. When the younger generation spoke out against established attitudes, attempts were quickly made to silence them. This was the case with Descaves's *Les Sous-Offs*, or with Rémy de Gourmont when he was sacked from his post at the Bibliothèque Nationale after the publication of his article 'Le Joujou patri-

218

178 Félix Vallotton, *A vingt ans* (At Twenty), 1894, woodcut, 18.1 × 22.5. Lausanne, Galerie Vallotton.

179 Caran d'Ache [Emmanuel Poiré], *La Révision* (The Re-Trial), reproduced in *Psst...!*, 3 September 1898. Paris, Bibliothèque Nationale de France.

otisme' in the *Mercure de France* of April 1891. Gourmont's argument was openly anti-*revanche*. Lausanne and Walloon Belgium are more 'French' than Alsace, but France does not blub for them 'like a little girl who has dropped her bread and jam the nice side down'. Although nationalists dismiss the Germans as barbarians, in fields such as philosophy and music they are superior to the French. France is superior in art and literature but, he went on, when do French patriots ever praise Odilon Redon or Jules Laforgue?[123] This was the young intellectuals' argument against conservative republicanism and the nationalist right: lack of cultural imagination, let alone respect for the avant-garde.

The right, of course, retaliated in kind. Detaille wrote the preface to Albert Guillaume's amusing text and drawings about military service, *Mes 28 jours*, published in 1899. The military painter admitted that the average French conscript lacked the martial presence of a Grenadier Guard but, he wrote, setting his sights on a specific opponent: 'I defy the most hardened "intellectual" not to feel a tear in his eye when saluting the Flag that makes these little men into giants!'[124] Detaille's rousing comment calls to mind the effect that paintings like Dagnan's *Les Conscrits* and his own *Le Rêve* sought to evoke in their spectators. And it was perhaps the very currency of that kind of art, its ubiquity through print, photograph and illustration, and the weight of the values that it promoted, that, compounded, stifled the coherent articulation of an anti-*revanchard* position in the visual arts. Two other fragments bring this out. In January 1892 the comic writer Pierre Veber published a short story in the *Revue blanche*. A young academic, intellectual but physically feeble, consults a doctor about his impotence. Sitting in the waiting room, he picks up a brochure about the spa of Plombières.

The text becomes a stream of consciousness: 'Is it far, Plombières? . . . near the Vosges, surely . . . frontier . . . Ah! *la Revanche*! . . . Detaille, battalions in the mud, defeat (or victory, which comes to the same thing for the thinking man).'[125] Irony also came to Jules Renard, who enjoyed his *28 jours*, as he asked Lucien Descaves – of course! – to write to him at his regiment: 'Your good wishes will prevent me having dreams Detaille might have painted.'[126] The fact that Detaille – what he painted, what he stood for – loomed large and present in the imagination even of those who were hardly his natural ideological allies tells us how powerful was the resonance of nationalist art. So dominant was that kind of imagery that pictorial counter-attacks amounted to little more than sniping. The imagery of nationalism and *revanche* held the line.

The Costs of Ambiguity

As demonstrated at the beginning of this chapter, evidence can be marshalled to make a strong case that during the 1890s *revanche* against Germany was not a viable option for France. It was not a leading issue in mainstream Republican politics, a framework for diplomatic negotiation or a practical objective for military planners. But I have attempted to demonstrate that, despite this, an insistently nationalist imagery flourished throughout the decade, in the widest possible range of media and with support from various and not necessarily allied groupings: publishing interests, municipal councils, the Ligue des Patriotes, even the state itself. Given this primarily visual evidence, I believe we do well to avoid overgeneralised denials of the role *revanche* played in the public imagination and to a certain extent in public policy during the 1890s.

The patterns and examples I have discussed do not fall easily into shapes that explain with any degree of exactitude towards whom these paintings, monuments and ephemera were directed. Sometimes they were at the service of right-wing nationalists. Both Detaille and Delahaye seem to have been close to the *revanchard* hostility to Germany at the core of Déroulède's Ligue des Patriotes. At others they were at the service of local interests, be they Mulhouse's use of culture as a mute protest against 'occupation' or Pantin's perceived municipal need to push vigorous *revanchard* images at its citizenry. Motives for producing or supporting such art could be episodic, sparked by an incident like the Schnaebelé affair or encouraged by an event such as the state visit of the Tsar. They could also be opportunistic and apparently contradictory, as was arguably the case with Arthur Meyer's contribution to the purchase of the Maison de la Dernière Cartouche, a tactical ploy to show that a Jew could support the army at the height of the Dreyfus Affair. The paintings, sculptures and other work I have considered had multiple purposes. They might assuage nationalist or local pride, satisfy the egos or fantasies of nationalist leaders, breathe confidence into the nation by lauding French *gloire*. Collectively, the very volume of imagery kept up a level of pressure. It spoke constantly and insistently in its many voices – paint and print, bronze and stone – of powerful, emotive forces in human experience: bravery and loss, grief and memory, death and glory. Some intended those voices to be heard; others, I think, did not conceive of the effect such voices might have. Of course, the message given by the paintings and the monuments was open to wide interpretation. To one person an image might seem to speak soberly about the citizen's duty to defend *la patrie*; to another it could cry *revanche*. From our position of hindsight we should respect the ambiguities that surrounded this kind of art.

Gambetta himself, a founding father of the Republic, had set the tone with his dictum *y penser toujours, n'en parler jamais*. It was a recipe for the nuanced, even the mute, attitude, which in works of art tended to take the form of ambiguity. Few of those I have considered are direct in their reading. Willette's print *Revanche*! may be, but there can be no single interpretation of Detaille's canvas *Le Rêve* or Gallé's table *Le Rhin*. The imagery's power, then, lay in a combination of factors: its ubiquity, the depth of the emotions it addressed and its flexibility, the way in which one interpretation could easily mutate into another.

This ambiguity had another dimension. It played with the perplexing dimension of time. It ran from the past into the present and from the present into the future. Ambiguities played over time and with time. A painting might look back to an episode from the battles of 1870, to provide a dramatic reconstruction for the public of the 1890s. But was its impact simply to stir memories of a past war, or to stir fresh emotions twenty years on, or to project the imagination into the future by urging a turning of the tables? *Le Rêve*'s spectral warriors evoke the flow of recent French history, stretching back to the specific date of 1792. First exhibited in 1888, the painting depicts soldiers who could be taken as soldiers of the present, but that 'today' could be almost constantly renewed, hence the picture's appearance as an educational slide in 1912. Memory could be reheated as political and ideological circumstances changed, and imagery, in particular the colour and immediacy of descriptive painting, harnessed to new times. The subject of the Froeschwiller cavalry charge, commissioned by Boulanger from Morot in 1887, took on new meaning when it was painted again by Pierre-Victor Robiquet for the Salon of 1911.[127] Then, with the war clouds gathering over Europe and tensions far higher than they had been in the late 1880s, representing the heroic self-sacrifice of those *cuirassiers* was less a memorial than a call to arms.

This pressure – the teaching, the boys' adventure comics, the *mairie* decorations and the constant visual reminders of past *gloire* and promptings of future *revanche* – set the tone for the patriotism that reached its climax in the declarations of war in August 1914. At the least, some idea of a future war needed to be promoted by the Republic in order to sustain conscription. If young men were going to be called to the colours every year in their tens of thousands, they needed motivation, some goal for their training. The state's consistent if generally discreet sustaining of monuments and military painting met this need, perhaps semi-consciously. But that process, necessary as it may have been in the 1890s, made commitments, mortgaged the future of the nation's young men. In a sense, cultivating the *mentalité* of *revanche*, however discreetly it was done, was similar to the practical military planning of mobilisation orders, on which modern industrialised war hinged. Both existed as schemas for future action in the abstract. But once they had been put into action, nothing could stop them becoming reality. That subtly but steadily nurtured *mentalité* was paid for between 1914 and 1918 with a butcher's bill far too rich in lives. Let me list just a few names which will be familiar from these pages. The painter and collector Etienne Moreau-Nélaton's only son was killed. Baron Denys Cochin, politician and *mécène*, lost two of his three sons, his son-in-law and a nephew. The painter Henri Daras came from a military family. Two of his sons were killed, and the other two wounded, one an amputee, while among their du Paty du Clam cousins – a name resonant from the Dreyfus Affair – one son was killed and another an amputee. Dr Variot, the paediatrician, lost both sons, while Dagnan-Bouveret's son, an army doctor, died of overwork.[128]

The avant-garde, as noted, flinched from the pressure that *revanchard* imagery applied. Perhaps one reason why progressive artists chose not to deal with this kind of imagery goes beyond rejection of the naturalist styles that the establishment promoted, beyond a loosely anarchist anti-militarism. The avant-garde's alienation from the military may also have been because the army did not seem involved with modernity. From the vantage point of the young radical, the army must have appeared tied to old systems of caste, burdened with dead resentments over past wars. In fact, the army was tightly involved with modernisation and the industrialisation of war. In a mean obituary of Helmuth von Moltke, the architect of the German victories in 1870, published in the conservative Catholic *La Croix* in April 1891, General Lewal had sneered that Moltke had been no battlefield commander but 'an industrialist soldier of the first rank'.[129] That judgement, meant as a dismissal, was ironically both accurate and prophetic. Moltke's mastery of the forces of modernity in war – speed, communication, precision – had introduced a new element to combat that the French found almost impossible to match.

The final irony again needs to be understood across the passage of time. Jump forward to the spring of 1940, and the German invasion of France that brought the Third Republic to an ignominious close. One of the leading architects of that mighty campaign was General Heinz Guderian, the first great commander of massed armour. Guderian had been brought up as a boy during the 1890s in Colmar, in 'occupied' Alsace, and his first posting as a junior officer in 1907 was to Bitche, in Lorraine. Although of impeccably Prussian stock, Guderian's formative years had been passed on 'French' soil. In May 1940 it was Guderian's XIX Panzer Corps which unhinged the French army by crossing the Meuse at Sedan. Its 10th Panzer Division forced the river at Bazeilles, near the Maison de la Dernière Cartouche, to take the commanding heights of La Marfée on the south bank. It had been from La Marfée that seventy years before Moltke had overseen the victory of Sedan, the battle that had started a grim cycle. Defeat of Napoleon III's army at Sedan in 1870 led immediately to the proclamation of the Third Republic; three generations later, finally united under the flag of *revanche*, it was the Third Republic that had survived and triumphed in La Grande Guerre of 1914–18; and with its forces brushed aside at Sedan in 1940 the Third Republic was doomed. The images of mourning, record and *revanche* created in the 1890s have their place in a linked chain of war and memory spanning four generations.

My arguments and analyses have tried to explore some crossroads where history and art history meet. By choosing four crucial social debates in France during the 1890s and looking closely at the imagery that intersected with them, I have been experimenting with how one might think about and write about the play of visual culture within the fabric of historical debate. In terms of history the four themes that have been tested produce different results. In the case of the crowd, the imagery seems to elide closely with contemporary discourse. Although the subjects of, for instance, Paul Buffet's *Le Défilé de la hâche* or Jean-Jacques Scherrer's *Charlotte Corday* (see figs 71, 74) are imaginary constructions of scenes from literature and history, both convey the fear of the collapse of social order that so taxed the Third Republic and its bourgeois power base. Such images seem as symptomatic of the anxieties and diagnoses of the period as the socio-psychological analyses of specialists such as Gustave LeBon and Gabriel Tarde. They also dovetail with modern historical writing about the late nineteenth-century crowd and its theorists, bringing contemporary visual evidence to reinforce the studies of scholars such as Robert Nye and Susanna Barrows. With *revanche*, on the other hand, I have put forward evidence which I hope strongly argues that historians need to revise their views. Imagery that either insistently clamoured for *revanche* or that could be interpreted as discreetly promoting it was prevalent throughout the 1890s. In that case, *revanche* was not the dormant issue it is often claimed to have been. As has been seen, these totems took multiple forms: public monument, children's illustration, sabre-rattling picture, elaborate decorative object and so on. The proliferation of this imagery, its accessibility to all ages and classes, gave it a universality that should not be down-played. The imagery of *revanche* may have been a clarion call to a fiercely nationalist minority, but to the mass of citizens it was a steady reminder of a patriotic issue painfully unresolved, a visual presence or pictorial drone – so common or oblique as to pass almost unnoticed – but which never entirely went away. Images kept *revanche* alive, and by their persistent universality helped consolidate the passion of a minority within the more passive mentality of the majority. *Revanche*, one might say, acted like a low-grade contagion, with imagery the bacteria that spread it. It might lie dormant in the body politic, but once infected it could, in certain conditions, swiftly be inflamed. In both these cases one is reminded, with hindsight, that the 1890s was the mid-point between the traumatic foundation of the Third Republic in 1870 and the outbreak of war in 1914, when crowds rallied behind the idea of nation to defend *la patrie* and win back Alsace-Lorraine.

With the other issues of the body and religion the findings are not as clear-cut. Whether France was decadent or not and, if so, how that debilitating condition could be treated, was not a subject on which opinion was going to coalesce as easily as social order and *revanchisme*. But in the broadest sense the body was of political concern. The

readiness of a woman to bear children; the fitness of a man for fatherhood, work and military service; the dangers of transgressive sexuality, clandestine and unproductive; adultery's menace to morality and family; the health and hygiene of the proletarian child, as well as the physical and moral welfare of the working classes: these were all pressing public business. It was in the interests of the Republic to promote best practice, and to do so it mobilised the visual arts. These issues, however, were so fundamental to the life of the nation that state commissions were not always needed for artists to respond to the body: it was their professional material, after all. Neither the socially conservative Renoir, from skilled working-class stock, nor the consciously perverse Lautrec, from the provincial aristocracy, needed prompting to use their work to engage with debates about health and decadence. Religion, that other sphere which sensitively encompassed the public and the private, was an issue that created complex and national divisions. On close analysis, the evidence of visual culture shows precisely that. Ambiguities abound. It is not known how Muenier intended his *La Leçon de catéchisme* (fig. 105) to be interpreted, and even if his views were clearly stated his contemporaries would have taken whatever position – Catholic, *laïque*, unconcerned – suited themselves. That said, one can usefully suggest ways in which making art effected conjunctions with contemporary religious trends, whether it is Tissot's with the Dominicans or Moreau-Nélaton's with Social Catholicism. That religion could still make the French fractious in the 1890s is not at issue. My case is that the period's imagery is indicative of the subtle patterns of taking sides, conveying one's beliefs, jumping on bandwagons or engaging with moral issues which were of general concern at the end of the nineteenth century.

As for the history of art, it seems to me a useful exercise to take multiple points of vantage. I have considered the canonical 'avant-garde' only when their works joined the debates under scrutiny. It is illuminating to see Degas and Renoir's work in terms of the healthy and degenerate body, to consider Pissarro's boulevard pictures in relation to crowd psychology, to recognise the sharply critical attitude of some of Bonnard or Vallotton's images to discipline and public order. It is significant that the young Pablo Picasso, arriving in Paris for the first time to visit the 1900 Exposition Universelle, rapidly responded in his work to the issues of degeneration, the crowd and religion, *revanche* being out of his range as a Spaniard. But an artist did not have to use radical means of expression to articulate oppositional opinions. Jules Adler is a case in point. His canvases of striking coal miners and the downtrodden urban proletariat (figs 73, 97) are unexceptional in their execution, but hard-hitting in their exposure of the Republic's failure to resolve *la question sociale*. Here is the point to make some larger claims. Distinguishing between the work of independent artists who operated through dealers and private shows to assert their modernity and artists who were content to show their work in the establishment Salons is conventional enough, and I have drawn them myself in this book. But some consistencies should be acknowledged between those apparently divergent camps. In much of the art from the 1890s that I have considered there is an important performative dimension. One needs to recall what is often forgotten: that artists were working from lived and imagined experience. Works as dif-ferent as Degas's *Jeune Femme sur un lit*, Adler's *Les Las*, Cottet's *Le Repas d'adieux* or Delahaye's *Mademoiselle Fifi* (figs 52, 97, 112, 156) are all imaginative acts. They visualise what it is like to see this, be like that, have these emotions. This is played out by the artist as he makes the work, which in turn encourages the spectator to re-imagine the invented

scene. Spectators for these works would have been varied, of course. Degas's pastel was made for the private collector, the others in the first instance for the heterogeneous Salon public. As fragments of lived experience invented as art and engaged with the flux of wider social debate, works of art like these dealt with the matter of the everyday: the patriotic, the fearful, the erotic, the moral, the religious. I have tried to demonstrate how artists made work that engaged with such fundamentals of human experience and imagination, and how they produced art for the functionary and for the voluptuary, for the Catholic industrialist, monarchist colonel, republican doctor and nationalist shopkeeper.

The history of art, I believe, needs to make itself more comfortable with dealing with art made in direct dialogue with the everyday, expressive of common experiences and states of mind. One should be prepared to read works of art in ways that take into account how they exist not only as discrete museum objects but also as expressions of shared social experience, attuned to the tenor of their time. Another dimension needs to be added to how work is analysed. Take two pictures which might be explained as studies of the figure, as exercises in foreshortening, in the articulation of a personal *graphisme*, as the male artist's functional use of the subservient female model. I have tried to go further, to acknowledge in these two cases an erotic impulse, explaining how Lautrec made paintings specifically about a certain kind of furtive masculine gaze, or Degas drew – and exhibited – a pose resonant of the sexual act (figs 34, 41). André Devambez's *La Charge* (fig. 99) is a completely different kind of work. But, again, one needs to go further than assessing it as a painted representation of a scene of crowd control in the modern metropolis. For its deliberately destabilising use of vertigo, its play of order and chaos, light and dark, are more than just compositional decisions; they project a sense of right and wrong, to moral purpose.

We as modern viewers need to see beyond the constrictions of modernism – preferring the avant-garde work to the Salon picture, privileging the individuality enshrined in the canon – and allow in ourselves a wider range of response, sensitive to the particular textures of the historical moment, conscious of lived experience, willing to embrace readings that acknowledge the sensuous, the moral or the spiritual.

Artists in France during the 1890s shared a range of social experience that was particular to their time and place. Each wanted to communicate this, to comment on it, to draw his audience's attention to it because, to the artist, the public is or should be aware of this: the deep fatigue of the proletariat, the crushing sense of peril and uplifting sense of hope in Breton fisherfolk, the heroism of the cavalry charge, the commanding presence of the cardinal, the delight in a newborn baby. Whether public or private imagery, most art in the 1890s still reached out wholeheartedly to human experience. It was work that belonged within, and was made as part of, the social debates of a fearful, highly charged period. The enormous variety of works of art that I have dealt with in these chapters are about feeling the world, making sense of this rapidly changing place, using the media the artist knew best, but also about how to bring into play notions and perceptions from the wider social world: anxiety about the crowd, a Darwinian diagnosis, a belief in God, a moment of lust, the nostalgia of the exile, loyalty to regiment, a resentment of Germany, the thrill of the Eiffel Tower. Within that maze of fears and passions, optimism and doubt, can be traced the modernity particular to France in the 1890s.

INTRODUCTION

1 Michalski, 1998, p. 22; *Quand Paris dansait*, 1989, p. 58; Mayeur/Rebérioux, 1984 (1987 ed.), p. 135.

2 'Danger public', *Le Gaulois*, 23 December 1889, in Maupassant, 1980, p. 388: *On a peur. On a peur de tout le monde, et tout le monde a peur sous ce régime. . . . Peur de l'électeur, peur des villes, peur des campagnes, peur des majorités.* Unless otherwise stated, all translations are mine.

3 Mayeur/Rebérioux, 1984 (1987 ed.), pp. 147, 204.

4 Huret, 1891 (1999 ed.), p. 18.

5 Nordau, 1895, p. 131.

6 Letter of 9 October 1890, Saint Germain-en-Laye, Musée départmental du Prieuré (I am grateful to Belinda Thomson for this reference); letter of 7 February 1890, Geffroy, 1924, pp. 232–3: *les hostilités . . . la guerre . . . le représentant d'une grande et féconde évolution.*

7 Uzanne, 1890, p. 207; Jammes, 1898, p. 386.

8 Flat, June 1893, p. 416: *une part de nos âmes modernes, éprise de complexités psychologiques et de sentimentalisme raffiné.*

9 D. Silverman, 1989, p. 78.

10 Barrows, 1981, pp. 120–1.

11 D. Silverman, 1989, p. 81.

12 Bénédite, August 1898, p. 130: *Dans quel monde incohérent et agité sommes-nous descendons! Quel Olympe de la Salpêtrière ou de Bicêtre! Rien de calme, rien de posé, rien d'assis. Tout le monde est en mouvement, dans une sorte de danse de Sainte-Guy générale. Ici un groupe s'embrasse avec effusion; là une femme courte risque de tout renversé; plus loin un grand gaillard brandit une lourde hâche, tandis qu'un militaire . . . vous menace de son revolver . . . C'est un ballet perpétuel d'épileptiques ou d'aliénés.*

13 'Les Isolés: Vincent van Gogh', *Mercure de France*, I, no. 1, January 1890, pp. 24–9; Aurier, 1995, pp. 69–70: *Un exalté . . . toujours relevant presque la pathologie . . . un hyperesthétique, nettement symptômatisé, percevant avec des intensités anormales.*

14 Simpson, 1999, p. 138, 139 n. 60.

15 *Le Phare de la Loire*, 10 August 1890 (Schwob, 1981, p. 68): *Nous vivons dans un terrible siècle où on n'a presque plus le temps de penser.*

16 Baedeker, 1900, p. 27; Weber, 1986, p. 71.

17 Morice, 1897, pp. 51–2.

18 Weber, 1986, p. 194.

19 Raoul Ponchon, *Le Journal*, 22 March 1897, in Velter, ed., 1996, pp. 416–19.

20 Thiébault-Sisson, 1897, pp. 100–1: *Au temps présent, on vit double. A notre activité décuplé, un nervosisme exalté correspond. Il nous faut tout, sur l'heure, sous la main.*

21 D. Silverman, 1989, pp. 175–8; *La Semeuse . . .*, 1998.

22 I am grateful to Belinda Thomson for this information.

23 *Le Triomphe des mairies*, 1986–7, pp. 345–7.

ONE PUBLIC HEALTH AND PRIVATE DESIRE

1 Castex/Bellefroid (eds), 1968, p. 40.

2 Gonse, 1889, p. 356: *légère, grise et estompée . . . quand souffle le vent et . . . son sommet plonge dans la nuée . . . mâle et rude.*

3 *Félicien Rops*, 1998, p. 254, fig. 263; p. 151, fig. 151.

4 *1889*, 1989, p. 202.

5 *Yvette Guilbert*, 1994, p. 91.

6 Harris, 1989, pp. 76–8; Nye, 1993, p. 77; Shapiro, 1996, pp. 16–17.

7 Fouillée, 1895, pp. 800, 813, 816–21: *un darwinisme à rebours.*

8 Nordau, 1892 (1895, p. 11).

9 Ibid., pp. 15, 38, 35.

10 Ibid., pp. 17, 22; see Harris, 1989, pp. 84–5.

11 Nye, 1993, pp. 77–8.

12 Nion, 1891, pp. 151–2: *Dans dix-huit ans si la progression décroissante se maintient, normalement il y aura deux soldats allemands contre un soldat français.*

13 Garb, 1998, pp. 55–6.

14 Nye, 1993, p. 220.

15 Henning Eichberg, 'Forward Race and the Laughter of Pygmies: on Olympic Sport', in Teich/Porter (eds), 1990, pp. 117–18, 121.

16 Callebat, 1988, pp. 169–71, 179. See also Eichberg, 'Forward Race', in Teich/Porter (eds), 1990, pp. 115–31.

17 Callebat, 1988, pp. 115–16.

18 Marx, July 1897, p. 242: *saine . . . la contagion de la moderne neurasthénie.*

19 Bénédite, 1899 (1998, pp. 14, 27, 12–13).

20 Marx, July 1895, p. 18; Natanson, 15 May 1895, p. 471.

21 Pottier, June 1892, pp. 458–9.

22 Pécaut/Baude, 1885, pp. 61–2.

23 Weiss, 1897, p. 4.

24 Coppier/Dampt, 1930, p. 16; Prouvé, 1958, p. 49.

25 Garb, 1985; House, 1985.

26 Geffroy, 1888: *des maigres filles vite poussées, hâtivement pubères . . . des villes et des métiers ardueux.* Anon., in *L'Echo du Nord*, 29 March 1888, in Rewald, 1948, p. 127: *Des lamentables squelettes rachitiques.*

27 Geffroy, 1892.

28 *Le Progrès de l'Est*, 6 May 1890, in *Peinture et art nouveau*, 1999, p. 139: *C'est bien une fille de notre grand Paris; elle est laide encore, ayant les traits anguleux, et, dans tout son être, la gracilité de l'âge ingrat. Mais viennent ses dix-huit ans, et elle sera jolie – ou pire – la maigriotte faubourienne. Pour quels atours quittera-t-elle son tablier de toile et ses pitoyables bottines – ces bottines mal boutonnées, où dansent ses petits pieds? C'est à cela qu'elle songe confusément sans doute, en présence de l'immense cité étalée devant elle et où elle doit trouver le revanche que lui réserve l'avenir.*

29 E. de M., *La Liberté*, 26 June 1889: A. Dalligny, *Le Journal des arts*, 5 July 1889; L. Roger-Milès, *L'Evénement*, 23 June 1889, in *Monet – Rodin*, 1989–90, pp. 225–6, 235: *un libertinage exalté . . . les curiosités malsaines; La passion dans l'amour, et non dans le vice; c'est la formule génétique de toutes les espèces, et ce n'est nullement l'acceptation malsaine inventée par les individus.*

30 Rosario, 1997, p. 84.

31 Ibid., pp. 100, 89–93.

32 Casselaer, 1986, pp. 6–8.

33 Julien Chevalier, *Inversion sexuelle*, Paris, 1893, p. 245 (quoted ibid., p. 14).

34 Taxil, 1891, pp. 248–9.

35 X., 1891, p. 319.

36 Souillac, 1889, pp. i, vii; Phillip Dennis Cate, 'Prints Abound: Paris in the 1890s', in *Prints Abound*, Washington, 2000–1, pp. 38–9. I am grateful to Dennis Cate for bringing this material to my attention.

37 Jourdain/Adhémar, 1952, p. 38; Joyant, II, 1927, p. 255.

38 Dortu, 1971, Painting 436, 439; 438, 598; 437, 545.

39 R. Thomson, 2002.

40 Taxil, 1891, p. 263: *La tribade, en quête d'une de ses pareilles, a un signe distinctif: c'est le magnifique caniche, frisé, pomponné, bichonné, enrubanné parfois, qui l'accompagne dans ses promenades, à pied ou en voiture. Aux Champs-Elysées, l'observateur remarque aisément le manège des élégantes lesbiennes à la recherche d'une camarade de vice. Voici un équipage attelé superbement: dans la voiture, une femme seule, en toilette plus ou moins luxueuse, avec l'inévitable caniche auprès d'elle. Cette femme, en descendant de la place de l'Etoile, regarde avec attention les promeneuses à pied, principalement entre le rond-point et la place de la Concorde. Une promeneuse voit la femme en caniche et croise son regard avec le sien, tout en exécutant un rapide mouvement de la langue et des lèvres; c'est le signe conventionnel, adopté entre tribades, pour dire: 'Je suis pour femme'.*

41 *Van Gogh and the Birth of Cloisonnism*, 1981, no. 81, figs 91–2.

42 Cate, 'Prints Abound', in *Prints Abound*, Washington, 2000–1, p. 35; McManners, 1972, p. 123.

43 Paul Richer/Jean-Martin Charcot, 'Note sur l'anatomie morphologique de la région lombaire: sillon lombaire médian', *La Nouvelle Iconographie de la Salpêtrière*, I, 1888, pp. 13–15; quoted in D. L. Silverman, 1989, p. 94.

44 *A notre ami Bigand*, 1992, p. 87: *J'ai commencé un portrait de femme nue, mais absolument vrai, et non pas comme Lefebvre, Carolus-Duran du nu rosé, ou fardé, mais de la chair, du sang, de la couleur, du poil, de la vie: point une tête banale, la tête de ma modèle, point des pieds de convention copiés de l'antique, mais ses vrais pieds.*

45 Bernier, 1887, p. 239.

46 Arsène Alexandre, *Paris*, 23 July 1887, quoted in *A notre ami Bigand*, 1992, p. 87. The surviving photograph of this lost work seems to have been taken either before the fan was painted on or after it was removed.

47 De la Faille, 1970, nos 329, 330, 1404.

48 Huysmans, 1887, p. 54.

49 Guisan/Jakubec (eds), I, 1973, letter of 4 May 1893. The 1894 painting, *Le Cadavre*, is in the Musée de Grenoble.

50 Natanson, 1948, pp. 168–9.

51 Prochasson, 1999, pp. 49–50 (journal entry of 13 May 1897).

52 Renard, 1892 (1957 ed.), pp. 70–2.

53 Davray, 1890, p. 126.

54 Taxil, 1891, pp. 229–42.

55 Retté, 1891, p. 296: *amoureusement peint*; Gauthier-Villars, 1891, p. 112: *Il caresse avec amour un virginal torse dévêtu.*

56 Geffroy, 1894, p. 383: *au corps si présent sous le corsage et la jupe de grosse étoffe.*

57 *L'Art du nu*, 1997–8, p. 104.

58 Mirbeau, 1900 (1906 ed., p. 52): *presque une amie ou une complice, souvent une esclave.*

59 Manet, 1979, p. 132 (17 September 1897): *C'est horrible! Tout de même il faut du courage pour se marier avec cela!*

60 *L'Evénement*, 2 September 1892, in Schwartz, 1998, pp. 67–8.

61 Rachilde, 1887, ch. 7.

62 Barrès, I, 1929, p. 118 (June 1896–September 1897).

63 Goncourt, 1989, p. 420 (2 May 1890).

64 E.g. Louÿs/de Tinan, 1995, pp. 238–9 (letter CII, 23 March 1897).

65 Poictevin, 1889 (1991 ed., p. 126).

66 R. Thomson, 1988, pp. 130–1; *Degas*, 1988–9, p. 385.

67 R. Thomson, 1988, p. 132.

68 E.g. *Degas*, 1988–9, no. 250.

69 Louÿs, 2000, p. 85; anon., 1884, p. 73.

70 Letter to Boldini, August 1889, in *Degas inédit*, 1989, p. 418.

71 Goncourt, 1989, p. 309 (10 August 1889): *une couleur qui est l'annonce de vilains choses*; Mirbeau, 1888 (1977 ed., p. 88).

72 Nordau, 1892 (1895 ed., pp. 28–9).

73 *Rodin's Monument to Victor Hugo*, 1998–9, pp. 97–9.

74 *Rodin en 1900*, 2001, no. 67, p. 186; p. 424. I am grateful to Antoinette Le Normand-Romain for confirming this with me in conversation. See also Lampert, 1986, p. 121.

75 François-Rupert *Carabin*, 1993, p. 32.

76 Ibid., 1993, no. 1.

77 Champaubert, 1896, p. 2: *la courbe adorable du dos . . . les ombres mystérieuses des cuisses.*

78 Huysmans, 1891 (1978 ed. p. 198).

79 *Carabin*, 1993, no. 5.

80 Nordau, 1892 (1895 ed., p. 11).

81 Gallé, 1897, p. 247: *corps de soeur et d'épouse. . . . esclaves dégradées.*

82 Monnier, 1985, n. 109.

83 Falguière's life-size sculpture had been exhibited in various

forms at the Salons of the 1880s: plaster, 1884; bronze, 1885; marble, 1888.

84 *Carabin, L'Oeuvre* 1974, nos 151, 168.
85 Dan-Léon, 1902, p. 112: *rendre à nos mains, à nos doigts, la même joie qu'à nos yeux.*
86 Louÿs, 1898.
87 Guisan/Jakubec (eds), I, 1973, letter 125, pp. 186–7: *avec qui je m'entendrai sans peine ... moi à mon travail, elle à son intérieur, ce sera très raisonnable.*
88 Ibid., letter 126, p. 188.
89 *Vallotton, Le très singulier,* 2001, no. 13 (1897); *Félix Vallotton,* 1991–2, fig. 160, p. 134 (1898).
90 E.g. *Femme enfilant ses bas* (Woman pulling on her Stockings; 1893); *Bonnard,* 1998, no. 6.
91 For Bonnard's work on *Parallèlement,* see *Pierre Bonnard,* 1989–90, pp. 162–72; the *Séguidille* illustration is repr. p. 168.
92 *Bonnard,* 1998, no. 11 and fig. 40, p. 84.
93 Alain Corbin, in M. Perrot (ed.), 1990, pp. 605–6.
94 For instance 8 May, 12 June, 7 August 1896: Steinlen, 1980, pp. 29, 33, 39.
95 Goujon, 2002, e.g., pp. 45–6, 54.
96 Natanson, 1948, p. 176.
97 Bernard, 1900, p. 102 (19 February 1899): *Pourquoi voulez-vous qu'un Président de la République n'ait pas eu ses petites faiblesses comme les autres?*
98 Chausson, letter of June 1897: Barricelli/Weinstein, 1955, p. 92.
99 Zola, 1898 (1968 ed., p. 1239): *Il lui semblait entendre un craquement formidable, la famille bourgeoise qui s'effondrait: le père chez une fille, la mère aux bras d'un amant, le frère et la soeur sachant tout ... les tortures, les misères physiologiques et morales.*
100 Harris, 1989, pp. 236–7.
101 Gausseron, 1892, p. 301: *les laides perspectives de la vie ... les principaux états psychologiques ... délicat anatomiste de l'âme découvre et étale avec sa plume pour scalpel.*
102 Robichez, 1978, p. 283: *manifestations pathologiques d'un cerveau dérangé.*
103 Mourre, 1900, p. 54.
104 Rambosson, 1895, p. 259: *Ce livre n'est pas immoral car il n'y est question que d'adultères.*
105 Huysmans, 1891 (1978, pp. 154–5: *un poisson de la dernière heure, une viande molle et froide ... des lentilles mortes, sans doute tuées par l'insecticide ... d'anciens pruneaux dont le jus sentait le moisi.*
106 *De Corot aux impressionnistes,* 1991, no. 287, p. 212.
107 Natanson, *Revue blanche,* 1 January 1899, in Guison/Jakubec, I, 1973, pp. 253–5: *la violence tragique d'une tache noire ... la naïveté et le ridicule, l'hypocrisie et le mensonge, la cruauté et jusqu'à ce goût de mort qui est dans notre conception de l'amour.*
108 Geffroy, *Le Journal,* 15 March 1899, in ibid., p. 258.
109 Renard, 1935, p. 281 (9 June 1897): *Lettre. Il me faudrait un petit adultère, oui, une courte passionnette pour une femme charmante. Vous n'auriez pas ça, des fois, ou chez vos amis, ou chez vous?*

TWO PICTURING AND POLICING THE CROWD

1 Goncourt, 1989, III, p. 418 (27 April 1890): *Des Barbares ... par les ouvriers ... comme agents de destruction dans les sociétés modernes.*
2 Herzl, 1995, pp. 276–7; Charle, 1998, pp. 10–11.
3 Huysmans, 1977, p. 166 (Letter 80, 27 May 1889): *La physionomie de la foule. Il y a comme un je m'enfoutisme;* Goncourt, 1989, III, p. 311 (16 August 1889): *la grosse joie bestiale.*
4 Mirbeau, 10 June 1889: *un tumulte de joie.*
5 Huysmans, 1977, p. 166: *des cataclysmes à venir;* Goncourt, 1989, III, p. 272 (20 May 1889).
6 R. Thomson, 1982.
7 Nye, 1975, pp. 74–5.
8 Ibid., pp. 44–5.
9 Ibid., p. 8.
10 Ibid., pp. 45, 47.
11 Barrows, 1981, p. 169.
12 Hippolyte Bernheim in *Revue de l'hypnotisme,* 4, 1890; see Harris, 1989, p. 183.
13 LeBon, 1896, p. 128.
14 Ibid., pp. xiv, xv, 19.
15 Ibid., p. xvii.
16 Ibid., p. 2.
17 Ibid., pp. 2, 119.
18 Ibid., pp. 39, 20.
19 Barrows, 1981, pp. 140–2.
20 Zola, 1898 (1968 ed., 7, p. 1493).
21 Mauclair, 'Du Symbole', 1894, pp. 81–2.
22 LeBon, 1896, p. 13.
23 Adam, August 1896, p. 110: *cette splendide et première étude de l'âme des foules.*
24 LeBon, 1896, pp. 21, 35; Barrows, 1981, p. 47.
25 Barrows, 1981, p. 144.
26 Agulhon, 1979.
27 Mariaux, 1993.
28 I am grateful to Patricia Leighten for this information.
29 Haudidier, 1994, p. 29.
30 LeBon, 1896, pp. 43, 63–4.
31 Prochasson, 1999, p. 140.
32 *L'Assiette au beurre,* no. 153, 1904; see Pernoud, 1999, p. 110.
33 Robichon, 1998, p. 84.
34 LeBon, 1896, pp. 126–7.
35 For these programmes see *Le Triomphe des mairies,* 1986–7, and O'Mahony, 1997; for Toulouse in particular see R. Thomson, 1998.
36 *Le Triomphe des mairies,* 1986–7, p. 428.
37 Ibid., p. 238.
38 LeBon, 1896, p. xx.
39 Marx, June 1895, p. 448: *l'âme même de la foule ... un seul être.*
40 Geffroy, 1895, pp. 243–5: *La foule joyeuse de la fête des rues ... la foule exaltée des révolutions ... instinctif, farouche, obscur.*
41 Brettell/Pissarro, 1993, p. 59.
42 House, 1993, p. 142.
43 Pissarro, 1989, p. 325, letter 1368, 13 February 1897: *J'ai un motif étatant qu'il va falloir interpréter par tous les effets possibles, à ma gauche, j'ai un autre motif qui est*

terriblement difficile, c'est presque à vol d'oiseau, des voitures, des omnibus, des personnages entre de grands arbres, de grandes maisons qu'il faut mettre d'aplomb, c'est roide!

44 Brettell/Pissarro, 1993, nos 43–56.

45 Michel Missoffe, *Gyp et ses amis*, Paris, 1932, pp. 148–9; quoted in W. Silverman, 1995, p. 142: *j'ai toujours choisi ceux qui m'ont semblé être les pires, les plus 'apaches'. . . . On les trouvait . . . à l'intérieur des barricades de planches qui longeaient le bout de la rue Réaumur alors en construction. Les 'quarante sous' marchaient pour nous ou pour les dreyfusards.*

46 *Lacoste*, 1985, pp. 27–9.

47 *Ibid.*, 1985, p. 99: *Crépuscule d'or ocreux, jaune et doux au bout dans la rue dans une trouée à l'horizon du ciel d'ardoise bleu lavé où se mêlent des nuées rose sombre. Les maisons sont un velours épais noir et doux, bleui, mais lumineux de la trace d'or rose que les yeux y traînent. La boue est bleue, bleu-lilas, mystérieuse au loin. L'ombre au loin est piquée de claires lumières verdies qui s'allument. C'est un dimanche soir où les familles rentrent. Une jeune fille tousse parmi les passants noirs dans la rue noire. Les figures dans l'aube crépusculaire sont blêmies, veloûtées et douces. Le temps est doux, humide comme le sueur.*

48 *La Lumière au zénith* (1900; private collection; *Lacoste*, 1985, no. 40), e.g., has a more luminous and evenly balanced character.

49 Huret, 1891 (1999 ed., p. 247): *Tenez, voilà la vie et l'art. Cette poésie du faubourg, c'est la leçon de littérature qu'on peut prendre tous les jours en sortant de chez soi, en se mettant en contact avec ce décor, ce ciel, ces pavés . . . avec ces personnages qui apparaissent et s'evanouissent comme des ombres, avec ce monde de passions et de souffrances qui palpite devant nous.*

50 'Fin d'année', *La Dépêche de Toulouse*, 1 January 1891, in Jaurès, 2000, p. 78: *vous sortez dans la rue: vous ne rencontrez que des ombres muettes et tristes qui circulent dans le brouillard en évitant de se heurter . . . elles glissent à deux pas de vous, mais séparées de vous par une de ces profondeurs étranges comme on en voit dans les rêves.*

51 Barrows, 1981, pp. 24–7.

52 Goncourt, 1989, p. 419 (1 May 1890).

53 Barrows, 1981, p. 29.

54 Kaplan, 1971, pp. 55–63; Barrows, 1981, pp. 35–7.

55 Anon., 'Lettre de Paris', *Journal de Genève*, 30 March 1892, in Guisan/Jakubec, 1, 1973, p. 233: *une rue, entre autres, coupée à mi-cadre, où une foule franchement populaire grouille derrière les bras étendus d'un consciencieux gardien de la paix. . . . l'art fruste, naïf et puissant.*

56 Mathias Morhardt, 'Les artistes vaudois à Paris. M. Félix Vallotton', *Gazette de Lausanne*, 24 March 1893, in ibid., p. 266: *La Manifestation ne plaira guère qu'aux Parisiens. Je crois qu'elle leur plaira beaucoup. Imaginez un boulevard très large. La foule s'enfuit en éventail, très loin, dans les attitudes les plus diverses et qui évoquent d'une façon surprenante le souvenir des scènes que nous avons eues depuis cinq ans si souvent devant les yeux. Personne ne poursuit, d'ailleurs, cette foule. Elle s'écrase cependant en une fuite éperdue. Seul, au premier plan, un bonhomme, à moitié accroupi, tourne le dos, et son expressive silhouette atteste qu'il attend le coup de pied réglementaire des gardiens de la paix, ce qui est la philosophie même des manifestations.*

57 LeBon, 1896, pp. 23, 42.

58 Agulhon, 1981, chs 6 and 7.

59 *Quand Paris dansait*, 1989, pp. 32–47; Michalski, 1998, pp. 17–18. The monument was completed in 1883.

60 Genevray, 1912, no. 13.

61 Weisberg, 1992, p. 91.

62 *The Nabis and the Parisian Avant-Garde*, 1988, p. 63.

THREE THE RELIGIOUS DEBATE

1 Pissarro, 3, 1988, p. 66 (letter 654, to Lucien Pissarro, 20 April 1891): *Un fond vermilion . . . notre philosophie moderne qui est absolument sociale, anti-authoritaire et antimystique . . . senti un retour rétrograde de la bourgeoisie en arrière par suite des grandes idées de solidarité qui germent dans le peuple.*

2 See in particular B. Thomson, 1982.

3 Morin, 1894, p. 275.

4 Mayeur/Rebérioux, 1984 (1987 ed.), p. 116.

5 Price, 1987, pp. 278, 282; Larkin, 1995, pp. 128–43.

6 Pagnol, 1989, p. 18.

7 Lalouette, 1992, p. 52.

8 *André Brouillet*, 2000–1, p. 73.

9 Perrot, 1984, p. 129.

10 Lalouette, 1992, p. 52.

11 Nye, 1993, p. 160.

12 Yourcenar, 1998, p. 298.

13 McManners, 1972, pp. 60–3, 71; Mayeur/Rebérioux, 1984 (1987 ed.), p. 151.

14 Mayeur/Rebérioux, 1984 (1987 ed.), pp. 150–1.

15 McManners, 1972, pp. 67–75; Zeldin, 1973, pp. 647–8; Mayeur/Rebérioux, 1984 (1987 ed.), pp. 150–5.

16 McManners, 1972, p. 76; Mayeur/Rebérioux, 1984 (1987 ed.), p. 160.

17 *La Phare de la Loire*, 3 April 1894 (Schwob, 1981, p. 174): *Nous avons un Messie. Il est revenu parmi nous pour prêcher la parole sainte. Il est réincarné encore une fois. Il a pris le nom de Spuller.*

18 Brunetière, 1895, pp. 99, 105–9, 111–13, 118: *La Science a perdu son prestige; et la Religion a reconquis une partie du sien.*

19 Gérault-Richard, 1893.

20 Gildea, 1994, pp. 218–19.

21 Zola, 1898 (1968 ed., 7, pp. 1241–2).

22 McManners, 1972, p. 79; Mayeur/Rebérioux, 1987, p. 169.

23 Zeldin, 1973, p. 647.

24 Vaisse, 1995, p. 139.

25 Price, 1987, pp. 286, 292; Larkin, 1995, p. 6.

26 Pange, 1960, pp. 183–6.

27 Chavanne/Gaudichon, 1988, no. 3.

28 *Rouen*, 1994, p. 26; *Renoir's Portraits*, 1996–7, p. 43.

29 *Eugène Carrière*, 1996–7, p. 49; Carrière, 1907, p. 150 (letter of 14 November 1896).

30 Goncourt, 1989, p. 322 (22 September 1889).

31 Pissarro, 3, 1988, p. 66 (letter 654, to Lucien Pissarro, 20 April 1891).

32 M. Orwicz, 'Confrontations et clivages dans les discours

des critiques du Salon, 1885–1889', in Bouillon, 1989, pp. 179–82.

33 Huysmans, 1977, p. 220 (letter 109, 23 May 1891).

34 Calvet, 1926, pp. 93–4, 97–8.

35 Ibid., pp. 98–101.

36 Lavergne, 1891.

37 Denis, 1957, p. 152 (March 1899): *commis, fonctionnaires, militaires, ingénieurs, commerçants.*

38 *Maurice Denis*, 1994, pp. 232–3, 234.

39 This account is based on Marlais, 1993. For Denis's religious work see also Dario Gamboni, '"The Baptism of Modern Art"? Maurice Denis and Religious Art', in *Denis*, 1994, pp. 75–92.

40 Destremau, 1988, p. 156; Dorra, 1982, pp. 254–5; R. Thomson, 1994, p. 116.

41 Greenspan, 1981, p. 364.

42 Dulac, 1905, pp. xix–xx.

43 Greenspan, 1981, p. 380.

44 *Maurice Denis*, 1999, pp. 15–16; Larkin, 1995, p. 39.

45 *Collection de M. le baron Denys Cochin*, Paris, Galerie Georges Petit, 26 March 1919, nos. 2, 5–7, 11.

46 *Maurice Denis*, 1999, pp. 7–37, 47–55, 62–115.

47 *La Semaine de Paris*, 20 January 1895, quoted in Lanoë, 1905, p. 375: *un primitif mystique et croyant égaré dans le XIX siècle.*

48 Bénédite, July 1898, p. 66.

49 *Charles Cottet*, 1984, n.p. (Biographie).

50 *Un Patriote aux origines de la puériculture*, 1984, pp. 25, 35, 45–7.

51 Ibid., p. 26.

52 *Geoffroy, Les enfants par*, 1989, p. 3.

53 Mayeur/Rebérioux, 1984 (1987 ed.), pp. 109, 168.

54 Ibid., p. 168.

55 *Cavaliers and Cardinals*, 1992, p. 118.

56 Tailhade, 1894, pp. 22, 21.

57 *Jean-Paul Laurens*, 1997–8, pp. 66–8.

58 Flat, May 1893, p. 339; Bouchot, June 1893, p. 445.

59 'Chez les barbouilleurs: Le Déballage des Champs-Elysées', *Le Père Peinard*, 14 May 1893, in Fénéon, I, 1970, p. 235: *De quoi qu'il se mêle, ce ratichon? Au moins, pendant ce temps-là, elle emmerdait pas le populo.*

60 Adam, August 1896, p. 114: *Sur un banc voisin de l'église Saint-Sulpice, M. Besson groupa ... l'embrassement de misérables amoureux adossés à une femme chauve qui la faim hallucine et qui allaite un nourrison serré contre ses loques. Vers l'église défile le cortège en surplis des séminaristes incapables d'offrir la certitude consolatrice du ciel.*

61 McManners, 1972, pp. 86–8; Mayeur/Rebérioux, 1984 (1987 ed.), pp. 149–50.

62 Driskel, 1992, p. 212.

63 Calvet, 1926, p. 78; Driskel, 1992, p. 213.

64 Lafenestre, July 1892, p. 202.

65 *Société Nationale des Beaux-Arts: Exposition de 1894*, Paris, 1894, p. 142.

66 Wentworth, 1984, ch. VII; Ian Thomson, 'Tissot as a Religious Artist', in *Tissot*, 1984, pp. 86–93; Driskel, 1992, pp. 214–15.

67 Tissot, 1897, p. 25.

68 Ibid., p. ix.

69 Gildea, 1994, pp. 218–19; McManners, 1972, p. 124.

70 'L'Oeuvre de James Tissot et l'édition Mame', *Le Correspondant*, 25 February 1896; Driskel, 1992, p. 217.

71 'Lettre parisienne', *Le Phare de la Loire*, 25 April 1894 (Schwob, 1981, p. 176): *C'est l'histoire de Jésus patiemment reconstituée et placée dans son milieu minutieusement étudié à travers un travail de dix ans.*

72 Lafenestre, June 1894, pp. 654–5.

73 'Tipereth', 1894, pp. 8–9.

74 Goncourt, 1989, pp. 381–3 (1 February 1890).

75 Antoine Sertillanges, 'L'Oeuvre de James Tissot et l'édition Mame', *Le Correspondant*, 25 February, 1896 (Driskel, 1992, p. 217).

76 'Tipereth', 1894, p. 8.

77 Driskel, 1992, p. 222.

78 'Mitchi', 1891, p. 270; Lafenestre, July 1891, p. 192.

79 Lafenestre, July 1891, pp. 192–3; Michelet, June 1891, pp. 353–4.

80 Rod, July 1891, pp. 18–20.

81 Driskel, 1992, p. 222.

82 I am grateful to Maurice Larkin for this insight.

83 Lafenestre, July 1892, p. 203.

84 *Jacques-Emile Blanche*, 1997–8, p. 88.

85 Lafenestre, July 1892, p. 203.

86 *Blanche*, 1997–8, p. 88.

87 Le Pelley Fonteny, 1991, nos 378, 89.

88 *Ker-Xavier Roussel*, 1994, no. 19.

89 'Salon de 1898: A la Société Nationale des Beaux-Arts', in Geffroy, VI, 1900, p. 330: *Tel Christ dégage des ondes de lumière électrique, tel autre projete des flammes violettes.*

90 Ibid., pp. 331–2.

91 Bénédite, January–June 1898, p. 147; Marest, 1901, p. 189.

92 Geffroy, VI, 1900, p. 331; Bénédite, June 1898, p. 452: *le mythe chrétien.*

93 Compin/Lacambre/Roquebert, 1990, II, p. 438.

94 Lafenestre, June 1894, p. 657: *'Fuite en Egypte' ou fuite en Suisse, c'est tout un ... Ce sont des pèlerins bavarois, le village qu'ils cherchent est Emmaüsdorf.*

95 Driskel, 1992, p. 218.

96 Weisberg, 2000, pp. 54–5.

97 Geffroy, 1910, pp. 179–80.

98 Roinard, 1892, p. 238: *de démocratiser le Nazaréen.*

99 Lafenestre, June 1894, p. 659: *le réalisme démocratique.*

100 Le Pelley Fonteny, 1991, p. 48.

101 Denis [pseud. Pierre L. Maud], June 1892, p. 362: *un souffle de christianisme ... malaise d'entendre prêcher l'Evangile en argot.*

102 Aubert, 1926, p. 169.

103 Denis, 'Notes sur la peinture religieuse', *L'Art et la vie*, October 1896, in Denis, 1993, pp. 32–48.

104 Denis, 1890.

105 Reprinted in Silva, 1991, pp. 112–16.

106 Ibid., pp. 60–4.

107 Ibid., pp. 25, 8, 56.

108 'La Rose+Croix', *La Justice*, 11 March 1892 (Geffroy, 1893, pp. 377–8, 375).

109 Rodolphe Rapetti, 'From Anguish to Ecstasy: Symbolism and the Study of Hysteria', in *Lost Paradise*, 1995, pp. 323–3.

110 Mayeur/Rebérioux, 1984 (1987 ed.), pp. 105, 104.
111 Datta, 1999, p. 29.
112 Vanor, September 1890, pp. 183–5.
113 Farinaux-Le Sidaner, 1989, no. 33.
114 McManners, 1972, pp. 81–2; Levillain, 1983, pp. 176–8.
115 Mayeur/Rebérioux, 1984 (1987 ed.), p. 150; McManners, 1972, pp. 94–5.
116 *Rémy Cogghe*, 1985.
117 Delmaire, 1991, p. 37; *Rémy Cogghe*, 1985, no. 304.
118 Watteeuw, 1902.
119 *De Corot aux impressionnistes*, 1991, pp. 11–38.
120 Marx, 1976, pl. 178; *De Corot aux impressionnistes*, 1991, p. 319.
121 M. Schwob, 'Lettre Parisien', *Le Phare de la Loire*, 5 April 1892 (Schwob, 1981, p. 112); P. Adam, 'Eloge de Ravachol', *Entretiens politiques et littéraires*, July 1892, in Oriel, 1992, p. 69; Zola, 1898 (1968 ed., p. 1178).
122 Angrand, 1988, pp. 62–3 (letter to Charles Frechon, late October 1893). I am grateful to François Lespinasse for information about Angrand's religious opinions.
123 My thanks to Peter Sharratt for this observation.

FOUR IMAGERY AND THE IDEA OF *REVANCHE*

1 Seager, 1969, p. 112.
2 Ibid., p. 114.
3 Ibid., pp. 117–18; Tint, 1964, p. 102.
4 D. P. Silverman, 1972, p. 72.
5 Mayeur/Rebérioux, 1984 (1987 ed.), p. 171.
6 A. Mitchell, 1984, p. 245.
7 Gildea, 1994, pp. 120–1.
8 Weber, 1986, p. 105.
9 *Mercure de France*, April 1895.
10 Barrès, 1929, p. 178.
11 Déroulède, 1889, dedication and p. 4.
12 Mayeur/Rebérioux, 1984 (1987 ed.), p. 170; Ralston, 1967, p. 88.
13 Ralston, 1967, pp. 130–3.
14 A. Mitchell, 1984, pp. 111–12.
15 Datta, 1999, p. 137.
16 Mitchell, 1984, p. 108; Mayeur/Rebérioux, 1984 (1987 ed.), pp. 188–9.
17 Mitchell, 1984, p. 106; Nye, 1975, p. 128.
18 Narducci, 1981, pp. vii, 39–56.
19 Robichon, 1998, p. 73.
20 Ibid., pp. 88–9.
21 Liverman Duval, 1961, pp. 82, 84–5.
22 Joze, 1894, pp. 8–10.
23 Fauré, 1988, p. 80 (letter 66, 9 August 1896).
24 Rioux, 1967, pp. 14–16. *A nos flancs une plaie sanglante. . . . des détrousseurs de nos provinces, des bourreaux de l'Alsace-Lorraine.*
25 K., 1891.
26 *Le Triomphe des mairies*, 1986–7, pp. 200–2.
27 *Henri Lévy*, 1996, p. 8.
28 Lafenestre, June 1891, p. 654.
29 Anon., 2 July 1892, pp. 195–6.
30 I am grateful to Dennis Cate for drawing this painting to my attention.
31 B. G. Verte, *Tableaux, dessins, gravures, 1780–1920*, Paris, September 1985, no. 127.
32 Société des Amis des Arts de Nantes, IIe Exposition, 19 January–8 March 1900, no. 401; Société des Artistes Lyonnais, 1 February–10 March 1902, no. 160.
33 Mayeur/Rebérioux, 1984 (1987 ed.), p. 170.
34 Tucker, 1989, p. 11.
35 Manet, 1979, pp. 111–13 (6 October 1896), 115 (8 October 1896).
36 Hérold, 1924, p. 104.
37 Constans, 1, 1995, no. 1586.
38 Wyzewa, June 1894, p. 467: *une quantité considérable de vues de Toulon.*
39 Anon., 1898, p. 32.
40 Wittrock, 1985, 1, no. 40.
41 See the review by Sainte-Claire, 1893.
42 See *L'Eventail*, 1985, nos 103–8.
43 Huysmans, 1977, p. 292 (letter 151, 27 September 1896); Mirbeau, 1990, p. 36 (letter 5, early September 1891).
44 Bloy, 1956, p. 209 (5 October 1896): *La haie de viande patriote . . . cet avorton.*
45 Ibid., p. 83 (22 October 1893).
46 Dayot, 1898, pp. 315–6.
47 Manet, 1979, p. 184 (3 September 1898).
48 Redon, 1961, pp. 97–8 (December 1897).
49 Leyret, 1895 (2000 ed., p. 58): *l'espoir flatteur des revanches promises.*
50 *Friant*, 1988, p. 24; *Carabin*, 1993, p. 9.
51 Bouillon, 1990, p. 306; *Toulouse-Lautrec*, 1991–2, p. 248.
52 *Carabin*, 1993, p. 17.
53 Mauclair, 1922, p. 113.
54 Léon Goulette, 'Avant, pendant et après l'affaire Schnaebelé', *Nancy-artiste*, 29 May 1887 (quoted in *Peinture et art nouveau*, 1999, p. 32): *un monstrueux cauchemar.*
55 Ibid., pp. 16, 20, 26.
56 McWilliam, 1996, pp. 474–82; McWilliam, 2000, ch. 3.
57 *De Carpeaux à Matisse*, 1982–3, no. 134: *Alors que nos vainqueurs ne laissent échapper aucune occasion de célébrer bruyamment les anniversaires glorieux de leurs armes . . . alors qu'ils élèvent jusque dans les plus modestes villages, des monuments pour perpétuer le souvenir de leur triomphe, nous avons nous aussi, non seulement le droit, mais le devoir de nous souvenir, et de décerner à ceux qui sont morts pour la patrie, les honneurs qui leur sont dues.*
58 Howard, 1961, p. 418.
59 *Grosjean, Sculptures de Jules*, 1984.
60 McWilliam, 1996, pp. 474, 491–2.
61 Robichon, 1998, p. 38.
62 Howard, 1961, pp. 111–12, 119; Robichon, 1998, p. 33.
63 Bouchot, June 1893, p. 451: *Le patriotisme paraît lassé de tueries.*
64 Robichon, 1981, pp. 259–61.
65 Anon., May 1892, pp. 162–3.
66 Robichon, 1998, p. 22.
67 Lostalot, 1898, p. 303.
68 D'Amat/Limouzin-Lamothe, 1965, p. 647; Robichon, 1998, p. 48.
69 Robichon, 1998, p. 35.
70 *Catalogue illustré*, 1899, no. 586; *Exposition Internationale Universelle*, 1900, p. 44.

71 *Le Drapeau*, 23 May 1885 (Gildea, 1994, pp. 180–1).

72 Déroulède, 1907.

73 Alexandre, 1889, pp. 561–4: *de fumée et de gloire*.

74 Zola, 1892 (1967, p. 883); La Rue Rufener, 1946, p. 54.

75 Anon., 1895, pp. 14, 79, 168, 10: *La nation tout entière est destinée à combattre.*

76 Seager, 1969, p. 117.

77 Marlais, 1993, pp. 141–3.

78 Ozouf, 1963 (1982 ed., p. 112).

79 *L'Ecole*, 24 February 1884; in ibid., p. 113.

80 Gérard Canini, 'The School Battalions in the East, 1882–92', in Tombs, 1991, pp. 248–54.

81 *Le Petit Français illustré*, no. 173, 18 June 1892, pp. 344–5; no. 112, 18 April 1891, pp. 238–9.

82 Ibid., no. 152, 23 January 1892, pp. 92, 85.

83 Ibid., no. 179, 30 July 1892, between pp. 414–15: *le régiment, fier de son passé, attend avec confiance la revanche éclatante que lui réserve l'avenir.*

84 Georgel/Amalvi, 1989, p. 40, repr.

85 Max de Nansouty, 'Centenaire de 1789', in *Le Génie Civil: Revue générale des industries françaises et étrangères*, VI, no. 7, 13 December 1884, pp. 108–9; see Cate (ed.), 1989, p. 25.

86 MS (Paris, Musée d'Orsay, fonds Eiffel), quoted in *1889*, 1989, p. 205.

87 Bac, 1935, pp. 457–9; Caradec/Weill, 1980, pp. 95–6.

88 Enault, 1890, p. 55. *aux mains sanglants . . . l'immortelle tendresse.*

89 Bouchot, June 1893, p. 451: *nos heures de veulerie.*

90 Dalligny, 1890, p. 1.

91 Wolff, 1890, p. 42.

92 Huret, 1893: *Une scène de Jean Berg, L'Alsacienne, qui montre dans les Tuileries . . . une bonne coiffée à l'alsacienne, portant un joli poupon et regardant défiler dans la rue de Rivoli un régiment de cuirassiers.*

93 Lannoy, 1990, no. 249, p. 135.

94 Henner, Musée Jean-Jacques, n.d., p. vii: *a été copiée, photographiée, gravée, lithographiée, à tel point qu'elle est partout en France.*

95 Vento, 1888, p. 33: *l'attitude de l'expectative: l'expectative de la revanche!*

96 Fred Licht, 'Tomb Sculpture', in *Romantics to Rodin*, 1980, p. 104.

97 Mauclair, 1922, p. 67.

98 Dayot, 1898, p. 315: *au loin le soleil mourant colore l'horizon d'une sorte de lueur d'aurore dont le rayonnement fait étinceler les sabres, les baïonnettes, la fôret des lances.*

99 Cochin, 1888, pp. 107–8: *Ce rêve de bataille n'est-il pas dans toutes les pensées, au premier coup d'oeil? . . . Une oeuvre d'art doit laisser quelque chose à faire à la pensée. N'aurions nous pas deviné le rêve de ces soldats couchés, sans qu'on nous le montrant?*

100 Michel, August 1888, pp. 144–5. Michel would have been referring to Auguste Raffet's well-known lithograph *La Revue nocturne* (1836), in which the ghostly Grande Armée parades in front of Napoleon.

101 Roze, 1888, p. 197: *composition magistrale qui symbolise les espoirs de la patrie . . . le résumé de toutes les gloires de la France, depuis les époques héroïques jusqu'aux jours que nous-mêmes avons vécus . . . un appel, un enseignement, un acte de foi.*

102 Hungerford, 1999, p. 153 and n. 56, p. 257.

103 *Paris illustré*, no. 91, 28 September 1888, p. 697.

104 'Les Peintres primés', *L'Echo de Paris*, 25 June 1889 (Mirbeau, 1986, pp. 107–8).

105 Cochin, 1888, p. 107; Michel, August 1888, p. 145; Robichon, 1998, p. 46.

106 'B'., 1891, p. 296: *un devoir sacré . . . la défense du sol envahi.*

107 Weisberg, 1992, p. 76.

108 Lafenestre, July 1891, pp. 190–1: *Agrandis et annoblis par l'âme de la patrie qui souffle, devant eux, dans les plis palpitants de la toile sacrée.*

109 Paul Mantz, *Le Temps*, 21 June 1891, in Robichon, 1998, p. 76.

110 *Le Spectateur militaire*, 1 June 1891, in ibid., p. 81, n. 4: *ce n'est pas sans reget qu'ils quitteront le pays, mais qu'une fois au régiment, ils sauront faire leur devoir tout comme les camarades.*

111 Robichon, 1998, p. 76: *On croirait que le but du peintre a été de montrer que les conscrits français ressentent de l'horreur en partant pour l'armée. Le gouvernement français, en achetant son tableau, ferait croire qu'il est de son avis. Est-ce bien le cas, au moment où la France entrevoit enfin l'espérance d'une revanche?*

112 Dagnan-Bouveret, letter to Charles Baude, in Weisberg, 1992, p. 76.

113 Robichon, 1998, p. 96; Coppier/Dampt, 1930, pp. 24–5.

114 Genevray, 1912, no. 7, p. 14.

115 'Sarkis', 1897, pp. 174–5: *Une chose rose, jaune et fade comme un abcès . . . Kiosques des journaux et aux fenêtres des mastroquets, sur les boulevards parisiens et dans les plus petit des petits villages . . . hurlé des désirs et délire . . . Tant que cette Paix existera, nous ne pourrons jamais reprendre l'Alsace et la Lorraine.*

116 Gildea, 1994, p. 142.

117 'Mélas', 1893, p. 206: *une vénération imbécile au drapeau. . . . Atrophie . . . son cerveau, réduit ses vertues initiatives à l'automatisme.*

118 Malquin, 1892, p. 194.

119 Lugné-Poe, 1930, pp. 242–3.

120 Descaves, 1946, pp. 109–13; Gildea, 1994, p. 142.

121 Jarry, 1968, pp. 110–111.

122 See Miller, 2002.

123 Gourmont, 1967, pp. 59–64: *Comme une fillette qui a laissé tomber sur le bon côte sa tartine de confitures.*

124 Detaille, n.d. [1899], n.p: *je défie l'intellectuel' le plus endurci de ne pas sentir une larme à sa paupière en saluant le Drapeau qui fait de ces petits hommes des géants!*

125 Veber, 1892, p. 29: *Est-ce bien loin, Plombières? . . . près des Vosges, sans doute . . . frontière . . . Ah! la Revanche! . . . Detaille, bataillons dans la boue, défaite (ou victoire, ce qui revient au même pour le penseur).*

126 Renard, 1957, letter 63, p. 65 (6 August 1891): *Votre bonne parole m'empêchera de rêver selon qu'il a été peint par Detaille.*

127 Repr. Robichon, 1998, p. 23.

128 *De Corot aux impressionnistes*, 1991, p. 17; *Maurice Denis: 'La Légende de Saint Hubert'*, 1999, pp. 17–18; *Daras*, 1986–7, p. 32; *Un Patriote . . .*, 1984, pp. 25, 32; Coppier/Dampt, 1930, p. 7.

129 Lewal, 1891: *Un industriel militaire de premier ordre.*

Exhibitions are listed in alphabetical order of title; only the first venue is cited.

Abélès, Luce, and Catherine Charpin, *Arts incohérents, académie du dérisoire*, Paris, Musée d'Orsay, February–May 1992.

Acker, P., 'Albert Besnard', *L'Echo de Paris*, 23 April 1903.

Ackerman, Gerald M., *The Life and Work of Jean-Léon Gérôme*, London and New York, 1986.

Adam, Paul, 'Artisans', *Entretiens politiques et littéraires*, no. 12, March 1891, pp. 67–73.

—, 'Pour la guerre', *Entretiens politiques et littéraires*, no. 16, July 1891, pp. 21–5.

—, 'Critique des moeurs', *Entretiens politiques et littéraires*, no. 36, 10 February 1893, pp. 135–7.

—, 'Critique du socialisme et de l'anarchie', *Revue blanche*, no. 19, May 1893, pp. 370–6.

—, 'Les Salons de 1896. I. La Sculpture', *Gazette des beaux-arts*, pér. 3, XV, June 1896, pp. 449–70; 'II. La Peinture, les dessins et les objets d'art au Salon du Champ-de-Mars', ibid., XVI, July 1896, pp. 5–35; 'III. La Peinture au Salon des Champs-Elysées', ibid., August 1896, pp. 102–25.

Agulhon, Maurice, *Marianne au combat: L'imagerie et la symbolique républicaines de 1789 à 1880*, Paris, 1979.

Alesson J. [A. Alès pseud.], *Le Monde est aux femmes*, Paris, 1889.

Alexandre, Arsène, 'L'Oeuvre d'Alphonse de Neuville', *Paris illustré*, no. 83, 3 August 1889, pp. 555–70.

—, *L'Art du rire et de la caricature*, Paris, 1892.

—, 'Note d'un Catholique sur un artiste Juif', *La Plume*, no. 187, 1 February 1897, pp. 79–82.

—, 'Les Beaux-Arts à l'Exposition Universelle de 1900', *Le Figaro*, 1 May 1900.

—, 'Le Jardin de Monet', *Le Figaro*, 9 August 1901.

Amalvi, Christine, 'Les Représentations du passé national dans la littérature de vulgarisation catholique et laïque, 1870–1914', in *Usages de l'image au XIXe siècle*, ed. S. Michaud, J.-Y. Mollier, N. Savy, Paris, 1992, pp. 62–75.

D'Amat, Roman, and R. Limouzin-Lamothe, *Diction-naire de Biographie Française*, vol. 10, Paris, 1965.

Nos Ancêtres ces enfants: Aspects de la vie de l'enfant de 1850 à 1900, Toulouse, Bibliothèque Municipale, April–May 1983.

'Angèle', 'Lettre d'Angèle', *L'Ermitage*, no. 4, April 1899, pp. 309–20.

Angrand, Charles, *Correspondances, 1883–1926*, ed. François Lespinasse, Rouen, 1988.

Anon., *The Pretty Women of Paris*, Paris, 1884.

—, 'Les Prix de Rome', *L'Art français*, no. 67, 4 August 1888, p. 9.

—, [F. Javel], 'Les Indépendants', *L'Art français*, no. 155, 12 April 1890, p. 4.

—, 'Les Ateliers de l'Ecole des Beaux-Arts', *La Chronique des arts et de la curiosité*, no. 35, 15 November 1890, pp. 273–4.

—, 'Conseil supérieur des Beaux-Arts', *La Chronique des arts et de la curiosité*, no. 25, 12 July 1891, p. 197.

—, 'Nouvelles', *La Chronique des arts et de la curiosité*, no. 7, 13 February 1892, p. 50.

—, 'Les Arts et les idées du moment', *L'Art et l'idée*, no. 3, 20 March 1892, pp. 217–34.

—, 'Vente du Panorama de Champigny', *La Chronique des arts et de la curiosité*, no. 21, 21 May 1892, pp. 162–3.

—, 'Les Achats de l'Etat aux deux Salons', *La Chronique des arts et de la curiosité*, no. 25, 2 July 1892, pp. 195–6.

—, 'Les Chasseurs d'Affrique', *Le Petit Français illustré*, no. 179, 30 July 1892, pp. 414–15.

—, 'Opinions d'artiste', *L'Escarmouche*, no. 2, 19 November 1893, n.p.

—, 'Les Néo-Impressionnistes', *L'Escarmouche*, vol. 2, no. 1, 7 January 1894, n.p.

—, *Gloria Victis: L'Armée Française devant l'invasion et les erreurs de 'La Débâcle', par une capitaine de l'armée à Metz*, Lavauzelle, 1895.

—, 'A Record of Art in 1898 (French Section)', *The Studio*, London, 1898.

—, 'Lautrec au Salon de 1894', *L'Oeil*, no. 180, December 1969, pp. 24–9.

Ansieau, J., 'Deux sculptures de Georges Lacombe: *Isis* et le *Christ*', *Revue du Louvre*, no. 4, 1983, pp. 287–95.

Antliff, Mark, *Inventing Bergson: Cultural Politics and the Parisian Avant-Garde*, Princeton, 1993.

Antoine, Jules, 'Le Concours de l'Hôtel de Ville', *Art et critique*, no. 23, 2 November 1889, pp. 364–5.

Aquilino, Marie Jeannine, ' The Decorating Campaigns at the Salon du Champ-de-Mars and the Salon des

Champs-Elysées in the 1890s', *Art Journal*, vol. 48, no. 1, Spring 1989, pp. 78–84.

—, 'Painted Promises: The Politics of Public Art in Late Nineteenth Century France', *Art Bulletin*, LXXV, no. 4, December 1993, pp. 697–712.

Argüelles, José A., *Charles Henry and the Formation of a Psychophysical Aesthetic*, Chicago and London, 1972.

L'Art du nu au XIXe siècle: Le photographe et son modèle, Paris, Bibliothèque Nationale, October 1997–January 1998. Cat. by Sylvie Aubenas, Hélène Pinet, Emmanuel Schwartz et al.

Art Nouveau, 1890–1914, ed. Paul Greenhalgh, London, 2000.

Aurier, G.-Albert, 'La Peinture à l'Exposition', *La Pléiade*, September 1889, pp. 102–4.

—, *Textes critiques, 1889–1892: De l'impressionnisme au symbolisme*, ed. Denis Mellier, Marie-Karine Schaub, Pierre Wat, Paris, 1995.

'B.', 'Le Rêve: Tableau de M. Ed. Detaille', *Le Petit Français illustré*, no. 117, 23 May 1891, p. 296.

Babin, G., 'Le Salon de 1903: Société Nationale des Beaux-Arts', *L'Echo de Paris*, 15 April 1903.

Bac, Fernand, *De Monsieur Thiers au Président Carnot: Souvenirs de jeunesse*, Paris, 1935.

Baedeker, Karl, *Paris and its Environs: Handbook for Travellers*, Leipzig and London, 1900.

Bajou, Valérie, *Eugène Carrière: Portrait intimiste, 1849–1906*, Lausanne, 1998.

Bantens, Robert James, *Eugène Carrière: The Symbol of Creation*, New York, 1990.

Barrès, Maurice, *Mes Cahiers*, I (January 1896–February 1898), Paris, 1929.

—, *Mes Cahiers*, II (February 1898–May 1902), Paris, 1930.

Barricelli, J. P. and L. Weinstein, *Ernest Chausson: The Composer's Life and Works*, Oklahoma, 1955.

Barrows, Susanna, *Distorting Mirrors: Visions of the Crowd in Late Nineteenth Century France*, Yale, 1981.

Bascou, Marc, 'Une boiserie art nouveau d'Alexandre Charpentier', *Revue du Louvre*, no. 3, 1979, pp. 219–28.

Paul Albert Baudoüin et les décors Rouennais, Rouen, Musée des Beaux-Arts, n.d. [1999?].

Bazalgette, Léon, 'Le Salon de la Rose+Croix', *Essais d'art libre*, no. 3, April 1892, pp. 125–34; ibid., no. 4, May 1892, pp. 164–68.

Beauçay, Jacqueline de, 'Le Carnet d'une Parisienne', *Le Triboulet*, XIV, no. 18, 3 May 1896, p. 6.

Beausire, Alain, *Quand Rodin exposait*, Paris, 1988.

Bénédite, Léonce, 'La Peinture décorative aux Salons', *Art et décoration*, III, January–June 1898, pp. 129–47.

—, 'Les Salons de 1898. I', *Gazette des beaux-arts*, pér. 3, XIX, May 1898, pp. 353–66; II, ibid., June 1898, pp. 44–163; III, ibid., XX, July 1898, pp. 55–76; IV, ibid., August 1898, pp. 129–48.

—, 'Puvis de Chavannes', *Art et décoration*, IV, July–December 1898, pp. 129–53.

—, 'La Peinture décorative au Salon de 1899', *Art et décoration*, V, July–December 1899, pp. 171–84.

—, 'Gustave Moreau', *Revue de l'art ancien et moderne*, April 1899; new ed., *L'Idéalisme en France et en Angleterre: Gustave Moreau et E. Burne-Jones*, La Rochelle, 1998.

Bergerat, Emile, 'Le Salon de 1892', *Le Figaro*, 30 April 1892.

Bergeret, Gaston, *Journal d'un nègre à l'Exposition Universelle de 1900*, Paris, 1901.

Bergman-Carton, J., 'The Medium is the Medium: Jules Bois, Spiritualism, and the Esoteric Interests of the Nabis', *Arts Magazine*, vol. 61, no. 4, December 1986, pp. 24–9.

Bergson, Henri, 'Le Rire', *Revue de Paris*, 1 and 15 February, 1 March 1899 (Paris, 1999 ed.).

—, 'Le Rêve', *Bulletin de l'Institut psychologique international*, I, no. 3, May 1901, pp. 103–22.

Bernard, Jean, *La Vie à Paris, 1899*, Paris, 1900.

Bernier, Robert, 'Chronique d'art: Les Indépendants', *La Revue moderne*, no. 40, 20 April 1887, pp. 236–9.

Besnard, Albert, 'Le Salon de 1897: Société Nationale des Beaux-Arts', *Gazette des beaux-arts*, pér. 3, XVII, June 1897, pp. 503–15.

Jacques-Emile Blanche, peintre (1861–1942), Rouen, Musée des beaux-arts, October 1997–February 1998. Cat. by Claude Pétry, Bruno Foucart, Jane Roberts et al.

Bloy, Léon, 'Les Funerailles du naturalisme', *La Plume*, no. 50, 15 May 1891, pp. 159–63.

—, *Journal de Léon Bloy: Le Mendiant ingrat. Mon journal*, I, ed. Joseph Bollery, Paris, 1956.

Boime, Albert, *Hollow Icons: The Politics of Sculpture in Nineteenth Century France*, Kent, Oh., and London, 1987.

Pierre Bonnard: The Graphic Art, New York, Metropolitan Museum, December 1989–February 1990. Cat. by Colta Ives, Helen Giambruni, Sasha M. Newman.

Bonnard, London, Tate Gallery, February–May 1998. Cat. by Sarah Whitfield and John Elderfield.

Bouchot, Henri, 'Les Salons de 1893: I. La Peinture', *Gazette des beaux-arts*, pér. 3 IX, June 1893, pp. 441–83; 'II. Dessins, gravure, architecture', ibid., X, July 1893, pp. 25–45.

—, 'Propos sur l'affiche', *Art et décoration*, III, January–June 1898, pp. 115–22.

Bouillon, Jean-Paul (ed.), *La critique d'art en France, 1850–1900: Actes du colloque de Clermont-Ferrand, 25–27 mai 1987*, Saint-Etienne, 1989.

—, (et al.), *La Promenade du critique influent: Anthologie de la critique d'art en France, 1850–1900*. Paris, 1990.

—, *Maurice Denis*, Geneva, 1993.

Bouyer, Raymond, 'L'Art et la vie au Salon du Champ-de-Mars', *L'Artiste*, nouv. pér., VII, June 1894, pp. 401–21.

—, 'Sur le Krach de l'art moderne', *L'Ermitage*, no. 8, August 1895, pp. 78–86.

—, *Les Artistes aux Salons de 1897*, Paris, 1897.

—, 'Les Arts', *L'Image*, no. 6, May 1897, pp. 186–92.

Bréon, Emmanuel, and Beatrice de Andia, *Claude-Marie, Edouard et Guillaume Dubufe: Portraits d'un siècle d'élégance parisienne*, Paris, 1988.

Bretons ou Chouans . . . Les paysans bretons dans la peinture d'histoire d'inspiration révolutionnaire au XIXe siècle, Quimper, Musée des beaux-arts, September–November 1989. Cat. by Pascal Aumasson and André Cariou.

Brinn' Gaubast, Louis-Pilate de, 'Un Grinchaux', *La Pléiade*, October 1889, pp. 111–14.

Brisson, Adolphe, 'Claude Monet', *La République Française*, 28 May 1895.

André Brouillet, 1857–1914, Poitiers, Musée Sainte-Croix, July–December, 2000. Cat. by Michèle Friang, Etienne Charles, Bruno Gaudichon, Philippe Bata, Catherine Duffault, Dominique Lobstein, and Marie-Véronique Clin.

Brunetière, Ferdinand, 'Après une visite au Vatican', *Revue des deux mondes*, pér. 4, LXIV, 1 January 1895, pp. 97–118.

—, 'L'Idée de Patrie', *Conférence prononcée à Marseille, le 28 octobre 1896, au profit de la sousscription ouverte pour élever un monument aux morts de Timbouctou*, Paris, 1896.

Buffet, Eugénie, *Ma Vie, mes amours, mes aventures: Confidences recueillies par Maurice Hamel*, Paris, 1930.

Buison, J., 'Pierre Puvis de Chavannes: Souvenirs intimes', *Gazette des beaux-arts*, pér. 3, XXII, 1 July 1899, pp. 5–20; ibid., 1 September 1899, pp. 208–25.

Butler, Ruth, *Rodin: The Shape of Genius*, New Haven and London, 1993.

Callebat, Louis, *Pierre de Coubertin*, Paris, 1988.

Callen, Anthea, 'The Body and Difference: Anatomy Training at the Ecole des Beaux-Arts in Paris in the Later Nineteenth Century', *Art History*, vol. 20, no. 1, March 1997, pp. 23–60.

Calvet, J., *Un Artiste Chrétien: Joseph Aubert (1849–1924)*, Paris, 1926.

Rupert Carabin, L'Oeuvre de, 1862–1932, Paris, Galerie du Luxembourg, 1974. Cat. by Yvonne Brunhammer and Colette Merklen.

François-Rupert Carabin, 1862–1932, Strasbourg, Musée d'Art Moderne, January–March 1993. Cat. by Nadine Lehni, Etienne Martin et al.

Caradec, François, and Alain Weill, *Le Café-concert*, Paris, 1980.

De Carpeaux à Matisse: La sculpture française de 1850 à 1914 dans les musées et collections publiques du Nord de la France, Calais, Musée des beaux-arts, March–June 1982. Cat. by Françoise Maison, Anne Pingeot, Dominique Viéville.

Carr, Reg, *Anarchism in France: The Case of Octave Mirbeau*, Manchester 1977.

Eugène Carrière, Paris, Boussod et Valadon, April–May 1891, pref. by Gustave Geffroy.

Carrière, Eugène, *Ecrits et lettres choisies*, Paris, 1907.

Eugène Carrière, 1849–1906, Musées de Strasbourg, October 1996–February 1997, Cat. by Rodolphe Rapetti, Marie-Jean Geyer, Marie-Pierre Salé et al.

Carrière, Jean-René, *De la Vie d'Eugène Carrière: Souvenirs, lettres, pensées, documents*, Toulouse, 1966.

Casselaer, Catherine van, *Lot's Wife: Lesbian Paris, 1890–1914*, Liverpool, 1986.

Castagnary, Jules, 'Le nouveau directeur des Beaux-Arts', *La Chronique des arts et de la curiosité*, no. 32, 8 October 1887, pp. 251–3.

Castellane, Marquis de, *Hommes et choses de mon temps*, Paris, 1909.

Castex, P.-G., and J.-M. Bellefroid (eds), *Nouvelles reliques de Villiers de l'Isle-Adam*, Paris, 1968.

Catalogue illustré du Salon de 1899: Société des artistes français, Paris, 1899.

Cate, Phillip Dennis (ed.), *The Graphic Arts and French Society, 1871–1914*, New Brunswick, 1988.

—, *The Eiffel Tower: A Tour de Force*, New York, Grolier Club, 1989.

—, and Mary Shaw (eds), *The Spirit of Montmartre. Cabarets, Humour and the Avant-Garde, 1875–1905*, New Brunswick, Jane Voorhees Zimmerli Art Museum, March–July 1996.

Cavaliers and Cardinals: Nineteenth Century French Anecdotal Paintings. Taft Museum, Cincinatti, June–August 1992. Cat. by Eric Zafran.

Certigny, Henry, *La Vérité sur le Douanier Rousseau: Le Conseil Municipal de Paris et les Artistes indépendants*, Lausanne/Paris, 1971.

Chadourne, André, *Les Cafés-Concerts*, Paris, 1889.

Champaubert, Jean, 'La Femme au chat', *Gil Blas illustré*, no. 7, 16 February 1896, p. 2.

Champier, Victor, *Les Industries d'art à l'Exposition Universelle, 1900*, Paris, 1902.

Charle, Christophe, *A Social History of France in the Nineteenth Century*, Oxford and Providence, R. I., 1994.

—, *Paris fin de siècle: Culture et politique*, Paris, 1998.

Charpentier-Darcy, Madeleine, 'Introduction à l'art d'Alexandre Charpentier: Catalogue sommaire de l'oeuvre (Sculpture–Art décoratif)', *Bulletin de la Société de l'Histoire de l'art français*, année 1996, (Paris) 1997, pp. 185–248.

Chavanne, Blandine, and Bruno Gaudichon, *Catalogue raisonné des peintures des XIXe et XXe siècles dans les collections du Musée de la Ville de Poitiers et de la Société des Antiquaires de L'Ouest*, Poitiers, 1988.

Christophe, Jules, 'L'Exposition des artistes indépendants', *Journal des artistes*, no. 39, 29 September 1889, pp. 305–6.

Cimaise, Henri de, 'Coup d'oeil sur les Champs-Elysées', *Le Triboulet*, XIX, no. 18, 3 May 1896, pp. 12–13.

The Circle of Toulouse-Lautrec, New Brunswick, Jane Voorhees Zimmerli Art Museum, November 1985–February 1986. Cat. by Phillip Dennis Cate and Patricia Eckert Boyer.

Clark, T. J., *Farewell to an Idea: Episodes from a History of Modernism*, New Haven and London, 1999.

Cochin, Henry, 'Réflexions sur le Salon de 1888', *Les Lettres et les arts*, III, 1 July 1888, pp. 97–120.

Rémy Cogghe (1854–1935), Roubaix, Musée des Beaux-Arts, November–December 1985. Cat. by Didier Schulmann.

Collignon, Maxime, *Phidias*, Paris, 1886.

Comlin, Jonathan, '"Le Musée de marchandises": The Origins of the Musée Cognacq-Jay', *Journal of the History of Collections*, vol. 12, no. 2, 2000, pp. 193–202.

Compin, Isabelle, Geneviève Lacambre and Anne Roquebert, *Musée d'Orsay: Catalogue sommaire des peintures*, 2 vols, Paris, 1990.

Constans, C., *Musée National du Château de Versailles: Les peintures*, 2 vols, Paris, 1995.

Cooke, Peter, 'History Painting as Apocalypse and Poetry: Gustave Moreau's *Les Prétendants*, 1852–1897, with Unpublished Documents', *Gazette des beaux-arts*, pér. 6, CXXVII, no. 1524, January 1996, pp. 27–47.

Coppier, André-Charles, and Jean Dampt, *Catalogue des oeuvres de M. Dagnan-Bouveret (peintures)*, Paris, 1930.

Coquiot, Gustave, *Les Cafés-Concerts*, Paris, 1896.

Cornell, Kenneth, *The Symbolist Movement*, New Haven, Conn., 1951.

De Corot aux impressionnistes, donations Moreau-Nélaton, Paris, Grand Palais, April–July 1991. Cat. by Vincent Pomarède et al.

Charles Cottet, 1863–1925, Quimper, Musée des Beaux-Arts, July–September 1984. Cat. by André Cariou.

Couafr, Albert, 'Sur la Côte Bretonne', *Revue indépendante*, no. 57, July 1891, pp. 94–103.

Cousturier, Edmond, 'L'Avenir des expositions de peinture', *Entretiens politiques et littéraires*, no. 16, July 1891, pp. 32–5.

Henri Edmond Cross, 1856–1910, Douai, Musée de la Chartreuse, October 1998–January 1999. Cat. by Françoise Baligand, Sylvie Carlier, Isabelle Compin, Monique Nonne.

Dalligny, Auguste, 'Le Salon de 1889', *Le Journal des arts*, vol. 11, no. 32, 30 April, 1889, p. 1.

—, 'Le Salon de 1890: Peinture', *Le Journal des arts*, vol. 12, no. 30, 2 May 1890, pp. 1–2.

Dalou inédit, Paris, Galerie Delestre, 1978.

Dan-Léon, 'De l'equilibre dans l'art', *Les Maîtres artistes*, no. 4, 30 August 1902, pp. 111–15.

Henri Daras (1850–1928), Angoulême, Musée des beaux-arts, October 1986–January 1987.

Dardel, Aline, *'Les Temps nouveaux', 1895–1914: Un hebdomadaire anarchiste et la propagande par l'image*, Paris, Musée d'Orsay, 1987.

Datta, Venita, *Birth of a National Icon: The Literary Avant-garde and the Origins of the Intellectual in France*, Albany, N. Y., 1999.

Davray, Jules, *L'Amour à Paris*, Paris, 1890.

Dayot, Armand, 'A la Galerie des machines: Le Salon des artistes français', *La Nouvelle Revue*, CXII, 15 May 1898, pp. 310–20.

Edouard Debat-Ponson, 1847–1915, Tours, Musée des Beaux-Arts, 1981.

Degas, Paris, Grand Palais, Ottawa, National Gallery of Canada, and New York, Metropolitan Museum, 1988–9. Cat. by Jean Sutherland Boggs, Douglas W. Druick, Henri Loyrette, Michael Pantazzi, Gary Tinterow.

Degas inédit, ed. Henri Loyrette, Paris, 1989.

Delmaire, Danielle, *Antisémitisme et catholiques dans le nord pendant l'affaire Dreyfus*, Lille, 1991.

Denis, Maurice, [pseud. Pierre Louis], 'Définition du néo-traditionnisme', *Art et critique*, no. 65, 23 August 1890, pp. 540–3; ibid., no. 66, 30 August, 1890, pp. 556–8.

—, [pseud. Pierre Louis], 'Notes sur l'exposition des Indépendants', *Revue blanche*, II, April 1892, pp. 232–4.

—, [pseud. Pierre L. Maud], 'Notes d'art et d'esthétique: Le Salon du Champ de Mars', *Revue blanche*, II, June 1892, p. 362.

—, *Théories*, Paris, 1912 (1920 ed.).

—, *Nouvelles théories sur l'art moderne et sur l'art sacré, 1914–1921*, Paris, 1922.

—, *Henry Lerolle et ses amis*, Paris, 1932.

—, *Journal, vol. 1 (1884–1904)*, Paris, 1957.

—, *Le Ciel et l'Arcadie*, ed. J.-P. Bouillon, Paris, 1993.

Maurice Denis, 1870–1943, Lyon, Musée des Beaux-Arts, September–December 1994 (quoted from Eng. ed., Liverpool, 1994). Cat. by Claire Denis, Guy Cogeval, Thérèse Barrvel et al.

Maurice Denis: La Légende de Saint Hubert, 1896–7, Saint-Germain-en-Laye, Musée Départementale Maurice Denis 'Le Prieuré', June–October 1999. Cat. by Agnès Delannoy, Marianne Barbey, Jean-Paul Bouillon.

Déroulède, Paul, *Refrains militaires*, Paris, 1889.

—, *Chants du paysan*, Paris, 1894.

—, *1870: Feuilles de route*, Paris, 1907.

Descaves, Lucien, 'Alexandre Charpentier', *Les Maîtres artistes*, no. 4, 30 August 1902, pp. 118–19.

—, *Souvenirs d'un ours*, Paris, 1946.

Desjardins, Paul, 'Les Salons de 1899, I', *Gazette des beaux-arts*, pér. 3, XXI, May 1898, pp. 353–9; II, ibid., June 1899, pp. 441–58; III, ibid., XXII, July 1899, pp. 37–56; IV, ibid., August 1899, pp. 132–56.

—, 'Artistes contemporains: Eugène Carrière. I', *Gazette des beaux-arts*, pér. 3, XXXVII, April 1907, pp. 265–76; II, ibid., XXXVIII, July 1907, pp. 12–26; III, ibid., August 1907, pp. 131–46.

Destremau, Frédéric, 'Le Chemin dans les arbres de Maurice Denis, 1891–1892', *Gazette des beaux-arts*, pér. VI, CXII, no. 1467, October 1988, pp. 155–62.

Detaille, Edouard, 'Préface', in Albert Guillaume, *Mes 28 Jours*, Paris, n.d. [1899].

Dietschy, Marcel, *A Portrait of Claude Debussy*, Oxford, 1990.

Diffloth, Paul, *La Beauté s'en va . . .*, Paris, n.d. [c.1905].

Dolent, Jean, *Amoureux d'art*, Paris, 1888.

Dorra, Henri, 'Extraits de la correspondance d'Emile Bernard des débuts à la Rose+Croix (1876–1892)', *Gazette des beaux-arts*, pér. 6, XCVI, no. 1343, December 1980, pp. 234–42.

—, 'La Symbolique du chemin et de l'arbre chez Maurice Denis', *Revue du Louvre*, 4, 1982, pp. 254–9.

Dortu, M.-G., *Toulouse-Lautrec et son œuvre*, 6 vols, New York, 1971.

Driskell, Michael Paul, *Representing Belief: Religion, Art and Society in Nineteenth-Century France*, Philadelphia, 1992.

Drumont, Edouard, *La Fin d'un monde: Etude psychologique et sociale*, Paris, 1889.

Ducatel, Paul, *Histoire de la IIIe République: Vue à travers l'imagerie populaire et la presse satirique. II. Naissance de la République (1871–1890)*, Paris, 1975. Ibid., III. *La Belle Epoque (1891–1910)*, Paris, 1976.

Dugnat, Gaïte, *Les Catalogues des Salons de la Société nationale des beaux-arts*, I: *1890–1895*, Paris, 2000; II: *1896–1900*, Paris, 2001.

Dulac, Marie-Charles, *Lettres de Marie-Charles Dulac*, pref. by R. Louis, Paris, 1905.

Duncan, Ann, *Les romans de Paul Adam: Du symbolisme littéraire au symbolisme cabalistique*, Berne, Frankfurt and Las Vegas, 1977.

Duret, Théodore, 'Degas', *Art Journal*, 1894, pp. 204–8.

E., 'Inauguration des peintures de M. Puvis de Chavannes au Musée d'Amiens', *La Chronique des arts et de la curiosité*, no. 6, 11 February 1888, pp. 43–4.

Enault, Louis, *Paris–Salon 1890*, Paris, 1890.

Eon, Henri, 'Exposition des artistes indépendants au Palais des Art Libéraux', *La Plume*, no. 145, 15 May 1895, pp. 195–6.

—, 'Salon des Champs-Elysées', *La Plume*, no. 95, 1 May 1896, pp. 309–17.

—, 'Salon des Champs-Elysées', *La Plume*, no. 194, 15 May 1897, pp. 306–11.

—, 'L'Art moderne', *Les Partisans*, vol. 1, 5 November 1900, pp. 45–8.

'L'Ermite, Kalophile', 'Les Arts: Camille Pissarro. Exposition Durand-Ruel', *L'Ermitage*, IV, February 1892, pp. 117–18.

—, 'Les Arts: Exposition des indépendants', *L'Ermitage*, IV, April 1892, pp. 243–5.

L'Eventail: Miroir de la belle époque, Paris, Musée de la Mode et du Costume, May–October 1985. Cat. by Madeleine Delpierre.

Exposition Internationale Universelle de 1900. Catalogue général officiel, Groupe II, Oeuvres d'art, classes 7–10, Paris, 1900.

Faille, Bart de la, *The Works of Vincent van Gogh: Paintings and Drawings*, London, 1970.

'Falstaff', 'Le Salon des Champs-Elysées', *Fin-de-siècle*, 25 April 1897.

Farinaux-Le Sidaner, Yann, *Le Sidaner: L'Oeuvre peint et gravé*, Milan, 1989.

Fénéon, Félix, *Oeuvres plus que complètes*, ed. Joan U. Halperin, 2 vols, Geneva, 1970.

Fiérens-Gevaert, H., 'Un maître affichiste: Steinlen', *Art et décoration*, II, July–December 1897, pp. 17–22.

Flat, Paul, 'La Peinture au Salon des Champs-Elysées', *L'Artiste*, nouv. pér., V, May 1893, pp. 326–41; 'La Peinture au Salon du Champ-de-Mars', ibid., June 1893, pp. 408–18.

—, 'Les Beaux-Arts à l'Exposition Universelle: La Décennale française', *La Revue bleue*, sér. 4, XIII, no. 20, 19 May 1900, pp. 613–19; ibid., 'La Centennale française', no. 24, 16 June 1900, pp. 741–6.

Fontainas, André, 'Art: Salons du Champ-de-Mars et des Champs-Elysées', *Mercure de France*, XXII, no. 90, June 1897, pp. 590–7.

—, 'Art moderne', *Mercure de France*, XXX, no. 112, 1899, pp. 247–52.

—, 'Art moderne', *Mercure de France*, XXXIII, February 1900, pp. 522–7.

Forgione, Nancy, ' "The Shadow Only": Shadow and Silhouette in Late Nineteenth Century Paris', *Art Bulletin*, LXXXI, no. 3, September 1999, pp. 491–512.

Fort, Paul, *Mes Mémoires: Toute la vie d'un poète, 1872–1944*, Paris, 1944.

Fouillée, Alfred, 'Dégénérescence? Le passé et le présent de notre race', *Revue des deux mondes*, pér. 4, LXXX, 131, LXV, 15 October 1895, pp. 793–824.

—, 'Le Progrès social en France', *Revue des deux mondes*, pér. 4, 153, 15 June 1899, pp. 815–43.

Fourcaud, Louis de, 'Le Salon du Champ-de-Mars', *Le Gaulois*, 9 May 1893.

Frèches-Thory, Claire, 'Paul Signac: Acquisitions récentes', *Revue du Louvre*, no. 1, 1983, pp. 35–46.

Emile Friant (1863–1932): Regard sur l'homme et son œuvre, Nancy, Musée des Beaux-Arts, July–October 1988. Cat. by Claude Petry.

G., M., 'L'Ecole moderne chez Durand-Ruel', *L'Art décoratif*, 1899, pp. 306–7.

Gachons, Jacques de, 'L'Art décoratif aux deux Salons de 1895: Au Champ de Mars', *L'Ermitage*, VI, June 1895, pp. 326–35.

Gallé, Emile, 'Les Salons de 1897: Objets d'art', *Gazette des beaux-arts*, pér. 3, XVIII, September 1897, pp. 229–50.

Gamboni, Dario, *La Plume et le pinceau: Odilon Redon et la littérature*, Paris, 1989.

Garb, Tamar, 'Renoir and the Natural Woman', *Oxford Art Journal*, vol. 8, no. 2, 1985, pp. 3–15.

—, *Sisters of the Brush: Women's Artistic Culture in Late Nineteenth Century Paris*, New Haven and London, 1994.

—, *Bodies of Modernity: Figure and Flesh in Fin-de-Siècle France*, London, 1998.

Garner, Philippe, *Emile Gallé*, London, 2nd edn, 1990.

Gauguin, Paul, 'Exposition de la Libre esthétique', *Essais d'art libre*, nos 25–7, February–April 1894, pp. 30–2.

—, *Lettres de Gauguin à sa femme et à ses amis*, ed. Maurice Malingue, Paris, 1946.

Gausseron, B.-H., 'Le Défilé littéraire', *L'Art et l'idée*, no. 3, 20 March 1892, pp. 196–209.

Gauthier-Villars, Henry, 'Le Salon des Indépendants', *Revue indépendante*, no. 19, April 1891, pp. 107–13.

Geffroy, Gustave, 'Pointillé-Cloisonnisme', *La Justice*, 11 April 1888.

—, 'Chronique d'art: Indépendants', *Revue d'aujour-d'hui*, nos 1–15, 1890, pp. 267–70.

—, 'Les Indépendants', *La Justice*, 29 March 1892.

—, and Henri de Toulouse-Lautrec, *Yvette Guilbert*, Paris 1894 (ed. Peter Wick; Harvard, 1968).

—, *La Vie Artistique*, II, Paris, 1893; III, Paris, 1894; V, Paris, 1895; VI, Paris, 1900.

—, 'Albert Besnard', *Art et décoration*, X, December 1901, pp. 165–82.

—, *Claude Monet: Sa vie, son oeuvre*, Paris, 1924 (new ed. C. Judrin, Paris, 1980).

Genevray, Louis, *Les Peintres de la vie moderne: Ministère de l'instruction publique et des beaux-arts. Bibliothèque, office et musée de l'enseignement publique (Musée pedagogique). Service des projections lumineuses. Notices sur les vues*, Melun, 1912.

Genty, Gilles, 'Maurice Denis: Des métamorphoses d'Eros à Clio', *Histoire de l'art*, 5/6, May 1989, pp. 99–108.

Geoffroy, Les enfants par, 1853–1924, Paris, Galerie Gary-Roche, June–July 1989. Cat. by Françoise Beaugrand.

Georgel, Chantal, and C. Amalvi, *Une icône républicaine: Rouget de Lisle chantant 'La Marseillaise' par Isidore Pils, 1849*. Paris, Musée d'Orsay, Dossier 28, 1989.

Gérault-Richard, 'L'Ennemi', *Le Chambard socialiste*, no. 2, 23 December 1893.

Germain, Alphonse, 'Puvis de Chavannes et son esthétique', *L'Ermitage*, III, March 1891, pp. 140–4.

—, 'Sur un tableau refusé: Théorie du symbolisme de teintes', *La Plume*, no. 50, 15 May 1891, pp. 171–2.

—, 'Théorie des déformateurs: Exposé et réfutation', *La Plume*, no. 57, 1 September 1891, pp. 289–90.

—, 'L'Art et l'idéalisme: Salon de la Rose+Croix', *L'Art et l'idée*, no. 3, 20 March 1892, pp. 176–80.

Jean-Léon Gérôme, 1824–1904, Vesoul, Musée, August 1981. Cat. by Pierre Chantelat, Albert Benamou, Jacques Foucart, Gerald M. Ackerman.

'Giboyer', 'Salon des indépendants', *Le Gueux*, no. 13, April 1892.

Gide, André, *Si le grain ni meurt*, Paris 1920 (1955 Gallimard ed.).

—, *Journals, 1889–1949*, ed. J. O'Brien, Harmondsworth, 1967.

Gildea, Robert, *The Past in French History*, London and New Haven, 1994.

Gill, Susan, 'Steinlen's Prints: Social Imagery in Late Nineteenth Century Graphic Art', *Print Collector's Newsletter*, X, no. 1, March–April 1979, pp. 8–12.

Van Gogh and the Birth of Cloisonnism, Toronto, Art Gallery of Ontario, January–March 1981. Cat. by Bogomila Welsh-Ovcharov.

Goldstein, J., 'The Hysteria Diagnosis and the Politics of Anticlericalism in Late Nineteenth Century France', *Journal of Modern History*, 54, June 1982, pp. 209–39.

Goldstein, Robert J., *Censorship of Political Caricature in Nineteenth Century France*, Kent, Oh., and London, 1989.

Goncourt, Edmond de, *Journal: Mémoires de la vie littéraire*, ed. Robert Ricatte, III, 1887–1896, Paris, 1989.

Gonse, Louis, 'Exposition Universelle de 1889: Coup d'oeil avant l'ouverture', *Gazette des beaux-arts*, pér. 3, XXXIII, 1 May 1889, pp. 353–8.

—, 'Le Monument d'Eugène Delacroix', *La Chronique des arts et de la curiosité*, no. 32, 11 October 1890, pp. 252–3.

Goujon, Jean-Paul, *Dossier secret: Pierre Louÿs – Marie de Régnier*, Paris, 2002.

Gourmont, Rémy de, *Promenades philosophiques*, I, Paris, 1905.

—, *Le Joujou patriotique: La fête nationale*, ed. J.-P. Rioux, Paris, 1967.

Grand-Carteret, Jean, *L'Année en images, 1893*, Paris, 1894.

Green, Nicholas, '"All the Flowers of the Field": The State, Liberalism and Art in France under the Early Third Republic', *Oxford Art Journal*, vol. 10, 1987, pp. 71–84.

Greenspan, Taube G., '"Les Nostalgiques" Re-Examined: The Idyllic Landscape in France, 1890–1905', Ph.D., City University, New York, 1981.

Jules Grosjean, Sculptures de, 1872–1906, Vesoul, Musée, 1984. Cat. by Pauline Grisel.

Grosjean-Maupin, 'L'Art français: L'Exposition centennale de 1900', *La Revue encyclopédique*, no. 381, 22 December 1900, pp. 1037–42.

Guderian, Heinz, *Panzer Leader*, London, 1952.

Guilbert, Yvette, *La Chanson de ma vie*, Paris, 1927.

Yvette Guilbert: Diseuse fin-de-siècle, Albi, Musée Toulouse-Lautrec, September–November 1994. Cat. by Jacques Paul Dauriac, Claudette Joannis, Danièle Devynck et al.

Guillemot, Maurice, 'Alexandre Charpentier', *Les Maîtres artistes*, no. 4, 30 August 1902, pp. 122–3.

Guisan, Gilbert, and Doris Jakubec (eds), *Félix Vallotton: Documents pour une biographie et pour l'histoire d'une oeuvre*, I, Lausanne and Paris, 1973.

Guy, Cécile, 'Le Barc de Boutteville', *L'Oeil*, no. 124, April 1965, pp. 31–6, 58–9.

Gyp, *Bob au Salon de 1889*, Paris, 1889.

Halperin, Joan U., *Félix Fénéon: Aesthete and Anarchist in Fin-de-siècle Paris*, New Haven and London, 1988.

Hamel, Maurice, 'Les Peintures murales de la salle des mariages à la mairie du Ier arrondissement', *La Chronique des arts et de la curiosité*, no. 1, 7 January 1888, pp. 4–5.

Harris, Ruth, *Murders and Madness: Medicine, Law, and Society in the Fin de Siècle*, Oxford, 1989.

Haudidier, Françoise, *De Jules Coignet à Félix Ziem: Peintures XIXe–XXe siècles*, Remiremont, Musée Municipal Charles de Bruyères, 1994.

Haussonville, Comte Othérin d', 'Socialisme d'état et socialisme chrétien', *Revue des deux mondes*, pér. 3, vol. 89, 15 June 1892, pp. 839–70.

Havemeyer, Louisine, *Sixteen to Sixty: Memoirs of a Collector*, New York, 1961.

Paul Helleu, 1859–1927, Honfleur, Musée Eugène Boudin, July–October 1993.

Henner, Musée National Jean-Jacques, *Notice sur la vie et les travaux de J.-J. Henner, membre de l'Institut*, Paris, n.d. [c.1906]

Herbert, Robert L., and Eugenia W. Herbert, 'Artists and Anarchism: Unpublished Letters of Pissarro, Signac and Others', *Burlington Magazine*, no. 102, November 1960, pp. 473–82; ibid., December 1960, pp. 517–22.

Hérold, A.-Ferdinand, *Roll*, Paris, 1924.

Herzl, Theodor, *Le Palais Bourbon: Tableaux de la vie parlementaire française*, Paris, 1995 (original ed., Leipzig, 1895).

Higgs, David, *Nobles in Nineteenth Century France: The Practice of Inegalitarianism*, Baltimore, 1987.

'L'Homme de la Montagne', 'Yvette Guilbert', *L'Echo du boulevard*, no. 1, 9 May 1891, p. 4.

'Homodei' [Arthur Huc], 'Nos Expositions: L'art nouveau', *La Dépêche de Toulouse*, 20 May 1894; 'Nos Expositions: Les oeuvres', ibid., 21 May 1894.

House, John, 'Renoir and the Earthly Paradise', *Oxford Art Journal*, vol. 8, no. 2, 1985, pp. 21–7.

—, 'Time's Cycles', *Art in America*, vol. 80, no. 10, October 1992, pp. 126–35, 161.

—, 'Anarchist or Esthete? Pissarro in the City', *Art in America*, vol. 81, no. 11, November 1993, pp. 81–8, 141–3.

Howard, Michael, *The Franco–Prussian War: The German Invasion of France, 1870–1871*, London, 1961.

Hugo, Victor, *Oeuvres complètes de Victor Hugo: Actes et paroles, III. Depuis l'exil, 1870–1885*, Paris, 1895.

Hungerford, Constance Cain, *Ernest Meissonier: Master in his Genre*, Cambridge, 1999.

Hunisak, J. M., 'Rodin, Dalou, and the Monument to Labour', in *Art the Ape of Nature: Studies in Honour of H. W. Janson*, ed. M. Barasch and L. Freeman Sandler, New York, 1981, pp. 689–705.

Huret, Jules, *Enquête sur l'évolution littéraire*, Paris, 1891 (ed. Daniel Grojnowski, Paris, 1999).

—, 'Figaro Salon', *Le Figaro*, 30 June 1893.

Huston, N., 'The Matrix of War: Mothers and Heroes', in *The Female Body in Western Culture*, ed. S. R. Suleiman, Harvard, 1986, pp. 119–36.

Hutton, John, *Neo-Impressionism and the Search for Solid Ground: Art, Science, and Anarchism in Fin-de-Siècle France*, Louisiana, 1994.

Huysmans, Joris-Karl, 'Chroniques d'art: Les Indépendants', *Revue indépendante*, no. 6, April 1887, pp. 54–6.

—, *Là-bas*, Paris, 1891 (ed. Pierre Cogny, 1978).

—, *En Route*, Paris, 1895.

—, *Lettres inédites à Emile Zola*, ed. Pierre Lambert, Geneva and Lille, 1953.

—, *Lettres inédites à Arij Prins, 1885–1907*, ed. Louis Gillet, Geneva, 1977.

Joris-Karl Huysmans: Du Naturalisme au satanisme et à Dieu, Paris, Bibliothèque Nationale and Bibliothèque de l'Arsenal, 1979.

Hyslop, F. E. *Henri Evenepoel: Belgian Painter in Paris, 1892–1899*, Philadelphia, 1975.

The Impressionist and the City: Pissarro's Series Paintings, Dallas, Philadelphia and London, 1992–3. Cat. by Richard R. Brettell and Joachim Pissarro.

Jackson, A. B., *La Revue blanche (1889–1903): Origine, influence, bibliographie*, Paris, 1960.

Jammes, Francis, 'Oeuvres de Charles Lacoste', *Revue blanche*, vol. 17, 15 November 1898, pp. 386–7.

Jarry, Alfred, 'Minutes d'art: Sixième exposition chez Le Barc de Bouteville', *Essais d'art libre*, nos 25–7, February–April 1894, pp. 40–2.

—, 'Les Indépendants', *Essais d'art libre*, nos 41–2, June–July 1894, pp. 124–5.

—, *The Ubu Plays* (ed. Simon Watson Taylor), London, 1968.

Jaurès, Jean, *Oeuvres de Jean Jaurès. Vol. 16: Critique littéraire et critique d'art*, ed. Michel Launay, Camille Grousselas and Françoise Laurent-Prigent, Paris, 2000.

Jensen, Robert, *Marketing Modernism in Fin-de-Siècle Europe*, Princeton, 1994.

Johnson, Una E., *Ambroise Vollard, Editeur: Prints, Books, Bronzes*, New York, 1944 (2nd edn, New York, 1977).

Jonas, R. A., 'Monument as Ex-Voto, Monument as Historiosophy: The Basilica of Sacré-Coeur', *French Historical Studies*, vol. 18, no. 2, Fall 1993, pp. 482–502.

Jordanova, Ludmilla, *Sexual Visions: Images of Gender in Science and Medicine between the Eighteenth and Twentieth Centuries*, New York and London, 1989.

Jourdain, Francis, and Jean Adhémar, *Toulouse-Lautrec*, Paris, 1952.

Jourdain, Frantz, 'Le peintre Albert Besnard', *Les Lettres et les arts*, IV, 1 November 1888, pp. 151–72.

—, *A la côte*, Paris, 1889.

Joyant, Maurice, *Henri de Toulouse-Lautrec, 1864–1901. I: Peintre*, Paris, 1926; *II: Dessins, estampes, affiches*, Paris, 1927.

Joze, Victor, *Babylone d'Allemagne*, Paris, 1894.

Juillard, Jacques, *Fernand Pelloutier et les origines du syndicalisme d'action directe*, Paris, 1971.

Jumeau-Lafond, Jean-David, 'L'Enfance de Sainte-Geneviève: une affiche de Puvis de Chavannes au service de l'Union pour l'action morale', *Revue de l'art*, 109, 1995, pp. 63–74.

K . . . , 'Les Envois des peintres français à Berlin', *La Vie parisienne*, 28 February 1891, pp. 116–17.

Kaplan, R. E., 'France, 1893–1898: The Fear of Revolution among the Bourgeoisie', Ph.D., Cornell University, 1971.

Kendall, Richard, *Degas Landscapes*, New Haven and London, 1993.

—, *Degas: Beyond Impressionism*, New Haven and London, 1996.

Krumreich, G., 'Joan of Arc between Right and Left', in Tombs, (ed.) 1991, pp. 63–73.

Charles Lacoste, 1870–1959, Paris, Mairie du XVIe arrondissement, April–May 1985.

Lacour, Léopold, 'La Question de la femme', *Revue Franco–Americaine*, July 1895, pp. 33–7.

Lafenestre, Georges, 'Les Salons de 1890: I. La Peinture aux Champs-Elysées', *Revue des deux mondes*, pér. 3, vol. 89, 1 June 1890, pp. 643–69; 'II. La Peinture au Champ de Mars', ibid., 15 June 1890, pp. 907–35.

—, 'Les Salons de 1891: I. La Peinture au Salon de Champs-Elysées', *Revue des deux mondes*, pér. 3, CV, 1 June 1891, pp. 645–72; 'III. Le Salon du Champ de Mars', ibid., CVI, 1 July 1891, pp. 181–206.

—, 'Les Salons de 1892: I. La Peinture aux Champs-Elysées', *Revue des deux mondes*, pér. 3, CXI, 1 June 1892, pp. 607–37; 'La Sculpture aux deux Salons et la Peinture au Champ de Mars', ibid., CXII, 1 July 1892, pp. 182–212.

—, 'Les Salons de 1894: I. La Peinture', *Revue des deux mondes*, pér. 4, CXIII, 1 June 1894, pp. 650–74.

—, 'Les Salons de 1895: I. La Peinture', *Revue des deux mondes*, pér. 4, CXXIX, 1 June 1895, pp. 643–72.

Lafond, Paul, *Degas*, 2 vols, Paris, 1918–19.

Lalouette, J., 'Iconoclastie et caricature dans le combat libre-penseur et anti-clérical, 1879–1914', in *Usages de l'image au XIXe siècle*, ed. S. Michaud, J.-Y. Mollier, N. Savy, Paris, 1992, pp. 50–61.

Lampérière, Anna, 'La Femme en France', *Revue Franco–Americaine*, August 1895, pp. 58–62.

Lampert, Catherine, *Rodin: Sculpture and Drawings*, London, Arts Council, 1986.

Langlois, Ch.-V., and Ch. Seignobos, *Introduction aux études historiques*, Paris, 1898.

Lannoy, Isabelle de, *Musée National Jean-Jacques Henner: Catalogue des peintures*, Paris, 1990.

Lanouë, Georges, *Histoire de l'école française du paysage depuis Chintreuil jusqu'à 1900*, Nantes, 1905.

Larkin, Maurice, *Religion, Politics and Preferment in France since 1890: La Belle Epoque and its Legacy*, Cambridge, 1995.

Larroumet, Gustave, 'Le Symbolisme de Gustave Moreau', *La Revue de Paris*, no. 18, 15 September 1895, pp. 408–39.

—, 'M. Jules Breton, un peintre poète', *La Vie contemporaine*, VI, 15 November 1895, pp. 381–96.

Achille Laugé, 1861–1944: Portraits pointillistes. Saint-Tropez, Musée de l'Annonciade, April–June 1990. Cat. by Nicole Tamburini.

Launay, Louis de, 'Etienne Moreau-Nélaton', *Revue des deux mondes*, XXXIX, 1 June 1927, pp. 683–6.

Jean-Paul Laurens, 1838–1921: Peintre d'histoire, Paris, Musée d'Orsay, October 1997–January 1998. Cat. by Laurence des Cars, Alain Daguerre de Hureaux, Kimberly Jones et al.

Lavergne, Georges Claudius, 'Beaux-Arts: Salon des Champs-Elysées', *La Croix*, 9 May 1891.

Lazare, Bernard, 'Les Livres: *Le Devoir présent*, par Paul Desjardins', *Entretiens politiques et littéraires*, no. 24, March 1892, pp. 129–36.

LeBon, G., *La Psychologie des foules*, Paris, 1895; trans. *The Crowd: A Study of the Popular Mind*, London, 1896.

'Leclerc', 'Peur', *La Croix*, 1 May 1891.

—, 'Le Premier Mai', *La Croix*, 2 May 1891.

—, 'Gare!', *La Croix*, 4 May 1891.

Leclercq, Julien, 'Aux Indépendants', *Mercure de France*, II, May 1891, pp. 298–300.

—, 'Albert Aurier', *Essais d'art libre*, no. 10, November 1892, pp. 201–8.

—, 'Petites Expositions: Galeries Durand-Ruel', *La Chronique des arts et de la curiosité*, no. 11, 18 March 1899, pp. 94–5.

—, *La Physionomie: Visages et caractères*, Paris, n.d. [c. 1902].

Lecomte, Georges, 'Le Salon des Indépendants', *L'Art dans les deux mondes*, no. 19, 28 March 1891, p. 225; ibid., no. 20, 4 April 1891, p. 234.

La Leçon de Charcot: Voyage dans une toile, Paris, Musée de l'Assistance Publique, September–December 1986. Cat. by Nadine Simon-Dhouailly.

Lemaitre, Jules, *Les Contemporains: Etudes et portraits littéraires*, sér. 6, Paris, 1896; sér. 7, Paris, 1899.

Lepenies, Wolf, *Between Literature and Science: The Rise of Sociology*, Cambridge, 1988.

Leprieur, Paul, 'Les Salons de 1897: Quelques peintures décoratives', *Art et décoration*, II, July–December 1897, pp. 65–7.

Le Sidaner, Henri, 1862–1939, Liège, Musée d'Art Moderne et Contemporaine, September–November 1996. Cat. by Yann Farineaux Le Sidaner.

Levillain, Pierre, *Albert de Mun: Catholicisme française et catholicisme romain du syllabus au ralliement*, Rome, 1983.

Henri Lévy et la tentation symboliste, Nancy, Musée des Beaux-Arts, July–September 1996. Cat. by Clara Gelly-Saldias.

Lewal, Général, 'Napoléon et Moltke', *La Croix*, 30 April 1891.

Leyret, Henry, *En Plein Faubourg*, Paris, 1895 (ed. Alain Faure; Cahors, 2000).

Liverman Duval, Elga, *Téodor de Wyzewa: Critic without a Country*, Geneva and Paris, 1961.

Lorrain, Jean, *Gustave Moreau, Correspondance et poèmes*, ed. Thalie Rapetti, Paris, 1998.

—, *Monsieur de Phocas: Astarté*, Paris, 1901.

Lost Paradise: Symbolist Europe, Montreal Museum of Fine Arts, June–October 1995. Cat. by Jean Clair, Guy Cogeval, Louise d'Argencourt, Constance Naubert-Reiser, Rosalind Pepall, Ulrich Pohlmann et al.

L(ostalot), A(lfred) de, 'La Rose+Croix du Temple', *La Chronique des arts et de la curiosité*, no. 29, 5 September 1891, pp. 227–8.

—, 'Concours et expositions', *La Chronique des arts et de la curiosité*, no. 6, 6 February 1892, pp. 41–2.

—, 'Concours et Expositions', *La Chronique des arts et de la curiosité*, no. 11, 12 March 1892, pp. 81–2.

—, 'Exposition de M. A. Renoir', *La Chronique des arts et de la curiosité*, no. 20, 14 May 1892, p. 155.

—, 'Société nationale des beaux-arts', *L'Illustration*, no. 2879, 30 April 1898, pp. 302–3.

Louÿs, Pierre, *La Femme et le pantin*, Paris, 1898.

—, and Jean de Tinan, *Correspondance, 1894–1898*, ed. Jean-Paul Goujon, Paris, 1995.

—, *Scènes de péripatéticiennes*, Paris, 2000.

Loyrette, Henri, *Degas*, Paris, 1991.

Lucie-Smith, Edward, and Célestine Dars, *How the Rich Lived: The Painter as Witness, 1870–1914*, New York and London, 1976.

—, *Work and Struggle: The Painter as Witness, 1870–1914*, New York and London, 1977.

Lugné-Poe, Aurélien, *La Parade, I. Le Sot du Tremplin: Souvenirs et impressions du théâtre*, Paris, 1930; *II. Acrobaties*, Paris, 1931.

M., T. A., 'M. Puvis de Chavannes', *Le Courrier de l'Art*, VIII, no. 8, 24 February 1888, pp. 58–60.

McManners, John, *Church and State in France, 1870–1914*, London, 1972.

McMillan, James F., *France and Women, 1789–1914: Gender, Society and Politics*, London and New York, 2000.

McWilliam, Neil, 'Monuments, Martyrdom, and the Politics of Religion in the French Third Republic', *Art Bulletin*, LXXVII, no. 2, June 1995, pp. 186–204.

—, 'Race, Remembrance and *Revanche*: Commemorating the Franco–Prussian War in the Third Republic', *Art History*, vol. 19, no. 4, December 1996, pp. 473–98.

—, *Monumental Intolerance: Jean Baffier, a Nationalist Sculptor in Fin-de-siècle France*, Philadelphia, 2000.

Mabilleau, Léopold, 'Le Salon du Champ de Mars', *Gazette des beaux-arts*, pér. 3, vol. 3, June 1890, pp. 474–93; vol. 4, July 1890, pp. 5–29.

Mabire, Jean-Christophe, *L'Exposition universelle de 1900*, Paris, 2000.

Maillard, Léon, 'I. La Femme du monde. II. Bourgeoise. III. Femme du peuple. IV. La Balance', *La Plume*, no. 49, 1 May 1891, p. 151.

—, 'Le Salon du Champ de Mars', *La Plume*, no. 194, 15 May 1897, pp. 314–20.

Maindron, Ernest, *Les Affiches illustrés, 1886–1895*, Paris, 1896.

Malato, Charles, 'Le Rêve d'Humanus', *La Revue anarchiste*, vol. 1, no. 6, 1 November 1893, pp. 76–8.

Mallet, Robert (ed.), *Francis Jammes–André Gide: Correspondance, 1893–1938*, Paris, 1948.

—, *André Gide–Paul Valéry: Correspondance, 1890–1942*, Paris, 1955.

Malquin, Ludovic, 'Notes sur obéir', *Revue blanche*, II, April 1892, pp. 193–201.

Manet, Julie, *Journal (1893–1899)*, Paris, 1979.

Mantz, Paul, 'Exposition universelle de 1889: La Peinture française. Troisième article', *Gazette des beaux-arts*, pér. 3, XXXIII, October 1889, pp. 345–67.

Marest, Azar du, *A travers l'idéal: Fragments du journal d'un peintre*, Paris, 1901.

Mariaux, P.-A., 'Détournements iconographiques chez Théophile-Alexandre Steinlen: A propos de la *La Libératrice*', *Gazette des beaux-arts*, pér. 6, CXXI, no. 1492–3, May–June 1993, pp. 231–40.

Marlais, Michael, *Conservative Echoes in Fin-de-Siècle Parisian Art Criticism*, Philadelphia, 1992.

—, 'Conservative Style/Conservative Politics: Maurice Denis at Le Vésinet', *Art History*, vol. 16, no. 1, March 1993, pp. 125–46.

—, 'Puvis de Chavannes and the Parisian daily press', *Apollo*, CXLIX, no. 444, February 1999, pp. 3–10.

Marx, Roger, 'Les Salons de 1895. I', *Gazette des beaux-arts*, pér. 3, XIII, May 1895, pp. 353–60; II, ibid, June, 1895, pp. 441–56; III, ibid., XIV, July 1895, pp. 15–32; IV, ibid., August 1895, pp. 105–22.

—, 'Cartons d'artistes: Puvis de Chavannes', *L'Image*, no. 8, July 1897, pp. 241–7.

—, 'Cartons d'artistes: Degas', *L'Image*, no. 11, October 1897, pp. 320–5.

—, *Masters of the Poster, 1896–1900*, ed. Alain Weill and Jack Rennert, London, 1976.

Mauclair, Camille, 'Albert Besnard et le symbolisme concret', *Revue indépendante*, vol. 21, October 1891, pp. 6–30.

—, *Eleusis: Causeries sur la cité intérieure*, Paris, 1894.

—, 'L'Art', *Revue franco–americaine*, July 1895, pp. 96–8.

—, 'Le Sens de beauté de l'Exposition universelle', *La Grande Revue de l'exposition*, no. 9, 10 June 1900, pp. 145–7.

—, 'Jean-Paul Laurens', *Art et décoration*, XIX, March 1906, pp. 85–98.

—, *Albert Besnard: L'Homme et l'oeuvre*, Paris, 1914.

—, *Servitudes et grandeurs littéraires*, Paris, 1922.

Maupassant, Guy de, *Chroniques 3. 26 août 1884–13 avril 1891*, ed. Hubert Juin, Paris, 1980.

Maurras, Charles, 'Conclusion: Barbares et romans', *La Plume*, no. 53, 1 July 1891, pp. 229–30.

Mayeur, Jean-Marie, and Madeleine Rebérioux, *The Third Republic from its Origins to the Great War, 1871–1914*, Cambridge, 1984 (1987 edn).

Mazel, Henri, 'L'Anarchisme', *Essais d'art libre*, no. 5, June 1892, pp. 198–207.

Méditerranée: De Courbet à Matisse, Paris, Grand Palais, September 2000–January 2001. Cat. by Françoise Cachin, Monique Nonne et al.

'Mélas', 'La Patrie', *La Plume*, no. 97, 1 May 1893, pp. 205–6.

Mellerio, André, 'Degas', *La Revue artistique*, April 1896, pp. 67–70.

—, *L'Exposition de 1900 et l'impressionnisme*, Paris, 1900.

Mercure de France, 'Une Enquête Franco–Allemande', XIV, April 1895, pp. 1–65.

Merson, Olivier, 'Le Salon de 1891: Palais des Champs-Elysées', *Le Monde illustré*, 2 May 1891, pp. 343, 346–7, 350; 9 May, p. 363; 23 May, p. 408; 6 June, p. 448; 13 June, p. 467; 20 June, pp. 482–3; 4 July, pp. 7–10.

—, 'Exposition de la Société nationale des beaux-arts', *Le Monde illustré*, 13 May 1893, pp. 303–6.

Méténier, Oscar, 'Aristide Bruant', *La Plume*, no. 43, 1 February 1891, pp. 39–42.

Michalski, Sergiusz, *Public Monuments: Art in Political Bondage, 1870–1997*, London, 1998.

Michel, André, 'Salon de 1888', *Gazette des beaux-arts*, pér. 3, XXXVII, June 1888, pp. 441–454; ibid., XXXVIII, July 1888, pp. 21–31; ibid., August 1888, pp. 137–53.

—, *Notes sur l'art moderne*, Paris, 1896.

Michel, Louise, *Histoire de ma vie: Seconde et troisième parties*. London, 1902. (ed. Xavière Gauthier, Lyon, 2000).

Michelet, Emile, 'Au Salon du Champ-de-Mars', *Revue indépendante*, June 1891, pp. 341–58.

Midant, Jean-Paul, *L'Art Nouveau en France*, Paris, 1999.

Miller, Paul B., *From Revolutionaries to Citizens: Antimilitarism in France, 1870–1914*, Durham, N. C., and London, 2002.

Mirbeau, Octave, *L'Abbé Jules*, Paris, 1888 (1977, ed. Hubert Juin).

—, 'Impressions d'un visiteur', *Le Figaro*, 10 June 1889.

—, *Le Journal d'une femme de chambre*, Paris, 1900 (1906 ed.).

—, *Des Artistes*, ed. Hubert Juin, Paris, 1986.

—, *Correspondance avec Camille Pissarro*, ed. Pierre Michel and Jean-François Nivet, Tusson, 1990.

Mitchell, A., *Victors and Vanquished: The German Influence on Army and Church in France after 1870*, Chapel Hill/London, 1984.

Mitchell, Claudine, 'Intellectuality and Sexuality: Camille Claudel, the Fin-de-siècle Sculptress', *Art History*, vol. 12, no. 4, December 1989, pp. 419–47.

'Mitchi', 'Le Salon du Champ de Mars', *La Vie parisienne*, 16 May 1891, pp. 269–71.

Mithouard, Adrien, *Le Tourment de l'unité*, Paris, 1901.

—, 'Maurice Denis', *Art et décoration*, XXII, July 1907, pp. 1–12.

Claude Monet–Auguste Rodin: Centenaire de l'exposition de 1889, Paris, Musée Rodin, November 1989–January 1990. Cat. by Pierre Gassier, Claudie Judrin, and Alain Beausire.

Monnier, Geneviève, *Musée du Louvre, Cabinet des dessins. Musée d'Orsay, pastels du XIXe siècle*, Paris, 1985.

Montorgueil, Georges, 'La Chanson zutiste', *La Plume*, no. 61, 1 November 1891, p. 365.

Montrosier, Eugène, 'Jean-Paul Laurens. I', *Gazette des beaux-arts*, pér. 3, XX, December 1898, pp. 441–51; II, ibid., XXI, February 1899, pp. 145–57.

Moréas, Jean, *Esquisses et souvenirs*, Paris, 1908.

Moreau, Gustave, *L'Assembleur des rêves: Ecrits complets de Gustave Moreau*, ed. Pierre-Louis Mathieu, Fontfroide, 1984.

Gustave Moreau, 1826–1898, Paris, Grand Palais, September 1998–January 1999. Cat. by Geneviève Lacambre, Douglas W. Druick, Larry J. Feinberg, Susan Stein.

Morice, Charles, *Paris–Almanach 1897*, Paris, 1897.

Morin, Louis, 'Quelques artistes de ce temps: IV. Louis Legrand', *L'Artiste*, nouv. pér., VI, April 1894, pp. 262–75.

Mourey, Gabriel, 'A Modern Portrait-Painter: M. Aman-Jean', *The Studio*, VIII, no. 42, September 1896, pp. 197–204.

—, 'Studio-Talk', *The Studio*, IX, no. 43, October 1896, pp. 67–8.

Mourre, Baron C., 'L'Affaiblissement de la natalité en France', *Revue bleue*, sér. 4, XIII, no. 2, 13 January 1900, pp. 51–6.

Muhlfeld, Lucien, 'Chronique de la littérature', *Revue blanche*, II, June 1892, pp. 352–9.

—, 'A propos de peintures', *Revue blanche*, IV, no. 20, June 1893, pp. 453–60.

The Nabis and the Parisian Avant-Garde, New Bruswick, Jane Voorhees Zimmerli Art Museum, 1988. Cat. by Patricia Eckert Boyer and Elizabeth Prelinger.

Nabis, 1888–1900, Zurich, Kunsthaus, May–August 1993. Cat. by Claire Frèches-Thory, Ursula Perucchi-Petri et al.

Napoléon au Chat Noir, 'L'Epopée' vue par Caran d'Ache. Paris, Musée de l'Armée, October 1999–February 2000. Cat. by Mariel Oberthür, Pierre Franc et al.

Narducci, H. M., 'The French Officer Corps and the Social Rôle of the Army, 1890–1908', Ph.D., Wayne State University, Detroit, 1981.

Natanson, Thadée, 'Expositions: IX Exposition de la Société des artistes indépendants', *Revue blanche*, no. 18, April 1893, pp. 271–6.

—, 'Expositions: Un groupe de peintres', *Revue blanche*, no. 25, November 1893, pp. 336–41.

—, 'Expositions: Collection Théodore Duret', *Revue blanche*, no. 30, April 1894, pp. 376–9.

—, 'Expositions: Exposition Odilon Redon', *Revue blanche*, no. 31, May 1894, pp. 470–3.

—, 'L'Art des Salons', *Revue blanche*, no. 46, 1 May 1895, pp. 421–4; ibid., no. 47, 15 May 1895, pp. 469–72.

—, 'Expositions', *Revue blanche*, no. 48, 1 June 1895, pp. 521–4.

—, 'Petite Gazette d'art', *Revue blanche*, XII, 1 February 1897, pp. 141–2.

—, 'Petite Gazette d'art: L'Art des Salons', *Revue blanche*, XII, 15 May 1897, pp. 141–2.

—, 'Notes sur l'art des Salons: II', *Revue blanche*, XVI, 15 June 1898, pp. 216–20.

—, 'Une Date de l'histoire de la peinture française:

Mars 1899', *Revue blanche*, XVII, 15 April 1899, pp. 504–12.

—, 'Des Peintres intelligents', *Revue blanche*, no. 22, May 1900, pp. 53–6.

—, *Peintres à leur tour*, Paris, 1948.

Nemo, 'Memento', *La Jeune Belgique*, X, no. 9, September 1891, pp. 354–5.

Nion, François de, 'La Ligue: Une campagne contre les grands magasins', *Revue indépendante*, no. 61, November 1891, pp. 145–54.

Nochlin, Linda, and Tamar Garb (eds), *The Jew in the Text: Modernity and the Construction of Identity*, London, 1995.

Nordau, Max, *Degeneration*, 1892 (US edn, New York, 1895).

A notre ami Bigand: Rodin, Redon, Moreau, Martigues, Musée Ziem, June–September 1992. Cat. by Gérard Fabre et al.

Nye, Robert A., *The Origins of Crowd Psychology: Gustave LeBon and the Crisis of Mass Democracy in the Third Republic*, London and Beverly Hills, 1975.

—, *Masculinity and Male Codes of Honour in Modern France*, Oxford, 1993.

Oberthür, Mariel, *Le Chat Noir, 1881–1897*, Paris, Musée d'Orsay, February–May 1992.

Offen, Karen, 'Depopulation, Nationalism and Feminism in Fin-de-siècle France', *American Historical Review*, vol. 89, no. 3, June 1984, pp. 648–76.

Ollinger-Zinque, Gisèle, 'Les Artistes Belges et la Rose+Croix', *Bulletin, Musées royaux des beaux-arts de belgique*, 1989–1991, 1–3, pp. 433–64.

O'Mahony, Claire, 'Municipalities and the Mural: The Decoration of Town Halls in Third Republic France', Ph. D., University of London, Courtauld Institute, 1997.

Oriol, Philippe, *Ravachol: Un saint nous est né!*, Paris, 1992.

Orwicz, Michael R. (ed.), *Art Criticism and its Institutions in Nineteenth Century France*, Manchester, 1994.

Ozouf, Mona, *L'Ecole, l'Eglise et la République, 1871–1914*, Paris, 1963 (1982 ed.).

Pange, Comtesse Jean de (Pauline de Broglie), *Comment j'ai vu 1900*, Paris, 1962.

Pagnol, Marcel, *My Father's Glory and My Mother's Castle*, London, 1989.

Painter, George D., *André Gide: A Critical Biography*, London, 1968.

Un Patriote aux origines de la puériculture: Gaston Variot (1855–1930), Paris, Musée de l'Assistance Publique, May–December 1984. Cat. by Nadine Simon-Dhouailly, Nicolas Sainte Fare Garnot, Françoise Beaugrand.

Pécaut E., and C. Baude, *L'Art: Simple entretiens à l'usage de la jeunesse*, Paris, 1885.

Les Peintres de l'âme: Le Symbolisme idéaliste en France, Brussels, Musée d'Ixelles, October–December 1999. Cat. by Jean-David Jumeau-Lafond.

Peinture et art nouveau, Nancy, Musée des Beaux-Arts, April–July 1999. Cat. by Jean-Paul Midant, Gabriel P. Weisberg and Michèle Leinen.

Péladan, Sâr, *Ordre de la Rose+Croix du Temple: Geste esthétique de 1892. Salon et soirées. Catalogue illustré du salon*, Paris, Galerie Durand-Ruel, 10 March–10 April, 1892.

—, 'L'Ordre de la Rose+Croix du temple et du Graal et ses salons', *L'Artiste*, nouv. pér., VIII, April 1894, pp. 241–8.

Pelley Fonteny, Monique Le, *Léon Augustin Lhermitte (1844–1925): Catalogue raisonné*, Paris, 1991.

Pernoud, Emmanuel, 'Peindre la foule: Un aspect du dessin satirique fin de siècle et ses relations avec la scène artistique', *Revue d'histoire du XIXe siècle*, vol. 19, no. 2, 1999, pp. 105–17.

—, 'The Art of Facsimile: Alfred Jarry and Reproduction', *Word & Image*, vol. 16, no. 4, October–December 2000, pp. 352–62.

Perrot, Michelle (ed.), *A History of Private Life*: IV. *From the Fires of Revolution to the Great War*, Cambridge, Mass., and London, 1990.

Perrot, Philippe, *Le Travail des apparences: Le corps féminin, XVIIIe–XIXe siècle*, Paris, 1984.

Persin, Patrick-Gilles, *Aman-Jean: Peintre de la femme*, Paris, 1993.

Perucchi-Petri, Ursula, 'Maurice Denis et le Japon', *Revue du Louvre*, 4, 1982, pp. 260–5.

Pick, Daniel, *War Machine: The Rationalisation of Slaughter in the Modern Age*, New Haven and London, 1993.

Pincus-Witten, Robert, 'Ideal Interlude: The First Retrospective of the Salons of the Rose-Croix', *Art Forum*, September 1968, pp. 51–4.

Pissarro, Camille, *Correspondance de Camille Pissarro*, ed. Janine Bailly-Herzberg, vol. 2, 1886–1890, Paris, 1986; vol. 3, 1891–1894, Paris, 1988; vol. 4, 1895–1898, Paris, 1989.

Pissarro, Lucien, *The Letters of Lucien to Camille Pissarro, 1883–1903*, ed. Anne Thorold, Cambridge, 1993.

Pissarro, Ludovic Rodo, and Lionello Venturi, *Camille Pissarro: Son art, son oeuvre*, 2 vols, Paris, 1939.

Poictevin, Francis, *Double*, Paris, 1889 (*Derniers Songes: Double*, ed. Bertrand Delcour, Paris, 1991).

Poinsot, M.-C., and A. Mérodack-Janneau, 'La Foule et la beauté', *Les Partisans*, no. 4, 20 December 1900, pp. 144–7.

Polyptyques: Le tableau multiple du moyen-âge au vingtième siècle, Paris, Louvre March–July 1990. Cat. by Michel Laclotte, Dominique Thiébaut, Rodophe Rapetti, Isabelle Monod-Fontaine et al.

Le Portrait à travers les collections du Musée Fabre, Montpellier, July–October 1979.

Pottier, Edmond, 'Les Salons de 1892: I', *Gazette des beaux-arts*, pér. 3, VII, June 1892, pp. 441–67; 'Les Salons de 1892: II', ibid., VIII, July 1892, pp. 5–44.

Price, Roger, *A Social History of Nineteenth-Century France*, London, 1987.

Prints Abound: Paris in the 1890s, Washington, D.C., National Gallery of Art, October 2000–February 2001. Cat. by Phillip Dennis Cate, Richard Thomson, Gale Murray.

Prochasson, Christophe, *Paris 1900: Essai d'histoire culturelle*, Paris, 1999.

La Promenade du critique influent: Anthologie de la critique d'art en France, 1850–1900, ed. Jean-Paul Bouillon, Nicole Dubreuil-Blondon, Antoinette Ehrard, Constance Naubert-Riser, Paris, 1990.

Proust, Marcel, *Jean Santeuil*, trans. Gerard Hopkins, London, 1985.

—, *Selected Letters, 1880–1903*, ed. Philip Kolb, Oxford, 1985.

Prouvé, Madeleine, *Victor Prouvé, 1858–1943*, Nancy, 1958.

M. *Puvis de Chavannes, Exposition de tableaux, pastels, dessins par*, Paris, Galerie Durand-Ruel, 1887. Preface by Roger-Ballu.

Puvis de Chavannes, 1824–1898, Paris, Grand Palais, November 1976–February 1977. Cat. by Louise d'Argencourt and Jacques Foucart.

Pierre Puvis de Chavannes, Amsterdam, Van Gogh Museum, February–May 1994. Cat. by Aimée Brown Price.

Quand Paris dansait avec Marianne, 1879–1889. Paris, Petit Palais, March–August 1989. Cat. by Thérèse Burollet, Guénola Groud and Daniel Imbert.

Rachilde, *La Marquise de Sade*, Paris, 1887.

Jean-François Raffaëlli, Paris, Musée Marmottan-Monet, September 1999. Cat. by Marianne Delafond and Caroline Genet-Bondeville.

Ralston, D., *The Army of the Republic: The Place of the Military in the Political Evolution of France, 1871–1914*, Cambridge, Mass., and London, 1967.

Rambosson, Yvanhoë, 'Les Livres', *Mercure de France*, XVI, November 1895, p. 259.

—, 'Le Salon des Indépendants', *La Plume*, no. 194, 15 May 1897, pp. 311–13.

Paul Elie Ranson, 1861–1909: Du symbolisme à l'art nouveau, Saint-Germain-en-Laye, Musée Départmental Maurice Denis 'Le Prieuré', October 1997–Janury 1998. Cat. by Brigitte Ranson Bitker, Gilles Genty, Agnes Delannoy.

Rearick, Charles, *Pleasures of the Belle Epoque: Entertainment and Festivity in Turn-of-the-Century France*, New Haven and London, 1985.

Rebell, Hugues, *De mon balcon*, ed. S. Le Couëdic, Paris, 1994.

Reclus, Elisée, *L'Homme et la terre*, I, ed. Béatrice Giblin, Paris, 1982.

Redon, Arï (ed.), *Lettres de Gauguin, Gide, Huysmans, Jammes, Mallarmé, Verhaeren . . . à Odilon Redon*, Paris, 1960.

Redon, Odilon, *A Soi-même: Journal, 1867–1915*, Paris, 1961.

—, *Lettres inédites d'Odilon Redon à Bonger, Jourdain, Viñes*, ed. Suzy Levy, Paris, 1987.

Régnier, Henri de, 'Philosophie du pastel', *Entretiens politiques et littéraires*, no. 2, 1 May 1890, pp. 46–51.

Renard, Jules, *L'Ecornifleur*, Paris, 1892 (Eng. ed., 1957).

—, *Correspondance de Jules Renard*, Paris, 1928.

—, *Journal*, Paris, 1935.

—, *Lettres inédites, 1883–1910*, ed. L. Guichard, Paris, 1957.

Renaud, J., 'Le Salon du Champ-de-Mars', *Le Triboulet*, no. 18, 3 May 1896, pp. 4–6.

Renoir, Paintings by, Chicago, Art Institute, February–April, 1973. Cat. by Jean Renoir, François Daulte, John Maxon.

Renoir, London, Hayward Gallery, January–April 1985. Cat. by Anne Distel, Lawrence Gowing and John House.

Retté, Adolphe, 'Septième exposition des artistes indépendants: Notes cursives', *L'Ermitage*, no. 5, May 1891, pp. 293–301.

—, 'L'Art et l'anarchie', *La Plume*, no. 91, 1 February 1893, pp. 45–6.

—, *Le Symbolisme: Anecdotes et souvenirs*, Paris, 1903.

La Révolution de la photographie instantanée, 1880–1900, Paris, Bibliothèque Nationale, October 1996–January 1997. Cat. by Sylvie Aubenas and André Gunthert.

Rewald, John, *Georges Seurat*, Paris, 1948.

Reynolds, Sîan, 'After Dreyfus and before the Entente: Patrick Geddes's Cultural Diplomacy at the Paris Exhibition of 1900', in *Problems in French History*, ed. Martyn Cornick and Ceri Crossley, Basingstoke, 2000, pp. 149–67.

Richer, Dr Paul, *Etudes cliniques sur la grande hystérie ou hystéro-épilepsie*, Paris, 1885.

Rictus, Jehan, *Les Soliloques du pauvre*, Paris, 1895.

Rivière, Jacques, 'Albert Besnard décorateur', *Art et décoration*, XXVII, May 1910, pp. 153–72.

Robichez, Jacques, 'La première représentation de Strindberg à Paris', *Revue d'histoire du théâtre*, no. 3, 1978, pp. 272–90.

Robichon, François, 'Les panoramas de Champigny et Rezonville par Edouard Detaille et Alphonse de Neuville', *Bulletin de la Société de l'Histoire de l'art français*, année 1979, Paris, 1981, pp. 259–77.

—, *L'Armée française vue par les peintres, 1870–1914*, Paris, 1998.

Robiquet, Jean, 'Chronique artistique: Le Salon du Champ-de-mars', *L'Art et la vie*, nos 15–16, July 1893, pp. 311–16.

Rod, Edouard, 'Les Salons de 1891 au Champ-de-Mars et aux Champs-Elysées. I', *Gazette des beaux-arts*, pér. 3, XXXIII, vol. 5, June 1891, pp. 441–69; II, ibid., XXXIII, vol. 6, July 1891, pp. 5–34.

Rodin et les écrivains de son temps, Paris, Musée Rodin, June–October 1976. Cat. by Claudie Judrin.

Rodin's Monument to Victor Hugo, Los Angeles County Museum of Art, December 1998–March 1999. Cat.

by Ruth Butler, Jeanine Pariser Plottel and Jane Mayo Roos.

Rodin en 1900: L'exposition de l'Alma, Paris, Musée du Luxembourg, March–July 2001. Cat. by Antoinette Le Normand-Romain, Claudie Judrin, Hélène Pinet.

Roinard, P. N., 'Calvaire annuel', *Essais d'art libre*, no. 6, July 1892, pp. 237–47.

The Romantics to Rodin: French Nineteenth Century Sculpture from North American Collections, Los Angeles County Museum of Art, March–May 1980. Cat. by Peter Fusco and H. W. Janson.

Félicien Rops: Rops suis, aultre ne veulx estre, Namur, Musée de la Culture, September–October 1998. Cat. by Hélène Védrine, Sébastien Clerbois, Catherine Méneux et al.

Rosario, Vernon A., *The Erotic Imagination: French Histories of Perversity*, Oxford, 1997.

Roslak, Robyn S., 'The Politics of Aesthetic Harmony: Neo-Impressionism, Science, and Anarchism', *Art Bulletin*, LXXIII, no. 3, September 1991, pp. 381–90.

Rothenstein, William, *Men and Memories: Recollections of William Rothenstein, 1872–1900*, I, London, 1931.

Rouen: Les cathédrales de Monet, Rouen, Musée des Beaux-Arts, June–November 1994.

Ker-Xavier Roussel, 1867–1944, St Germain-en-Laye, Musée Départemental Maurice Denis 'Le Prieuré', March–May 1994. Cat. by Agnès Delannoy et al.

Roze, Francis, 'Edouard Detaille et l'Armée française', *Paris illustré*, no. 91, 28 September 1888, pp. 686–97.

Rubin, William, 'Shadows, Pantomimes and the Art of the Fin-de-Siècle', *Magazine of Art*, XLVI, no. 3, March 1953, pp. 114–22.

Rue Rufener, H. La, *Biography of a War Novel: Zola's 'La Débâcle'*, New York, 1946.

Sainte-Claire, 'Les Livres', *La Plume*, no. 112, 15 December 1893, p. 542.

'Sarkis', 'En liberté: A propos d'une icone', *La Plume*, no. 190, 15 March 1897, pp. 174–5.

Sarraut, [Maurice], 'Une Exposition décentralisatrice', *L'Artiste*, nouv. pér., VIII, July 1894, pp. 4–12.

Saunier, Charles, 'Jean Baffier', *Revue indépendante*, no. 60, October 1891, pp. 90–3.

—, 'Emile Bourdelle', *Revue indépendante*, no. 62, December 1891, pp. 371–81.

—, 'Critique d'art: Salon des indépendants', *La Plume*, no. 96, 15 April 1893, pp. 171–3.

—, 'Vitraux pour Jeanne d'Arc', *La Plume*, no. 109, 1 November 1893, pp. 456–8.

—, 'Alexandre Charpentier', *Les Maîtres artistes*, no. 4, 30 August 1902, pp. 106–11.

Sautman, Francesca Canadé, 'Invisible Women: Lesbian Working-Class Culture in France, 1880–1930', in Jeffrey Merrick and Bryant T. Ragan Jr (eds), *Homosexuality in Modern France*, New York and Oxford, 1996, pp. 177–201.

Schade, Sigrid, 'Charcot and the Spectacle of the Hysterical Body: The 'Pathos Formula' as an Aesthetic Staging of Psychiatric Discourse – a Blind Spot in the Reception of Warburg', *Art History*, vol. 18, no. 4, December 1995, pp. 499–517.

Schwartz, Vanessa R., 'Museums and Mass Spectacle: The Musée Grévin as a Monument to Modern Life', *French Historical Studies*, vol. 19, no. 1, Spring 1995, pp. 7–26.

—, *Spectacular Bodies: Early Mass Culture in Fin-de-siècle Paris*, Berkeley, Los Angeles and London, 1998.

Schwarz, Dieter (ed.), *Les Interviews de Mallarmé*, Paris, 1995.

Schwob, Marcel, *Chroniques*, ed. John Alden Green, Geneva, 1981.

Seager, F. H., 'The Alsace-Lorraine Question in France, 1871–1914', in *From the Ancien Régime to the Popular Front: Essays in the History of Modern France*, ed. C. K. Warner, New York and London, 1969, pp. 111–26.

Séailles, Gabriel, *Eugène Carrière: Essai de biographie psychologique*, Paris, 1911.

La Semeuse a 100 ans: Hommage à Oscar Roty (1846–1911), Paris, Hôtel de la Monnaie, May–June 1998. Cat. by Evelyne Cohen.

Sérusier, Paul, *ABC de la peinture*, Paris, 1921 (La Rochelle, 1995 ed.).

Shapiro, Ann-Louise, *Breaking the Codes: Female Criminality in Fin-de-siècle Paris*, Stanford, 1996.

Shattuck, Roger, *The Banquet Years: The Origins of the Avant-Garde in France. 1885 to World War I*, New York, 1968 (rev. ed.).

Shaw, Jennifer L., 'Imagining the Motherland: Puvis de Chavannes, Modernism, and the Fantasy of France', *Art Bulletin*, LXXIX, no. 4, December 1997, pp. 586–610.

Silverman, D. P., *Reluctant Union: Alsace-Lorraine and Imperial Germany, 1871–1918*, Philadelphia, 1972.

Silverman, Debora L., *Art Nouveau in Fin-de-siècle France: Politics, Psychology, and Style*, Berkeley, Los Angeles and London, 1989.

Silverman, Willa Z., *The Notorious Life of Gyp: Right-Wing Anarchist in Fin-de-Siècle France*, Oxford, 1995.

Silvestre, Armand, *Le Nu au Salon de 1889*, Paris, 1889.

—, *Le Nu au Salon 1890 (Champ de Mars)*, Paris, 1890.

—, *Le Nu au Champ de Mars*, Paris, 1891.

Simpson, Juliet, *Aurier, Symbolism and the Visual Arts*, Bern, 1999.

—, 'The Société Nationale: The Politics of Innovation in Late Nineteenth Century France', *Apollo*, CXLIX, no. 444, February 1999, pp. 49–54.

—, 'Symbolist Aesthetics and the Decorative Image/Text', *French Forum*, vol. 25, no. 2, May 2000, pp. 177–204.

Sizeranne, Robert de la, 'Les Paysans aux Salons de 1899', *Revue des deux mondes*, pér. 4, vol. 153, 15 May 1899, pp. 407–34.

Slatkin, Wendy, 'Maternity and Sexuality in the 1890s', *Women's Art Journal*, vol. 1, no. 1, Spring/Summer 1980, pp. 13–19.

Smith, Paul, ' "Parbleu": Pissarro and the Political Colour of an Original Vision', *Art History*, vol. 15, no. 2, June 1992, pp. 223–47.

Sonn, Richard D., *Anarchism*, New York, 1992.

Soucy, R., *Fascism in France: The Case of Maurice Barrès*, Berkeley and Los Angeles, 1972.

Souillac, Maurice de, *Zé'Boïm*, Paris, 1889.

Soulier, Gustave, 'Conclusion sur la peinture aux salons', *Art et décoration*, II, July–December 1897, pp. 43–8.

Stars et monstres sacrés, Paris, Musée d'Orsay, December 1986–March 1987. Cat. by Jean-Michel Nectoux.

Stasi, Laure, '*La Salle du Chevalier*: "le charme de parcourir ensemble les chemins mystérieux de l'idéal"', *48 14. La revue du Musée d'Orsay*, no. 11, Autumn 2000, pp. 56–63.

Steinlen, Théophile, *Dans la vie*, Paris, 1901. Pref. by Camille de Sainte-Croix.

—, *Steinlen's Drawings: 121 Plates from 'Gil Blas illustré'*, New York, 1980.

Steinlen et l'époque 1900, Geneva, Musée Rath, September 1999–January 2000. Cat. by Stéphane Cecconi, Nathalie Chaix, Brigitte Monti et al.

Sutcliffe, A., 'The Impressionists and Haussmann's Paris', *French Cultural Studies*, VI, 1995, pp. 197–219.

Sutter, Jean, *Maximilien Luce, 1858–1941: Peintre anarchiste*, Paris, 1986.

Sutton, Michael, *Nationalism, Positivism and Catholicism: The Politics of Charles Maurras and French Catholics, 1890–1914*, Cambridge, 1982.

Tabarant, Adolphe, *Maximilien Luce*, Paris, 1928.

Tailhade, Laurent, *Au Pays du mufle*, new edn, Paris, 1894.

Talmeyr, Maurice, 'L'Age de l'affiche', *Revue des deux mondes*, CXXXVII, September 1896, pp. 201–16.

Taxil, Léo, *La Corruption fin-de-siècle*, Paris, 1891.

Teich, M., and R. Porter (eds), *Fin de Siècle and its Legacy*, Cambridge, 1990.

Thiébault-Sisson, 'L'Art décoratif aux salons, ou en est le nouveau style?', *Art et décoration*, I, January–June 1897, pp. 97–104.

Thiesse, Anne-Marie, *Le Roman du quotidien: Lecteurs et lectures populaires à la belle époque*, Paris, 1984 (2000 ed.).

Thomson, Belinda, 'Camille Pissarro and Symbolism: Some Thoughts prompted by the Recent Discovery of an Annotated Article', *Burlington Magazine*, CXXIV, no. 946, January 1982, pp. 14–23.

—, *Vuillard*, Oxford, 1988.

Thomson, Richard, 'Camille Pissarro, *Turpitudes sociales*, and the Universal Exhibition of 1889', *Arts Magazine*, vol. 56, no. 8, April 1982, pp. 82–8.

—, *Seurat*, Oxford, 1985.

—, *The Private Degas*, London, 1987.

—, *Degas: The Nudes*, London, 1988.

—, *Camille Pissarro: Impressionism, Landscape and Rural Labour*, London, 1990.

—, 'Rubens, Cézanne and Late Nineteenth Century French Art', *Cézanne and Poussin: A Symposium*, ed. Richard Kendall, Sheffield, 1993, pp. 113–28.

—, 'Toulouse-Lautrec, Arthur Huc et le "néo-réalisme"', *Actes du colloque Toulouse-Lautrec, Albi, mai 1992*, ed. Danièle Devynck, Albi, 1994, pp. 117–31.

—, *Monet to Matisse: Landscape Painting in France, 1874–1914*, Edinburgh, National Gallery of Scotland, 1994. Essay by Michael Clarke.

—, 'Henri Martin at Toulouse: *terre natale* and *juste milieu*', in *Framing France: The Representation of Landscape in France, 1870–1914*, ed. R. Thomson, Manchester, 1998, pp. 147–72.

—, 'A propos de lesbianisme clandestin en plein Paris: La décadence et le *Rond-point des Champs-Elysées* de Louis Anquetin', *Histoire de l'Art*, no. 50, June 2002, pp. 77–83.

Thulié, H., *La Femme: Essai de Sociologie Physiologique*, Paris, 1885.

Tint, H., *The Decline of French Patriotism, 1870–1940*, London, 1964.

'Tipereth', 'L'Art', *Le Coeur*, no. 1, April 1893, pp. 6–7.

—, 'Le Salon du Champ-de-Mars', *Le Coeur*, no. 3, June 1893, pp. 5–8.

—, 'Regard en arrière et simples refléxions sur l'art en 1894', *Le Coeur*, no. 9, December 1894, pp. 6–8.

Tissot, James, *The Life of our Saviour Jesus Christ*, 2 vols, London, 1897.

James Tissot, ed. Krystyna Matyjaszkiewicz, Oxford, 1984.

Tombs, Robert (ed.), *Nationhood and Nationalism in France: From Boulangism to the Great War, 1889–1918*, London, 1991.

Tomlinson, R., 'The 'Disappearance' of France, 1896–1940: French Politics and the Birth Rate', *Historical Journal*, vol. 28, no. 2, 1985, pp. 405–15.

Toulouse-Lautrec, Henri de, *The Letters of Henri de Toulouse-Lautrec*, ed. Herbert Schimmel, intro. Gale B. Murray, Oxford, 1991.

Toulouse-Lautrec, London, Hayward Gallery, October 1991–January 1992. Cat. by Richard Thomson, Claire Frèches-Thory, Anne Roquebert and Danièle Devynck.

Le Triomphe des mairies: Grands décors républicains à Paris, 1870–1914, Paris, Petit Palais, November 1986–January 1987. Cat. by Thérèse Burollet, Daniel Imbert and Frank Foliot.

Tucker, Paul Hayes, *Monet in the '90s: The Series Paintings*, New Haven and London, 1989.

Uzanne, Octave, *The Mirror of the World*, London, 1889.

—, 'Les Artistes originaux: Eugène Grasset. Illustrateur, architecte, et décorateur', *L'Art et l'idée*, no. 10, 20 October 1890, pp. 192–220.

Vaisse, Pierre, *La Troisième République et les peintres*, Paris, 1995.

Valabrègue, Antony, 'Les Artistes décorateurs, III: M. Albert Besnard', *Revue des arts décoratifs*, III, November–December 1891, pp. 136–45.

Val-d'Orcédès, 'Les Passants: Jean Veber', *La Route*, 15 November 1912.

Valin, Pierre, 'Les Lettres prochaines: Essai sur les tendances des écrivains de demain', *L'Art et l'idée*, no. 8, 20 August 1892, pp. 81–92.

V(allotton), F(élix), 'Beaux-Arts: Le Salon de la Rose+Croix', *Gazette de Lausanne*, 4 December 1891.

—, 'Beaux-Arts: Le Salon du Champ-de-Mars', *Gazette de Lausanne*, 2 May 1895.

—, 'Beaux-Arts: Le Salon des Champs-Elysées', *Gazette de Lausanne*, 16 May 1895.

Félix Vallotton, The Graphic Work of, 1865–1925, London, Arts Council, 1976. Cat. by MaryAnne Stevens and Ashley St James.

Félix Vallotton: A Retrospective, New Haven, Yale University Art Gallery, October 1991–January 1992. Cat. by Sasha M. Newman et al.

Vallotton, Le très singulier, Lyon, Musée des Beaux-Arts, February–May 2001. Cat. by Marina Ducrey, Claire Frèches-Thory, Dominique Brachlianoff et al.

Vanderspelden, Jean-Pierre, *Jean-Antoine Injalbert, statuaire, 1845–1933: Catalogue du fonds des ateliers de Paris et de Béziers au Musée des beaux-arts*, Béziers, 1991.

Vanor, Georges, 'Notes et Notules', *Entretiens politiques et littéraires*, no. 4, 1 July 1890, p. 134.

—, 'La Nouvelle Jérusalem', *Entretiens politiques et littéraires*, no. 6, 1 September 1890, pp. 183–5.

Varias, Alexander, *Paris and the Anarchists: Aesthetes and Subversives during the fin-de-siècle*, London, 1997.

Veber, Pierre, 'L'Irréparable', *Revue blanche*, no. 3, January 1892, pp. 28–40.

—, and Jean Veber, *Les Vebers*, Paris, 1895.

—, and Louis Lacroix, *L'Oeuvre lithographique de Jean Veber*, Paris, 1931.

Veidaux, André, 'Philosophie d'anarchie', *La Plume*, no. 97, 1 May 1893, pp. 189–93.

Velde, Henry van de, 'Notes sur l'Art: Chahut', *La Wallonie*, V, 1890, pp. 122–5.

Velter, André (ed.), *Les Poètes du Chat Noir*, Paris, 1996.

Vento, Claude, *Les Peintres de la femme*, Paris, 1888.

Verkade O.S.B., Dom Willibrord, *Le Tourment de Dieu*, Paris, 1923.

Vielé-Griffin, Francis, 'Le Banquet d'hier', *Entretiens politiques et littéraires*, no. 11, 1 February 1891, pp. 58–62.

Vitry, Paul, 'La *Frise du Travail* de M. Guillot', *Art et décoration*, VII, January–June 1900, pp. 155–60.

Vogüé, Melchior de, *Devant le siècle*, Paris, 1896.

Vollard, Ambroise, *Souvenirs d'un marchand de tableaux*, Paris, 1937.

Vuillard, Glasgow Art Gallery and Museum, September–October 1991. Cat. by Belinda Thomson.

W., J.-E., 'Notes sur les Salons de 1892: Palais des beaux-arts et de l'Industrie. Société des artistes français', *Revue blanche*, II, May 1892, pp. 290–301.

Ward, Martha, *Pissarro, Neo-Impressionism and the Spaces of the Avant-Garde*, Chicago and London, 1996.

Warner, Marina, *Joan of Arc: The Image of Female Heroism*, London, 1981 (1983 ed.).

Watteeuw, Jules, 'Rémy Cogghe', *La Brouette* (Tourcoing), 10 August 1902.

Weber, Eugen, *France fin-de-siècle*, Harvard, 1986.

Jean-Joseph Weerts, Roubaix, Musée des Beaux-Arts, 1989. Cat. by Didier Schulmann.

Weisberg, Gabriel P., 'From the Real to the Unreal: Religious Painting and Photography at the Salons of the Third Republic', *Arts Magazine*, vol. 60, no. 4, December 1985, pp. 58–63.

—, 'Louis Legrand's Battle over *Prostitution*: The Uneasy Censoring of *Le Courrier français*', *Art Journal*, vol. 51, no. 1, Spring 1992, pp. 45–50.

—, 'Albert Besnard at Berck-sur-Mer: Decorative Art Nouveau Painting in Public Buildings', *Apollo*, CLI, no. 459, May 2000, pp. 52–8.

Weiss, Mme Augusta, *La Femme. La Mère. L'Enfant. Guide à l'usage des jeunes mères*, Paris, 1897.

Weisz, G., *The Emergence of Modern Universities in France, 1863–1914*, Princeton, 1983.

Wentworth, Michael, *James Tissot*, Oxford, 1984.

Williams, Rosalind H., *Dream Worlds: Mass Consumption in Late Nineteenth Century France*, Berkeley, Los Angeles and Oxford, 1982.

Wilson, Michael, ' "Sans les femmes, qu'est-ce qui nous resterait?": Gender and Transgression in Bohemian Montmartre', in *Body Guards: The Cultural Politics of Gender Ambiguity*, ed. Julia Epstein and Kristina Straub, New York and London, 1991, pp. 195–222.

Wolff, Albert, *1890: Figaro-Salon*, Paris, 1890.

Wittrock, Wolfgang, *Toulouse-Lautrec: The Complete Prints*, 2 vols, London, 1985. Essays by Antony Griffiths and Richard Thomson.

Wright, G., *Between the Guillotine and Liberty. Two Centuries of the Crime Problem in France*, New York/Oxford, 1983.

Wyzewa, Téodor de, 'Le Salon de 1894: I. La Peinture', *Gazette des beaux-arts*, pér. 3, XI, June 1894, pp. 449–68; Le Salon de 1894: II. La Sculpture', ibid., XII, July 1894, pp. 25–42.

—, *Peintres de jadis et d'aujourd'hui*, Paris, 1903.

X., 'Choses et autres', *La Vie parisienne*, 6 June 1891, p. 319.

—, 'Choses et autres', *La Vie parisienne*, 6 October 1894, p. 563.

Yourcenar, Marguerite, *How Many Years*, London, 1998.

Yriarte, Charles, 'Le Salon du Champ-de-Mars', *Le Figaro*, 9 May 1893.

—, 'Beaux-Arts: Salon du Champ-de-Mars. Gravures.

Dessins. Aquarelles. Pastels. Objets d'art', *Le Figaro*, 21 June 1893.

Zeldin, Theodore, *France 1848–1945: I. Ambition, Love and Politics*, Oxford, 1973.

Zévaès, Alexandre, *Aristide Bruant*, Paris, 1943.

Zimmermann, Michael F., *Seurat and the Art Theory of his Time*, Antwerp, 1991.

Zola, Emile, *La Débâcle*, Paris, 1892; *Oeuvres complètes*, ed. H. Mitterand, vol. 6, Paris, 1967.

—, *Paris*, Paris, 1898; *Oeuvres complètes*, ed. H. Mitterand, vol. 7, Paris, 1968.

—, *Le Bon Combat: De Courbet aux impressionnistes*, ed. Jean-Paul Bouillon, Paris, 1974.

—, *Carnets d'enquêtes: Une ethnographie inédite de la France*, ed. H. Mitterand, Paris, 1986.

1889: La Tour Eiffel et l'Exposition Universelle, Paris, Musée d'Orsay, May–August 1989. Cat. by Caroline Mathieu, Laurence Le Loup, Henri Loyrette et al.

1900, Paris, Grand Palais, 14 March–26 June 2000. Cat. by Philippe Thiébaut, Bruno Girveau, Marie-Pierre Salé, Emmanuelle Héran, Françoise Heilbrun and Luce Abélès.

PHOTOGRAPH CREDITS

© LL-Viollet: 1, 2; All rights reserved: Musée Toulouse-Lautrec, Albi, Tarn, France: 3; Roger-viollet: 4, 5; © ADAGP, Paris, and DACS, London, 2004/ Cliché P. Cadiou: 7; © ADAGP, Paris, and DACS, London, 2004: 8, 17, 23, 49, 53, 57, 58 59, 60, 66, 68, 73, 76, 86, 89, 104, 107, 110, 124, 126, 127, 162; Coll. Dutailly, Les silos, maison du livre et de l'affiche (Chaumont); Photo C. Jobard: 9; May Voigt, Cheminitz: 11; © Photo RMN: 12, 15, 18, 20, 22, 57, 59, 75, 78, 88, 101, 107, 112, 124, 175, 176; Studio Monique Bernaz, Genève: 21; © Musée Rodin (photo Adam Rzepka): 25, 43, 47, 81; photo by Jack Abraham: 26, 27, 37, 46, 63, 72, 116, 159, 169; © Fondation Félix Vallotton, Lausanne, photographie François Vallotton, Lausanne: 30; © Fondation Félix Vallotton, Lausanne, photographie François Vallotton, Lausanne/ Courtesy of the J. Paul Getty

Museum: 34; © Photo RMN – Hervé Lewandowski: 49, 129; © PMVP/cliché Pierrain: 50, 137, 140, 173; © Fondation Félix Vallotton, Lausanne, photographie Jean Testard, Lausanne: 55; © Fondation Félix Vallotton, Lausanne: 56; Photo P. S. Azema: 60; Bridgeman Art Library: 62, 67; image © The Art Institute of Chicago: 64; © PMVP/cliché Ladet: 66; Cliché Ville de Nantes – Musée des Beaux-Arts: 71; © Board of Trustees, National Gallery of Art, Washington: 83; © 2004 President and Fellows of Harvard College: 84; photo by Victor Pustai: 89; All rights reserved, The Metropolitan Museum of Art: 93, 94; © PMVP/cliché Andreani: 96; © Photo RMN – B. Hatala: 99; Photo Musée de Poitiers, Ch. Vignaud: 102; Photo Laurent-Sully Jaulmes, tous droits réservés: 107, 147; Cliché Charles Choffet: 109; Arsène Bonafous-Murat, Paris: 109; Photothèque de l'Assistance

Publique-Hôpitaux de Paris: 113; © Photo RMN – Arnaudet: 114, 146; The Abraham Lincoln Foundation of the Union League of Philadelphia: 115; Photograph © 2004 Museum of Fine Arts, Boston: 125; Rouen, Musée des Beaux-Arts. Don de l'artiste 1922. Musées de la ville de Rouen/photographie Catherine Lancien, Carole Loisel: 126; Carnegie Museum of Art, Pittsburgh; Gift of Henry Clay Frick: 128; © Studio Basset: 131; Cliché: Madame Chapeaux, Musée des Beaux-Arts, Arras: 133; Arnaud Loubry – Photographe: 134; Avec l'autorisation du Pyrtanée National Militaire: 139; © PMVP/cliché Jean-Yves Trocaz: 142; © PMVP/cliché Joffre: 145a, 145b; © Centre de monuments nationaux: 152; Cussac: 162; photo: Patrick Flesch, archives municipales de Colmar: 172.